NEW YORK REVIEW BOOKS CLASSICS

LIFE WITH PICASSO

FRANÇOISE GILOT (b. 1921) was born in Paris to an agronomist father and an artist mother. Having decided to be a painter at the age of five, she began her training in art while still in her early youth. She later studied law at her father's insistence but returned to painting during the Second World War. Because of the censorship of art in Nazi-occupied France, Gilot's early work relied heavily on symbols. In 1943 she met Pablo Picasso and they lived together for ten years. They had two children: Claude, born in 1947, and Paloma, born in 1949. In 1950, the art dealer Daniel-Henry Kahnweiler took Gilot under contract at his gallery. After leaving Picasso in 1953, Gilot rekindled a friendship with the surrealist painter Luc Simon. They were married in 1955 and their daughter, Aurélia, was born the following year, though the couple would separate in 1961. Gilot began exhibiting in the United States in the early 1960s and in 1962 the Tate Gallery provided her a studio in London where she painted an abstract series about the myth of Theseus and the Minotaur. In 1969, after an exhibition in Los Angeles, she met Jonas Salk; they were married in 1970 and lived and worked in California, Paris, and New York until Salk's death in 1995. Gilot's American period is marked by a bold use of color and movement. In addition to painting, Gilot has written several books, including Interface: The Painter and the Mask (1975), the biography Matisse and Picasso: A Friendship in Art (1990), and, with Lisa Alther, About Women: Conversations Between a Writer and a Painter (2016). Her art is in the collections of, among other museums, MoMA, the Metropolitan Museum of Art, and the Pompidou Center; she has shown around the world, including a 2012 dual exhibition with Picasso's

work at the Gagosian Gallery in New York and a series of retrospectives from 2010 to 2012 in Japan, Hungary, Germany, and the United States. She was made an Officer of the Légion d'Honneur in 2009.

CARLTON LAKE (1915–2006) was an art critic, curator, and collector. He was the Paris art critic for *The Christian Science Monitor* and contributed art criticism to a number of publications, including *The New Yorker* and *The Atlantic*. After returning to the United States in 1975, he became the curator of the French Collection at the Harry Ransom Center at the University of Texas at Austin, where he had donated his extensive collection of French art, manuscripts, and music. His other books include *A Dictionary of Modern Painting* (1956), *In Quest of Dali* (1969), and *Confessions of a Literary Archaeologist* (1990).

LISA ALTHER is the author of seven novels, a memoir, a short-story collection, and a narrative history. In addition to writing *About Women* with Françoise Gilot, Alther's novella *Birdman and the Dancer* is illustrated with monotypes by the artist.

FRANÇOISE GILOT and CARLTON LAKE

Introduction by

LISA ALTHER

NEW YORK REVIEW BOOKS

New York

THIS IS A NEW YORK REVIEW BOOK PUBLISHED BY THE NEW YORK REVIEW OF BOOKS 435 Hudson Street, New York, NY 10014 www.nyrb.com

Copyright © 1964 by Françoise Gilot and Carlton Lake Introduction copyright © 2019 by Lisa Alther All rights reserved.

Frontis: Robert Capa, *Pablo Picasso and Françoise Gilot at Their Home*, 1951; copyright © by the International Center of Photography/Magnum Photos

The publishers would like to thank Aurélia Engel for her assistance in the publication of this volume.

Library of Congress Cataloging-in-Publication Data Names: Gilot, Françoise, 1921– author. | Lake, Carlton, author. Title: Life with Picasso / by Françoise Gilot and Carlton Lake. Description: New York : New York Review Books, [2019] | Series: New York Review Books Classics | Originally published: New York : McGraw-Hill, c1964. Identifiers: LCCN 2018025719| ISBN 9781681373195 (alk. paper) | ISBN 9781681373201 (epub) Subjects: LCSH: Gilot, Françoise, 1921– | Picasso, Pablo, 1881–1973. | Painters—France—Biography. Classification: LCC ND553.P5 G55 2019 | DDC 759.4 [B]—dc23 LC record available at https://lccn.loc.gov/2018025719

ISBN 978-1-68137-319-5 Available as an electronic book; ISBN 978-1-68137-320-1

Printed in the United States of America on acid-free paper. 1 0 9 8 7 6 5

CONTENTS

Introduction · vii LIFE WITH PICASSO · 5 Part I · 11 Part II · 47 Part III · 105 Part IV · 153 Part V · 197 Part VI · 235 Part VII · 301 Index · 337 Illustration Credits · 343

I FIRST encountered Françoise Gilot as a painter, not a writer, at an exhibition of her work in Paris in 1986. Small and slender with excellent posture and intense green eyes, she was friendly and funny. She also struck me as a powerful person, an impression her paintings reinforced with their bold shapes and vibrant colors.

A couple of years later I came across her memoir *Life with Picasso*. Although of course aware of Pablo Picasso's status as a demigod in the art world, I read the book from an interest in its author rather than its subject. What most impressed me, as a writer myself, was how well written it was. Although French was Gilot's first language, she had composed the book in a much better English than most of us native English speakers can usually muster. Once I got to know her, I asked her about this, and she replied that she has written all her books, of which there are now a dozen, in English because she prefers the shorter sentences. French sentences can run on for an entire page, she explained, including many unnecessary details and qualifications, whereas English sentences are usually more crisp and succinct. She also mentioned that the nuns in her convent school were so severe in their criticisms that she feels less inhibited when writing in English, which she learned in school and during childhood summers in England.

Gilot also expressed gratitude to Carlton Lake, an American journalist listed as her co-author on *Life with Picasso*, for persuading her to undertake the book and for handling the technical aspects of the project—the taping and typing. They met three afternoons a week for a couple of years, on the first afternoon taping Gilot's recollections of her relationship with Picasso. The next day she would rework the typescript, and on the third day she would review the edited episodes and place them within the text.

When *Life with Picasso* was published in 1964, it generated a lot of controversy. Picasso launched—and lost—three lawsuits trying to prevent its

publication. Some forty French artists and intellectuals, many presumed champions of free speech, many former "friends" of Gilot when they believed she could smooth their pathway to Picasso, signed a manifesto demanding that the book be banned. They evidently found it acceptable for Picasso to have used Gilot's likeness in hundreds of his artworks—but scandalous if she portrayed him in hers. In that pre–Me Too era, women were not supposed to bite the tires of the Humvees that were rolling over them.

More than fifty years later, I have difficulty comprehending the objections to this book, since Picasso emerges from its pages as the supremely gifted artist that he undoubtedly was. His methods and rationales regarding his painting and drawing are lucidly described, as are his groundbreaking excursions into etching, lithography, sculpture, and pottery. Gilot makes it clear that he was a genius of invention and a force of nature, someone whose compulsive creativity was constantly percolating. He deconstructed and reconfigured everything he encountered, including the works of old masters as well as those of his own contemporaries. His goal seemed always to dismantle stale visual clichés and to employ familiar forms in unusual ways, in order to stimulate fresh perceptions and emotions in his viewers. Picasso also comes across in the book as an amusing character at times, with an antic sense of humor.

But all accurate portraits must include some shadows. That Gilot exposed his shadows—his moodiness, selfishness, perversity, and casual cruelty—was what Picasso could not endure. When Gilot met Picasso, he was on the verge of becoming a media star. Because he had stayed in Paris during the German occupation, he was widely admired. Later, he became a darling of the International Communist Party. His accomplishments from a lifetime of hard work were being widely shown and appreciated, selling for large sums. Unfortunately, he began to believe the hype, and to expect and demand only praise. Also, Picasso turned seventy during his relationship with Gilot, and his apparent fear of death, no doubt magnified by various unresolved childhood traumas, led him to require a parade of increasingly younger women to help him avoid facing the sobering realities of aging.

Although nonfiction, Life with Picasso first read to me like a bildungsro-

man—a novel that concerns the education of a young person in the ways of the world. But this memoir was even more compelling than a good novel because it had really happened. I became intrigued watching this young woman, raised by extremely cultivated parents who belonged to the intellectual bourgeoisie of Paris, as she fell in love with—and then fell out of love with—the bohemian who became the most famous artist of the twentieth century.

Gilot acknowledges all that she learned from Picasso about the hard work and household asceticism necessary for artistic creation. But she had been drawing and painting for several years before meeting Picasso when she was twenty-one. She had already been showing and selling her work. She had developed her own style and artistic beliefs, and she understood the need to guard them from distortion by the powerful influence of Picasso. In fact, John Richardson, Picasso's Boswell, has said of Gilot, "Picasso took from her rather more than she took from him."

Through Picasso, Gilot got to know the painter she most admired— Matisse. A northerner and former law student like herself, Matisse possessed a style and temperament more akin to her own, with his use of complimentary and contrasting color schemes to define space and with his search for harmony—in contrast to Picasso's penchant for disruption and deformation. Picasso helped Gilot define who she was *not* as a painter, at the same time that Matisse was helping her better understand who she was.

But Gilot also chronicles the abuse and insults she underwent as she struggled to overcome the demons that seemed to render Picasso incapable of sustaining lasting human relationships. Picasso, forty years older than Gilot, presented a challenge similar to the one she had confronted with her volatile father. She was in an almost untenable situation, surrounded by many people two generations older than herself. Some wanted to use her to gain access to Picasso. Others wanted to dethrone her from her privileged position with him. Yet others were watching for excuses to criticize and demean her as the new kid on the block. She had no real allies. But as an only child, she was accustomed to keeping her own counsel. Eventually, though, she was forced to

х

recognize that there were limitations to love—and that Picasso was an egoist with no real interest in her, except insofar as she could reflect him back to himself in a glowing light. When she asked him for a break of several months so that she could go to the mountains and refresh herself and reflect upon their troubled relationship, he refused, precipitating her decision to split from him.

Much is made in the media of the fact that Gilot is the only one of Picasso's several wives and companions who managed to leave him. The others remained obsessed by him and continued to revolve around him even after he had moved on to other women. Two had breakdowns, and two more committed suicide after his death. But Gilot was also his only companion who didn't need his financial support. Although her parents and many of her friends faded away during her Picasso years, her maternal grandmother stood by her and continued to visit her. When she died, she willed Gilot her house. In addition, Gilot had income from the sale of her own artwork. She knew that she could support herself and her children if they returned to Paris without Picasso.

Ten years after her departure, in trying to document and lay to rest this epic episode in her life, Gilot managed to compose the best account yet written of Picasso's moods and methods, in what has become one of the most important biographies of the twentieth century. Although only in her early forties when writing the book, Gilot displays the psychological acuity of someone much older. Its pages exude detachment and a calm objectivity. There is no evidence of the malice and vindictiveness that the forty-four signers of the manifesto demanding that the book be banned purported to have found in it (despite the fact that some signers confessed to not having read it).

Life with Picasso is also fascinating as a social history of the French art scene during and immediately after World War II. Gilot provides vivid sketches of many of the artists and writers of that era, along with accounts of their interactions with Picasso and with each other. Georges Braque, Marc Chagall, Henri Matisse, Paul Éluard, Jean Cocteau, Fernand Léger, Juan

Gris, and others emerge from the pages with all their idiosyncratic talents and petty rivalries.

Before Gilot left Picasso, he warned her, "You imagine people will be interested in *you*? They won't ever, really, just for yourself. Even if you think people like you, it will only be a kind of curiosity they will have about a person whose life has touched mine so intimately." Happily, this grim forecast has turned out to be incorrect. Gilot has lived a full life, both professionally and personally. Her body of work includes more than six thousand pieces that are eagerly sought after when they appear in galleries and at auctions. Some are owned by the Museum of Modern Art in New York, as well as by other museums around the world. It feels deeply ironic now to browse the catalogs of the international auction houses and discover Gilot's pieces featured alongside those of Picasso and Matisse.

Gilot went on to marry twice. Her first husband was the French painter Luc Simon, with whom she had a daughter, Aurélia, who graduated from Harvard with a degree in museum studies and who now manages Gilot's archives. Claude, her son with Picasso, administers Picasso's estate. Paloma, her daughter with Picasso, designs jewelry for Tiffany & Co. Gilot's second husband was Jonas Salk, the inventor of the polio vaccine. She lived with him for twenty-five years until his death in 1995. In contrast to Picasso's dire prediction about Gilot's dismal future without him, she has enjoyed a long life and a successful career, surrounded by children, grandchildren, collectors, dealers, admirers, and friends.

-LISA ALTHER

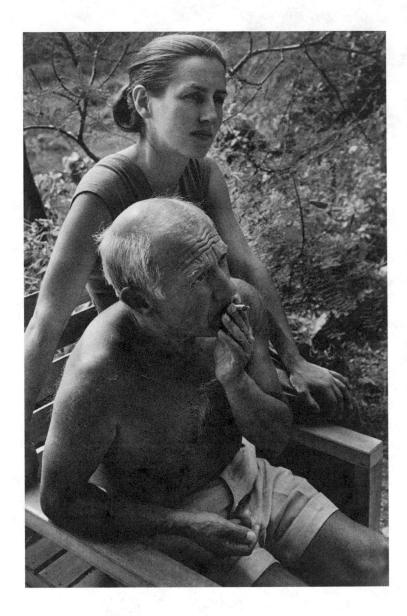

To Pablo

FOREWORD

Like a good many others whose primary interest is the art of our time, I have followed Picasso's work and life as closely as possible for many years. And I have tried to see him through as many pairs of eyes as have presented themselves. One of the first pairs, both in Picasso's experience and in my own, belonged to Fernande Olivier, who had been the companion of Picasso's early days at the *Bateau Lavoir* in Montmartre, and many years later brought bittersweet reminiscences of those days to my house in Paris when she came to give my wife French lessons.

About a dozen years ago Alice Toklas described to me a visit she had recently made to Picasso and Françoise Gilot in the Midi. She gave Françoise very faint praise indeed but in the process she succeeded, against her own best efforts, in convincing me that Françoise Gilot was a person of very considerable interest. When I saw one of her paintings at the *Salon de Mai* some months later, my interest was sharpened. But it was several more years before I met her.

While I was working on a cover story about Picasso for *The Atlantic Monthly* in 1956, I talked with Françoise Gilot for the first time. Long before the end of our conversation that afternoon, I realized that she had an infinitely deeper and truer appreciation of Picasso's thought and work than anyone I had encountered. Over the years since then we have talked often about Picasso and painting. During the course of a luncheon in Neuilly one raw January day, we discovered we had been working toward this book.

Throughout our work on it, I have been continuously impressed by her demonstration of the extent to which that much abused term "total recall" can be literally true. Françoise knows exactly what she said, what Pablo said, every step of the way for the ten years and more that they spent together. The direct quotations from Picasso are exactly that.

I retraced with her, time and again, the threads of many of these episodes, always from a different vantage point. Each time they checked out—even to the smaller touches of phrasing, style, figures of speech—although weeks or months may have intervened between our original discussion of a subject and our return to it. Along the way, various points which Picasso had taken up in some detail with me in

the course of our discussions in the Midi, and which I wrote down in his presence at the time, came out in Françoise's conversations with me in exactly the same form, the only difference being that this time it was Françoise speaking for Pablo.

Further checks and controls were made possible by my having access to Picasso's letters to her, her own notes and journals of the period, and many other pertinent documents—three large boxes of them—which, because they happened to be in the attic, miraculously escaped the fate of the other personal effects stored in her house in the south of France in 1955.

Carlton Lake

PART I

MET PABLO PICASSO in May 1943, during the German Occupation of France. I was twenty-one and I felt already that painting was my whole life. At that time I had as house-guest an old school friend named Geneviève, who had come up from her home near Montpellier, in the south of France, to spend a month with me. With her and the actor Alain Cuny, I went to have dinner one Wednesday at a small restaurant then much frequented by painters and writers. It was called *Le Catalan* and was in the Rue des Grands-Augustins on the Left Bank, not far from Notre Dame.

When we got there that evening and were seated, I saw Picasso for the first time. He was at the next table with a group of friends: a man, whom I didn't recognize, and two women. One of the women I knew to be Marie-Laure, Vicomtesse de Noailles, the owner of an important collection of paintings, who is now something of a painter herself. At that time, though, she had not yet taken up painting—at least publicly—but she had written a poetic little book called *The Tower of Babel*. She had a long, narrow, somewhat decadent-looking face framed by an ornate coiffure that reminded me of Rigaud's portrait of Louis XIV in the Louvre.

The other woman, Alain Cuny whispered to me, was Dora Maar, a Yugoslav photographer and painter who, as everyone knew, had been Picasso's companion since 1936. Even without his help I would have had no trouble identifying her, because I knew Picasso's work well enough to see that this was the woman who was shown in the *Portrait*

of Dora Maar in its many forms and variants. She had a beautiful oval face but a heavy jaw, which is a characteristic trait of almost all the portraits Picasso has made of her. Her hair was black and pulled back in a severe, starkly dramatic coiffure. I noticed her intense bronzegreen eyes, and her slender hands with their long, tapering fingers. The most remarkable thing about her was her extraordinary immobility. She talked little, made no gestures at all, and there was something in her bearing that was more than dignity—a certain rigidity. There is a French expression that is very apt: she carried herself like the holy sacrament.

I was a little surprised at Picasso's appearance. My impression of what he ought to look like had been founded on the photograph by Man Ray in the special Picasso number that the art review Cahiers d'Art had published in 1936: dark hair, bright flashing eyes, very squarely built, rugged—a handsome animal. Now, his graying hair and absent look—either distracted or bored—gave him a withdrawn, Oriental appearance that reminded me of the statue of the Egyptian scribe in the Louvre. There was nothing sculptural or fixed in his manner of moving, however: he gesticulated, he twisted and turned, he got up, he moved rapidly back and forth.

As the meal went on I noticed Picasso watching us, and from time to time acting a bit for our benefit. It was evident that he recognized Cuny, and he made remarks that we were obviously supposed to overhear. Whenever he said something particularly amusing, he smiled at us rather than just at his dinner companions. Finally, he got up and came over to our table. He brought with him a bowl of cherries and offered some to all of us, in his strong Spanish accent, calling them *cerisses*, with a soft, double-s sound.

Geneviève was a very beautiful girl, of French Catalan ancestry but a Grecian type, with a nose that was a direct prolongation of her forehead. It was a head, Picasso later told me, that he felt he had already painted in his work of the Ingresque or Roman period. She often accentuated that Grecian quality, as she did that evening, by wearing a flowing, pleated dress.

"Well, Cuny," Picasso said. "Are you going to introduce me to your friends?" Cuny introduced us and then said, "Françoise is the intelligent one." Pointing to Geneviève, he said, "She's the beautiful one. Isn't she just like an Attic marble?"

Picasso shrugged. "You talk like an actor," he said. "How would you characterize the intelligent one?" That evening I was wearing a green turban that covered much of my brow and cheeks. Geneviève answered his question.

"Françoise is a Florentine virgin," she said.

"But not the usual kind," Cuny added. "A secularized virgin." Everybody laughed.

"All the more interesting if she's not the ordinary kind," Picasso said. "But what do they do, your two refugees from the history of art?"

"We're painters," Geneviève answered.

Picasso burst out laughing. "That's the funniest thing I've heard all day. Girls who look like that can't be painters." I told him that Geneviève was only on holiday in Paris and that she was a pupil of Maillol in Banyuls and that although I wasn't anybody's pupil, I was very much a painter. In fact, I said, we were having a joint exhibition of paintings and drawings right at the moment in a gallery in the Rue Boissy d'Anglas, behind the Place de la Concorde.

Picasso looked down at us in mock-surprise. "Well . . . I'm a painter, too," he said. "You must come to my studio and see some of my paintings."

"When?" I asked him.

"Tomorrow. The next day. When you want to."

Geneviève and I compared notes. We told him we'd come not tomorrow, not the next day, but perhaps the first of the next week. Picasso bowed. "As you wish," he said. He shook hands all around, picked up his bowl of cherries, and went back to his table.

We were still at table when Picasso and his friends left. It was a cool evening and he put on a heavy mackinaw and a beret. Dora Maar was wearing a fur coat with square shoulders and shoes of a type many girls wore during the Occupation, when leather, along with so many other things, was scarce. They had thick wooden soles and high heels. With those high heels, the padded shoulders, and her hieratic carriage, she seemed a majestic Amazon, towering a full head over the man in the hip-length mackinaw and the *béret basque*.

15

HE FOLLOWING MONDAY MORNING, about eleven o'clock, Geneviève and I climbed a dark, narrow, winding staircase hidden away in a corner of the cobblestone courtyard at 7 Rue des Grands-Augustins and knocked on the door of Picasso's apartment. After a short wait it was opened about three or four inches, to reveal the long, thin nose of his secretary, Jaime Sabartés. We had never seen him before but we knew who he was. We had seen reproductions of drawings Picasso had made of him, and Cuny had told us that Sabartés would be the one to receive us. He looked at us suspiciously and asked, "Do you have an appointment?" I said we did. He let us in. He looked anxious as he peered out from behind his thick-lensed glasses.

We entered an anteroom where there were many birds—turtledoves and a number of exotic species in wicker cages—and plants. The plants were not pretty; they were the spiky green ones you see frequently in copper pots in a concierge's *loge*. Here they were arranged more appealingly, though, and in front of the high open window they made a rather pleasing effect. I had seen one of those plants a month before in a recent portrait of Dora Maar that was hung, in spite of the Nazi ban on Picasso's work, in an out-of-the-way alcove of the Louise Leiris gallery in the Rue d'Astorg. It was a magnificent portrait, in pink and gray. In the background of the picture there was a framework of panels like the panes of the large antique window I now saw, a cage of birds, and one of those spiky plants.

We followed Sabartés into a second room which was very long. I saw several old Louis XIII sofas and chairs, and spread out on them, guitars, mandolins, and other musical instruments which, I supposed, Picasso must have used in his painting during the Cubist period. He later told me that he had bought them after he painted the pictures, not before, and kept them there now as a remembrance of his Cubist days. The room had noble proportions but everything was at sixes and sevens. The long table that stretched out before us and two long carpenter's tables, one after the other, against the right-hand wall, were covered with an accumulation of books, magazines, newspapers, photographs, hats, and miscellaneous clutter. Resting on one of these tables was a rough piece of amethyst crystal, about the size of a human head, in the center of which was a small, totally enclosed cavity filled with what appeared to be water. On a shelf underneath the table I saw several men's suits folded up and three or four pairs of old shoes.

As we walked past the long table in the center of the room, I noticed that Sabartés moved out around a dull brownish object lying on the floor near the door that led into the next room. When I came closer to it I saw that it was a sculpture of a skull cast in bronze.

The next room was a studio almost entirely filled with sculptures. I saw *The Man with the Sheep*, now cast in bronze and standing in the square at Vallauris, but at that time simply in plaster. There were a number of large heads of women that Picasso had done at Boisgeloup in 1932. There was a wild disorder of bicycle handlebars, rolls of canvas, a fifteenth-century Spanish polychromed wooden Christ, and a weird and spindly sculpture of a woman holding an apple in one hand and what looked like a hot-water bottle in the other arm.

The most striking thing, though, was a glowing canvas by Matisse, a still life of 1912, with a bowl of oranges on a pink tablecloth against a light ultramarine and bright pink background. I remember also a Vuillard, a Douanier Rousseau, and a Modigliani; but in that shadowy studio, the glow of color of the Matisse shone among the sculptures. I couldn't resist saying, "Oh, what a beautiful Matisse!" Sabartés turned and said austerely, "Here there is only Picasso."

By another little winding staircase, on the far side of the room, we climbed to the second floor of Picasso's apartments. Upstairs the ceiling was much lower. We passed into a large studio. On the other side of the room I saw Picasso, surrounded by six or eight people. He was dressed in an old pair of trousers that hung loosely from his hips, and a blue-striped sailor's jersey. When he saw us, his face lighted up in a pleasant smile. He left the group and came over to us. Sabartés muttered something about our having an appointment and then went downstairs.

"Would you like me to show you around?" Picasso asked. We said we would indeed. We hoped he would show us some of his paintings but we didn't dare ask. He took us back downstairs into the sculpture studio.

"Before I came here," he said, "this lower floor was used as a workshop by a weaver, and the upper floor was an actor's studio—Jean-Louis Barrault's. It was here, in this room, that I painted *Guernica*." He settled back on one of the Louis XIII tables in front of a pair of windows that looked out onto an interior courtyard. "Other than that, though, I hardly ever work in this room. I did L'Homme au Mouton

here," he said, pointing to the large plaster sculpture of the man holding the sheep in his arms, "but I do my painting upstairs and I generally work on my sculpture in another studio I have a little way up the street.

"That covered spiral stairway you walked up to get here," he said, "is the one the young painter in Balzac's *Le Chef-d'Oeuvre Inconnu* climbed when he came to see old Pourbus, the friend of Poussin who painted pictures nobody understood. Oh, the whole place is full of historical and literary ghosts. Well, let's get back upstairs," he said. He slid off the table and we followed him up the winding staircase. He took us through the big studio, around the group of people, none of whom looked up at us as we passed through, and into a small room in the far corner.

"This is where I do my engraving," he said. "And look here." He walked over to a sink and turned on a faucet. After a while the water became steamy. "Isn't it marvelous," he said. "In spite of the war, I have hot water. In fact," he added, "you could come here and have a hot bath any time you liked." Hot water wasn't really the thing that interested us most, in spite of its scarcity at that time. Looking over at Geneviève I thought, Oh, if he'll only stop going on about the hot water and show us some pictures! Instead, he gave us a short course in how to make resin. I was just at the point of deciding we'd probably have to leave without seeing any paintings and never get back there again when finally he took us out into the large studio and began to show us some. I remember one was a cock, very colorful and powerful in its features, crowing lustily. Then there was another one, of the same period but very severe, all in black and white.

About one o'clock the group around us broke up and everyone started to leave. The thing that struck me as most curious that first day was the fact that the studio seemed the temple of a kind of Picasso religion, and all the people who were there appeared to be completely immersed in that religion—all except the one to whom it was addressed. He seemed to be taking it all for granted but not attaching any importance to it, as if he were trying to show us that he didn't have any desire to be the central figure of a cult.

As we turned to go, Picasso said, "If you want to come back again, by all means come. But if you do come, don't come like pilgrims to Mecca. Come because you like me, because you find my company interesting and because you want to have a simple, direct relationship

PART I

with me. If you only want to see my paintings, you'd do just as well to go to a museum."

I didn't take that remark too seriously. In the first place, there were almost no paintings of his to be seen in any of the Paris museums at that time. Then, too, since he was on the Nazi list of proscribed painters, no private gallery was able to show his work openly or in quantity. And looking at another painter's work in a book of reproductions is no satisfaction for a painter. So if anyone wanted to see more of his work—as I did—there was almost nowhere to go but 7 Rue des Grands-Augustins.

A few days after that first visit I dropped in at the gallery where Geneviève and I were having our exhibition. The woman who ran it told me excitedly that a little earlier a short man with piercing dark eyes, wearing a blue-and-white-striped sailor's jersey, had come in. She had realized, after the first shock, that he was Picasso. He had studied the paintings intently and then walked out without saying anything, she told me. When I got home I told Geneviève about his visit. I said he had probably gone to see how bad our paintings were and prove to himself the truth of what he had said when he met us at *Le Catalan*: "Girls who look like that can't be painters."

Geneviève took a more idealistic view of it. "I think it's a nice human touch," she said. "It shows he takes a real interest in young artists' work."

I wasn't convinced. At best it was curiosity, I felt. "He just wanted to see what we had inside—if anything."

"Oh, you're so cynical," she said. "He seemed to me very kind, open-minded, and simple."

I told her I thought he perhaps wanted to appear simple but I had looked into those eyes of his and seen something quite different. It hadn't frightened me, though. In fact it made me want to go back. I temporized for about another week and then, one morning, with Geneviève in tow, returned to the Rue des Grands-Augustins. It was Sabartés, of course, who opened the door for us again, his head sticking outside like a little sand fox. This time he admitted us without comment.

Remembering, from our first visit, the very pleasant entrance with its many plants and exotic birds in wicker cages lighted by the high window, we had decided to add a little color to the greenery and so we arrived carrying a pot of cineraria. When Picasso saw us he laughed.

"Nobody brings flowers to an old gent," he said. Then he noticed

that my dress was the same color as the blossoms, or vice versa. "You think of everything; I can see that," he said. I pushed Geneviève in front of me. "Here's beauty, followed by intelligence," I reminded him.

He looked us over carefully, then said, "That remains to be seen. What I see now are simply two different styles: archaic Greece and Jean Goujon."

On our first visit he had shown us only a few pictures. This time he made up for it. He piled them up almost like a scaffolding. There was a painting on the easel; he stuck another on top of that; one on each side; piled others on top of those, until it seemed like a highly skilled balancing act of the human-pyramid kind. As I found out later, he used to arrange them that way almost every day. They always held together by some kind of miracle, but as soon as anyone else touched them they came tumbling down. That morning there were cocks; a buffet of Le Catalan with cherries against a background of brown, black, and white; small still lifes, some with lemon and many with glasses, a cup, and a coffeepot, or with fruit against a checked tablecloth. He seemed to be playing with colors as he sorted them out and tossed them up onto the scaffolding. There was a large nude, a three-quarter rear view that one saw at the same time front view, in earth tones, very close to the palette of the Cubist period. There were also scenes of the Vert Galant, that little tip of the Ile de la Cité near the Pont-Neuf, with trees on which each branch was made out of separate spots of paint, much in the manner of van Gogh. There were several mothers with enormous children whose heads reached the very top of the canvas, somewhat in the spirit of the Catalan primitives.

Many of the paintings he showed us that morning had a culinary basis—skinned rabbits or pigeons with peas—a kind of reflection of the hard time most people were having in getting food. There were others with a sausage stuck, almost like a *papier collé*, onto an otherwise carefully composed background; also, some portraits of women wearing hats topped with forks or fishes and other kinds of food. Finally he showed us a group of portraits of Dora Maar, very tortured in form, which he had painted over the past two years. They are among the finest paintings he has ever done, I believe. Generally on an off-white background, these figures seemed symbolic of human tragedy, rather than the simple deformation of a female face that they might appear on a superficial level.

Suddenly he decided he had shown us enough. He walked away from his pyramid. "I saw your exhibition," he said, looking at me. I didn't have the courage to ask him what he thought of it, so I just looked surprised. "You're very gifted for drawing," he went on. "I think you should keep on working—hard—every day. I'll be curious to see how your work develops. I hope you'll show me other things from time to time." Then he added, to Geneviève, "I think you've found the right teacher in Maillol. One good Catalan deserves another."

After that, little else he said that morning registered very deeply with me. I left the Rue des Grands-Augustins feeling very buoyant, impatient to get back to my studio and go to work.

SOON AFTER THAT SECOND VISIT, Geneviève went back to the Midi. I wanted to return to the Rue des Grands-Augustins by myself but I felt it was a little early to show Picasso any new work even though he had been more than cordial in his invitation to come see him as often as I wanted to.

I must admit I wondered more than once whether, if he had met me alone, he would even have noticed me. Meeting me with Geneviève, he saw a theme that runs throughout his entire work and was particularly marked during the 1930s: two women together, one fair and the other dark, the one all curves and the other externalizing her internal conflicts, with a personality that goes beyond the pictorial; one, the kind of woman who has a purely aesthetic and plastic life with him, the other, the type whose nature is reflected in dramatic expression. When he saw the two of us that morning, he saw in Geneviève a version of formal perfection, and in me, who lacked that formal perfection, a quality of unquiet which was actually an echo of his own nature. That created an image for him, I'm sure. He even said, "I'm meeting beings I painted twenty years ago." It was certainly one of the original causes of the interest he showed.

When I did go back to see him, it wasn't long before he began to make very clear another side of the nature of his interest in me.

There were always quite a few people waiting to see him: some in the long room on the lower floor, where Sabartés held forth; others in the large painting atelier on the floor above. Picasso, I soon noticed, was always looking for some excuse to get me off into another room where

he could be alone with me for a few minutes. The first time, I remember, the pretext was some tubes of paint he wanted to give me. Having an idea that there was more involved than just paints, I asked him why he didn't bring them to me. Sabartés, never very far away, said, "Yes, Pablo, you should bring them to her."

"Why?" Picasso asked. "If I'm going to give her a gift, the least she can do is make the effort to go after it."

Another morning, I had gone there on my bicycle, since that was the only way one could get around conveniently at that period. En route it had started to rain and my hair was soaking wet. "Just look at the poor girl," Picasso said to Sabartés. "We can't leave her in that state." He took me by the arm. "You come with me into the bathroom and let me dry your hair," he said.

"Look, Pablo," Sabartés said, "perhaps I should get Inès to do it. She'll do it better."

"You leave Inès where she is," Picasso said. "She's got her own work to do." He guided me into the bathroom and carefully dried my hair for me.

Of course, Picasso didn't have a situation like that handed to him every time. He had to manufacture his own. And so the next time it might be some special drawing paper he had uncovered in one of the countless dusty corners of the atelier. But whatever the pretext, it was quite clear that he was trying to discover to what degree I might be receptive to his attentions. I had no desire to give him grounds to make up his mind, one way or the other. I was having too much fun watching him try to figure it out.

One day he said to me, "I want to show you my museum." He took me into a small room adjoining the sculpture studio. Against the left-hand wall was a glass case about seven feet high, five feet wide, and a foot deep. It had four or five shelves and held many different kinds of art objects.

"These are my treasures," he said. He led me over to the center of the vitrine and pointed to a very striking wooden foot on one of the shelves. "That's Old Kingdom," he said. "There's all of Egypt in that foot. With a fragment like that, I don't need the rest of the statue."

Ranged across the top shelf were about ten very slender sculptures of women, from a foot to a foot and a half high, cast in bronze. "Those I carved in wood in 1931," he said. "And look over here." He pushed me very gently toward the end of the case and tapped on the glass in front of a group of small stones incised with female profiles, the head of a bull and of a faun. "I did those with this," he said, and fished out of his pocket a small jackknife, labeled *Opinel*, with a single folding blade. On another shelf, and next to a wooden hand and forearm that were recognizably Easter Island, I noticed a small flat piece of bone, about three inches long. On its long sides were painted parallel lines imitating the teeth of a comb. In the center, between the two strips of "teeth," was a cartouche showing two bugs meeting in head-on combat, one about to swallow up the other. I asked Picasso what that was. "That's a comb for lice," he said. "I'd give it to you but I don't imagine you'd have any use for it." He ran his fingers through my hair and parted it at the roots here and there. "No," he said, "you seem to be all right in that department."

I moved back to the center of the vitrine. There was a cast of his sculpture A Glass of Absinthe, about nine inches high, with a hole cut into the front of the glass and a real spoon on top, bearing a simulated lump of sugar. "I did that long before you were born," he said. "Back in 1914. I modeled it in wax and added a real spoon and had six of them cast in bronze, then painted each one differently. Here, this will amuse you." He put his arm around me and sidled over to another part of the case, drawing me along with him. I saw a small match box on which he had painted the head of a woman in a post-Cubist manner. I asked him when he had done that.

"Oh, two or three years ago," he said. "These, too." He pointed to a group of cigarette boxes on which he had painted women seated in armchairs. Three of them, I noticed, were dated 1940. "You see, I built them up in relief by pasting other bits of cardboard in various places," he said. He pointed to the one in the center. "For that one, I sewed on the panel that makes the central part of the torso. Notice the hair. It's pretty close to *being* hair—it's string. These things are midway between sculpture and painting, I suppose." I noticed, too, that the frame of the chair occupied by the woman with the sewn-on torso was formed in part by a piece of knotted string.

Below these were several tiny stage sets, inside cigar boxes, with painted cut-out cardboard actors no larger than small safety-pins. The most curious things, though, were a number of reliefs built up, surrealist-fashion, by groupings of heterogeneous objects—matches, a butterfly, a toy boat, leaves, twigs—and covered with sand. Each one was about ten by twelve inches. I asked him what they were. He shrugged. "Just what they look like," he said. "I had a spell of doing things like that about ten years ago, on the surface or the underside of small canvases.

I assembled the compositions—some of those things are sewn on covered them with glue and sanded them."

I finished looking at the sanded reliefs and then poked my head through a doorway cut into the back wall of the room. It opened into another small room, filled with frames. Behind them was a life-sized cutout photograph of a Catalan peasant, who looked as though he might be guarding the museum's treasures. I backed out again. On the opposite side of the room from the vitrine was a table covered with tools. I walked over to it. Picasso followed me.

"These I use in finishing my sculpture," he said. He picked up a file. "This is something I use all the time." He tossed it back and picked up another. "This one is for finer surfaces." One after another he handled a plane, pincers, nails of all kinds ("for engraving on plaster"), a hammer, and with each one he came closer to me. When he dropped the last piece back onto the table he turned abruptly and kissed me, full on the mouth. I let him. He looked at me in surprise.

"You don't mind?" he asked. I said no—should I? He seemed shocked. "That's disgusting," he said. "At least you could have pushed me away. Otherwise I might get the idea I could do anything I wanted to." I smiled and told him to go ahead. By now he was thrown completely off the track. I knew very well he didn't know what he wanted to do—or even whether—and I had an idea that by saying, placidly, yes, I would discourage him from doing anything at all. So I said, "I'm at your disposition." He looked at me cautiously, then asked, "Are you in love with me?" I said I couldn't guarantee that, but at least I liked him and I felt very much at ease with him and I saw no reason for setting up in advance any limits to our relationship. Again he said, "That's disgusting. How do you expect me to seduce anyone under conditions like that? If you're not going to resist—well, then it's out of the question. I'll have to think it over." And he walked back out into the sculpture studio to join the others.

A few days later he brought up the question in a similar manner. I told him I could promise him nothing in advance, but he could always try and see for himself. That nettled him. "In spite of your age," he said, "I get the impression that you've had a lot of experience in that sort of thing." I said no, not really. "Well, then, I don't understand you," he said. "It doesn't make sense, the way you act." I said I couldn't help that. That was the way it was, sense or nonsense. Besides, I wasn't afraid of him, so I couldn't very well act as though I were. "You're too complicated for me," he said. That slowed him down for a while longer. A week or so later, I went to see him. Using the by now familiar technique, he managed to maneuver me into his bedroom. He picked up a book from a chair near his bed. "Have you read the Marquis de Sade?" he asked me. I told him no. "Aha! I shock you, don't I?" he said, looking very proud of himself. I said no. I told him that although I hadn't read Sade, I had no objection to it. And I had read Choderlos de Laclos and Restif de la Bretonne. As for Sade, I could make out without it, but perhaps he couldn't, I suggested. In any case, I told him, the principle of the victim and the executioner didn't interest me. I didn't think either one of those roles suited me very well.

"No, no, I didn't mean that," he said. "I just wondered if that might shock you." He seemed a little disappointed. "You're more English than French, I think," he told me. "You've got that English kind of reserve."

After that his campaign slacked off. He was no less friendly whenever I dropped in mornings but since I hadn't encouraged his early approaches he was clearly hesitant about attempting further advances. My "English reserve" was holding him off successfully. I was just as well pleased.

One morning toward the end of June, he told me he wanted to show me the view from "the forest." In French that word is used to refer to the framework of beams that come together to form the support for the roof. He took me into the hallway outside his painting studio on the upper floor. There, at an angle against the wall, was a miller's ladder leading up to a small door about three feet above our heads. He bowed gallantly. "You go first," he said. I had some qualms about it but it seemed awkward to argue the point, so I climbed the ladder and he followed right behind. At the top I pushed open the door and stepped into a small room, about twelve feet by twenty, under the eaves. On the right side of the room was a small open window, almost to the floor. I walked over to it and looked out on a kind of Cubist pattern formed by the roofs and chimney pots of the Left Bank. Picasso came up behind me and put his arms around me. "I'd better hold on to you," he said. "I wouldn't like to have you fall out and give the house a bad name." It had grown warmer in the last few days and he was wearing what seemed to be his usual warm-weather outfit for receiving his friends in the morning: a pair of white shorts and his slippers.

"That's nice, the roofs of Paris," he said. "One could make paintings of that." I continued to look out the window. Opposite us, a little to the right, across a courtyard, an empty building was being re-

modeled. On one of the outside walls, a workman had drawn in whitewash an enormous phallus, about seven feet long, with baroque subsidiary decoration. Picasso went on talking about the view and the handsome old roofs against the light gray-blue of the sky. He moved his hands up and lightly cupped them over my breasts. I didn't move. Finally, a bit too innocently I thought, he said, "*Tiens!* That drawing in whitewash on the wall over there—what do you suppose that represents?" Trying to sound as offhand as he had, I said I didn't know. It didn't seem to me to be at all figurative, I told him.

He took his hands away. Not suddenly, but carefully, as though my breasts were two peaches whose form and color had attracted him; he had picked them up, satisfied himself that they were ripe but then realized that it wasn't yet time for lunch.

He backed away. I turned and faced him. He was slightly flushed, and he looked pleased. I had the feeling he was glad I hadn't committed myself, either to draw away or to fall too easily. He guided me gently by the arm out of the forest and helped me onto the ladder. I went down, he following, and we joined the group in the painting atelier. Everyone talked animatedly as if neither our departure nor our return had been noticed.

IHAT SUMMER I went to a little village called Fontès, near Montpellier, which was then in the Free Zone—not occupied by the Germans —to spend my vacation with Geneviève. While I was there, I passed through one of those crises young people sometimes experience in the process of growing up. Picasso wasn't the cause of it; it had been coming on for some time before I met him. It was a kind of mental stocktaking brought on by the conflict between the life I had led up until then and the vision I had of the kind of life I should be leading.

Ever since early childhood I had suffered from insomnia and had used my nights more for reading than for sleeping. And since I was a rapid reader, I had managed to work my way through a considerable number of books. My father had encouraged this bent in me. He was, by training, an agronomical engineer, and had built up several manufacturing businesses in chemicals. But he was also a man with a passionate interest in literature and his large library was never closed to me. By the time I was twelve he had read me enormous chunks of the works of Joinville, Villon, Rabelais, Poe, and Baudelaire, and by the age of fourteen, all of Jarry. By the time I was seventeen I was rather proud of my attainments and fond of imagining that I knew what life was all about, even though whatever I did know came out of books.

My physical appearance did not seem extraordinary to me; on the other hand, I did not consider it a handicap. I felt afraid of nothing, objective and detached in all my judgments and serenely free from the various illusions inexperience confers on youth. In short, I saw myself a seasoned philosopher disguised as a young girl.

My father tried to wake me up by telling me, "You're floating on air. You'd better put on some lead-soled shoes and get down to earth. Otherwise you're in for a rude awakening." That awakening came when I decided to become a painter. For the first time I got a sense of my own limitations. In my studies, even in areas that didn't interest me at all, such as mathematics and law, I had no trouble handling whatever problems came up. But when I took up painting, and no matter how singlemindedly I gave myself over to it, I gradually came to realize there were things I could not bring off. I had difficulties of all kinds, conceptual as well as technical. For a long time I felt I was up against a wall. Then suddenly it occurred to me that, at bottom, a good part of my difficulty came from my lack of the experience of living. I had an intellectual grasp of many things, but as far as first-hand experience went, I was pretty close to being a total ignoramus.

I had started to paint at the age of seventeen. For the past two years I had been working under the guidance of a Hungarian painter named Rozsda. At the same time, I was studying for my *licence* in literature at the Sorbonne (roughly the equivalent of an A.B. degree in an American or English university) and for a law degree, as well. My father would not have allowed me to drop out of the university and devote all my time to painting, but I used to cut my morning classes and go to Rozsda's studio to paint.

Rozsda had come to Paris from Budapest in 1938. He was Jewish on his mother's side. Under Occupation law, he should have worn a yellow Star of David. Not wearing one, he had greater freedom of movement but at a very considerable risk. In addition to that, since Hungary was a German satellite, Rozsda should have been doing military service for the Nazis. That made him not only an undeclared Jew but, in their eyes, a deserter as well. He was, then, doubly liable for early shipment

to the gas chamber. He was in danger of being picked up from day to day. My father, who could be as hard as nails when his will was frustrated, could also be very generous when he wanted to be. When I told him about Rozsda's situation he helped him to get papers that would take him safely back to Budapest.

When he left, in February 1943, I saw him off at the Gare de l'Est. I was sad to see him go because he had been a good friend to me. I was unhappy, also, to think that the progress I had been making in my painting might be threatened. I told him I didn't know what I was going to do about that, nor whom I could work with. The train started up. He hopped aboard and called out, "Don't worry about that. In three months' time, you may know Picasso." He was right, almost to the day.

My problems with painting weren't my only source of frustration. During the two or three years leading up to my meeting with Picasso, most of my male friends were men about ten years older than I. Many of them were active in the Resistance in one way or another and I think they all looked upon me as a child. For that reason, perhaps, they let me alone. Then, too, although I had never been taken in by the theological fairy tales the Dominican sisters had done their best to sell me as truth during my years at boarding school, nevertheless I think that a bit of the general atmosphere had stayed with me in the form of inhibitions. I wasn't convinced that I should believe in their tall tales and yet I wasn't positive that I should not.

Between the ages of seventeen and twenty I had been very much in love with a boy my own age. He was going through the same growing pains that I was having. Every time I felt it would be all right to give myself to him, he would feel inhibited, and when he felt more adventurous, I would have doubts. Then he fell ill with pleurisy, and during that time my parents tried to break up our friendship. While he was away convalescing, I decided I had to get beyond that barrier called virginity. When he returned, I must have been so aggressive that I frightened him out of his wits. He told me he didn't really love me and that I might as well leave him out of my plans.

Instead of realizing that I had a lifetime before me, I felt that time was running short. I dramatized this first rejection to a degree that made me think, Well, after that, what else matters? Rozsda, my teacher, had gone. The boy I wanted had thrown me over. I had nothing more to lose. It was just at that time that I met Picasso. And after our brief skirmishes of May and June, when I left for the Midi to spend the summer with Geneviève I was still stirred up by everything that had taken place before I met him. In my eyes the villains were my parents, and my conclusion was: They've ruined my life so far. From now on I'll take over.

The first step, it seemed to me, was to face up to my father and tell him I had decided to be a painter and in order to give myself over completely to that, I would need to stop my other studies. Knowing how strong-willed he was, I realized that announcement would probably lead to a break between us. But I sensed that by accepting the consequences, I would find myself on the other side of the wall that now separated me from everything I wanted.

Until then I had been cushioned by a kind of cocoon that my milieu formed around me. I had the impression that the noises of life had been reaching me so muted that all connection with reality was strained out. But I knew that an artist draws from his direct experience of life whatever quality of vision he brings to his work and that I had to break out of the cocoon. I think this was more than an intellectual crisis. It was almost a rebirth, and when I had made my decision, I felt as naked as the day I was born.

In October I wrote my father a letter in which I tried to explain all this. His answer was to send my mother, who, like me, had always been completely under his domination, to bring me back to Paris at once. When we reached home he was waiting for us, seething with anger. My attitude was scandalous, he said, and I must be out of my mind. If I persisted, he would know I was seriously ill and he would have me committed, he threatened. He gave me a half hour to change my mind and went out to do an errand. I knew I had to act quickly. I left the house saying nothing to my mother and ran to my grandmother's house, which was not far from ours. My grandmother was out. I decided to wait for her to return. In a few minutes my father and mother arrived. By now my mother, too, must have been convinced I was out of my mind. Until now I had always obeyed, even though it was painful. Suddenly, at twenty-one, I was as inflexible as my father.

When I saw them coming, I ran up to the top floor. Knowing the mood my father was in, I was certain he would try to drag me out of the house and take me back home; he might have a harder time of it, I thought, if I was as far away from the front door as possible. He followed me upstairs. I had never seen him in such a rage. He had always been a violent man and was in the habit of having everyone—at home, among the rest of the family, in his factories, in the world at large—obey him immediately. He asked me if I would return home. I told him no. I

said I had made up my mind that if he wouldn't agree to my terms, I would leave home. I told him I would never ask him for another thing but from now on I intended to live my life as I saw fit.

He began to beat me—my head, shoulders, face, and back with all his might. He was so much bigger and stronger than I, I knew I could never hold out against him if he continued like that. I sat down on the stairway and managed to slip my legs between the balusters. I put my arms through them and joined my hands together; in that way he couldn't hit my face any more. My face was bleeding badly and the blood was running down the white balusters onto my knees. I could feel one eye swelling. He tried to pull me away but I held on tight.

At that point I heard the front door open, below us, and my grandmother walked in. She came upstairs as quickly as she could. She asked my father what was going on. He told her that whatever she saw, I had done to myself. I told her this was not true. She said she was in no position to make up her mind about that but it was obvious that I was in very bad shape and she was putting me to bed and calling a doctor at once. "We'll see about the rest tomorrow," she said.

My grandmother was seventy-five at the time. After the death of my grandfather four years before, she had had a nervous breakdown. She had spent nearly three years in a rest home and had been back in her own home, well again, for about a year. She was my mother's mother. She had her own fortune and was not dependent on my father. As it happened, though, her money was managed by a lawyer who was a friend of my father's and a bit under his thumb. My father took advantage of this situation to include her in his threats. "I'll have you both committed," he said. "You're both crazy. Furthermore, you may discover, both of you, that money won't be quite so easy to come by from now on. We'll see how you like that."

My grandmother stood right up to him. "Go ahead," she told him. "And by all means try to have us put away. I'd like to see you get away with that. From now on, Françoise will stay with me if she wants to. As a matter of fact, just to help you along, she'll undergo psychiatric examination voluntarily."

French law requires that two independent psychiatrists concur in a judgment of insanity before anyone can be committed to an institution. The first man my father had examine me could find nothing wrong beyond the fact that my metabolism was more than 30 per cent below normal and that led him only to the conclusion that I was very fatigued. After that fiasco my father found a woman psychiatrist. Whether she was actually convinced by his story that I was crazy or had been instructed to see that I left her in that state, I don't know, but for two hours she quizzed, harangued, and threatened me. Nothing came of that, either. I went the rounds of a few others that my father had lined up to examine me, including a cousin of his, and with each consultation I felt calmer and more sure of my ground. Finally the ordeal came to an end.

Now THAT I WAS LIVING with my grandmother, I had money problems, since my father had always been the source of my money. The only clothes I had were the ones I was wearing the day I ran to my grandmother's. It was impossible, of course, to get anything out of my father's house.

His house was just outside the entrance to the Bois de Boulogne and I had always done a great deal of horseback riding in the Bois. I went to see my old riding master and told him I needed a job. He put me to work giving lessons to beginners. Some days I had to go to Maisons-Laffitte, a racing and riding center about twelve miles outside Paris. That kept me pretty busy.

It was November before I had a chance to visit Picasso again. One thing stood out very clearly: the ease with which I could communicate with him. With my father there had been no communication for years. Even my relations with the one boy my own age I thought I loved were often difficult and complicated, almost negative. Now suddenly with someone who was three times as old as I was, there was from the start an ease of understanding that made it possible to talk of anything. It seemed miraculous.

Seeing him after an absence of four or five months and across the filter of my summer's experiences, I had the impression I was rejoining a friend whose nature was not very far from my own. Often during my adolescence I had felt like a solitary traveler crossing a desert. In spite of my intellectual smugness, socially I was timid and I was often silent even among my friends. Now I was completely at ease with someone I hardly knew. In theory we had nothing in common, Picasso and I, but in fact we had a great deal in common. When I told him, one morning,

in a flash of warmth quite unlike the "English reserve" I had shown before, how much at ease I felt with him, he grabbed my arm and burst out excitedly, "But that's exactly the way I feel. When I was young, even before I was your age, I never found anybody that seemed like me. I felt I was living in complete solitude, and I never talked to anybody about what I really thought. I took refuge entirely in my painting. As I went along through life, gradually I met people with whom I could exchange a little bit and then a little bit more. And I had that same feeling with you—of speaking the same language. From the very first moment I knew we could communicate."

I told him that made me feel better. I said that before the vacation I had felt a bit guilty about coming to see him so often and that I didn't want to disturb him by coming too often now.

"Let's understand each other right now on that point," he said. "In any case, whether you come or not, I'm disturbed by somebody. When I was young, nobody knew me and nobody disturbed me. I could work all day long. Maybe if you had come then, even without saying a word, you might have disturbed me. But now there are so many who do disturb me, if it's not you it will be someone else. And frankly" here his face, which had been very serious, broke into a grin—"there are others who bore me more than you do."

So the mornings I had no riding lessons to give—perhaps two or three days a week—I spent at the Rue des Grands-Augustins. Most of the people I saw there were people who came nearly every day. If Picasso felt like showing them some paintings, they would look at them. If he didn't they would just sit around, not saying very much, and then at lunchtime go their separate ways. They weren't just hangers-on; they were people who were somehow connected with Picasso's life. Christian Zervos, for instance, the publisher of *Cahiers d'Art*, was compiling his catalog of Picasso's work and often brought his photographer to take pictures of recent drawings and paintings.

Then there was "Baron" Jean Mollet, who had been secretary to the poet Guillaume Apollinaire when Apollinaire was the official spokesman for the Cubist movement. Apollinaire had been dead for twenty-five years but the "Baron" was still a more or less permanent fixture in Picasso's studio.

Another man who came a great deal at that time was André Dubois, who later on became Prefect of Police and after that went to the magazine *Match*. At that time he worked in the Ministry of the Interior and since the Germans were finding little ways of bothering Picasso and might well have bothered him a great deal more, André Dubois came almost every day to see that everything was all right. Jean-Paul Sartre came frequently, and Simone de Beauvoir, and the poet Pierre Reverdy. Sartre and Simone de Beauvoir talked mostly to each other. When Sartre talked with Picasso, it was off in a corner, as a rule, and he looked so mysterious and confidential I felt he must be talking about the Resistance and some of its clandestine publications. Whenever Sartre had anything to say in my presence, it was never about painting in general or Picasso's painting in particular and I found him usually so didactic that I formed the habit of talking with others, such as the poet Jacques Prévert. At a time when most people weren't joking much, Prévert generally managed to find something funny. Picasso had had a sculpture of his own hand cast in bronze. One day Prévert amused himself and the rest of us by sticking the bronze hand into his sleeve and shaking hands with the others, then walking away and leaving the bronze hand in theirs.

One morning that winter I went to the Rue des Grands-Augustins with several paintings I had just finished and wanted to show to Picasso. I noticed that a number of the regulars I often saw in the painting studio upstairs were in the long room on the lower floor where Sabartés worked. Sabartés looked very conspiratorial. He signaled to me to follow him. When we were out of the room he whispered, "He said I could take *you* upstairs, but he's not seeing anyone else today. You're going to see someone who'll give you a shock."

When we reached the painting studio I saw Picasso talking with a thin, dark, intense man who, I must admit, did give me a shock. It was André Malraux. More than anyone else at that time, Malraux was the idol of our generation. We had all devoured his books—*The Conquerors, Man's Fate, Man's Hope*—and been excited not only by them but by the exploits of Malraux himself, in China, in Indo-China, in Spain, and now as one of the leaders of the Corrèze maquis in the Resistance.

Picasso introduced me to Malraux and asked me to show my paintings to both of them. Feeling very timid, I did. I referred to something in one of them as having arisen from the memory of a trip I had made to Les Baux the previous summer. That reminded Picasso that he and Malraux had met there on Christmas day about five years before. "There's an other-worldly atmosphere you feel as you stand there looking down on the Val d'Enfer that makes me think of Dante," Picasso said.

"It should," Malraux replied. "During Dante's exile from

Florence, he went there in his wanderings through France and wrote that setting into L'Inferno."

After Malraux had gone, Picasso said, "I hope you appreciate the gift I just made you." I asked him what gift. "Letting you talk to Malraux," he said. "After all, no one should have seen him here. It's too dangerous. He just slipped in from the maquis." I told him I didn't know whether I was grateful for it or not. Until then I had been happy with the romantic legend. But seeing him now for the first time, his face twitching with a nervous tic, I had been disillusioned.

At the other end of the spectrum, politically and otherwise, there was Jean Cocteau. One day that winter he came with his friend the actor Jean Marais—"Jeannot," as he called him—to tell Picasso that Marais had the role of Pyrrhus in a production of Racine's Andromaque. "Our little Jeannot is going to have a huge success," Cocteau assured us. Jeannot had even designed the settings and costumes, and Cocteau described them in detail, laying great stress on the dramatic contrast between the white costumes and the black columns of the palace. And if Pablo could only imagine how regal Jeannot looked in his magnificent purple cape, over fifteen feet long, as he threw himself headlong, in one powerful scene, down the staircase! There was only one problem: Jeannot needed a scepter. Couldn't Pablo design him one?

Picasso thought for a moment, then said, "You know the little street market over in the Rue de Buci?" Cocteau and Marais looked puzzled but said yes, they did.

"All right," Picasso said. "You go over there and bring me back a broomstick." They looked a bit disconcerted by that but in the end they went out and returned with one. Picasso took it. "Come back in two days," he said. "I'll work something out."

After they had gone he took an iron poker, heated it in his big stove and burned a primitive-looking abstract decoration along its full length. I asked him if it wasn't rather long. "That will keep Jeannot from getting all tangled up in his magnificent fifteen-foot purple cape," he said. "He can lean on it, too."

When it came time for the opening, Picasso didn't want to gonot even to see Jeannot brandishing the scepter he had made for him--so he gave his invitation to me. As one might have expected, the women were covered modestly----and drably----from chin to floor. The men, however, frisked about like little *rats de l'Opéra*, in very short tunics that showed off their legs and bottoms to the fullest advantage. The most amusing thing about the play was the black columns of the palace. Whenever Pyrrhus leaned against one of them, the cheap water paint smutted his hand. Then, when he went over to clutch Andromaque for one of his dramatic moments, he left the print of it on her flowing white gown. It wasn't long before she looked less Grecian than avant-garde. The audience howled. Soon they were whistling, hissing, and booing. I think the play closed after three nights.

Another one of the studio regulars was the photographer Brassaï, who came often to photograph Picasso's sculpture. Picasso delighted in teasing him and would generally greet him with, "What are you going to break on me today?" Brassaï was accident-prone, and a simple remark like that was enough to start him off. At that time Picasso was working on the sculpture of the pregnant cat with its tail sticking out stiffly behind. One morning as Brassaï was setting up his tripod. Picasso said to him, "For heaven's sake don't go near that tail; you'll make it fall off." Brassaï obligingly drew away from the cat, pulled his tripod around, made another movement to the side and, of course, knocked off the cat's tail. As soon as he could disengage himself from the sculpture, he began to pull his tripod toward him. Picasso said, "You'd be better off to stop pulling at that tripod and pull in your eyes"-not a very kind remark, because Brassaï suffered from a condition-thyroid, perhaps-that made his eyes bulge out of his head. But I could see from the start that no one ever got angry at Picasso's jibes. Brassaï began to laugh so hard-whether because he thought it was funny or because he thought he had to-that he got his legs mixed up with his tripod and fell over backwards into a big basin of water that Picasso kept in the studio for Kasbek, his Afghan hound. As Brassaï fell, he splashed water over everybody. That was enough to put Picasso in a good mood for the rest of the morning.

"If no one came to see me in the morning, I'd have nothing to start working on in the afternoon," he told me later. "These contacts are a way of recharging my battery, even if what takes place has no apparent connection with my work. It's like the flare of a match. It lights up my whole day."

But not all of Picasso's visitors were welcome ones. The Germans, of course, had forbidden anyone to exhibit his painting. In their eyes, he was a "degenerate" artist and, worse still, an enemy of the Franco government. They were always looking for pretexts to make more trouble for him. Every week or two a group of uniformed Germans would come

and with an ominous air ask, "This is where Monsieur Lipchitz lives, isn't it?"

"No," Sabartés would say. "This is Monsieur Picasso."

"Oh, no. We know it's Monsieur Lipchitz's apartment."

"But, no," Sabartés would insist. "This is Monsieur Picasso." "Monsieur Picasso isn't a Jew, by any chance?"

"Of course not," said Sabartés. And since one's Aryan or non-Aryan status was established on the basis of one's grandparents' baptismal certificates, no one could say Picasso was Jewish. But they used to come, anyway, and say they were looking for the sculptor Lipchitz, knowing very well that he was in America at that moment, and that he had never lived there in the first place. But they would pretend they had to satisfy themselves that he wasn't there, so they'd say, "We want to be sure. We're coming in to search for papers." Three or four of them would come in, with an extremely polite officer who spoke French. The disorder everywhere was an invitation to them and they would look around and behind everything.

Picasso had had a brush with the Germans before I knew him and he told me about it one day with considerable satisfaction. One of the first things the Germans did in 1940, right after the armistice, was to inventory the contents of all safe-deposit vaults in banks. The property of Jews was confiscated. That of the others was set down in the record to be available if needed. Foreign stocks and bonds, gold, jewelry, and valuable works of art were what interested the Germans most.

As soon as the inventorying started, most people who were away from Paris rushed back in order to be present when their boxes or vaults were opened. Everyone realized that at the start, before the "technicians" arrived from Germany, things would be handled somewhat haphazardly by the occupying soldiers and they might, therefore, have more of a chance of protecting their valuables. That was what my family did and, as I learned later, Picasso too. And in taking care of his own vaults, Picasso had looked after Matisse's as well.

Matisse had had a very serious abdominal operation and had gone to live in the south of France. His paintings were stored in a vault at the main office of the B.N.C.I.—the Banque Nationale pour le Commerce et l'Industrie—adjacent to Picasso's vaults. When Picasso's vaults were opened, he made it a point to be there. There were three large rooms full of paintings down in the basement: two for him and one for Matisse. The manager of the bank was a friend of both of them. Because Picasso was Spanish it would have been difficult for the Germans to touch his property if his papers had been in order, but since he was persona non grata with the Franco regime, his situation was precarious. And since both he and Matisse were classified by the Nazis as "degenerate" artists, there was all the more reason to be apprehensive. The inspectors were two German soldiers, very well disciplined but not very bright, he told me. He got them so confused, he said, rushing them from one room into the next, pulling out canvases, inspecting them, shoving them back in again, leading the soldiers around corners, making wrong turns, that in the end they were all at sea. And since they were not at all familiar with his work or with Matisse's either, they didn't know what they were looking at, no matter which room they were in. He wound up by inventorying only one-third of his paintings, and when it came to Matisse's, he said, "Oh, we've seen these." Not knowing one painting from another, they asked him what all those things were worth. He told them 8,000 francs-about \$1,600 in today's money-for all his paintings and the same for Matisse's. They took his word for it. None of his things or Matisse's were taken away. It must not have seemed worth the trouble.

"Germans always have a respect for authority," he said, "whatever form it may take. The fact that I was somebody everyone had heard of and I came there myself and gave them exact details of sizes, values, and dates—all that impressed them very much. And they couldn't imagine anyone telling them a story that might cost him very dear if he had been found out."

There was a Kafkaesque uncertainty surrounding some of the people who drifted in and out of Picasso's studio at that time: a rather mystifying art historian, for one, and a photographer who came from time to time on some vague mission. Picasso thought they were spies but there was no way of proving they were and no basis on which to refuse to let them in. What he feared most was that one day one of these dubious Germans—the photographer, for example, who came more often than any of the others—would plant some incriminating papers so that the next time the Gestapo came to search, they *would* find something.

It took a good deal of courage for him to stay there during the war, since his paintings had been denounced by Hitler and since the Occupation authorities took such a dim view of intellectuals. Many artists and writers—Léger, André Breton, Max Ernst, André Masson,

Zadkine, and others—had gone off to America before the Germans arrived. It must have seemed wiser to many not to run the risk of staying. One day I asked Picasso why he had.

"Oh, I'm not looking for risks to take," he said, "but in a sort of passive way I don't care to yield to either force or terror. I want to stay here because I'm here. The only kind of force that could make me leave would be the desire to leave. Staying on isn't really a manifestation of courage; it's just a form of inertia. I suppose it's simply that I prefer to be here. So I'll stay, whatever the cost."

As I CONTINUED to turn up regularly at the Rue des Grands-Augustins mornings, Sabartés grew more and more glum in my presence. One morning when only he and Picasso and I were in the painting studio, he apparently decided he had been diplomatic long enough. I suspected they had been talking about me before I arrived that morning because I hadn't been there but a few minutes when Sabartés said, as though he were simply contributing an opinion to a conversation that had been under way for some time already, "All this looks pretty bad to me, Pablo. And it will end badly. You see, I know you. Furthermore she has too many changes of clothing and that's not a good sign."

It was true that a week or two earlier my mother had had a change of heart and had smuggled some of my clothes out of the house and brought them to my grandmother's. I suppose I had been making the most of them after weeks of wearing the same outfit every day.

"You mind your business, Sabartés," Picasso said. "You don't understand anything. You haven't got the intelligence to realize this girl is walking a tightrope—and sound asleep, at that. You want to wake her up? You want her to fall down? You just don't understand us somnambulists. And what you don't understand, either, is the fact that I *like* this girl. I'd like her just as much if she were a boy. In fact she's a little like Rimbaud. So keep your gloomy, evil thoughts to yourself. You better get back downstairs and do some work."

Sabartés looked unconvinced. He sighed heavily and went downstairs. Picasso shook his head.

"What a treasure of incomprehension," he said. "In life you throw a ball. You hope it will reach a wall and bounce back so you can throw it again. You hope your friends will provide that wall. Well, they're almost never a wall. They're like old wet bedsheets, and that ball you throw, when it strikes those wet sheets, just falls. It almost never comes back." Then, looking at me out of the corner of his eye, he said, "I guess I'll die without ever having loved." I laughed and said, "No point in making up your mind now. You haven't got there yet." Picasso grew quiet for a moment and then said, "Do you remember the time we went up the miller's ladder into the forest, where we could look out over the rooftops?" I told him I did. "There's one thing I'd like very much," he said, "and that is if you would stay there, beginning right now, up in the forest; just disappear completely so that no one would ever know you were here. I'd bring you food twice a day. You could work up there in tranquillity, and I'd have a secret in my life that no one could take away from me. At night we could go out together. wandering wherever we wanted to, and you, who don't like crowds of people, you'd be completely happy, because you wouldn't have to worry about the rest of the world, just about me." I said I thought that was a very good idea. But then he began to think it over and he said. "I don't know whether it's such a good idea or not because it's binding on me. too. If you're agreeable to having no more liberty, that means I wouldn't have any more, either."

I could see it was hard for him to let go of the idea, all the same. "It would be nice, though," he went on. "You'd live here without seeing anyone else in the world but me, either writing or painting, and I'd give you all the materials you needed for your work, and we'd have that secret to share. We'd go out only after dark and only in quarters where we wouldn't run into anyone we knew."

I must admit that, at least poetically, the idea had a strong appeal for me at that moment. Living up there alone would have cut me off from all the people I would have preferred to avoid and left me in contact with one person who interested me enormously and who would have been quite sufficient for me at that time. I knew it wasn't yet a question of love, but I knew also that there was a very strong mutual attraction, a need to be together.

When I left, that morning, Picasso said, "I'm as tired as you must be of listening to Sabartés grumbling about finding you here mornings. Since he's never here after lunch, why don't you come see

me afternoons from now on?" I said I'd like that, but not to count on me for the forest right now. Since it was February, I had an idea I'd find it rather cold up there under the eaves.

"I agree," he said. "Besides, I've got a better idea for February. Since nobody is allowed in here afternoons and I don't even answer the telephone if it rings, we'll be completely undisturbed and I'll give you lessons in engraving. Would you like that?" I told him I believed I would.

Before my first afternoon visit to the Rue des Grands-Augustins, I telephoned to Picasso in the morning to make an appointment. I arrived on time, wearing a black velvet dress with a high white lace collar, my dark-red hair done up in a coiffure I had taken from a painting of the Infanta by Velázquez. Picasso let me in. His mouth dropped open. "Is that the kind of costume you put on to learn engraving?" he finally asked.

Certainly not, I told him. But since I was sure he hadn't the slightest intention of teaching me engraving, I had put on the costume that seemed most appropriate to the real circumstances. In other words, I was simply trying to look beautiful, I said.

He threw up his hands. "Good God! What nerve! You do everything you can to make things difficult for me. Couldn't you at least *pretend* to be taken in, the way women generally do? If you don't fall in with my subterfuges, how are we ever going to get together?" He stopped. He seemed to be reconsidering his criticism. Then he said, more slowly, "You're right, really. It's better that way, with the eyes open. But you realize, don't you, that if you don't want anything but the truth—no subterfuges—you're asking to be spared nothing. Broad daylight is pretty harsh." He paused, as though he felt unsure. "Well," he said, "we've got plenty of time. We'll see."

I followed him into the long room where Sabartés worked mornings. The room was empty now, except for its usual clutter. Picasso left the room and came back in a few minutes with a large album. He pushed aside some of the piles of papers and books on the long table in the center of the room and set it down. He untied the cover and folded it back. Inside was a thick pile of prints.

"You see, we're going to get around to the subject of engraving, after all," he said. "This is a series of etchings, a hundred of them, that I made for Vollard in the 1930s."

On top of the pile were three etched portrait heads, two of them with aquatint, of the picture-dealer Ambroise Vollard. Picasso laughed.

PART I

"The most beautiful woman who ever lived never had her portrait painted, drawn, or engraved any oftener than Vollard—by Cézanne, Renoir, Rouault, Bonnard, Forain, almost everybody, in fact. I think they all did him through a sense of competition, each one wanting to do him better than the others. He had the vanity of a woman, that man. Renoir did him as a toreador, stealing my stuff, really. But my Cubist portrait of him is the best one of them all."

He turned to a print that showed a fair-haired seated nude wearing a flower-covered picture hat. Opposite her was a standing nude with dark hair and eyes, partly draped. He pointed to the one who was standing. "There you are. That's you. You see it, don't you? You know, I've always been haunted by a certain few faces and yours is one of them." He turned to another print that showed another partially draped nude standing beside a curious looking male figure who held her by the hand —a painter, apparently, because he seemed to be holding in his other hand a palette and brushes. He was a very hairy fellow, wearing a ruff and a crumpled hat. "You see this truculent character here, with the curly hair and mustache? That's Rembrandt," Picasso said. "Or maybe it's Balzac; I'm not sure. It's a compromise, I suppose. It doesn't really matter. They're only two of the people who haunt me. Every human being is a whole colony, you know."

He turned over several more of the prints. They were filled with bearded and clean-shaven men, with minotaurs, centaurs, faunlike figures, and all kinds of women. Everyone was nude or nearly so and they seemed to be playing out a drama from Greek mythology.

"All this takes place on a hilly island in the Mediterranean," Picasso said. "Like Crete. That's where the the minotaurs live, along the coast. They're the rich *seigneurs* of the island. They know they're monsters and they live, like dandies and dilettantes everywhere, the kind of existence that reeks of decadence in houses filled with works of art by the most fashionable painters and sculptors. They love being surrounded by pretty women. They get the local fishermen to go out and round up girls from the neighboring islands. After the heat of the day has passed, they bring in the sculptors and their models for parties, with music and dancing, and everybody gorges himself on mussels and champagne until melancholy fades away and euphoria takes over. From there on it's an orgy."

He turned to another plate that showed a minotaur down on his knees, a male gladiator giving him the *coup de grâce* with a dagger. A crowd of faces, mostly women's, peered down on them from behind a barrier. "We're taught that Theseus came and killed a minotaur but he

was only one of many. It happened every Sunday: a young Attic Greek came over from the mainland and when he killed a minotaur he made all the women happy, especially the old ones. A minotaur keeps his women lavishly but he reigns by terror and they're glad to see him killed."

Picasso was speaking very quietly now. "A minotaur can't be loved for himself," he said. "At least he doesn't think he can. It just doesn't seem reasonable to him, somehow. Perhaps that's why he goes in for orgies." He turned to another print, a minotaur watching over a sleeping woman. "He's studying her, trying to read her thoughts," he said, "trying to decide whether she loves him *because* he's a monster." He looked up at me. "Women are odd enough for that, you know." He looked down at the etching again. "It's hard to say whether he wants to wake her or kill her," he said.

He turned to another plate. "The painters are a little out of contact with reality. Look at this one: someone brings him a girl and what does he draw? A line. He's a nonfigurative. But at least the painters live a more orderly life than the sculptors. You'll notice that wherever there are orgies, there are beards. That's the sculptors: warm flesh in one hand, cool champagne in the other. No doubt about it, the sculptors are very much in contact with reality."

He turned over several more prints. He came to a fair-haired nude in the arms of a sculptor. On a plinth beside them was a female head in profile that resembled several pieces of his that I had seen in his sculpture studio. "The sculptor's a little mixed up, too, you see." he said. "He's not sure of which way he wants to work. Of course if you note all the different shapes, sizes, and colors of models he works from, vou can understand his confusion. He doesn't know what he wants. No wonder his style is so ambiguous. It's like God's. God is really only another artist. He invented the giraffe, the elephant, and the cat. He has no real style. He just keeps on trying other things. The same with this sculptor. First he works from nature; then he tries abstraction. Finally he winds up lying around caressing his models. And look here." He pointed to a model standing in front of a sculptor's construction that appeared to be made from a rococo armchair some of whose elements were based on the forms of a woman. "Who could make sculpture with odds and ends of junk like that?" he asked, grinning. "He's not serious. Of course, he does take himself pretty seriously: the very fact that he grows a beard shows that. Then, too"-he pointed, in another etching, to a fair-haired model lying in a sculptor's arms-"twining the garlands around their hair like that . . ." He looked more closely. "I imagine that's wild clematis in her hair," he saïd, "but he's got ivy in his. Men are always so much more faithful than girls!"

He turned to the next sheet. A sculptor worked at a portrait head, looking very pleased with himself. Rays emanated from the head. "While he's working on it, he's sure it's pure genius, you see." He turned to another. The sculptor sat before his work, the model standing between him and the sculpture. "She's telling him, 'I never looked like that.'" He took another look at the sheet, then looked at me. "But of course, that's you again, that model. If I had to do your eyes right now, I'd do them just that way."

The next print showed a darkly bearded Rembrandt-like figure facing a young painter wearing a Phrygian cap. Picasso sighed. "Every painter takes himself for Rembrandt," he said. "Even this one, and you can tell from the cap he flourished at least three thousand years before Rembrandt came along. Everybody has the same delusions."

In the next plate a nude model was bending over a reclining sculptor. The weight and curve of her body were defined in a few slender lines. "He's got a very serene look on his face, hasn't he?" Picasso said. "When he succeeds in doing something with one pure line, he's sure then that he's found something. If sculpture is well done—if the forms are perfect and the volumes full—and you pour water from a pitcher held over the head, after it's run down, the whole sculpture ought to be wet."

He turned to another print. A partially draped model stood beside another one, seated in front of a painting that looked like a bouquet of flowers in ebullition. "The one sitting down looks like a model of Matisse's who had decided to try another painter and now that she's seen the results, she's wishing she'd stayed home—it's all too confusing. The other one's telling her, 'He's a genius. Do you *have* to understand what it's all about?"

He looked over at me. "What is it all about, anyway? Do you know?" I told him I wasn't altogether certain, but I had the beginnings of an idea, at least.

"In that case you've seen enough, then. Enough for today." He closed the album. "Let's go upstairs," he said. "I'd like to get an idea about something, too."

We climbed the winding stairs to the floor above. Picasso linked his arm through mine and guided me into the bedroom. In the middle of the room he stopped and turned to me. "I told you I wanted to get an

idea about something," he said. "What I really meant was that I wanted to see if the idea I already have is right." I asked him what that idea was.

"I want to see if your body corresponds to the mental image I have of it. Also, I want to see how it relates to your head." I stood there and he undressed me. When he had finished, he put my clothes on a chair, stood back near the bed, nine or ten feet from me, and began to study me. After a while he said, "You know, it's incredible the degree to which I had prefigured your form." I must have seemed a little unsure of myself standing there in the middle of the room. He sat down on the bed and told me to come to him. I walked over to him and he pulled me down onto his knees. I think he saw that I was embarrassed and that I would certainly have done whatever he asked me to, not because I really wanted to, but because I had made up my mind to. He must have sensed that and realized I was still, in a measure, undecided and had no real desire, because he began to reassure me. He told me that what he wanted was to have me there beside him but that he didn't feel the consummation of our relationship was irrevocably fixed, like the striking of a clock, to take place at a predetermined moment. He said that whatever there was between us, or whatever was to be, was surely a wonderful thing and that we must both feel completely free; that whatever was to happen should happen only because we both wanted it.

I had said I would come to see him and I knew what that would lead to. I was willing to accept the consequences but I didn't really want to. Whatever I might have done I would have done to please him, but not wholeheartedly. He understood the difference. From the moment he undressed me and studied me as I stood there in the middle of the room, my whole point of view had begun to change, because his doing that had produced a kind of shock. I suddenly felt that I could trust him completely, and that I was beginning to live the beginning of my life. One doesn't necessarily live the beginning at the beginning.

He stretched me out on the bed and lay down beside me. He looked at me minutely, more tenderly, moving his hand lightly over my body like a sculptor working over his sculpture to assure himself that the forms were as they should be. He was very gentle, and that is the impression that remains with me to this day—his extraordinary gentleness.

He told me that from then on, everything I did and everything he did was of the utmost importance: any word spoken, the slightest gesture, would take on meaning, and everything that happened between us would change us continually. "For that reason," he said, "I wish I

were able to suspend time at this moment and keep things exactly at this point, because I feel that this instant is a true beginning. We have a definite but unknown quantity of experience at our disposal. As soon as the hourglass is turned, the sand will begin to run out and once it starts, it cannot stop until it's all gone. That's why I wish I could hold it back at the start. We should make a minimum of gestures, pronounce a minimum of words, even see each other as seldom as possible, if that would prolong things. We don't know how much of everything we have ahead of us so we have to take the greatest precautions not to destroy the beauty of what we have. Everything exists in limited quantityespecially happiness. If a love is to come into being, it is all written down somewhere, and also its duration and content. If you could arrive at a complete intensity the first day, it would be ended the first day. And so if it's something you want so much that you'd like to have it prolonged in time, you must be extremely careful not to make the slightest excessive demand that might prevent it from developing to the greatest extent over the longest period."

I lay there in his arms as he explained his point of view, completely happy without feeling the necessity of anything beyond just being together. Finally he finished talking. We continued to lie there, without saying a word, and I felt that it was the beginning of something very marvelous, in the true sense of the word. I knew he wasn't pretending. He didn't say he loved me—it was too soon. He said it, and showed it, but weeks later. If he had taken possession of me then by the power of his body or unleashed a torrent of sentiment in declaring his love, I would not have believed in either one. But as it was, I believed in him completely.

Until then he had been, for me, the great painter that everyone knew about and admired, a very intelligent, witty man but impersonal. From then on he became a person. Until then he had aroused my interest and engaged my mind. Now my emotions and affections were involved. I had not thought before then that I could ever love him. Now I knew it could be no other way. He was obviously capable of sidestepping all stereotyped formulas in his human relations just as completely as in his art. One recognizes the stereotypes even if one has not experienced them all. He took command of the situation by stopping the intellectual game, sidestepping the erotic one, and putting our relationship on the only basis possible in order to be significant for him and as I even then realized—for me as well.

Finally I knew it was time to go and I told him. He said, "We

mustn't see each other too often. If the wings of the butterfly are to keep their sheen, you mustn't touch them. We mustn't abuse something which is to bring light into both our lives. Everything else in my life only weighs me down and shuts out the light. This thing with you seems to me like a window that is opening up. I want it to remain open. We must see each other but not too often. When you want to see me, you call me and tell me so."

When I left there that day, I knew that whatever came to passhowever wonderful or painful, or both mixed together—it would be tremendously important. For six months we had been walking all around each other in an ironic sort of way and now, in the space of an hour, in our first real face-to-face meeting, the irony had been taken out of it and it had become very serious, a kind of revelation.

It was a cold gray February day, but my recollection of it is filled with midsummer sunlight.

46

PART II

DURING THAT WINTER and spring of 1944 I worked harder than ever at my painting. Sometimes when I went to the Rue des Grands-Augustins I would take a drawing or a painting to show Pablo. He never gave me any direct criticism. His instruction was always in the form of general principles: for example, "You know, we need one tool to do one thing, and we should limit ourselves to that one tool. In that way the hand trains itself. It becomes supple and skillful, and that single tool brings with it a sense of measure that is reflected harmoniously in everything we do. The Chinese taught that for a watercolor or a wash drawing you use a single brush. In that way everything you do takes on the same proportion. Harmony is created in the work as a result of that proportion, and in a much more obvious fashion than if you had used brushes of different sizes. Then, too, forcing yourself to use restricted means is the sort of restraint that liberates invention. It obliges you to make a kind of progress that you can't even imagine in advance." So even though he appeared not to be giving me any direct advice, whenever I applied those general principles of his, I would make progress.

Sometimes he would have me do things for composition. He would give me a piece of blue paper—perhaps a cigarette wrapper and a match, tear off a piece of cardboard and say, "Make me a composition with those. Organize them for me into this," and he would draw a form on a piece of paper to indicate the size and shape. "Do whatever you want, but make a composition out of it that stands on its own feet." It's incredible the number of possibilities one has with

49

three or four elements like that. He used to say to me, "You must always work not just within but below your means. If you can handle three elements, handle only two. If you can handle ten, then handle only five. In that way the ones you do handle, you handle with more ease, more mastery, and you create a feeling of strength in reserve."

At that time he was painting a series of views of Paris and the bridges of the Seine, with three or four bridges, one above another, then Notre Dame or the boats in the Seine. He did also a series of canvases of the Vert Galant, the western point of the Ile de la Cité, with an enormous tree-now no longer there-bent way over and held up by a kind of crutch. That end of the island was a meeting-ground for lovers in the springtime. All that (including the amatory legend of Henri IV, the original Vert Galant) inspired Pablo to make several versions of the scene. He always put in the lovers and the river, and the essential element of the composition was always that large hanging tree. He liked to walk along the guays of the Seine between the Quai des Grands-Augustins and the Pont du Carrousel. Even in wartime there were plenty of painters who came to paint that historic site. Pablo made a series of caricatures in an old daybook, showing dozens of them in the form of monkeys, or with angels' wings and donkeys' ears, in the act of painting. He said, "Every time I see a painter like that working from nature and I look at his canvas, I always see bad painting."

As a rule, when I got to the Rue des Grands-Augustins in the afternoon, Pablo was not yet at work. One day after he had let me in, he took me into his studio. On the easel was a canvas that he must have started a day or two before and then set aside. There was a fat round spot like a green sun at the right center of the canvas. Lunging up through the center from the lower left-hand corner was a violet triangular shape that came to a point just above the green sun. They were linked by a heavy black line like a slightly curving V that passed through both of the colored forms. I asked him what this was in the process of becoming.

"It's already a still life," he said. "That's the pictorial idea. It makes no difference whether the principal element turns out to be a glass or a bottle. That's only a detail. And there may be moments all along when reality comes close and then recedes. It's like the tide rising and falling, but the sea is always there.

"What you see now is the first proposition: the spot of green, the thrust of the violet, and the black line that joins them. Those elements are struggling with one another. And there are intrigues everywhere. The green spot, for instance, has a tendency to grow, to work out from

PART II

the center. It's not contained within a line or a form—color never should be. It's there to send out rays. It's dynamic by its very nature. So it will expand. On the other hand, the violet starts big and grows smaller all the way up to its point. And aside from the forms of the green and the violet, there's a struggle between the colors themselves, just as there is between the straight line and the curve. In each case they're strangers to each other. Now I have to heighten the contrast."

I asked him if he thought the green was balanced by the violet. "That's not the question," he said. "I don't need to know that. I'm not trying to make this first proposition more coherent. Right now I'm interested in making it more disturbing. After that I'll start to construct—but not to harmonize; to make it more deeply disturbing, more subversive.

"So far it's instinctive, you see. Now I've got to set down something that goes further than that, something a good deal more audacious. The problem is, how can I shake up that first proposition? How can I, without destroying it completely, make it more subversive? How can I make it unique—not simply new, but stripped down and lacerating? You see, for me a painting is a dramatic action in the course of which reality finds itself split apart. For me, that dramatic action takes precedence over all other considerations. The pure plastic act is only secondary as far as I'm concerned. What counts is the drama of that plastic act, the moment at which the universe comes out of itself and meets its own destruction.

"Juan Gris said, 'I take a cylinder and I make a bottle out of it,' reversing, in a sense, Cézanne's remark. His idea was that beginning with an ideal plastic form-a cylinder-one can make a portion of realitythe bottle-enter into that form. Gris's method was a grammarian's. I suppose you might call mine an entirely romantic one. I start with a head and wind up with an egg. Or even if I start with an egg and wind up with a head, I'm always on the way between the two and I'm never happy with either one or the other. What interests me is to set up what you might call the rapports de grand écart-the most unexpected relationship possible between the things I want to speak about, because there is a certain difficulty in establishing the relationships in just that way. and in that difficulty there is an interest, and in that interest there's a certain tension and for me that tension is a lot more important than the stable equilibrium of harmony, which doesn't interest me at all. Reality must be torn apart in every sense of the word. What people forget is that everything is unique. Nature never produces the same thing twice. Hence my stress on seeking the rapports de grand écart: a small head

on a large body; a large head on a small body. I want to draw the mind in a direction it's not used to and wake it up. I want to help the viewer discover something he wouldn't have discovered without me. That's why I stress the dissimilarity, for example, between the left eye and the right eye. A painter shouldn't make them so similar. They're just not that way. So my purpose is to set things in movement, to provoke this movement by contradictory tensions, opposing forces, and in that tension or opposition, to find the moment which seems most interesting to me."

I told him if he had never painted a single picture in his life, we would probably have known of him as a philosopher. He laughed. "When I was a child, my mother said to me, 'If you become a soldier you'll be a general. If you become a monk you'll end up as the Pope.' Instead, I became a painter and wound up as Picasso."

I HAT SUMMER, just before the Liberation, there were many airraid alarms. The only way of getting around Paris was the subway but very few took it, because once you were in, it was often hard to get out. What with one alarm after another, you might go down into the *métro* in the morning and not come out all day long. The only practical method of locomotion for me was my bicycle. When I crossed Paris from my grandmother's house in Neuilly to see Pablo, I would take my bicycle, whatever the weather, and often arrive at his house spattered with mud. One day when I showed up in that condition, he laughed and said, "This must be the new kind of make-up. In my day girls went to a great deal of trouble to make up their face and eyes but now the latest thing is mud on the legs."

In the last few days before the Liberation, I talked with Pablo by telephone, but it was next to impossible to get to see him. People were already beginning to bring out the cobblestones to build the barricades. Even children were working at the job, especially in the sixth *arrondissement*, where Pablo lived; around the Senate, where there was a great deal of fighting, and as far over as the Pont Sully, at the tip of the Ile Saint-Louis. Resistance was organizing, also, around the Prefecture of Police, so to get into those quarters and out again was difficult. German snipers were everywhere. The last time I talked to Pablo before the Liberation he told me he had been looking out the window that morning and a bullet had passed just a few inches from his head and embedded itself in the wall. He was planning to spend the next few days with his nine-year-old daughter Maya and her mother, Marie-Thérèse Walter, who lived in an apartment on the Boulevard Henri IV at the eastern end of the Ile Saint-Louis. There was a great deal of fighting in that area and he was concerned for their safety.

Paris was finally liberated a few days later, on the twenty-fourth of August. Soon after that, Pablo returned to the Rue des Grands-Augustins with two small gouaches he had painted while he was there from a reproduction of a bacchanalian scene by Poussin, *The Triumph of Pan*.

One of the first effects of the Liberation was the arrival of Hemingway at the Rue des Grands-Augustins. Pablo was still with Maya and her mother when he arrived. The concierge in Pablo's building was a very timid woman but not at all bashful. She had no idea who Hemingway was but she had been used to having many of Pablo's friends and admirers leave gifts for him when they called in his absence. From time to time South American friends of his had sent him such things as hams so that he could eat a little better than the average during the war. In fact Pablo had more than once shared his food parcels with her. When she told Hemingway that Pablo was not there and Hemingway said he'd like to leave a message for him, she asked him-so she told us later-"Wouldn't you perhaps like to leave a gift for Monsieur?" Hemingway said he hadn't thought about it before but perhaps it was a good idea. He went out to his jeep and brought back a case of hand grenades. He set it down inside her loge and marked it "To Picasso from Hemingway." As soon as the concierge deciphered the other markings on the case, she ran out of the loge and refused to go back until someone took the case away.

Once Paris was liberated, all the cultural key points, such as the Office of the Director of the Museums of France, were cleaned out. Collaborators and Pétainists were fired at once. As a result, since Picasso was the painter who was Number One on the German Index, the first revenge to take on the Germans was to mount a big Picasso retrospective as a token of the change in policy. The exhibition was arranged by Jean Cassou, chief curator of the Musée d'Art Moderne, and it formed part of the Salon d'Automne. It created an immediate scandal, and drew fire chiefly from two groups: artistic reactionaries and political agitators. The first group was made up of the many people who had never seen a large and representative collection of Picasso's paintings, especially

those of the war period, with their tortured forms, or even those of the period 1932–1936, which are not completely naturalistic. They revolted immediately against the massive exhibition of this violent art that overnight had become official, in a sense.

The other group was composed of right-wing students and ex-Pétainists. They came en masse shouting their protests and trying to pull the paintings off the walls. Theirs was really a political protest disguised as aesthetic disapproval.

During the Occupation, many French Communists had been active and heroic workers in the Resistance. One of the most important of these was Laurent Casanova. His wife, Danielle Casanova, had been killed by the Germans. He had made three escapes from prison camp but had been recaptured each time. On a fourth attempt he reached the outskirts of Paris. Friends of his got in touch with Pablo's friend, the poet Paul Eluard, also a Party member, and told him Casanova must be hidden somewhere, preferably with people who would not know whom they were sheltering. Paul asked the writer Michel Leiris if he would be willing to hide a Communist in his apartment for a month or so, not telling him who Casanova was. At that time to give asylum to an escaped prisoner, a Communist or a Jew, was risking the death sentence.

Michel Leiris agreed and Casanova went to live just around the corner from Pablo's studio, in the apartment at 53 *bis*, Quai des Grands-Augustins, which, before the Occupation, Pablo's dealer D.-H. Kahnweiler and his wife had bought to share with the Leirises.

Kahnweiler had been Pablo's dealer, off and on, for many years. As a German, Kahnweiler had been obliged to flee from France during World War I and his pictures had been confiscated and sold by the French government. He had gone back into the picture business after that war but had now been forced to flee again, and he and his wife, at the time, were hidden in the Free Zone. Since 1940 his gallery had been called the Galerie Louise Leiris. Louise, "Zette," Leiris, was the wife of Michel Leiris and was Kahnweiler's sister-in-law. She was not merely a front for him; she was an active co-worker in the business, and had been with Kahnweiler since 1921. Now that Kahnweiler was again in hiding—this time as a Jew fleeing from the Germans—the business could go on, reasonably intact, because his gallery was officially hers.

During the month Casanova stayed in the apartment he had much influence on all that group. For the first time Pablo had the occasion to talk with a Communist Party figure who was at the same time sufficiently intelligent and open-minded to be acceptable to someone whom the Party dogmatists would not have impressed. As a result of those contacts with Casanova, a number of intellectuals entered the Communist Party, Pablo among them.

Although Pablo's art was anathema to most of the Party hierarchy, they realized how useful his name and image would be to their cause. I knew Casanova had impressed him greatly. I knew also that two of his closest friends, the poets Louis Aragon and Paul Eluard, had played a part in his conversion. But when I asked him what, exactly, had made him join the Party—since all the "statements" I had read in the press sounded like propaganda hand-outs—he said, "I came into the Party as one goes to the fountain." The right-wing groups, then, who marched on the exhibition so vociferously were trying to discredit Pablo in the hope of blocking his potential usefulness to the Communist Party.

I was often on duty at the exhibition, along with other young painters and art students who admired Picasso's work without any particular political affiliation. Our job was to protect the paintings and hang again those that the demonstrators occasionally succeeded in pulling down. Two months earlier, armed militia had been shooting at people in the streets. Now that the Liberation had come, the agitation was simply carried over into other forms. People came to the exhibition to vent their political venom.

Many of the paintings, called simply *Femme Couchée*, were very rhythmical portraits of Marie-Thérèse Walter. Some of these had been shown before by the dealer Paul Rosenberg. There were other portraits, much more tormented and of a slightly later period, of Dora Maar, and still lifes with a candle and the head of a bull, or a cat catching a bird, all rather hallucinatory and somber. After the nightmare of the Occupation it must have been a shock for the general public to be exposed to work that was so close in spirit to the years they had just lived through. Seeing the image of a period in which all norms had been swept aside was perhaps in some ways more difficult than living through it.

All of a sudden Picasso was the Man of the Hour. For weeks after the Liberation you couldn't walk ten feet inside his atelier without falling over the recumbent body of some young GI. They all had to see Picasso but they were so tired they would just make it to the studio and then fall asleep. I remember once counting twenty of them sleeping in various parts of the studio. In the beginning they were mostly young writers, artists, and intellectuals. After a while they were simply tourists and at the head of their list, apparently, along with the Eiffel Tower, was Picasso's studio.

From that moment on, Picasso stopped being a private citizen and became public property. I remember one day bicycling across the Place Clichy and stopping at an intersection where there was a newspaper kiosk. I looked up and saw Picasso's face staring down at me from the cover of some picture magazine, like *Life* or *Match*, with his favorite pigeon perched on his head or shoulder. It gave me quite a shock. I had always realized that he was, of course, in part a public personage, but I had felt that that aspect was a façade, and that beneath it there was the private person, intact and inaccessible to the public gaze. But when I saw the photograph with that bird, which was quite untamed and would never allow anyone but Pablo to touch it and would come to him only when he was alone and fly away again when anyone else approached, it seemed to me a kind of invitation to the whole world to come close enough to touch.

NE OF THE EARLY VISITORS from America after the war was a picture dealer whom I shall call Jacques. In the past, he had bought many of Picasso's finest paintings. Before the war he had left Paris to settle in New York. Now that the war was over, he had returned to Europe on a Liberty ship to search for treasures. But by the time he reached the Rue des Grands-Augustins he had already lost some of his enthusiasm. He told Pablo he had brought very little baggage but had made room for a three-pound can of bismuth-he suffered from a stomach ulcer-and a very considerable number of American cigarettes, which he was sure were not available in Europe. The customs officers at Le Havre had lost no time impounding this suspicious-looking cargo. Jacques had tried to explain that the can contained bismuth for his ulcer. The customs officers had another idea: that it might be, at least in part, cocaine, and they sent it off for chemical analysis. The cigarettes-well, they might just possibly contain marijuana, some of them. Meanwhile Jacques was told to stay on call at a hotel in Le Havre. After two days, the analyses proved negative and Jacques was allowed to proceed to Paris, after payment of a substantial sum for laboratory charges and, of course, a confiscatory import duty on the cigarettes. Since armies of GI's were unloading various PX supplies on the black market, Paris

was flooded with American cigarettes, which he could have bought for considerably less than what his own now stood him.

As it happened, Pablo's joining the Communist Party had resulted in a temporary cooling off in the affections of certain American buyers and a drop in the sales and prices of his paintings in America. Jacques said he thought that was a shame. But, he told Pablo, he didn't intend to let that fact interfere with either his friendship for Pablo or his interest in Pablo's work. "In spite of everything, I'm here to buy," he said, "if your prices are reasonable enough. You know I'm not one to want to profit from another man's hard luck. When Renoir died, I learned about it at ten o'clock in the morning. At 10:30 a man came into my gallery and asked if I had any Renoirs. I couldn't imagine how he'd had the news so soon but I showed him two or three small paintings. He wanted something more important, he said. Then I was sure he knew. I brought out a much bigger painting and I could see that was it. He asked me the price. I can't stand the idea of people trafficking on the death of a painter, so I made him a price for Renoir dead, not Renoir alive."

Pablo was not deeply moved. "I'm sure you don't speculate on the death of artists," he said, "but it won't do you any good to try to speculate on me alive. My prices are higher that way. I suggest you go back to America and try to pick up some Picassos at prewar prices there. Here there's a certain value attached to being still alive in spite of the war. That makes my paintings more expensive."

"You have no heart," Jacques protested. "You're not my friend. Everything I say you use against me. And to think I wanted to do you a good turn!"

But since Pablo wasn't interested in this good turn, they did no business that day.

A few years after that, Jacques returned to see Pablo. By then the Picasso market was thriving as never before, and Jacques was very eager to do business. I think he had a sincere affection and admiration for Pablo but he wanted paintings, too. He arrived almost breathless at the Rue des Grands-Augustins. He was a very thin man and must have weighed not much more than a hundred pounds. But that day he looked almost fat. He was literally stuffed with dollars. He said to Pablo, "At last I'm going to have some paintings again. And I've got money. Look." He pulled out rolls of bills and began to pile them up on the table. Every once in a while he would snap a sheaf of them under Pablo's nose. Pablo wasn't at all impressed, but looked at him

sadly and said, "It's too bad, my poor friend. You're not really rich enough for me now. I don't think you can buy any more paintings from me."

"What are you talking about?" said Jacques. "You sell to Kahnweiler. Even to Carré. Why not to me? Look here." He found another pocket that was untapped and brought out several more rolls of bills. Finally, he pulled out his checkbook and laid it on the table. Pablo shook his head. Then he noticed Jacques' hat. "That's a nice hat," he said. "I like it."

"You should," Jacques said. 'It's from Lock, in London." He took it off, showed Pablo the label and his initials in gold-leaf on the band. Pablo tried it on. It was so small it perched on the top of his head like a peanut on an elephant's back. He took it off and returned it. "But I'll get you one in your size," Jacques offered.

"Well, all right," Pablo said. "If you want to go to London and buy me a hat—just like that one—then *perhaps*, in spite of everything, I might sell you a painting, because I'm a nice guy and I like you." Jacques left immediately, hopped on the next plane for London and was back at the atelier the following day with a duplicate of his Lock hat, with Pablo's initials in gold on the hatband. "Fine," said Pablo. He tried it on, looked at himself in the mirror, then said, "You know, this doesn't look at all good on me, this hat. You keep it." He took it off and set it onto Jacques' head. It was much too large. He pulled it down over Jacques' ears and walked away. There were no paintings for Jacques that day.

WHEN PABLO WAS YOUNG, the dealers took advantage of him whenever they could; they would buy his paintings at their price. Later, things were reversed: Everyone wanted his paintings and it was *he* who made the price. From then on, it was simply a question of deciding whether a dealer would or would not have any paintings and if so, which ones, since Pablo always kept the best for himself. He went to great pains not to let the dealer know until the very last minute whether or not he would get any pictures, and if he did, whether they would be important paintings or just relatively minor ones.

I soon had occasion to see that with his dealers, just as with everyone else, Pablo had a manner all his own of utilizing the aphorism. "divide and conquer." In 1944 and 1945 Kahnweiler was not his only dealer. He sold also to Louis Carré. He would sometimes arrange to have the two of them call at the Rue des Grands-Augustins on the same morning. Under the circumstances Carré and Kahnweiler were not very fond of each other and Pablo would see to it that they were kept waiting for nearly an hour in the anteroom. They were obliged to talk to each other: they couldn't sit there and say nothing. Then, after a long wait, Pablo would let one of them come into the Holy of Holies. As a rule, since he liked Kahnweiler better, he would let Louis Carré come in first. Carré knew very well that Kahnweiler, like the lover one dangles on a string, was waiting anxiously to see the expression on his face when he came out, thinking: If Carré is smiling, it's because he's got paintings; if he looks sad, it's because he didn't get any. And Carré was intelligent enough to lend himself to this little game. So, especially if he had no paintings, he would pat Pablo on the back, calling him "Mon cher ami," and give every evidence of being very pleased with himself. Sometimes I would see Kahnweiler's face go ashen when Carré came out like that. He could do nothing about it. It was stronger than he was. It was not simply a question of jealousy between picture dealers: I think Kahnweiler felt, really, such an exceptionally strong personal involvement with Picasso and his work, in addition to the normal business instincts of a picture dealer, that when his rival Carré would come out, looking delighted, slapping Pablo on the back, that meant not only that he probably had paintings, but also that someone else had enjoyed the confidence of this man who was so terribly important to Kahnweiler. And that must have seemed far worse. Very often it meant no such thing, but Kahnweiler nevertheless assumed it did and his suffering softened him up considerably. Pablo would then have him come in, but he was so depleted by the spectacle of Carré leaving so jauntily that Pablo could manipulate him very easily. If Pablo wanted, for example, to raise his prices with Kahnweiler, he was sure to let Louis Carré in first. At that time, Carré had a very youthful appearance, with a great deal of zest, a well-built stocky figure, and a facility with words and gesturesthe man of action. Kahnweiler, of course, was an introvert, with the manner of a man raised in Frankfort in rather puritan fashion.

That was one of my first insights into Pablo's standard technique of using people like ninepins, of hitting one person with the ball in order to make another fall down.

T HAT WINTER, Pablo had given me The Autobiography of Alice B. Toklas to read. I had found it very entertaining and told him I'd like to meet Gertrude Stein. One spring morning he said to me, "We're going to see Gertrude this week. That will amuse you. Besides, I have a lot of confidence in her judgment. If she approves of you, that will reinforce whatever good opinion I might have of you." From that moment on, I lost all desire to meet Gertrude Stein. But I had to go; he had made an appointment with her.

When the day arrived, I had lunch with Pablo at *Le Catalan*. He was unusually cheerful, but I couldn't swallow a thing. Toward 3:30 we climbed the broad, cold, exposed stairway of Gertrude Stein's house in the Rue Christine and Pablo knocked at the door. After a little wait, the door was opened a crack, almost grudgingly, like the door to the studio in the Rue des Grands-Augustins. Through the slit I saw a thin, swarthy face with large, heavy-lidded eyes, a long hooked nose, and a dark, furry mustache. When this apparition recognized Pablo, the door was opened wider and I saw a little old lady wearing an enormous hat. It was Alice B. Toklas.

She let us into the hallway and greeted Pablo in a deep baritone voice. When Pablo introduced me, she ground out a "Bonjour, Mademoiselle," with an accent that sounded like a music-hall caricature of an American tourist reading from a French phrase book. We took off our coats and hung them in a little vestibule. We passed into a larger gallery lined with paintings, many of them from the Cubist period and mostly by Pablo and Juan Gris. From that room we went into a salon flooded with sunlight. There, in an armchair facing the door, under her portrait painted by Pablo in 1906, sat Gertrude Stein, broad, solid, imposing, her gray hair cropped very close. She had on a long brown skirt to the ankles, a dull beige blouse, and her feet were bare inside heavy leather sandals.

Pablo presented me and she waved me to a seat on a horsehair divan facing her. Pablo sat on a window ledge beside and slightly behind her with his back to the light, as though he wanted to survey the scene yet not be obliged to participate. A gleam in his eyes indicated that he was expecting to enjoy himself immensely. Alice Toklas sat down on the divan beside me but as far away as possible. In the center of our little circle were several low tables covered with plates of *petits fours*, cakes, cookies, and all kinds of luxuries one didn't see at that period, right after the war.

I was intimidated by Gertrude Stein's first questions, which were a little sharp and sometimes obvious. It was quite clear that she was asking herself, What's going on between Pablo and this girl? And first in English and then in French—not very good French—she tried to get me to talk. It was worse than the oral examination for the *baccalauréat*.

I did my best with her questions but I was distracted by the enormous hat on Alice Toklas's head. She was dressed in very dark gray and black, and her huge hat was black with a little gray trim. She looked as though she had dressed for a funeral, but the tailoring was obviously of the very first quality. I learned afterwards that her couturier was Pierre Balmain. I felt ill at ease with her there beside me. She looked hostile, as though she were predisposed against me. She spoke infrequently, occasionally supplying Gertrude Stein with a detail. Her voice was very low, like a man's, and rasping, and one could hear the air passing loudly through her teeth. It made a most disagreeable sound, like the sharpening of a scythe.

As the afternoon went on, Gertrude Stein seemed more relaxed in her interrogation. She wanted to know how well I knew her work and whether I had read the American writers. Fortunately I had read quite a few. She told me she was the spiritual mother of them all: Sherwood Anderson, Hemingway, Scott Fitzgerald. She talked especially about Dos Passos as having been greatly influenced by her; even Erskine Caldwell. She wanted me to understand the importance of her influence, even on those who had never come to sit at her feet, like Faulkner and Steinbeck. She said that without her, there would be no modern American literature as we know it.

After straightening out the literary matters, she got around to the subject of painting and she began to cross-examine me on Cubism. With all the pedantry of my twenty-three years, I replied with whatever seemed the appropriate observations on analytic Cubism, synthetic Cubism, the influence of Negro art, of Cézanne, and so on. I wasn't trying to make a good impression on her; I simply wanted to make sure that Pablo didn't feel disappointed in me. Finally she turned and pointed to her portrait by Pablo and said, "What do you think of my portrait?" I told her I knew her friends had thought that although in the beginning she didn't look like that, after a while she had come to resemble it. But after all those years, it seemed to me, she had begun to move in the

other direction, I said, because she didn't resemble it any longer. Now she had come a lot closer to the idea I had of what a Tibetan monk ought to look like. She looked at me disapprovingly.

The most disturbing thing about the whole afternoon, though, was that while all this was going on, Alice Toklas was not sitting still, but bobbing up and down, moving back and forth, going out into the dining room to get more cakes, bringing them in, and passing them around. And she looked so glum at some of my answers to Gertrude Stein. Perhaps they didn't seem respectful enough. I admired Gertrude Stein, but I could see no reason to play up to her. And so whenever I said anything displeasing to Alice Toklas, she would dart another plate of cakes at me and I would be forced to take one and bite into it. They were all very rich and gooey and with nothing to drink, talking was not easy. I suppose I should have said something about her cooking, but I just ate her cakes and went back to talking with Gertrude Stein, so I guess I made an enemy of Alice Toklas that day. But Gertrude Stein seemed, if I could judge from her hearty laughter, to find me rather entertaining, at least for the moment. At the end of the afternoon she left the room and came back with three of her books. One of them, I remember, was Wars I Have Seen. She wrote in them all, and in that one she wrote, "Rose is a rose is a rose is a rose-once more for Françoise Gilot."

When we got ready to leave, Gertrude Stein said to me, "Now you can come to see me all by yourself." And there was another dark look from Alice Toklas. I might have gone back if I hadn't been so terrorized by Miss Stein's little acolyte, but I was and so I promised myself never to set foot in that apartment again.

Throughout all this, Pablo had not said a word, although I could see his eyes sparkling and could read his thoughts from time to time. It was clear that he was just letting me skirt the quicksand to the best of my ability. When we got to the door on the way out, he said, quite innocently, "Well, Gertrude, you haven't discovered any more painters lately?" She apparently sensed a trap, and said, "What do you mean?" He said, "Oh, no doubt about it, Gertrude, you're the grandmother of American literature, but are you sure that in the domain of painting you have had quite as good judgment for the generation that succeeded us? When there were Matisse and Picasso to be discovered, things went well. You finally got around to Gris, too, but since then, it seems to me your discoveries have been somewhat less interesting."

She looked angry but made no answer. Just to stick the needle in a little deeper, Pablo said, "You helped discover one generation and

62

PART II

that's fine, but to discover two or three generations is really difficult and that I don't think you've done."

There was a moment of silence and then she said, "Look, Pablo, I tell a painter what is good in a painting of his and in that way I encourage him to keep on searching in the direction of his own special gift. As a result, what is bad disappears because he forgets it. I don't know if my critical judgment has lost its keenness or not, but I'm sure that my advice to painters has always been constructive."

After that, I saw Gertrude Stein occasionally in the Rue de Buci, doing a bit of marketing around noontime. She seemed always to be wearing the same costume, covered by a cape, that I had seen her wear the day Pablo and I called on her. She always urged me, in a friendly way, to come see her in the Rue Christine. I would say, "Oh, yes, yes," but do nothing about it, because I found it easier to get along without her than to take her in tandem with Alice B. Toklas.

BEFORE I MET PICASSO and for some months after, my painting was figurative in an experimental way. Early in 1944 I decided that what people were referring to in the jargon as "the anecdote" was useless and I began to work in a completely nonfigurative manner. My grandmother used to come upstairs to my studio every evening to see what I had done during the day. Several months earlier I had done figurative portraits and still lifes, rather tortured in their forms, and they had shocked her. But when I began to do nonfigurative painting, she liked it immediately.

"I didn't understand what you were doing before," she said, "and although I don't understand this either, I find it pleasing. I see the harmony of color and design, and since you don't twist and torture nature, I like it better." I told her I didn't have the impression that it was any more pleasing than what I had been doing before. On the contrary, in my own mind the compositions I was doing now had rather dramatic intentions and they were not pleasing for me. I asked her if she found them dramatic. She said, "Not at all. I can look at those by the hour and find them restful."

I told Pablo about that one afternoon before he settled down

to painting. He laughed. "Naturally," he said. "Nonfigurative painting is never subversive. It's always a kind of bag into which the viewer can throw anything he wants to get rid of. You can't impose your thought on people if there's no relation between your painting and their visual habits. I'm not speaking of the connoisseur of painting. I mean the average person, whose visual habits are pretty conventional. He sees a tree in a certain fashion, in accordance with habits he formed in childhood. Someone who has a very cultivated vision may see a landscape of Aix as a Cézanne, a landscape of Arles as a van Gogh. But in general, people see nature in conventional fashion and they don't want anybody tampering with it. They are willing to be shown things that resemble nothing because those things correspond to a kind of invertebrate, unformulated interior dream. But if you take a commonplace way of seeing and try to change the slightest detail in it, everyone shouts, 'Oh, no, it's not possible. That's not the portrait of my grandmother.'

"When I paint, I always try to give an image people are not expecting and, beyond that, one they reject. That's what interests me. It's in this sense that I mean I always try to be subversive. That is, I give a man an image of himself whose elements are collected from among the usual way of seeing things in traditional painting and then reassembled in a fashion that is unexpected and disturbing enough to make it impossible for him to escape the questions it raises."

I told Pablo I thought nobody could have done completely nonfigurative painting better than he. "I suppose so," he said. "In those polyhedric Cubist portraits I did in tones of white and gray and ocher, beginning around 1909, there were references to natural forms, but in the early stages there were practically none. I painted them in afterwards. I call them 'attributes.' At that period I was doing painting for its own sake. It was really pure painting, and the composition was done as a composition. It was only toward the end of a portrait that I brought in the attributes. At a certain moment I simply put in three or four black touches and what was around those touches became a vest.

"I suppose I use that word 'attribute' in the way a writer might use it rather than a painter; that is, as one speaks of a sentence with a subject, verb, and attribute. The attribute is an adjective. It serves to qualify the subject. But the verb and the subject are the whole painting, really. The attributes were the few points of reference designed to bring one back to visual reality, recognizable to anyone. And they were put in, also, to hide the pure painting behind them. I've never believed in doing painting for 'the happy few.' I've always felt that painting must awaken something even in the man who doesn't ordinarily look at pictures, just as in Molière there is always something to make the very intelligent person laugh and also the person who understands nothing. In Shakespeare, too. And in my work, just as in Shakespeare, there are often burlesque things and relatively vulgar things. In that way I reach everybody. It's not that I want to prostrate myself in front of the public, but I want to provide something for every level of thinking.

"But to get back to the matter of attributes: You know my Cubist portrait of Kahnweiler?" I told him I did-in reproduction, at least. "All right," he said. "In its original form it looked to me as though it were about to go up in smoke. But when I paint smoke, I want you to be able to drive a nail into it. So I added the attributes-a suggestion of eyes, the wave in the hair, an ear lobe, the clasped hands-and now you can. You see, at that time and in those portraits I felt that what I had to say was fairly hard to understand. It's like Hegel. Hegel is a very interesting man but there aren't many people who want to take the trouble to read him. He's up there where he is for the few people who do want to give themselves that trouble and will go in search of whatever nourishment is there. If you want to give nourishment like that in painting, which is not easy to absorb for most people, who don't have the organs to assimilate it, you need some kind of subterfuge. It's like giving a long and difficult explanation to a child: you add certain details that he understands immediately in order to sustain his interest and buoy him up for the difficult parts. The great majority of people have no spirit of creation or invention. As Hegel says, they can know only what they already know. So how do you go about teaching them something new? By mixing what they know with what they don't know. Then, when they see vaguely in their fog something they recognize, they think, 'Ah, I know that.' And then it's just one more step to, 'Ah, I know the whole thing.' And their mind thrusts forward into the unknown and they begin to recognize what they didn't know before and they increase their powers of understanding."

That sounded very reasonable to me, I told him. "Of course it's reasonable," he said. "It's purest Hegel."

I told him these applications of Hegel were very impressive. How much of him had he read?

"None," he said. "I told you there weren't many people who wanted to take the trouble to go that far. And I don't either. I picked up my information on the subject from Kahnweiler. But I keep getting away from my attributes. What you have to understand is that if the

attributes-or, in a more general sense, the objects-were the main point of my painting, I would choose them with great care. For example, in a painting by Matisse the object plays a major role. It isn't any old object that is chosen to receive the honor of becoming an object in a painting by Matisse. They're all things that are most unusual in themselves. The objects that go into my paintings are not that at all. They're common objects from anywhere: a pitcher, a mug of beer, a pipe, a package of tobacco, a bowl, a kitchen chair with a cane seat, a plain common table-the object at its most ordinary. I don't go out of my way to find a rare object that nobody ever heard of, like one of Matisse's Venetian chairs in the form of an ovster, and then transform it. That wouldn't make sense. I want to tell something by means of the most common object: for example, a casserole, any old casserole, the one everybody knows. For me it is a vessel in the metaphorical sense, just like Christ's use of parables. He had an idea; he formulated it in parables so that it would be acceptable to the greatest number. That's the way I use objects. I will never paint a Louis XV chair, for example. It's a reserved object, an object for certain people but not for everybody. I make reference to objects that belong to everybody; at least they belong to them in theory. In any case, they're what I wrap up my thought in. They're my parables."

I told Pablo he was making progress in the order of sanctity: first Hegel, then Christ. Who next? He thought about that for a moment. "I'm not sure," he said. "Perhaps Aristotle. Someone, at least, who might be able to get painting back on the rails again." Where had it gone off, I asked him.

"That's a long story," he said, "but you're a good listener, so I'll tell you. You have to go all the way back to the Greeks and the Egyptians. Today we are in the unfortunate position of having no order or canon whereby all artistic production is submitted to rules. They the Greeks, the Romans, the Egyptians—did. Their canon was inescapable because beauty, so-called, was, by definition, contained in those rules. But as soon as art had lost all link with tradition, and the kind of liberation that came in with Impressionism permitted every painter to do what he wanted to do, painting was finished. When they decided it was the painter's sensations and emotions that mattered, and every man could recreate painting as he understood it from any basis whatever, then there was no more painting; there were only individuals. Sculpture died the same death.

"Beginning with van Gogh, however great we may be, we are

all, in a measure, autodidacts—you might almost say primitive painters. Painters no longer live within a tradition and so each one of us must recreate an entire language. Every painter of our times is fully authorized to recreate that language from A to Z. No criterion can be applied to him *a priori*, since we don't believe in rigid standards any longer. In a certain sense, that's a liberation but at the same time it's an enormous limitation, because when the individuality of the artist begins to express itself, what the artist gains in the way of liberty he loses in the way of order, and when you're no longer able to attach yourself to an order, basically that's very bad."

I brought up the question of Cubism. Wasn't that a kind of order, I asked him. He shrugged. "It was really the manifestation of a vague desire on the part of those of us who participated in it to get back to some kind of order, yes. We were trying to move in a direction opposite to Impressionism. That was the reason we abandoned color, emotion, sensation, and everything that had been introduced into painting by the Impressionists, to search again for an architectonic basis in the composition, trying to make an order of it. People didn't understand very well at the time why very often we didn't sign our canvases. Most of those that are signed we signed years later. It was because we felt the temptation, the hope, of an anonymous art, not in its expression but in its point of departure. We were trying to set up a new order and it had to express itself through different individuals. Nobody needed to know that it was so-and-so who had done this or that painting. But individualism was already too strong and that resulted in a failure, because after a few years all Cubists who were any good at all were no longer Cubists. Those who remained Cubists were those who weren't really true painters. Braque was saying the other day, 'Cubism is a word invented by the critics, but we were never Cubists.' That isn't exactly so. We were, at one time, Cubists, but as we drew away from that period we found that, more than just Cubists, we were individuals dedicated to ourselves. As soon as we saw that the collective adventure was a lost cause, each one of us had to find an individual adventure. And the individual adventure always goes back to the one which is the archetype of our times: that is, van Gogh's-an essentially solitary and tragic adventure. That's why I said a few minutes ago that we were all autodidacts. That's literally true, I think, but I realized even when Cubism was breaking up that we were saved from complete isolation as individuals by the fact that however different we might have the appearance of being, we were all Modern-Style artists. There were so many wild, delirious curves in

those subway entrances and in all the other Modern-Style manifestations, that I, even though I limited myself almost exclusively to straight lines, was participating in my fashion in the Modern-Style movement. Because even if you are against a movement, you're still part of it. The pro and the con are, after all, two aspects of the same movement. In that way those of us who attempted to escape from Modern-Style became more Modern-Style than anybody else. You can't escape your own period. Whether you take sides for or against, you're always inside it."

I told Pablo I had always looked upon Cubism as the period of pure painting. I felt that after it, he had gone elsewhere but no higher; that he had made, since then, a more powerful work in the immediacy and force of its expression, but that he had done nothing greater than his work of the Cubist period.

"I won't hold you to that opinion five years from now," he said. "Meantime it wouldn't do you any harm to study Cubism more in depth. On the other hand, I suppose I can't blame you for feeling that way. At that period I had just about the same attitude toward it myself, although I hadn't, of course, had the chance to see it in retrospect." He smiled. "Just imagine. Almost every evening, either I went to Braque's studio or Braque came to mine. Each of us *had* to see what the other had done during the day. We criticized each other's work. A canvas wasn't finished unless both of us felt it was."

He chuckled. "I remember one evening I arrived at Braque's studio. He was working on a large oval still life with a package of tobacco, a pipe, and all the usual paraphernalia of Cubism. I looked at it, drew back and said, 'My poor friend, this is dreadful. I see a squirrel in your canvas.' Braque said, 'That's not possible.' I said, 'Yes, I know, it's a paranoiac vision, but it so happens that I see a squirrel. That canvas is made to be a painting, not an optical illusion. Since people need to see something in it, you want them to see a package of tobacco, a pipe, and the other things you're putting in. But for God's sake get rid of that squirrel.' Braque stepped back a few feet and looked carefully and sure enough, he too saw the squirrel, because that kind of paranoiac vision is extremely communicable. Day after day Braque fought that squirrel. He changed the structure, the light, the composition, but the squirrel always came back, because once it was in our minds it was almost impossible to get it out. However different the forms became, the squirrel somehow always managed to return. Finally, after eight or ten days, Braque was able to turn the trick and the canvas again became a package of tobacco, a pipe, a deck of cards, and above all a Cubist painting. So you see how closely we worked together. At that time our work was a kind of laboratory research from which every pretension or individual vanity was excluded. You have to understand that state of mind." I told him I could, very easily, because I had always felt a kind of religious veneration for Cubist painting. But, I said, I couldn't see exactly the interior necessity that had brought forth the *papier collé*. It had always seemed to me that *papier collé* was a kind of by-product or perhaps even the fading-out of Cubist painting.

"Not at all," Pablo said. "The *papier collé* was really the important thing, although aesthetically speaking, one may prefer a Cubist painting. You see, one of the fundamental points about Cubism is this: Not only did we try to displace reality; reality was no longer in the object. Reality was in the painting. When the Cubist painter said to himself, 'I will paint a bowl,' he set out to do it with the full realization that a bowl in painting has nothing to do with a bowl in real life. We always had the idea that we were realists, but in the sense of the Chinese who said, 'I don't imitate nature; I work like her.' "

I asked him how a painter could work like nature. "Well," he said, "aside from rhythm, one of the things that strikes us most strongly in nature is the difference of textures: the texture of space, the texture of an object in that space-a tobacco wrapper, a porcelain vase-and beyond that the relation of form, color, and volume to the question of texture. The purpose of the papier collé was to give the idea that different textures can enter into composition to become the reality in the painting that competes with the reality in nature. We tried to get rid of trompel'oeil to find a trompe-l'esprit. We didn't any longer want to fool the eye; we wanted to fool the mind. The sheet of newspaper was never used in order to make a newspaper. It was used to become a bottle or something like that. It was never used literally but always as an element displaced from its habitual meaning into another meaning to produce a shock between the usual definition at the point of departure and its new definition at the point of arrival. If a piece of newspaper can become a bottle, that gives us something to think about in connection with both newspapers and bottles, too. This displaced object has entered a universe for which it was not made and where it retains, in a measure, its strangeness. And this strangeness was what we wanted to make people think about because we were quite aware that our world was becoming very strange and not exactly reassuring."

OVER THE WEEKS that followed that first discussion of Cubism, I began to do just what Pablo had advised me to do: to study Cubism more in depth. In the course of my studies and reflections I worked back to its roots and even beyond them to his early days in Paris, the years he spent, between 1904 and 1909, at the *Bateau Lavoir*, where he had met and lived with Fernande Olivier and where he had painted the Harlequin and circus pictures, the rose-toned nudes that followed his Blue Period paintings, and finally, the early Cubist works.

He often talked to me about those days and always with a good deal of nostalgia. One Tuesday I arrived at the Rue des Grands-Augustins, expecting to spend the afternoon there while Pablo painted, only to find him poised on the threshold, dressed for the crisp early-autumn weather outside. He was wearing an old gray mackinaw, his usual wrinkled gray trousers, a battered felt hat whose brim was snapped low over his eyes and whose folds had long since given up the struggle for form. A long, greenish-brown, knitted woolen scarf was wrapped around his neck outside his coat and thrown back to trail off one shoulder in the manner of the old Montmartre *chansonnier*, Aristide Bruant.

"I'm going to take you to see the *Bateau Lavoir* today," he announced. "I have to go see an old friend from those days who lives near there."

Marcel, Pablo's chauffeur, drove us up near the top of Montmartre. Pablo had him stop at an open, deserted corner and we left the car. The trees were all stripped of their leaves. The houses were small and shabby-looking but there was something very appealing about their quiet air of neglect. The rest of Paris seemed far away. Except for an occasional modern apartment building, I would have thought we had made a long journey through time and space to reach this faded corner of the past. Pablo pointed behind us to a low, shedlike structure set back from the street on a slight rise. "There's where Modigliani lived," he said. We walked slowly down the hill, toward a gray house with a big studio window facing north. "That was my first studio, the one straight ahead," he said. We turned off to the right, into the Rue Ravignan and continued to walk downhill. Pablo pointed to a high, boxlike house that stood on higher ground to our right, in a little garden surrounded by a wroughtiron fence. "That's where Pierre Reverdy lived in those days," he told me. Just beyond that, on the right, I noticed the Rue d'Orchampt with its tiny pavilions and nineteenth-century street lamps, just the way I had seen them in Utrillo's lithographs of that corner.

A little farther along we reached a sloping paved square, rather pretty and a little melancholy. Ahead of us was the Hôtel Paradis and beside it, a low, flat, one-story building with two entrance doors, which I recognized, without his telling me, as the Bateau Lavoir. Pablo nodded toward it. "That's where it all started," he said quietly. We walked across the little square to the left-hand door. To the left of it the windows were shuttered. "That was where Juan Gris worked," Pablo said, pointing to the shutters. He opened the door and we went inside. There was a stale, damp smell. The walls were dirty-white and brown. The floorboards were wide and ill-fitting and wobbled under our steps. "It hasn't changed much in forty years," Pablo said with an attempt at a laugh. Straight ahead of us was a stairway that led down to the floor below. We walked down. He pointed to a small door that looked as though it might be the entrance to a water closet. "That was Max Jacob's room," he said. "It's almost under my studio. You'll see when we go back upstairs. Next door to Max lived a fellow named Soriol, who sold artichokes. One night when Max and Apollinaire and all the gang were in my studio, we were making so much noise over Soriol's head that he couldn't sleep. He shouted up to us, 'Hey, dunghill, how about letting the honest workers sleep.' I started to bang on the floor-his ceilingwith a big stick and Max ran around shouting, 'Soriol, ta gueule, ta gueule. Soriol, ta gueule, ta gueule.' We kept up our racket long enough for him to figure out that he'd have been far better off without the protest. He never gave us any trouble after that."

Pablo shook his head. "Max was marvelous," he said. "He always knew how to touch the sore spot. He loved gossip, of course, and any hint of scandal. He heard once that Apollinaire had arranged for Marie Laurencin to have an abortion. One night a little while after that, at one of our poets' dinners, Max announced he had composed a song in honor of Apollinaire. He stood up and, facing toward Marie Laurencin, he sang,

> Ah, l'envie me démange de te faire un ange de te faire un ange en farfouillant ton sein Marie Laurencin Marie Laurencin.

Marie Laurencin turned red, Apollinaire grew purple, but Max stayed very calm and angelic-looking.

"I think Apollinaire was Max's favorite target," Pablo said. "He could always be sure of getting a rise out of him. Apollinaire's mother, who called herself the Comtesse de Kostrowitzky, was a very flamboyant figure. She had been kept by a long series of admirers, but Apollinaire didn't like to hear references to her amatory career. One night Max sang a song that started,

> Epouser la mère d'Apollinaire de quoi qu'on aurait l'air? de quoi qu'on aurait l'air?

He never did get a chance to finish the song. Apollinaire got up in a rage and chased him around the table.

"Apollinaire was very careful with money, too. One night he invited Max and me over to his place. Marie Laurencin was with him. He had bought a good-sized sausage and had cut off eight slices-two for each of us, I suppose-but he didn't offer us any. He and Marie Laurencin had been drinking and were pretty high. After we'd been there a few minutes they left the room to be alone together. Since it looked to us as though that sausage was going to be a long time coming, Max and I each ate one of the slices Apollinaire had cut off. When Apollinaire and Marie Laurencin came back into the room, the first thing Apollinaire did was count the slices. When he saw there were only six he looked at us suspiciously but didn't say anything; he just cut off two more. In a few minutes they left the room again and Max and I ate those two. We had hardly got them down before Apollinaire was back again, counting the ones that remained. Still six. He looked puzzled but cut off two more and left again. By the time he came back for good, the whole sausage had gone, two slices at a time."

Pablo looked down another corridor, then turned abruptly and started back upstairs. This time we went around the stairwell to the back, and on the right came to a door with a *carte de visite* tacked onto it. He looked at it carefully. "Never heard of him," he said. "Anyway, this was my studio." He put one hand on the doorknob and the other on my arm. "All we need to do," he said, "is open this door and we'll be back in the Blue Period. You were made to live in the Blue Period and you should have met me when I lived here. If we had met then, everything would have been perfect because whatever happened, we would never have gone away from the Rue Ravignan. With you, I would never have wanted to leave this place." He knocked at the door but no one came. He tried to open it but it was locked. The Blue Period remained shut away on the other side of the door.

When we went outside into the square again, it was still deserted. We walked over to the fountain in the center. "The first time I saw Fernande Olivier was here at this fountain." he said. We walked down some stairs at the lower end of the square onto the street that ran behind the Hôtel Paradis. In back of the hotel was a driveway that led to the rear of the Bateau Lavoir. We followed it to the end. Pablo pointed up to two large windows. "That was my studio," he said. Since the ground sloped away sharply from the front of the building, the windows were too high to see into. At the ground level were several workshops. I said that the building looked about ready to crumble. Pablo nodded. "It always did. It just holds together by the force of habit," he said. "When I lived here, there was a little girl, the concierge's daughter, who used to play hopscotch and jump rope outside my windows all day long. She was so sweet I would have liked to have her never grow up. After I moved away and came back to visit, I saw that she had become a serious young woman. The next time I saw her she was rather fat. Years later I saw her here again and she looked quite old and it depressed me enormously. In my mind's eye I had kept on seeing that little girl with her jump rope and I realized how fast time was flowing and how far away I was from the Rue Ravignan." He started to walk down the driveway, controlling his emotions with difficulty. He was quiet all the way back to the square.

I thought back to the time Pablo had urged me, half seriously, to come stay under the eaves at the Rue des Grands-Augustins, so that we could live together in secret. From time to time since then he had brought up the idea again, now in one form, now in another: "You should wear a black dress right down to the ground," he had told me one afternoon, "with a kerchief over your head so that no one will see your face. In that way you'll belong even less to the others. They won't even have you with their eyes." He had the idea that if someone is precious to you, you must keep her for yourself alone, because all the accidental contacts she might have with the outside world would somehow tarnish her and, to a degree, spoil her for you.

In the light of that I could understand even better the meaning the *Bateau Lavoir* had for him. It represented the golden age, when everything was fresh and untarnished, before he had conquered the world and then discovered that his conquest was a reciprocal action,

and that sometimes it seemed that the world had conquered him. Whenever the irony of that paradox bore in on him strongly enough, he was ready to try anything, to suggest anything, that might possibly return him to that golden age.

We made our way up the hill again until he found the Rue des Saules. We went into a small house. He knocked at a door and then walked inside without waiting for an answer. I saw a little old lady, toothless and sick, lying in bed. I stood by the door while Pablo talked quietly with her. After a few minutes he laid some money on her night table. She thanked him profusely and we went out again. Pablo didn't say anything as we walked down the street. I asked him why he had brought me to see the woman.

"I want you to learn about life," he said quietly. But why especially that old woman? I asked him. "That woman's name is Germaine Pichot. She's old and toothless and poor and unfortunate now," he said. "But when she was young she was very pretty and she made a painter friend of mine suffer so much that he committed suicide. She was a young laundress when I first came to Paris. The first people we looked up, this friend of mine and I, were this woman and friends of hers with whom she was living. We had been given their names by friends in Spain and they used to have us come eat with them from time to time. She turned a lot of heads. Now look at her."

I think Pablo had the idea that he was showing me something new and revealing by bringing me to see that woman, a little like showing someone a skull to encourage him to meditate on the vanity of human existence. But my grandmother had got there before him. She had already given me, several years earlier, a number of lessons of that kind—all I was capable of assimilating at that period. She had the habit of going every day to the cemetery across from her house. She walked slowly, being old and tired, and she would sit down tranquilly on the tomb of her husband and three of her children and those of her relatives who were buried in that family plot. She said nothing but she always had a gentle smile on her face. At that age, still in my teens, I felt that such familiarity with death was frightful. I asked her why she sat there like that.

"You will see," she told me. "There comes a day in life when you have undergone so much suffering that you have what feels like an enormous stone on your heart. From that day on, you can afford the luxury of sitting on a stone like this. We are living out a kind of reprieve and when you come to realize that, you live no longer for yourself, but as much for the sight of a flower or for the odor of something or for other people as for your own desires or comfort. Because you know your time is limited."

BEGINNING IN 1945 there were several periods when I completely stopped seeing Pablo—for a week, two weeks, or as much as two months. In spite of my feeling for him and his desire to have me with him, I had learned fairly early that there was a real conflict between our temperaments. For one thing, he was very moody: one day brilliant sunshine, the next day thunder and lightning.

In his conversations with me he gave me plenty of rein, encouraged me to speak about everything that went through my head. He stimulated me enormously. At the same time I sensed that the interest he had in me did not suit him completely. I realized that although I amused him and interested him, the deeper feelings that came into play troubled him, at least periodically, and that he was saying to himself at such times, "I mustn't get too involved with her." There was the attraction and then, to counterbalance it, the disturbance this attraction stirred up.

In our lovemaking, whenever he let himself go too far and became especially tender and childlike, the next time we were together he would invariably be hard and brutal. Obviously Pablo felt he could permit himself everything with everyone and I have always been someone who accepts "everything" with great difficulty.

From time to time, he said to me, "You mustn't think that I would ever get permanently attached to you." That bothered me a little because at the start I had not expected that he would. I thought we ought to go along as we were, without asking where it was taking us. I felt that since I was asking for nothing, he had no reason to defend himself against me. I wasn't the one who wanted him to burden himself with me; he was the one, I realized, who wanted that. I suppose that was why periodically he told me that he didn't. He was struggling not against me but against the effect I was making on him. But since he was struggling with the effect, he found it necessary to struggle with me too.

After a while when he said such things as, "Don't think you

mean anything to me. I like my independence," I learned to say, "I do, too," and then stay away for a week or two. He would be all smiles when I returned.

One afternoon he said, "I don't know why I told you to come. It would be more fun to go to a brothel." I asked him why he didn't, in that case.

"That's just it," he burst out. "On account of you I don't even have any desire to go. You're spoiling my life."

Of course I knew he wasn't all that fond of "public" girls. I think he wanted to sound rakish. One day he told me he had picked up a girl on the Boulevard des Capucines. "I took her into a bar," he said, "and told her about all the trouble I have on account of women. She was very nice to me and she told me I have too strong a sense of duty. She's a realist, you see. She understood. That's probably the only kind of woman I could get comfort from." I told him to go right ahead. I understood how it was.

"But it doesn't amuse me," he said. "It bores me." Having admitted that much, he then went on the defensive by tossing off one of his favorite quips: "There's nothing so similar to one poodle dog as another poodle dog and that goes for women, too." He was rather fond, also, of saying, "For me, there are only two kinds of women-goddesses and doormats." And whenever he thought I might be feeling too much like a goddess, he did his best to turn me into a doormat. One day when I went to see him, we were looking at the dust dancing in a ray of sunlight that slanted in through one of the high windows. He said to me, "Nobody has any real importance for me. As far as I'm concerned, other people are like those little grains of dust floating in the sunlight. It takes only a push of the broom and out they go." I told him I had often noticed in his dealings with others that he considered the rest of the world only little grains of dust. But, I said, as it happened, I was a little grain of dust who was gifted with autonomous movement and who didn't, therefore, need any broom. I could go out by myself. And I did. I didn't return for three months. It wasn't that I didn't admire his greatness; it was, rather, that I didn't enjoy seeing it cheapened by a kind of imperialism which I thought incompatible with true greatness. I could admire him tremendously as an artist but I did not want to become his victim or a martyr. It seemed to me that some of his other friends had: Dora Maar, for example.

Pablo had told me that when he first met Dora Maar, she belonged to the surrealist group. She had been friendly since girlhood with Michel Leiris, Man Ray, André Breton, and Paul Eluard. She was a bit younger than the poets of the movement but she was very much part of the milieu. Her father, a Yugoslav, was a rather successful architect. Her mother, according to Pablo, had been an exceedingly pious woman, who had belonged to the Orthodox church but had later been converted to Roman Catholicism.

When Pablo met Dora she had been working as a photographer. Her photographs, he told me, had a quality he always associated with the early paintings of Chirico. They often showed a long tunnel with light at the end, and an object, rather difficult to identify, in the shadowy corridor between the lens and the light. He told me she had asked to make some portraits of him, and he had gone to her atelier for that purpose.

"There are two professions," he said, "whose practitioners are never satisfied with what they do: dentists and photographers. Every dentist would like to be a doctor and every photographer would like to be a painter. Brassaï is a very gifted draftsman, Man Ray is a painter of sorts, and Dora, too, was right in the tradition. Inside Dora Maar, the photographer, was a painter trying to get out."

It was Dora, he told me, who had found him the atelier in the Rue des Grands-Augustins. Soon after, she moved into an apartment around the corner, in the Rue de Savoie. She began to devote herself more and more to painting. Gradually, she gave up her photographic laboratory. Some of her equipment—spotlights, backdrops and so on eventually found its way to Pablo's studio in the Rue des Grands-Augustins. The black curtains came in very handy for blackouts during the Occupation, and he often painted at night by training Dora's spots on his canvas.

When I first went to the Rue des Grands-Augustins I saw the first two canvases she had given him. They were heads painted by someone with a strong feeling for the occult. They were symbolic and esoteric rather than pictorial and seemed to stem from psychic preoccupations. I felt they were related to work I had seen by Victor Brauner.

Pablo told me that one of the first times he saw Dora she was sitting at the *Deux Magots*. She was wearing black gloves with little pink flowers appliquéed on them. She took off the gloves and picked up a long, pointed knife, which she began to drive into the table between her outstretched fingers to see how close she could come to each finger without actually cutting herself. From time to time she missed by a tiny fraction of an inch and before she stopped playing with the knife, her

hand was covered with blood. Pablo told me that was what made up his mind to interest himself in her. He was fascinated. He asked her to give him the gloves and he used to keep them in a vitrine at the Rue des Grands-Augustins, along with other mementos.

When I met Pablo, in 1943, I knew about Dora Maar because everyone did. After I began to see him regularly, I learned more about her, most of it from him. She did not come to the Rue des Grands-Augustins except on special occasions. Pablo would telephone to her when he wanted to see her. She never knew whether she would be having lunch or dinner with him— not from one meal to the next—but she had to hold herself in a state of permanent availability so that if he phoned or dropped by, he would find her there. But she could never just drop in to his place, or phone to say she would not be available for dinner that evening. The painter André Beaudin, who liked Dora, told me once that he had asked her to eat with him one evening. She told him she couldn't say yes or no until dinnertime because if she made a date with him and then Pablo called to say he was coming to take her to dinner, he would be furious to learn she had made other plans.

In the spring of 1945 Dora Maar had an exhibition of painting at Jeanne Bucher's gallery in Montparnasse. I went alone to the exhibition and enjoyed it very much. I think the paintings she showed then were the finest she has ever done. They were almost all still lifes, very severe, most of them showing just one object. They may have reflected, in a measure, her community of spirit with Picasso, but they brought to that a feeling that was entirely different. The work was not derivative; there was nothing sharp or angular about her forms. In fact she had a way of handling chiaroscuro that was quite alien to his work. She had taken the most ordinary objects—a lamp or an alarm-clock or a piece of bread—and made you feel she wasn't so much interested in them as in their solitude, the terrible solitude and void that surrounded everything in that penumbra.

I went to the exhibition because I was interested to see what she was doing, and not at all because I thought Pablo might be there. As it happened, he arrived only a few minutes after I did. I was wearing a dress striped with all the colors of the rainbow, and the contrast between my dress and the severity of Dora Maar's painting and of her dress—she was all in black—made me feel so much out of place that I slipped away and ran down the stairs. I thought that would save complications but it only created some, because Pablo ran down the stairs after me, hollering, "Where do you think you're going? You haven't even said 'Hello.' " I stopped long enough to say "Hello," hopped onto my bicycle and rode away.

Pablo's moods, in general, followed the weather. One late spring afternoon, about two months after Dora Maar's exhibition at the Jeanne Bucher gallery, I decided to go see him-I assumed the weather might be helping him to be in a good frame of mind. When I phoned, he said, "Fine," but he sounded a little unenthusiastic. I said I would be there at two. I arrived a bit late, as usual, and as I approached his building I looked up to the window that opened on the stairway leading from the first to the second floor of his apartment and saw him sitting there waiting for me, as he often did. (He had told me more than once, in his way of passing out left-handed compliments, that the nicest part of my visits was the time he sat on the stairway looking out the window, waiting for me to arrive. Generally his pigeons would fly up and perch on his shoulders as he sat there.) That afternoon I felt rather disappointed because it looked to me, from the expression on his face, as though my meteorological calculations were wide of the mark. When he let me in I asked him what was wrong. It was obvious that something was bothering him.

"Come upstairs," he said. "I'll tell you about it." We went into his bedroom and he sat down on the bed. I sat down not very far from him. He took my hand, something he was not at all given to doing, and sat there without speaking for two or three minutes. I realized then that he wasn't angry with me but that he must be terribly shaken up. Finally he said, "I'm glad you've come. I'm a little calmer now. For two weeks I've had a feeling something was wrong but I wasn't sure so I didn't say anything about it. But now—well, you'll see.

"A very strange thing happened with Dora Maar about two weeks ago," he said. "I went to her apartment to take her to dinner and found that she wasn't home. I waited for her. When she finally showed up, her hair was all disheveled and her clothes were torn. A man had attacked her in the street, she said, and made off with her dog, a little Maltese lapdog I had given her and to which she was very attached." The story might have been true, of course, but, as he pointed out, in those early months after the Liberation, everyone was happy; there weren't even any *clochards* along the banks of the Seine as there are now. Pablo said he had been puzzled by the story. "I couldn't believe it was true," he told me. "Besides, why would anyone want to steal a little dog like that?" Then, two nights ago, he said, there had been another incident. Dora had been found by a policeman wandering along the quay

near the Pont-Neuf in the same condition. She told him she had been attacked by a man who stole her bicycle. The policeman took her home, since she seemed very dazed. Later on, Pablo said, her bicycle was found, apparently untouched, right near the spot where she claimed to have been attacked. It looked as though she had just left it there, he said. He told me he began to wonder if she hadn't made up the stories. "I thought she was looking for sympathy," he said, "feeling that maybe I wasn't so much interested in her as I had been. And since it's her nature to do things in dramatic fashion, I thought this might be her way of attracting attention to herself. So I didn't take it too seriously.

"Last night I went to her place to take her to dinner. I found her extremely upset, moving about the room nervously. She began straight off to call me to account for the way I live. She told me I led a shameful kind of life, from a moral point of view, and that I should be thinking of what lies in wait for me in the hereafter. I told her I wasn't in the habit of having that kind of talk from anyone. And then, as I thought it over, it seemed funny and I began to laugh. But she didn't think it at all funny. I knew she had always had a mystical point of view and been drawn toward the occult but she had never tried to impose it on others. I wouldn't have minded if she had said all that with a smile but she was in dead earnest. She told me I had better repent while there was still time. She said, 'As an artist you may be extraordinary, but morally speaking you're worthless.' I tried to shut her up and told her that questions of conscience concern only the person whose problem they are, not others. 'You work out your own salvation in the way you see fit and keep your advice to yourself,' I told her, but she kept repeating those things over and over. Finally I got her to stop talking long enough to say we'd go have dinner and talk about it another time. During the dinner she talked of other things but in a kind of hallucinatory way. At times I couldn't understand what she was talking about. I knew she hadn't been drinking, so I decided something must be very wrong. I took her home after dinner and told her I'd be back in the morning to see her.

"This morning, after I got up, I was worried about her and I called Eluard and asked him to come right over. I knew he was fond enough of Dora to be concerned about something like that and I wanted to get his idea on it. After he got here, I had just started to tell him what had happened, when Dora came in. When she saw us together she began to talk in a very strange way.

"You both should get down on your knees before me, you

ungodly pair," Pablo quoted her as saying. Both Paul and Pablo had always been atheists but Dora had always had religious tendencies, semiphilosophical in nature at first and then veering more and more toward Buddhism. "I have the revelation of the inner voice," Pablo said she told them. "I see things as they really are, past, present, and future. If you go on living as you have been, you'll bring down a terrible catastrophe on your heads." She grabbed them by the arms and tried to force them to their knees, Pablo said. He wanted to call Doctor Lacan, the psychoanalyst he used for most of his medical problems, but he didn't want to telephone in front of Dora, so he sent Sabartés out to call, he said. Lacan came at once.

"After Lacan had left with Dora, Eluard was so upset he accused me of being responsible for her state because I had made her so unhappy," Pablo said. "I told him that if I hadn't taken her up, she'd have reached that state long ago. 'If anyone is to blame, it's you and the rest of the surrealists,' I told him, 'with all those wild ideas promoting antirationalism and the derangement of all the senses.' Eluard said that any influence they had had on her was indirect, since it was all theoretical, but that I had made her unhappy in a very concrete way. He was so angry he picked up a chair and smashed it against the floor.

"What I do know," Pablo told me, "is that after she met me, she had a more constructive life than before. Her life became more concentrated. Photography didn't satisfy her. She began to paint more and was making real progress. I built her up."

I told him that perhaps he had built her up, but only to let her down afterward. She had made progress, no doubt, but just at that moment he had begun to detach himself from her, I pointed out.

"One doesn't go to pieces all of a sudden without an underlying cause," he said. "It's like a fire that smoulders for a long time and then, when the wind picks it up, begins to rage. Don't forget that the leading surrealists, the ones who survived the heyday of the movement— Breton, Eluard, Aragon—have very strong characters. The weaker ones who trailed after them haven't always fared as well: Crevel committed suicide, Artaud went mad, and there are plenty of other cases. As an ideology, it sowed disaster pretty generally. The sources of Surrealism are a rather dubious mixture. It's not strange that with a hodgepodge like that, so many lost their way."

I felt very upset about his story. I suggested that now that we had talked about it, he might like to be alone. He said, "No. The present always has precedence over the past. That's a victory for you."

I suppose we must have talked about Dora Maar for two or three hours. The longer we talked about her, the more I associated myself with the situation in which she now found herself. When I spoke of that to Pablo, he brushed it aside. "Let's drop the whole matter," he said. "Life is like that. It's set up to automatically eliminate those who can't adapt. And there's no sense talking a minute longer about what happened today. Life must go on, and life is us." I said that seemed a quick, easy way to eliminate from one's life whoever might be passing through a weak moment. I said I didn't think it was right to say, when someone fell by the wayside, "I'm going to keep on walking. It's up to her to do the same."

"That kind of charity is very unrealistic," he said. "It's only sentimentality, a kind of pseudo-humanitarianism you've picked up from that whining, weepy phony, Jean-Jacques Rousseau. Furthermore, everyone's nature is determined in advance."

I think that with the Spanish sense of pride, Pablo considered that weakness on Dora's part was inexcusable. She had lost face with him. In her weakness there must have been the smell of death for him, and as I came to see later, Pablo found that, too, inexcusable.

Doctor Lacan kept Dora at the clinic for three weeks. At the end of that period he let her go home. He continued to treat her and she underwent analysis with him.

When she first came back from the clinic, she seemed very little changed, Pablo said. She wasn't quite well for a while but she began to paint again as her analysis progressed. Pablo continued to see her, as he always had. I told him I thought he ought to be very solicitous of her well-being and not let her feel, at least for the time being, that there was anyone else in his life that meant anything to him. I told him I was prepared to see less of him if that would help.

"All right," he said. "I told her I would take her to the Midi during the vacation." He had also accepted an invitation to stay a while with his old friend the art collector Marie Cuttoli at Cap d'Antibes. I went off to Brittany for the summer, feeling that everything was as it should be. I had hardly arrived when I got a letter from Pablo saying he had rented a place for me in the house of another old friend of his, an engraver named Louis Fort, at Golfe-Juan. "Please come at once," he wrote. "I'm terribly bored."

The Good Samaritan, as I was finding out, was not one of Pablo's better roles. I knew that if I accepted his invitation, he would be running away from Dora at odd hours during the day and it would not take her long to discover the reason. Once she did, she might well have a relapse. Besides, I was not at all sure that I wanted to be so close to Pablo for such an unbroken period. In Paris I saw him when I wanted to and that was all. But the idea of making myself available to him whenever he felt like seeing me and, at the same time, running the risk of creating new difficulties for Dora Maar didn't please me at all. I wrote him that I was staying put. My summer in Brittany was not very exciting but I had a lot of time to think things over.

When I returned to Paris, I stayed away from the Rue des Grands-Augustins. I had decided not to interrupt the rhythm of lives that already had complications enough without my adding more. And from a purely selfish point of view it seemed to me that if I insisted on going further, I might be letting myself in for something I would not be able to cope with. For over two months I stayed home, determined to conquer my feeling for Pablo, to put an end to our relationship. But the longer I stayed away, the more clearly I understood that I had a real need to see him. There were moments when it seemed almost a physical impossibility to go on breathing outside his presence. Toward the end of November, realizing that I was curing myself of nothing and that my staying away probably would not restore his deteriorating relationship with Dora Maar, I began to see him again.

WHEN I RETURNED to the Rue des Grands-Augustins that November—on the twenty-sixth, as a birthday present for myself—I found Pablo deep in lithography. "I thought you weren't coming back," he said, "and that put me in a very black mood. A while ago, Mourlot asked me if I wouldn't like to do some lithographs. Since I hadn't done any for fifteen years, I thought this would be a good time to start again." Besides, he explained, he was being more and more distracted from his work by an increasing flow of visitors, English and American, as well as old French friends, back from the war, whom he hadn't seen in years. The chance to get out of the atelier of the Rue des Grands-Augustins and into the relative seclusion of Mourlot's printshop seemed a good idea.

Until then, Pablo had made only a few drawings of me and two

portraits in oil: small canvases in gray and white with contrasting profiles that he had done earlier that year. Now, in the proofs of the lithographs he showed me, I saw evidence that I had been much on his mind. Most of the things he had been doing were, in one way or another, portraits of me. One of the lithographs was a still life and another, I was amused to see, apparently a portrait of himself as a boy. And there was a portrait of two women, one sleeping, the other sitting beside her. The one sitting was obviously me. The other I wasn't sure about. When I asked him who it was, he told me he wasn't sure, either. It was either Dora Maar or my friend Geneviève, he said. When I first saw that lithograph, he had made six states of it. He continued to make changes in it throughout the winter and by the time it reached the definitive state -there were eighteen in all-its character had changed radically from highly representational to unrecognizably abstract. But in losing her pictorial identity, the sleeping woman had regained her actual one. Pablo had come to realize that she was, after all, Dora Maar, he told me. And as though to prove it he pointed, in the margins of the paper, to a number of remargues: there were little birds of various kinds and two insects drawn in minute detail. He said he had always considered Dora had such a Kafkaesque personality, that whenever he noted a spot or a stain on the wall of her apartment, he would work at it with his pen until it became a small but very lifelike insect. The fact that he had been led to make the same kind of "comment" in the margins of the stone made him realize that the sleeping woman was, indeed, Dora. The birds in the upper and lower margins were for me, he said.

I was pleased to see the evidence of his new preoccupation with lithography, not simply because much of it referred to me but because, although he had always done a great deal of etching, I had often heard him refer to lithography in what seemed unjustifiably disparaging terms. I had an idea this would prove to be more than a passing interest, and for four months he worked constantly at Mourlot's.

One of the most interesting lithographs he produced during that time was a bullfight scene in which he applied the principle of the *papier collé* to lithography. He took a piece of lithographic paper, applied it to a rough surface and rubbed it at each end and at one or two other spots with a lithographic crayon until those areas had the grainy texture of a Max Ernst *frottage*. From the darkest of these parts he cut out the figure of a picador and pasted it down in the white area near the right-hand side. Other elements, such as the bull and the sun, he painted in with lithographic ink. On each side of the bull he had a

PART II

picador: at the left a picador in white—created by the empty space left by the cut-out—against a grainy black background, and on the right, in black, the cut-out piece itself against a white background. It was an imaginative *tour de force* that no one had tried before. Mourlot was delighted with such a fresh approach by an "outsider."

"You must always work with economy in mind," Pablo said. "What I've done, you see, is to use the same form twice—first as positive form and then as negative form. That's the basis of my two picadors. Besides, it makes a kind of plastic reference—one part to the other which is very effective composition."

From time to time Pablo took me with him to Mourlot's. It was then in the Rue de Chabrol, near the Gare de l'Est. It was a dim, cluttered, ramshackle place, full of piles of posters, lithographic stones, and general confusion, but for a great many years it had been turning out the finest lithography ever known. It was always rather dark, damp, and cool because if it had been kept comfortably warm, the wax in the lithographic ink would have flowed too freely and direct sunlight would have made the stones and the paper too dry. It was almost like a scene from Daumier, all black and white, with just one spot of color-the big presses that turned out the bright-colored posters advertising Paris art exhibitions. There was Daumier, too, in the stones themselves. Many of the stones at Mourlot's had been in use since well back in the nineteenth century. After each impression the stone is rubbed down to remove the drawing. But since lithographic stone is limestone, soft and porous, it absorbs a bit of the ink and an impression of the drawing penetrates beneath the surface. Portions of an old drawing occasionally seep back up to the surface again after a stone has been rubbed down. Lithographers call that the stone's "mcmory" and occasionally we would see one of the stones "recalling" a passage from Daumier.

Every time Pablo went there to work, he would greet all the workmen, shake hands with them and call them by their first names. They would show him their choicest treasures, all their cut-out pin-up girls, cycling champions, and other folk heroes. They were a sharptongued but friendly crowd, disorderly almost to the point of anarchy. All but one.

At the very back, in the darkest of the cubicles, worked an old man named Monsieur Tuttin. For the skillful printing of the most technically exacting work he had no peer. He didn't have the sloppy, anarchic appearance of most of Mourlot's employees. He looked like an elderly accountant out of a Dickens novel, with his sharp blue eyes, steel-rimmed

spectacles, pointed features, white hair, and carefully buttoned, neatly pressed black suit. It was Monsieur Tuttin who was always given Pablo's work to print, since Pablo's disregard for conventional lithographic processes created all kinds of problems for the printers. The difficulty was, Monsieur Tuttin did not like Pablo's work. In fact he detested it.

Pablo had done a lithograph of one of his pigeons in a highly unconventional way. The background coat was in black lithographic ink and the pigeon itself had been painted on top of that in white gouache. Since lithographic ink has wax in it, gouache normally wouldn't "take" very well but in spite of that fact, Pablo had carried it off brilliantly on the lithographic paper. When Mourlot came to the Rue des Grands-Augustins and saw what Pablo had done, he said, "How do you expect us to print that? It's not possible." He pointed out to Pablo that in theory, when the drawing was transferred from the paper to the stone, the gouache would protect the stone and the ink would run only onto those parts where there was no gouache; but, on the other hand, on contact with the liquid ink the gouache itself would surely dissolve, at least in part, and run.

"You give it to Monsieur Tuttin; he'll know how to handle it," Pablo told him.

The next time we went to Mourlot's shop, Monsieur Tuttin was still fussing about the pigeon. "Nobody ever did a thing like that before," he fumed. "I can't work on it. It will never come out."

"I'm sure you can handle it," Pablo said. "Besides, I have an idea Madame Tuttin would be very happy to have a proof of the pigeon. I'll inscribe it to her."

"Anything but," Monsieur Tuttin replied in disgust. "Besides, with that gouache you've put on, it will never work."

"All right, then," Pablo said. "I'll take your daughter out to dinner some evening and tell her what kind of a printer her father is." Monsieur Tuttin looked startled. "I know, of course," Pablo went on, "that a job like that might be a little difficult for most of the people around here, but I had an idea—mistakenly, I can see now—that you were probably the one man who could do it." Finally, his professional pride at stake, Monsieur Tuttin gave in grudgingly.

Sometimes Pablo would bring him lithographs drawn with ordinary crayons rather than with lithographic crayon. Monsieur Tuttin would be horrified. "How could anyone possibly print from that?" he would ask. "It's a monstrosity." In the end, after Pablo had finished building him up, Monsieur Tuttin would agree to give it a try and one way or another he always managed to make it work. I think that finally he came to look forward to those challenges as a chance to prove to Pablo that he was just as good a man as *he* was.

IN FEBRUARY 1946, although the war had been over for a year and a half, electricity was still being rationed. Late one afternoon, while the current was off, I fell on the stairway of my grandmother's house and broke my arm. They had to operate on my elbow and I spent ten days in the hospital. One afternoon while I was there, a delivery boy came with an enormous package: a giant azalea with bright red flowers, covered with little bows of pink and blue ribbon. It was truly hideous; enough to set your teeth on edge. At the same time it struck me so funny I couldn't help laughing. In it was a note from Pablo saying that he had been driving along in his car and seen this plant in a show window. It had seemed to him in such bad taste that he had found it irresistible. He hoped I would appreciate his intention at its true value. I think the prettiest bouquet in the world would have been less effective than that absurd assemblage of colors. I understood very well why he had sent it. One bouquet more or less, what difference did that make? But this monstrous thing was something one could never forget.

When I came out of the hospital, I decided to go down to the Midi with my grandmother. Pablo gave me the address of his old friend Louis Fort, who lived at Golfe-Juan and who still had his handpresses and copperplates and everything necessary to make etchings. Since I had to go for a rest anyway, he said, I might as well go there and perhaps learn something, too. I left my grandmother in Antibes, where she had been in the habit of going, and then went over to Golfe-Juan to stay at Monsieur Fort's.

Pablo had rented the two upper floors of Monsieur Fort's house for me and I had arranged with Geneviève to come over from Montpellier and stay with me. The house was in the same taste as the massive azalea Pablo had sent me while I was in the hospital. Outside, it looked like all the other houses along the harbor of Golfe-Juan, but inside it

resembled only itself. It had four floors, with two rooms on each floor. Monsieur Fort, in all his naïveté, had worked very hard to decorate it in a manner that was, to say the least, original. One room was painted royal blue and spattered with white. The ceiling was studded with white stars edged in red, and all the furniture was painted red with white stars. That room wasn't very big so the fourth "wall" was the bay window that looked out over the sea. It seemed a bit like a planetarium, a dark hole from which one could see the infinite expanse of the sea on one side and, in a somewhat vaguer way, the infinite expanse of the stars on all the other sides. The other rooms were simply ugly, decorated in pyrography, with designs of chestnut trees burned into the wood, and the furniture painted white with flowering almond trees on it.

Monsieur Fort was a very thin man, over eighty at the time, with a red face, white hair, blue eyes, and a very long nose. He wore a *béret basque* and leaned into the wind, whether he stood or walked. After all those years of bending over his copperplates he was no longer capable of standing up straight. He always looked a little drunk, too, and once I had seen his wife, about thirty years younger than he, I understood his need to bolster up his courage in that way.

By trade he was an artisan-engraver and he had printed the illustrations for many of Ambroise Vollard's editions, including Pablo's famous series of etchings and drypoints, *Les Saltimbanques*. He taught me the rudiments of the various techniques of engraving and etching. I learned how to use varnish, how to do soft-ground etching, how to bite into the copperplate with acid, and all about the various tools—the etching needle, the scraper, the burnisher. I began to try my hand in the medium. At the end of a week, I found it all so interesting that I wrote to Pablo, since he had said he might visit me for a while, telling him I was working very well and that there was no point in his taking the trouble to come down. I was astonished, two days later, to see Pablo and Marcel drive up. I asked Pablo why he had come, since I had told him I was getting along fine by myself.

"Exactly," he said. "I don't know what you think you are but how could you write me that you were happy without me?" That, of course, wasn't just what I had meant. He said, "I had an idea that since you didn't want to see me, I'd better get here as quickly as I could." The next day he was already in a bad mood just because he was there.

Geneviève had arrived from Montpellier only the day before, a week late. Pablo's first act was to pack her off to stay at the little

PART II

hotel-restaurant, *Chez Marcel*, down the street. I tried to protest, but he didn't want any company, not even a pretty girl like Geneviève. From the start it was apparent that they couldn't get along. Pablo's ribbing, which he spared no one, didn't go down with Geneviève. She had been rather strictly brought up, had a somewhat limited sense of humor, and I think Pablo found her a bit stiffnecked.

Each afternoon, I went to Antibes to see my grandmother. The first two days, when I returned, I could see that Pablo and Geneviève were at swords' points, but with a certain reserve. The third day, when I reached Monsieur Fort's after my visit to Antibes and got upstairs, I found Pablo looking very red and angry, and Geneviève rather white but even angrier, glaring at each other across the front room on the third floor. I looked from one to the other.

"I want to talk to you in private, Françoise," Geneviève blurted out.

"I'll do the talking," Pablo said.

I had a pretty good idea what they both wanted to talk about. I told Pablo I'd talk to him later and I took Geneviève downstairs and walked with her toward the hotel.

"How can you put up with a monster like that?" she said. Why a monster? I asked her.

"It's not only what he did, or what he tried to do, but the way he took to go about it," she said. "He brought me back to the house after we left you at Antibes. He said—with a straight face—he would give me a lesson in etching and then, without a lesson or anything else, he simply looked at me and said, 'I'm going to take advantage of Francoise's absence and you at the same time.' I told him he wasn't going to do anything of the sort. Then he sat me down on the bed and said, 'What's more, I'm going to make you a child. That's just what you need.' I got up off the bed immediately because I'm sure he intended to do just that."

Geneviève was beginning to get some of her color back now but she didn't look any less angry. I realized, of course, that whatever Pablo might have said, his chief desire was to be rid of her but I couldn't tell her that. I told her I believed her but I thought she would have done better not to have gotten so excited. I said if she had laughed at him she might have had an easier time of it.

"That may work for you," she said, "but I don't have that kind of laugh, unfortunately." For the next hour she tried to convince me

that the only reasonable, decent, sane thing to do, the only way to save, if not my skin at least my soul (Geneviève had always been more amenable to the nuns' teachings than I, during our days at boarding school), was for me to leave with her for Montpellier the next day. Besides, my elbow would heal a lot more quickly in the calm and proper atmosphere of her parents' home, she assured me, than in the company of a monster like Pablo. I told her I would think it over and come back and talk with her in the morning. "One way or the other, I'm leaving for Montpellier in the morning," she warned me.

When I got back to Monsieur Fort's, Pablo was quite calm, as I had expected. "I can imagine the pack of lies *she's* told you," he said. I decided to teach him a lesson. I told him I had known Geneviève for a great many years and I believed all that she had told me. I said that she was leaving for Montpellier in the morning and that I was going with her.

He scowled and shook his head. "How can you put your faith in the kind of girl who would try to seduce me behind your back? How can you even have that kind of girl as your friend? I don't understand things like that. But to leave me and go off with her—well, in that case there's only one answer: there's some sort of unnatural relationship between you."

It was my turn to take the advice I had given Geneviève. I laughed in Pablo's face. "You missed your vocation," I said. "You're pure Jesuit." He grew very red all over again and started dancing around me. "Petit monstre! Serpent! Vipère!" he shouted. I kept on laughing. Gradually he calmed down. "How long are you going to stay away?" he asked me. I told him I thought I would stay away, period. He suddenly grew very morose. "I came down here to be alone with you," he said, "because in Paris we're never really alone—not for more than a few hours. Now that I'm here, you talk about going away. You're ready to leave me. I don't have many more years to live, you know. And you don't have the right to take away whatever little bit of happiness remains for me." He went on in that vein for at least an hour. When he had talked himself out and I saw that he was genuinely repentant, I told him that perhaps I would stay, after all. The next morning I went back to the hotel and told Geneviève.

"You're headed for a catastrophe," she said. I told her she was probably right but I felt it was the kind of catastrophe I didn't want to avoid. She went back to Montpellier and I went back to Pablo. FTER GENEVIÈVE HAD LEFT, Pablo became relatively agreeable. A day or two later he said, "Since we're down here, let's go see Matisse. You put on your mauve blouse and those willow-green slacks; they're two colors Matisse likes very much."

At that time Matisse was living in a house he had rented before the end of the Occupation in Vence, close to where his chapel is now. When we got there, he was in bed, since he could get up for only an hour or two a day as a result of his operation. He looked very benevolent, almost like a Buddha. He was cutting out forms, with a large pair of scissors, from very handsome papers that had been painted with gouache according to his directions. "I call this drawing with scissors," he said. He told us that often he worked by having paper attached to the ceiling and drawing on it, as he lay in bed, with charcoal tied to the end of a bamboo stick. When he had finished his cutouts, Lydia, his secretary, attached them to the wall on a background paper on which Matisse had drawn, with his bamboo and charcoal, marks indicating where they should be pasted down. First she pinned the papers in place and then changed them around until he had settled on their exact position and the relationship they should have to one another.

That day we saw several of a series of paintings he had been working on: among them, there were variations on two women in an interior. One was a nude, rather naturalistic and painted in blue. It seemed not entirely in balance. Pablo said to Matisse, "It seems to me that in a composition like that the color can't be blue because the color that kind of drawing suggests is pink. In a more transposed drawing, perhaps, the local color of the nude could be blue, but here the drawing is still that of a pink nude." Matisse thought that was quite true and said he would change it. Then he turned to me and said, laughing, "Well, in any case, if I made a portrait of Françoise, I would make her hair green." Pablo said, "But why would you make a portrait of her?"

"Because she has a head that interests me," Matisse said, "with her eyebrows sticking up like circumflex accents."

"You're not fooling me," Pablo said. "If you made her hair green, you'd make it that way to go with the Oriental carpet in the painting."

"And you'd make the body blue to go with the red-tile kitchen floor," Matisse answered.

Up to that time Pablo had painted only two small gray-and-white portraits of me, but when we got back into the car, all of a sudden a proprietary instinct took possession of him.

"Really, that's going pretty far," he said. "Do I make portraits of Lydia?" I said I didn't see any connection between the two things. "In any case," he said, "now I know how I should make your portrait."

A few days after our visit to Matisse, I told Pablo I was ready to go back to Paris.

"When we return I want you to come live with me," he said bluntly. He had skirted that idea before, mostly in a semiserious vein, but I wasn't eager to take him up on it and I had turned his suggestion aside each time it came up. My grandmother was giving me whatever liberty I needed. Furthermore, I found the idea of abandoning her unpleasant. After all, she had not abandoned me. I told Pablo that even if I wanted to, it would be impossible for me to make her understand such a move.

"That's true," he said, "so you just come, without giving her any warning. Your grandmother needs you less than I do." I told him I was very attached to him but that I wasn't ready for such a step.

"Look at it this way," he said. "What you can bring to your grandmother, aside from the affection you have for her, is not something essentially constructive. When you're with me, on the other hand, you help me to realize something very constructive. It's more logical and more positive for you to be close to me, in view of the fact that I really need you. As far as your grandmother's feelings are concerned, there are things one can do and make them understood, and there are other things that can only be done by *coup d'état* since they go beyond the limits of another person's understanding. It's almost better to strike a blow and after people have recovered from it, let them accept the fact." I told him that sounded rather brutal to me.

"But there are some things you can't spare other people," he said. "It may cost a terrible price to act in this way but there are moments in life when we don't have a choice. If there is one necessity which for you dominates all others, then necessarily you must act badly in some respect. There is no total, absolute purity other than the purity of refusal. In the acceptance of a passion one considers extremely important and in which one accepts for oneself a share of tragedy, one steps outside the usual laws and has the right to act as one should not act under ordinary conditions." I asked him how he arrived at that rationalization.

"At a time like that, the sufferings one has inflicted on others, one begins to inflict on oneself equally," he said. "It's a question of the recognition of one's destiny and not a matter of unkindness or insensitivity. Theoretically one might say one hasn't the right to reach out for a share of happiness, however minute it may be, which rests on someone else's misfortune, but the question can't be resolved on that theoretical basis. We are always in the midst of a mixture of good and evil, right and wrong, and the elements of any situation are always hopelessly tangled. One person's good is antagonistic to another's. To choose one person is always, in a measure, to kill someone else. And so one has to have the courage of the surgeon or the murderer, if you will, and to accept the share of guilt which that gives, and to attempt, later on, to be as decent about it as possible. In certain situations one can't be an angel."

I told him that a primitive person could face up to that idea much more easily than someone who thought in terms of principles of good and evil and who tried to act on the basis of them.

"Never mind your theories," he said. "You must realize that there is a price on everything in life. Anything of great value—creation, a new idea—carries its shadow zone with it. You have to accept it that way. Otherwise there is only the stagnation of inaction. But every action has an implicit share of negativity. There is no escaping it. Every positive value has its price in negative terms and you never see anything very great which is not, at the same time, horrible in some respect. The genius of Einstein leads to Hiroshima."

I told him I had often thought he was the devil and now I knew it. His eyes narrowed.

"And you—you're an angel," he said, scornfully, "but an angel from the hot place. Since I'm the devil, that makes you one of my subjects. I think I'll brand you."

He took the cigarette he was smoking and touched it to my right cheek and held it there. He must have expected me to pull away, but I was determined not to give him the satisfaction. After what seemed a long time, he took it away. "No," he said, "that's not a very good idea. After all, I may still want to look at you."

We started back to Paris the next day. Pablo never liked to ride in the back seat, so we sat in front with Marcel, the chauffeur. Pablo sat in the middle. Marcel entered freely into the conversation. From

time to time Pablo would begin again to argue with me about coming to live with him. Marcel would look over and smile, occasionally putting in something like, "I think she's right there. Let her go home now. Give her some time to think it over." And Pablo always listened to Marcel. So when we reached Paris I went back to my grandmother's house with no further comments from Pablo. But from that moment on, since he had launched in earnest the idea that I must come live with him, he worked every day toward moving me in that direction.

NE MORNING a few weeks after our return from the Midi I was working in my studio. I had the bad habit of getting out of bed, not bothering to wash, eat, or dress, putting on an old bathrobe, now paint-spattered, that had once belonged to my grandmother, tying it around me with a rope because it was too big for me and then starting to paint, with my hair flying, and working like that until noon. It was a kind of warm-up session for me but it gave me something to work on later in the afternoon with more order and purpose. That morning I was in the midst of my work looking like some kind of witch when suddenly the door opened. I saw Pablo, in a heavy sheep-lined khaki mackinaw, peeking out from behind two dozen long-stemmed white roses. Both of us must have had quite a shock, because I had never seen him hiding behind two dozen white roses before and he had certainly never seen me wrapped up in a paint-stained old bathrobe tied with a rope, barefooted and hair uncombed. When the astonishment had passed, we both began to laugh. I said to him, "Don't tell me you went out and bought those roses for me."

"Of course not," he said. "Somebody brought them to me, but I thought it would be more appropriate to give them to you. Now I'm beginning to doubt it. I never would have believed you could look like this."

I told him to wait a minute and I went into my bathroom to clean up. While I was changing, a strong, low-pitched masculine voice from the floor below called to me. "What is this?" Pablo asked. "A man in this house?" I told him it wasn't a man; it was my grandmother. Skeptical as always, he said, "I'd like to meet your grandmother. She has a most extraordinary voice." On our way out to lunch we ran into her on the landing. She had come out of her sitting room to say good-bye. It was a historic meeting. My grandmother was a small woman but she had a very strong personality and an unforgettable head, like an aged lion, very wrinkled and with a great mane of white hair that stood out in all directions. Her massive head together with her tiny body and her extremely deep, powerful voice made an unbelievable combination and when she spoke to Pablo, he said to me, in a stage whisper, "I've just met the great German orchestra leader." It was a nickname that stuck. As for my grandmother, I didn't learn her opinion on the spot, but in the afternoon when I came back, I asked her what she thought of him. She said, "It's extraordinary. I've never seen a man with such a smooth skin. It's like a piece of polished marble." I said it wasn't so smooth as all that. She said, "Yes, and hard and solid like a statue, I assure you, just like a statue." I think Pablo's way of looking at people with those piercing dark eyes exerted a fascination and might even have suggested something smooth. In any case, the opinion of both of them was fixed forever.

A SIDE FROM MY DISINCLINATION to leave my grandmother, and all the other reasons I had or thought I had for not going to live with Pablo, I had little desire to go there as long as there was any tie between him and Dora Maar. He assured me, naturally, that he would have no major interest in his life but me. In fact, he told me, he had already given Dora to understand that there was no longer anything between them. He insisted they understood each other perfectly on that point. When I seemed reluctant to believe him, he urged me to go to her apartment with him so I could see for myself. I was even more reluctant to do that. But he kept on urging.

A few weeks after his first meeting with my grandmother, Pablo drove up to the house with Marcel one morning to take me to an exhibition of French tapestries that included the famous series of the Lady of the Unicorn. As we were leaving the exhibition, we stopped at a vitrine in the center of the hall to look at a narwhal tusk they had on display as the nearest thing available to the unicorn variety. The hall was nearly empty but just ahead of us, studying one of the tapestries, I saw Dora

Maar. I felt a little embarrassed but Pablo seemed delighted to meet her and began questioning her about the exhibition. After they had discussed the tapestries, he said, facing her directly, "What would you say about having lunch together?" It seemed to me, when she accepted, that she was thinking that "having lunch together" meant together with him. Then Pablo said, "That's very nice. I see you're broad-minded. In that case I'll take you both to *Chez Francis.*" I thought Dora looked surprised and disappointed, but she said nothing. We all went outside, where Marcel was waiting with the car, and drove down to the Place de l'Alma, to *Chez Francis.* During the short ride, Dora, I felt, was sizing up the situation and deciding that in all likelihood things had reached a phase she didn't much care for. We went inside the restaurant, were seated, and began to study the menu.

"You don't mind if I order the most expensive thing on the card, do you?" Dora asked. "I suppose I still have the right to a little luxury, for the time being."

"By all means," Pablo said. "Whatever you like." Dora ordered caviar and the rest of the lunch in keeping with it. She kept up a steady stream of very witty conversation, but Pablo didn't laugh at all. On the other hand, whenever I tried to say something reasonably clever, in order not to be totally eclipsed, he laughed so heartily, it was embarrassing. Throughout the meal, he kept saying to Dora such things as, "Isn't she marvelous? What a mind! I've really discovered somebody, haven't I?" It looked to me as though none of this was making Dora any happier.

Âfter lunch Pablo said to Dora, "Well, you don't need me to take you home, Dora. You're a big girl now."

Dora didn't smile. "Of course not. I'm perfectly capable of getting home by myself," she said. "I imagine you need to lean on youth, though. About fifteen minutes ought to do it, I should think."

DOMETIMES WHEN I VISITED PABLO in the afternoon he would ask me to have dinner with him. I wasn't much interested in being seen with him in restaurants, so either Inès, the chambermaid, would prepare something for us or if she wasn't there, Pablo would go to the ample stock of American canned goods he had accumulated through gifts from GI's who had come to call on him at the Liberation and find something edible there. One evening after we'd gotten rid of our quota of the inevitable little Vienna sausages Pablo said, "We'll take a walk before you go home. That will give me some fresh air before I go back to work. Let's go to the *Flore*." That was the last place I wanted to go; I knew many of his friends would be there and the next day everybody would know something was going on between us. When I explained that to him, he said, "You're right. In that case we'll just go up to the Boulevard St.-Germain." I said no; on the Boulevard St.-Germain we'd meet the same people on their way to or from the *Flore*, probably. "Oh, that's right," he said. "Well, we'll just go as far as the Rue de l'Abbaye, then." I made the point that once we reached the end of the Rue de l'Abbaye, parallel to the Boulevard St.-Germain and one short block behind the *Flore*, we were practically there.

"You're hard to please," Pablo said. "I'll tell you what. We won't go inside; we'll just stand outside and look in." I finally gave in. At that period there wasn't the covered terrace that now stands outside the *Café de Flore* until warm weather. Everyone sat inside. When we got there Pablo said, "I'll just look through the window. Nobody will recognize me." But as soon as he had looked he said, "Oh, there's Dora Maar sitting with some friends, and I'm sure she saw me. She'll think it very strange if we don't go in now." We went in. Full of good cheer, Pablo went over to the table where Dora was sitting and said, "I didn't want to pass by without saying hello, since I saw you were in here. I haven't seen you for such a long time. You remember Françoise." Dora didn't acknowledge my presence but told him he needn't have come that far if he only wanted to see her; he could have walked around the corner to her apartment.

"Of course," Pablo said, still brimming over with good cheer. "It would be much better at your place."

"Why not?" said Dora, assuming again, I suppose, that he was talking about the two of them. When we got outside he said to me, "You see? She invited us to call on her." I told him I hadn't understood it that way. In any case, I said, I wouldn't go.

"Oh, yes, you will," he said. "My mind is made up. I want to straighten out a few things with her, first of all, and I want you to hear from both of us the fact that we are completely detached from each other."

One evening about a week after that, Pablo maneuvered himself, and me, into another "chance" meeting with Dora Maar at the *Flore*.

This time he said he wanted to talk with her at her place in an hour. I dreaded the visit. I told Pablo I didn't want to go but he was in no mood to listen. When we reached her place, she looked at us coldly but was very composed. To break the ice, Pablo asked her to show us some of her paintings. She showed us five or six still lifes. I said I thought them very handsome. She said to Pablo, "I imagine you came for something else."

"That's right," he said. "You know what it is. I simply want Françoise to hear it. She's troubled about coming to live with me because she thinks she'd be usurping your place. I've told her it's all finished between us, and I want you to tell her, too, so she'll believe it. She's worried about her responsibility in all this."

Dora Maar looked over at me briefly and witheringly. It was true; there was no longer anything between Pablo and her, she said, and I certainly shouldn't worry about being the cause of their break-up. That was about as preposterous an assumption as she could imagine, she said.

I looked a good deal younger than my age at that time. That evening I had on flat-heeled shoes, a plaid skirt, and a loose sweater, and wore my hair long in back; there was certainly nothing about my appearance that spelled seduction. Pablo had walked into the apartment dragging me by the hand, and when he went into his speech, I'm sure Dora Maar thought he had lost his mind. She told him he must be crazy to think he could live with "that schoolgirl."

Since Dora was perhaps twenty years younger than Pablo and I was forty years younger than he was, I did feel a little bit like a schoolgirl listening to an argument between the teacher and the principal of the school. A good many of their allusions were over my head. Furthermore, neither one of them spoke to me nor drew me into the conversation. If Dora *had* spoken to me, I doubt that I could have answered her, I felt so ill at ease.

"You're very funny," Dora said to him. "You take so many precautions in embarking on something that isn't going to last around the corner." She'd be very surprised, she said, if I wasn't out on the ash-heap before three months had passed, all the more so since he was the kind of person who couldn't attach himself to anyone. "You've never loved anyone in your life," she said to Pablo. "You don't know how to love."

"You're in no position to decide whether I know how to love or not," he said.

Dora stared at him for a moment. "I think we've said everything we had to say," she said, finally.

"That's right," Pablo said, and he left, dragging me behind him. Outside I found my tongue. I told him I was going home to Neuilly and that he could walk me to the Pont-Neuf *métro* station. As we were crossing the bridge to get to the *métro* entrance on the Right Bank of the Seine, I asked him how he could have precipitated a scene that was so disagreeable for everybody, showing his feelings in such an ugly way and hurting Dora in front of me. For him to have acted that way showed a total lack of understanding of others. I told him that didn't make me feel like rushing into his arms; on the contrary, I felt very much apart from him and very doubtful about the possibility of ever fathoming the workings of such a mind. He burst into a rage.

"I did that for you," he said, "just to make you realize there's nobody else as important as you in my life. And this is the thanks I get —your aloofness and a bawling-out. You're not able to feel intensely about anything. You have no grasp of what life is really like. I ought to throw you into the Seine. That's what you deserve." He grabbed me and pushed me into one of the semicircular setbacks on the bridge. He held me against the parapet and twisted me around so that I was looking down into the water.

"How would you like it?" he said. I told him to go ahead if he wanted to—it was spring now and I was a good swimmer. Finally he let go of me and I ran down into the subway, leaving him behind me on the bridge.

IN VIEW OF THE SCENE that took place in Dora Maar's apartment, I suppose that I should have cooled off toward Pablo. But I didn't. I was bothered by what had happened and by its implications, but my feeling for him had deepened to the point where it was stronger than any of the warning signals. It is difficult to explain why this should have been true, but perhaps I can make it at least a little clearer by dropping back, briefly, a dozen or so years to my childhood.

My father had four sisters, and his mother had been widowed when he was fifteen. He must have had his fill of women. When he

married, my mother bore him only one child. He often reproached me for not being a boy. I was dressed in a boyish fashion, with short hair, at a time when that wasn't done in our milieu. My father supervised my studies and insisted that I be active in athletics. I had to pass tests as well as any boy and run and jump as well as any boy. He saw to it that I did.

In the summer he used to take me sailing. He taught me to love the sea. Once the shoreline had disappeared, and we were all alone on a sailboat with only the sky to witness, then and only then could my father and I manage to get along. He was a very solitary man and the Brittany coastline, which was wild and rugged, suited him to a T. And I grew up liking solitude and wild places, as a result. Whenever we were in that kind of place, he smiled frequently, which he never did at home, and he talked easily about everything with me. But as soon as we were back in Paris, we clashed constantly.

In winter my father used to take me hunting to La Brière, a marshy country at the mouth of the Loire, just below Brittany. There are almost no trees there and the landscape is made up of small islands and peninsulas. Everything—even the water and the reeds—is in pearly tones of greenish-gray. We would go far out into the marshes in a flatbottomed boat. There were hundreds of birds of all kinds—wild ducks, teal, curlews, wild geese, cranes, and herons—that came in from the sea in the evening to sleep on those ponds and then, the next morning, went back to the sea again. I used to get up at five o'clock to see the dawn and watch the birds fly back to the sea against that cold, sad landscape. I think I gained from that experience a vision that served as the basis of my painting: subtle mutations of shifting light against those pale gray-green stretches.

When I was very young I was afraid of everything, particularly of the sight of blood. If I had a cut that bled freely, I would faint. I remember, also, being afraid of the dark and of high places. My father reacted vigorously against all that. He used to make me climb up onto high rocks and then jump down. It was frightening enough to have to climb up but jumping down was a nightmare. At first I cried and howled, but with my father that achieved nothing. If he had made up his mind that I was to do something, I could protest for hours but in the end I had to do it. And as soon as I had accomplished one thing, he forced me to do something else, even harder. I felt powerless in the face of his will. My only possible reaction was anger. And the anger grew to such proportions there was no room left for fear. But since I could not show my anger, I began to nourish an inner resentment.

He wanted me to learn to swim, but I was afraid of the water. He forced me to learn and once I had learned, he made me swim faster and faster and always for greater distances than the week before. By the time I was eight, I was afraid of nothing; in fact, my nature had changed so that I sought out difficulty and danger. I had become another person, really. He had made me fearless and stoical, but in the end his training boomeranged against him. If there was something I wanted to do that I knew he would disapprove of, I would figure out in advance what his reaction would be and the kind of punishment he would mete out, and then prepare myself for it. I would do it, but prepared as I was, my father's reaction and the punishment didn't bother me.

Later on, that psychology worked against me, too. As I was growing up, whenever anything frightened me in any degree, it fascinated me at the same time. I felt the need of going too far simply to prove to myself that I was capable of it. And when I met Pablo, I knew that here was something larger than life, something to match myself against. The prospect sometimes seemed overpowering, but fear itself can be a delicious sensation. And so I had the feeling that even though the struggle between us was so disproportionate that I ran the risk of a resounding failure, it was a challenge I could not turn down. That, by way of background.

There was another reason, more specific and immediate: I knew by now that although Pablo had been receiving the world's adulation for at least thirty years before I met him, he was the most solitary of men within that inner world that shut him off from the army of admirers and sycophants that surrounded him.

"Of course people like me; they even love me," he complained one afternoon when I was trying to break the spell of pessimism I found engulfing him when I arrived. "But in the same way they like chicken. Because I nourish them. But who nourishes me?" I never told him so, but I thought that I could. I knew I couldn't carry the full burden of that solitude, which at times seemed crushing to him, but I felt I could lighten it through my presence.

The thing that troubled me most was the thought of leaving my grandmother, of disappointing her confidence in me. I could not explain to her what Pablo wanted me to do because she would have said, "Don't do anything as foolish as that. Do what you want to as long as you don't

leave. Don't live completely with that man; it would certainly be a mistake."

Whether she sensed the dilemma that was troubling me, I don't know, but just a little while earlier she had said to me, "Love flows naturally from one generation on down to the next. You are doing just the reverse. You're trying to swim upstream against the current. What is there about the natural flow of the river of life that has shocked you so strongly that you should want to swim against the current, even against time? You ought to know you're lost even before you begin. I don't understand you but I love you and I suppose you are obeying the law of your being."

I don't believe I could have made her understand that the question of age was the least of my concerns. Pablo not only didn't seem old to me; in some ways he seemed more youthful—mature but vigorous —than friends my own age. But most of all, the fact that from the moment I knew him, I had seen that we spoke the same language made the matter of age seem irrelevant. And so, knowing very well what she would have said to me and not being able to change her feelings, I had to leave like a thief in the night, just going away, not coming back, and sending her a note the next day. That, I must say, is one of my most painful memories.

It happened this way: Early one evening toward the end of May 1946, as I was getting ready to leave the Rue des Grands-Augustins to return to my grandmother's house, Pablo began again, as he did almost every day at that period, to urge me to break the last tie and stay with him. He argued that if two people don't live together, there comes a time when they begin to drift apart. He said we had gone as far as we could go in our relationship living separately and that if we didn't change that, everything would fall apart. "Given your age, you'll be picked off sooner or later by someone else, and I don't look forward to that with much pleasure. And in view of my age, you have to realize that in a moment of discouragement I'd be bound, one day, to tell myself I'd be better off to make some other arrangement. So if I mean anything to you, you've got to make up your mind to come live with me, in spite of the difficulties. Whatever they are, they are certainly less than the problems of living apart."

I answered, perhaps a shade too flippantly, that I thought it was just the other way around, and that if I yielded, only bad would come of it. Pablo flew into a rage. He was wearing, as he often did, a wide leather belt like a gendarme's. He unbuckled it, pulled it out of his trousers, and held it up as though he were going to whip me. I began to laugh. He grew angrier and shouted, "Don't I count in your life? Is this all a game for you? Are you so insensitive as that?" The more he stormed, the harder I laughed. I suppose I was almost hysterical, but I felt as though I were witnessing the scene as a spectator. Finally he stopped. He looked disgusted. "Who ever heard of anyone laughing under such conditions," he said. "It's fine to have a sense of humor but I think you overdo it." Suddenly he looked very depleted and dejected. "You're worried all the time about your grandmother," he said. "I'm almost as old as she is. You should be worrying about me. I need you and I'm tired of getting along without you." And then he added, a little more fiercely, "And since I can't get along without you, you have to come live with me."

I told him I found his reasoning so childish and his violence so pathetic, I could only assume he must love me very much, to show off, in both respects, to such disadvantage. I said that if he loved me that much, I would come live with him. I could see it bothered him to have me put it on that basis but he was in no mood to argue himself out of what must have seemed a sudden and unexpected victory. All he said was, "Just watch out that you don't forget what I said about your sense of humor."

So I stayed there without saying good-bye or offering any explanation to anyone. The next morning I wrote a letter to my grandmother and another one to my mother to explain to them, without saying exactly where I was or what I was doing, that I had decided to go away, to live in another manner and that they would hear from me afterward and not to worry. Pablo dictated the letters for me. I was incapable at the moment of writing anything of that kind on my own.

PART III

DURING THE FIRST MONTH after I went to live with Pablo, I never left the house. Most of that time I spent in the studio watching him draw and paint.

"I almost never work from a model, but since you're here, maybe I ought to try," he said to me one afternoon. He posed me on a low tabouret, then sat down on a long green wooden bench—the kind one sees in all the Paris parks. He picked up a large sketching pad and made three drawings of my head. When he had finished, he studied the results, then frowned.

"No good," he said. "It just doesn't work." He tore up the drawings.

The next day he said, "You'd be better posing for me nude." When I had taken off my clothes, he had me stand back to the entrance, very erect, with my arms at my side. Except for the shaft of daylight coming in through the high windows at my right, the whole place was bathed in a dim, uniform light that was on the edge of shadow. Pablo stood off, three or four yards from me, looking tense and remote. His eyes didn't leave me for a second. He didn't touch his drawing pad; he wasn't even holding a pencil. It seemed a very long time.

Finally he said, "I see what I need to do. You can dress now. You won't have to pose again." When I went to get my clothes I saw that I had been standing there just over an hour.

The following day Pablo began, from memory, a series of drawings of me in that pose. He made also a series of eleven lithographs of

my head and on each one he placed a tiny mole under my left eye and drew my right eyebrow in the form of a circumflex accent.

That same day he began to paint the portrait of me that has come to be called *La Femme-Fleur*. I asked him if it would bother him to have me watch him as he worked on it.

"By no means," he said. "In fact I'm sure it will help me, even though I don't need you to pose."

Over the next month I watched him paint, alternating between that portrait and several still lifes. He used no palette. At his right was a small table covered with newspapers and three or four large cans filled with brushes standing in turpentine. Every time he took a brush he wiped it off on the newspapers, which were a jungle of colored smudges and slashes. Whenever he wanted pure color, he squeezed some from a tube onto the newspaper. From time to time he would mix small quantities of color on the paper. At his feet and around the base of the easel were cans—mostly tomato cans of various sizes—that held grays and neutral tones and other colors which he had previously mixed.

He stood before the canvas for three or four hours at a stretch. He made almost no superfluous gestures. I asked him if it didn't tire him to stand so long in one spot. He shook his head.

"No," he said. "That's why painters live so long. While I work I leave my body outside the door, the way Moslems take off their shoes before entering the mosque."

Occasionally he walked to the other end of the atelier and sat in a wicker armchair with a high Gothic back that appears in many of his paintings. He would cross his legs, plant one elbow on his knee and, resting his chin on his fist, the other hand behind, would stay there studying the painting without speaking for as long as an hour. After that he would generally go back to work on the portrait. Sometimes he would say, "I can't carry that plastic idea any further today," and then begin work on another painting. He always had several half-dry unfinished canvases to choose from. He worked like that from two in the afternoon until eleven in the evening before stopping to eat.

There was total silence in the atelier, broken only by Pablo's monologues or an occasional conversation; never an interruption from the world outside. When daylight began to fade from the canvas, he switched on two spotlights and everything but the picture surface fell away into the shadows.

"There must be darkness everywhere except on the canvas, so that the painter becomes hypnotized by his own work and paints almost

PART III

as though he were in a trance," he said. "He must stay as close as possible to his own inner world if he wants to transcend the limitations his reason is always trying to impose on him."

Originally, La Femme-Fleur was a fairly realistic portrait of a seated woman. You can still see the underpainting of that form beneath the final version. I was sitting on a long, curved African tabouret shaped something like a conch shell and Pablo painted me there in a generally realistic manner. After working a while he said, "No, it's just not your style. A realistic portrait wouldn't represent you at all." Then he tried to do the tabouret in another rhythm, since it was curved, but that didn't work out, either. "I don't see you seated," he said. "You're not at all the passive type. I only see you standing," and he began to simplify my figure by making it longer. Suddenly he remembered that Matisse had spoken of doing my portrait with green hair and he fell in with that suggestion. "Matisse isn't the only one who can paint you with green hair," he said. From that point the hair developed into a leaf form and once he had done that, the portrait resolved itself in a symbolic floral pattern. He worked in the breasts with the same curving rhythm.

The face had remained quite realistic all during these phases. It seemed out of character with the rest. He studied it for a moment. "I have to bring in the face on the basis of another idea," he said, "not by continuing the lines of the forms that are already there and the space around them. Even though you have a fairly long oval face, what I need, in order to show its light and its expression, is to make it a wide oval. I'll compensate for the length by making it a cold color—blue. It will be like a little blue moon."

He painted a sheet of paper sky-blue and began to cut out oval shapes corresponding in varying degrees to this concept of my head: first, two that were perfectly round, then three or four more based on his idea of doing it in width. When he had finished cutting them out, he drew in, on each of them, little signs for the eyes, nose, and mouth. Then he pinned them onto the canvas, one after another, moving each one a little to the left or right, up or down, as it suited him. None seemed really appropriate until he reached the last one. Having tried all the others in various spots, he knew where he wanted it, and when he applied it to the canvas, the form seemed exactly right just where he put it. It was completely convincing. He stuck it to the damp canvas, stood aside and said, "Now it's your portrait." He marked the contour lightly in charcoal, took off the paper, then painted in, slowly and care-

fully, exactly what was drawn on the paper. When that was finished, he didn't touch the head again. From there he was carried along by the mood of the situation to feel that the torso itself could be much smaller than he had first made it. He covered the original torso by a second one, narrow and stemlike, as a kind of imaginative fantasy that would lead one to believe that this woman might be ever so much smaller than most.

He had painted my right hand holding a circular form cut by a horizontal line. He pointed to it and said, "That hand holds the earth, half-land, half-water, in the tradition of classical paintings in which the subject is holding or handling a globe. I put that in to rhyme with the two circles of the breasts. Of course, the breasts are not symmetrical; nothing ever is. Every woman has two arms, two legs, two breasts, which may in real life be more or less symmetrical, but in painting they shouldn't be shown to have any similarity. In a naturalistic painting, it's the gesture that one arm or the other makes that differentiates them. They're drawn according to what they're doing. I individualize them by the different forms I give them, so that there often seems to be no relationship between them. From these differing forms one can infer that there is a gesture. But it isn't the gesture that determines the form. The form exists in its own right. Here I've made a circle for the end of the right arm, because the left arm ends in a triangle and a right arm is completely different from a left arm, just as a circle is different from a triangle. And the circle in the right hand rhymes with the circular form of the breast. In real life one arm bears more relation to the other arm than it does to a breast, but that has nothing to do with painting."

Originally the left arm was much larger and had more of a leaf shape, but Pablo found it too heavy and decided it couldn't stay that way. The right arm first came out of the hair, as though it were falling. After studying it a while, he said, "A falling form is never beautiful. Besides, it isn't in harmony with the rhythm of your nature. I need to find something that stays up in the air. Then he drew the arm extended from the center of the body stem, ending in a circle. As he did it, he said, half-facetiously, lest I take him too seriously, "You see now, a woman holds the whole world—heaven and earth—in her hand." I noticed often at that period that his pictorial decisions were made half for plastic reasons, half for symbolic ones. Or sometimes for plastic reasons that stemmed from symbolic ones, rather hidden, but accessible once you understood his humor.

In the beginning the hair was divided in a more evenly balanced way, with a large bun hanging down on the right side. He removed that because he found it too symmetrical. "I want an equilibrium you can grab for and catch hold of, not one that sits there, ready-made, waiting for you. I want to get it just the way a juggler reaches out for a ball," he said. "I like nature, but I want her proportions to be supple and free, not fixed. When I was a child. I often had a dream that used to frighten me greatly. I dreamed that my legs and arms grew to an enormous size and then shrank back just as much in the other direction. And all around me, in my dream, I saw other people going through the same transformations, getting huge or very tiny. I felt terribly anguished every time I dreamed about that." When he told me that, I understood the origin of those many paintings and drawings he did in the early 1920s, which show women with huge hands and legs and sometimes very small heads: nudes, bathers, maternity scenes, draped women sitting in armchairs or running on the beach, and occasionally male figures and gigantic infants. They had started through the recollection of those dreams and been carried on as a means of breaking the monotony of classical body forms.

When Pablo had finished the portrait he seemed satisfied. "We're all animals, more or less," he said, "and about three-quarters of the human race look like animals. But you don't. You're like a growing plant and I'd been wondering how I could get across the idea that you belong to the vegetable kingdom rather than the animal. I've never felt impelled to portray anyone else this way. It's strange, isn't it? I think it's just right, though. It represents you."

Over the days that followed, I often noticed Pablo studying the wide oval head on my portrait. "As long as you paint just a head, it's all right," he said one day, "but when you paint the whole human figure, it's often the head that spoils everything. If you don't put in any details, it remains just an egg, not a head. You've got a mannequin and not a human figure. And if you put too much detail onto the head, that spoils the light, in painting just as in sculpture. Instead of light you've got shadow, which makes holes in your composition, and the eye can't circulate freely where it wants to. One of the possibilities open to you is to keep the complete volume of the head in its normal proportions, or even slightly larger, and to add, so as not to disturb the average viewer's habits too much, a minimum of small graphic signs close together for the eyes, nose, mouth, and so on. This gives him the necessary

references to the various functional features. In that fashion you lose nothing in the way of luminosity, you gain an advantage for the composition of the painting as a whole, and you add an element of surprise. The viewer who is interested in the plastic problems involved will understand why you've done this and the interest it has. And for the viewer who understands nothing about painting, it becomes subversive: 'How *can* that man put only two dots for the eyes, a button for the nose and a bit of a line for the mouth?' he says. He rages, he fumes, he foams at the mouth. And for a painter, that's not a negligible accomplishment, either."

At that time Pablo had been working for several months on a series of still lifes built around the theme of a skull and some leeks on a table. From the point of view of form, the leeks replaced the crossbones that traditionally accompany a skull, their onionlike ends corresponding to the joints of the bones.

"Painting is poetry and is always written in verse with plastic rhymes, never in prose," Pablo said to me one day when he was working on one of those still lifes. "Plastic rhymes are forms that rhyme with one another or supply assonances either with other forms or with the space that surrounds them; also, sometimes, through their symbolism, but their symbolism mustn't be too apparent. What have leeks got to do with a skull? Plastically, they have everything to do with it. You can't keep on painting the skull and crossbones, any more that you can keep on rhyming *amour* with *toujours*. So you bring in the leeks instead and they make your point without forcing you to spell it out so obviously."

One of this group of paintings I thought extremely well arranged: the forms and the space around them were nicely balanced. It seemed to me it wasn't possible to change anything about it. The skull itself was particularly expressive. But Pablo was dissatisfied. "That's just the trouble," he said. "It's so well balanced it annoys me. I can't leave it like that. It's a stable kind of balance, not an unstable one. It's too solid. I prefer a more precarious one. I want it to hold itself together—but just barely."

I suggested that since all the elements of the composition were perfect and it was only the question of balance that bothered him, he try the solution he had brought to my portrait: cut out the skull from a piece of paper and move it around in different areas of the canvas. He cut out another skull form and, hiding the painted one with one hand, moved the paper skull wherever he felt it might prove sufficiently disturbing. He finally found a spot that was much more unexpected than the original one and provided just the kind of fateful juxtaposition he was seeking, where the balance hung by a thread. Then he was satisfied.

"When you compose a painting," he said, "you build around lines of force that guide you in your construction. There's one area where the first graphic sketch evokes the idea of a table, for example; another one, where you create the idea of the movement of space behind the table. Those lines of force set up a resonance that leads you to where you are going, because in general you don't arbitrarily decide for yourself. But once you remove one of those elements from your composition and move it around as though it were walking at will through that two-dimensional space, you're able to achieve a far greater effect of surprise than you could ever do by leaving it in the first position." He painted out the first skull, pinned down the paper one and marked carefully the area it occupied. Then he removed the paper and painted in the skull in its new location. When he had finished, he saw that one portion of the first skull was still partly visible beneath the surface. He studied it for a moment, then guickly painted in a piece of Gruvère cheese over the obtrusive edge of the original skull, in such a way as to make the two forms coincide.

"The cheese serves a dual purpose," he pointed out. "It eliminates the void created by the disappearance of the old skull, but since it has the same form, in part, as the new one, which was modeled after the old, it sets up a plastic rhyme between cheese and skull. And wait." He added holes to the cheese. It was now unmistakably Gruyère. "You see how the holes in the cheese rhyme with the eye cavities in the skull?" he said. He set down his brush. The picture was finished and Pablo was happy. In solving the problem of balance, he had created and simultaneously solved another problem in a manner that made the painting far more effective than it could have been if the problem had never been raised. And it happened so quickly, it seemed almost like a miracle taking place before my eyes.

Over the months that followed, Pablo worked on other portraits of me. He seemed greatly interested in doing a different kind of head, using a different symbol, but he kept coming back to the oval moon-shape and the plant forms. It exasperated him.

"I can't do a thing about it," he said. "It just wants to be represented in that way. That's the way it is sometimes. There are forms that

impose themselves on the painter. He doesn't choose them. And they stem sometimes from an atavism that antedates animal life. It's very mysterious, and damned annoying."

The insistent moon-shape of the head was particularly annoying to him. "I've never thought in terms of the stellar zones before," he said. "Those are not my preferred structures. They're something from another kingdom. But I just don't have any control over it. An artist isn't as free as he sometimes appears. It's the same way with the portraits I've done of Dora Maar. I couldn't make a portrait of her laughing. For me she's the weeping woman. For years I've painted her in tortured forms, not through sadism, and not with pleasure, either; just obeying a vision that forced itself on me. It was the deep reality, not the superficial one. You see, a painter has limits, not always of the kind one imagines."

It wasn't until two years later that Pablo was able to break out of those limits in painting me. By then I had surely become more real to him. He could no longer think of me as someone from another kingdom and his portraits of me began to reflect that fact. He was making many lithographs at that period and Mourlot arrived at the atelier one day bringing the proof of a portrait Pablo had recently done of me. That morning Pablo had on the easel an unfinished painting, also a portrait of me, with a very rhythmic pattern, in which the proportion of the head was giving him a great deal of trouble. He had made it smaller, larger, moved it about, painted it out, but nothing satisfied him. If it was small he complained it was too close to the proportion of the hands. If it became larger it corresponded too closely to the proportion of the legs, he said. He had put it aside because he could see no solution. That morning he took the lithograph Mourlot had brought and pinned it, just as it was, onto the canvas, the top edge of the lithograph corresponding exactly to the top edge of the canvas. It was really an "impossible" thing to do because it threw the picture plane completely out of focus. Introducing an extraneous element into the composition in that way was like opening a window in the painting and letting in another structure from another plane. The painting was very colorful and the lithograph was black-and-white. It made, therefore, such a tremendous contrast in color as well as in form and plane, that it delighted him. He removed the lithograph and immediately painted in, in the spot where he had pinned it up, the same composition-a head of me-that was represented in the lithograph. He considered it such an exciting discovery that he made four or five other paintings embodying the same principle, but not based on any existing lithograph.

SOMETIMES PABLO WOULD BEGIN a canvas in the morning and in the evening he would say, "Oh, well, it's done, I suppose. What I had to say plastically is there, but it came almost too quickly. If I leave it like that, with only the appearance of having what I wanted to put into it, it doesn't satisfy me. But I'm interrupted continually every day and I'm hardly ever in a position to push my thought right up to its last implication. A painting has to be transformed slowly and sometimes I can't get to the point of adding that last weight of reflection that it needs. My thought moves rapidly and since my hand obeys so fast, in a day's work I can give myself the satisfaction of having said almost what I wanted to say before I was disturbed and had to abandon that thought. Then, being obliged to take up another thought the next day, I leave things as they are, as thoughts that came to me too quickly, which I left too quickly and which I really ought to go back to and do more work on. But I rarely get a chance to go back. Sometimes it might take me six months to work over that thought in order to reach its exact weight."

I asked him why he didn't shut out the world, and with it the interruptions. "But I can't," he said. "What I create in painting is what comes from my interior world. But at the same time I need the contacts and exchanges I have with others. If I tell Sabartés I'm not available, and people come and I know they're there and I don't let them in, then I'm tormented by the idea that maybe there's something I ought to know and don't and I can't concentrate on my work. Braque's a lucky devil. He's a solitary, meditative type who lives completely within himself. I need others, not simply because they bring me something but because I have this damnable curiosity that has to be satisfied by them.

"I paint the way some people write their autobiography. The paintings, finished or not, are the pages of my journal, and as such they are valid. The future will choose the pages it prefers. It's not up to me to make the choice. I have the impression that time is speeding on past me more and more rapidly. I'm like a river that rolls on, dragging with it the trees that grow too close to its banks or dead calves one might have thrown into it or any kind of microbes that develop in it. I carry all that along with me and go on. It's the movement of painting that inter-

ests me, the dramatic movement from one effort to the next, even if those efforts are perhaps not pushed to their ultimate end. In some of my paintings I can say with certainty that the effort has been brought to its full weight and its conclusion, because there I have been able to stop the flow of life around me. I have less and less time, and yet I have more and more to say, and what I have to say is, increasingly, something about what goes on in the movement of my thought. I've reached the moment, you see, when the movement of my thought interests me more than the thought itself."

I asked him if he wouldn't be better off to paint fewer pictures; in that way the insufficiency of time or thought wouldn't trouble him so. He shook his head. "One must be the painter, never the connoisseur of painting," he said. "The connoisseur gives only bad advice to the painter. For that reason I have given up trying to judge myself. Of course, when one paints, one must utilize, along with his own inspiration, all the conscious deductions one might make. But between using a conscious and relatively dialectical thought and having a rational thought. there's an enormous difference. It is because I am antirationalist that I have decided I have no reason to be the judge of my own work. I leave that to time and to the others. What is important for me now is to be, and to leave the trace of my footsteps, and let others judge if this or that step was in accord with or divergent from my general evolution. I sometimes feel it's a mistake on my part even to bend over and pick up a piece of paper on which I had done something that didn't please me completely and rework it somewhat, rather than to do a second drawing more in accord with my thought.

"There's also the question of fatalism. I have long since come to an agreement with destiny: that is, I have, myself, become destiny destiny in action. I'm in complete disagreement with Cézanne's idea about making over Poussin in accordance with nature. In order to work that way I'd have to choose in nature those branches of the tree that would fit into a painting in a way that Poussin might have conceived it. But I don't choose anything; I take what comes. My trees aren't made up of structures I have chosen but structures which the chance of my own dynamism imposes on me. Cézanne meant that in looking at nature, to receive the sensation of an object outside himself, he sought what corresponded to a certain aesthetic demand that pre-existed in him. When I make a tree, I don't choose the tree; I don't even look at one. The problem doesn't present itself on that basis for me. I have no preestablished aesthetic basis on which to make a choice. I have no predetermined tree, either. My tree is one that doesn't exist, and I use my own psycho-physiological dynamism in my movement toward its branches. It's not really an aesthetic attitude at all."

FEW WEEKS AFTER I went to live with Pablo, Dora Maar had an exhibition at Pierre Loeb's gallery. It was made up in part of the same kind of still life that she had shown a year earlier at Jeanne Bucher's. There were, also, a few views of Paris quays, done from the Pont-Neuf looking toward the Châtelet. In her handling of the Seine, there was a translucent quality that suggested great depth, a depth that wasn't there, but which she had achieved through the deftness of her touch. Both her conception and her technique were interesting and whatever influence of Picasso's work she still showed seemed to be fading away, perhaps as a result of her break with Picasso.

After that period, she began to have conversations about painting with Balthus. Once after Pablo had called on her and looked at the work she was doing, he told me he saw in it the results of those contacts with Balthus. That disturbed him.

"One can't work toward a tendency that lies ahead and then do an about-face toward something that is another world entirely," he said. "That kind of painting may not be outgrown for Balthus but it certainly is for someone who has been working against the tradition that Balthus is working. Balthus began with Courbet and never got very much beyond him. For Dora Maar it's an anachronism."

Pablo had said that we were going to the Midi that summer. I assumed he meant the Côte d'Azur. But one day he came back to the atelier and said, "We're leaving on vacation and we're going first to Ménerbes, to Dora Maar's house." That seemed a strange thing to be doing. For me it couldn't be very pleasant and for her, I thought, extremely unpleasant. I told him so. He said, with that side of him that was both eminently practical and quite incredible, "But I'm the one who gave that house to Dora Maar. There's no reason why I shouldn't use it." I said I thought she would be very happy to let him take it—for himself —but perhaps not if I went with him. He said, "Of course she will. Besides I insisted on her lending us the house. And now that I have it,

I'm going to insist on your going there with me." That gave me a bit of a jolt, but I didn't react strongly at the moment. After all, I had left everything behind me to please him, so one more concession didn't seem important.

Ménerbes is in the Vaucluse, near Gordes, situated, like a fortified village, on high ground overlooking the farmland of the rich Cavaillon valley. The countryside is very pretty but the house was right in the village.

It was a large house, and since it was built on a sloping rock, on the street side it had four stories but in the rear, because of the pitch of the rock, there was only one. The fourth floor in front became the ground floor in the rear. The ground floor in front was a dark, highstudded hall, which served chiefly as a shower room, since it was the only floor that had running water. The next floor above had large rooms decorated in the Empire Style. The house had belonged to one of Napoleon's generals, who had settled there after Napoleon's final defeat.

Mornings we did little else but relax. At noon we went to a bistro in the heart of the village. Most of the customers were the stone-cutters who worked the quarries nearby. We heard lots of talk about scorpions. Almost every noon one of the laborers would tell about someone who had just been bitten by one that morning. The first time I heard that, I paid no attention, but after a few times more I must have begun to look worried, because Pablo tried to cheer me up by telling me that the year before Marie Cuttoli had been bitten by one. "As you see, she didn't die. Of course, she was pretty sick for a while," he said. Half the village was situated on the sunny side of a huge rock gable, facing south, but Dora Maar's house was on what the natives referred to as the "Cold Coast," facing north. Since the house was intended only for summer occupancy, that location had a certain advantage: it was never hot inside. The scorpions, I soon discovered, liked shade, too. First I noticed one or two in the garden; after that, a few more on the outside wall of the house. There was a monumental staircase inside and there, too, I ran across a number of scorpions no less monumental. After that I found one in our bedroom. During the day all was well but as night fell, the scorpions came out in droves. So we had to turn everything inside out and look very carefully before dressing.

From the house we could see the village of Gordes, situated on the hill facing us across the valley. Every evening we heard the sound of bugles being played in all the little farms that dotted the valley, as discordant a chorus as anyone could wish for. The sunsets are magnifi-

cent in that part of the country and I found it a little disconcerting to be enjoying one, and all the peace and calm that went with it, and then suddenly have it shattered by bugle blasts from all over the valley. That went on every night from sundown until well after ten o'clock. Pablo, on the other hand, was thrilled. One of his chief delights, I had learned, was blowing the bugle. In the studio in the Rue des Grands-Augustins he kept an old French Army bugle, from which hung a red, white, and blue cord. He never let a day pass without picking it up and letting out a few good blasts, as loud as he dared. He was a little frustrated because in Paris there were laws governing noises like that, and during the Occupation, particularly, it would have gone hard with him if he had blown it too loud. But right after the Liberation, in the general excitement, he grew very courageous and worked up to the point of blowing as many as thirty notes a day. I think it was one of his greatest satisfactions. If ever there was a day when for one reason or another, he missed blowing his thirty notes, he was miserable. So for him, now in Ménerbes and temporarily deprived of his daily quota, it was balm in Gilead-at first. But as time went on, it only made him unhappy. He wanted his bugle and it was back in Paris.

On the Fourteenth of July, Bastille Day, we reaped the fruit of all those rehearsals: a torchlight tattoo with all the buglers of Ménerbes and the surrounding valley taking part; big burly specimens, high in color and in spirits, brandishing their torches and blowing with all their might at their horns, each one more off-key than the next. It lasted nearly three hours. I couldn't drag Pablo away. I never saw him more excited than he was as he watched those rugged blacksmith types, most of them stripped to the waist, blowing his beloved bugle and waving their torches. This was real he-man's country and the women were practically excluded. That meant-and this must be unique for a Bastille Day-there was no dancing. That was made to order for Pablo. Not only did he hate dancing, but he considered it the most shameful of all possible pastimes. For a man as uninhibited as he was, he had a curious puritanical streak in him when it came to dancing. To sleep with a woman, any woman, any number of women, was perfectly all right. But to dance with one was the last word in decadence. Obviously, in Ménerbes nobody was decadent and so nobody danced. They only indulged in purely masculine entertainment: making all the noise it was humanly possible to make.

The next morning, still excited by the spectacle, Pablo painted a large gouache showing the men parading in the night with a red, white, and blue flag, brandishing their torches and their bugles.

Every night we took a walk around the village. On one of our first walks after dark we ran into something Pablo found fascinating and which held his interest as long as we stayed in Ménerbes. There were many large owls in that region and as soon as it grew dark they would come out in search of unwary rabbits to carry off in their claws. Since most of the local people were well aware of this, they kept their rabbits safely shut up at night. But there were always a number of emaciated cats at large. If you said anything about their leanness to any of the natives they would tell you the cats got that way because they ate only grasshoppers and lizards, and the lizards, being still alive after the cats swallowed them, moved around so much inside that it made the cats grow thin. But the fact was, nobody fed them. So the cats went prowling at night in search of lizards and the owls prowled to pick off the cats.

After dinner at the *Café de l'Union* we would walk to the other café, where the men went to drink. After sitting there for a while over our coffee, we had a half-mile walk to get home. And on that road, almost invariably, we would see two or three fights between owls and cats. The stars were very bright and the air clear, so although the night was dark there was almost a transparency to the darkness. Then, too, every fifty yards or so there was a street lamp. Suddenly one of the owls would swoop out of the dark. The tops of his wings were a grayish beige but his front was golden white and he would make for a cat skulking along the roadside ahead of us. Sometimes he would manage to pick the cat up in his claws and carry it off to eat somewhere else. But if the cat was a big one, the battle would last a fairly long time. Pablo would stand there, fascinated, as long as the fight lasted. He made at least five or six drawings of those fights.

Not far from Ménerbes was another rocky promontory we could reach by a foot path. There was no village; just a few cabins where shepherds sometimes stayed in the summertime. That was the only time I ever saw Pablo interested in nature. The fact that he was sure of meeting no one made him feel free to explore. One day, returning from one of those walks, he picked up a piece of the rib of a cow, about four inches long and worn smooth by exposure to the weather. He held it up to me. "That's Adam's rib," he said. "I'm going to draw an Eve on there for you." He incised it with his small pocket-knife and when he had finished, Eve had a mythological appearance, with two small horns. She was seated like a sphinx and had the same kind of cloven hooves for feet that he often made in that kind of drawing.

Meanwhile, the scorpions kept coming closer. One evening as

I leaned back against the wall, Pablo called out, "Look behind you." I turned and saw three of them scuttling around my head. "That's the kind of crown I like to see on you. They're my sign of the zodiac," he said.

The idea of staying any longer in Ménerbes became each day more unpleasant. I was hoping something would give Pablo the desire to leave without my having to demand it because then he would have been able to triumph over me by saying, "Ah, you're sensitive to the categories of pleasure and pain," and so there was a kind of philosophical competition between us and I had no alternative but to try to be the perfect stoic. I kept up my courage for nearly three weeks. By then it began to look as if Pablo intended to spend the whole summer there, and I started to have serious second thoughts about the wisdom of having come to Ménerbes in the first place; in fact, I wasn't at all certain that I wanted to go through with my new mode of life anywhere. And not just because of the scorpions. There was another element in the situation that I found far more disturbing than that.

When Pablo broke with Dora Maar, I assumed there were no other real entanglements in his life. I knew, of course, that he had been married to a Russian ballet dancer, Olga Khoklova and had a son by her, a boy about my own age named Paul, whom everyone called Paulo. But Pablo and Olga had been separated since 1935. I had met her once, briefly, when I was walking with Pablo on the Left Bank and she had seemed quite detached from him, emotionally. I knew also that he had had a mistress named Marie-Thérèse Walter, and had a daughter, Maya, by her. I knew that Pablo went to see her and their daughter occasionally but I had no reason to look beyond that fact. However, as soon as I moved into the Rue des Grands-Augustins, I noticed that every Thursday and Sunday Pablo dropped out of sight for the day. After a few weeks I began to sense there was a pattern to his disappearances. When I asked him, he explained that he had always been in the habit of spending those days with Maya and her mother, since those were the two days Maya was out of school. Almost as soon as we got to Ménerbes Pablo began receiving daily letters from Marie-Thérèse, which he made it a point to read to me every morning in detail and with comments-invariably highly approving ones. She always wrote in the most affectionate vein, and addressed him with great tenderness. She gave him an account of each day, right down to its most personal detail, and there was much discussion of finances. There was always news of Maya, their daughter, and sometimes snapshots of them both.

Pablo would read me some of the more ardent passages, sigh with satisfaction, and say, "Somehow I don't see you writing me a letter like that." I told him I didn't, either.

"It's because you don't love me enough," he said. "That woman *really* loves me." I told him we all had different ways of feeling and of expressing our feelings.

"You're too immature to understand things like that," he told me loftily. "You're not a fully developed woman, you know. You're just a girl." He read me another passage to show me just how much of a woman Marie-Thérèse was. Very nice, I said, and bit my lips to prevent myself from showing my anger.

By the time I began living with Pablo in the atelier of the Rue des Grands-Augustins, I had come to consider that place hallowed ground. Everything had seemed right and natural as long as we were there. Our relationship was reduced to its simplest form, and the framework in which it existed was impressive enough to favor its evolution. But to be abruptly transferred to what was essentially a hostile environment, both physically and psychologically, was too much. Between Dora's house and Marie-Thérèse's letters, I felt very uncomfortable. I decided to get down off that hill and follow the road to the sea. Casting about for a goal to set my sights on, I remembered that a friend of mine, a painter, had written to me from Tunisia saying that I could have a job there as a drawing teacher any time I wanted it.

One day when Pablo had gone out for a drive, I decided I couldn't go on living with him in such circumstances any longer. I had no money but I walked out to the main road leading south to hitchhike to Marseilles. There I had friends from whom I could borrow money to go to North Africa. There was very little traffic along the road that day and I hadn't been there long before Marcel and Pablo drove up. The car stopped beside me and Pablo got out, breathing fire. He asked me what I was doing there. I told him.

"You must be out of your mind," he said. "Why do you want to leave me?" I told him I didn't feel at ease in that house. Beyond that, I said, I could see already that life with him would never be a natural, spontaneous relationship: it was far too complex.

"What are you looking for?" he asked me, planted squarely in front of me, his hands on his hips. Marcel peered over his shoulder, making no attempt to disguise his interest in all this. I told Pablo I didn't want to be there any more. I said I had gone through the very painful process of breaking all the bonds that had bound me to another

PART III

way of life and I didn't like feeling even more strait-jacketed in my new one. I said it was difficult enough to adapt myself to a completely new environment without being tied to a rigidly inflexible way of life that was shaped and bounded by his past.

Pablo looked incredulous. "After what you've given up in order to come live with me, don't tell me you're going to throw everything over just for that! If you finally came, after all your doubts and hesitations, I suppose it was because you decided you loved me. It ought to have been clear to you long before now that I love you, too. We may have a few difficulties in making the adjustment, but now that we've come together it's up to us to build something together. Let's not toss away our chance so lightly."

This was such an unexpected reversal of the way Pablo had been talking ever since we reached Ménerbes that I must have begun to look less sure of myself. Pablo grabbed me by the arm and pushed me into the car. Marcel started the motor and turned back toward Ménerbes. With one hand Pablo kept tight hold on my right arm. With his other arm around my shoulders he drew me close to him. After a moment he turned toward me, relaxed his grip, and kissed me. He didn't speak right away, but when he began he spoke more softly.

"You mustn't listen to your head for things like that," he said. "You'll talk yourself out of the deepest things in life. What you need is a child. That will bring you back to nature and put you in tune with the rest of the world."

I told him nothing was more simple than to have a child at my age; it was only a matter of choice. But I didn't feel that having one would add anything that was especially relevant to the experience I was right now coming to grips with. Children were useful in a negative rather than a positive sense. I said, in that when one becomes mature and there are none, the lack makes itself felt, because by that time one must get out of oneself, and being occupied with the problems of others helps to ease one's own anguish. But children, I told him, were only one solution among several. After all, there were other forms of creation. The fact that I had undertaken to become a painter and, on top of that, to live with him and help bear the burden of his solitude showed that I was trying to make something creative out of my life, and to get out of myself. Each one of those steps had forced itself on me, and I felt I had no choice: but the idea of having a child was something that up to now had never crossed my mind, and it seemed to me entirely irrelevant. It was just as though he had told me that I ought to

learn how to sole shoes. I would have said yes, I was sure it was a very practical thing to know but not at all urgent just at the moment. And that was the way I felt about having a child, I tried to explain.

Pablo sighed. "Words, words, words," he said. "You are developed only on the intellectual level. Everywhere else you're retarded. You won't know what it means to be a woman until you have a child."

I didn't feel altogether sanguine about that, considering the effects to date of my radical attempts to stand on my own feet like a grown woman, and I told him so. He brushed me aside. "I've seen it work before and I assure you that you'll be completely transformed. Please don't deny it until you've at least tried."

I couldn't feel, all at once, the same kind of buoyant enthusiasm that Pablo was displaying but before he dropped the subject, I had decided to take his advice, and to stop listening to my head. Since Pablo, I was convinced, had been talking with his heart, I could at least listen with mine. I put Marie-Thérèse and all the other negative elements out of my mind and I took the rest of Pablo's advice: I tried.

Escape from Ménerbes came sooner that I had expected. Marie Cuttoli asked us to come down to her place and stay for a few days. Pablo didn't say no, so I said we'd go for three days and then come back, but my mind was made up not to come back, ever. We left for Cap d'Antibes, and stayed three or four days with the Cuttolis. While we were there we went over to visit Monsieur Fort at his little house in Golfe-Juan. I told Pablo I liked the sea much better than the country and I wanted to do some swimming. Presented in that fashion the idea was acceptable, so Pablo rented the two upper floors of Monsieur Fort's house and sent Marcel back to fetch the things we had left at Dora Maar's. In a few weeks I knew I was pregnant.

Nowadays at Golfe-Juan there are private beaches, parasols by the score, and tourists by the thousands, including parts of the United States Sixth Fleet, but in August 1946 it was almost deserted, and when Pablo and I left Monsieur Fort's villa *Pour Toi* mornings and walked across the street for a swim, we were nearly always alone. Since Monsieur Fort's house was small and we had only the

124

upper two floors, which were very cramped, there was little room to work in. Pablo was beginning to be restless without a place to paint. He was enough of a Mediterranean, though, to enjoy lying on the beach and doing nothing all morning, and that was the position we were in one day when the sculptor and photographer Sima came along to tell us about a place where he thought Pablo might like to work. It was the Château Grimaldi, up on the ramparts overlooking the harbor at Antibes. It had been a museum of sorts, called the Musée d'Antibes, since 1928. The curator, Monsieur Dor de la Souchère. a teacher of Latin and Greek at the Lycée Carnot in Cannes, had not been able to fill the museum adequately; it had very few art objects and a minuscule budget. At the moment its chief asset was a collection of documents relating to Napoleon, kept there, perhaps, because Napoleon had landed at Golfe-Juan when he returned from Elba. That was about all there was to the museum except for some large, high, empty rooms on the second floor not being used for anything. Sima said.

Pablo perked up. "All right," he said. "If you want to bring the curator here to see me one morning and he really wants me to work there, I'd be delighted, because I don't have any room where I am now." After Sima had left, Pablo began to dance up and down for joy.

"I almost bought that place about twenty years ago," he told me. "It belonged to the Army and had been lying empty for a long time. The Army offered to sell it for eighty thousand francs. I was on the point of buying it when the town of Antibes got interested. The Army preferred to sell it to the town rather than to a private buyer since it was part of the national patrimony."

Very soon after Sima's visit, Monsieur Jules-César Romuald Dor de la Souchère came to the beach one morning and said he would be very happy to have Pablo work at the Musée d'Antibes and would turn over to him one of the large rooms upstairs for his atelier. The next morning Pablo and I went to look at it. He decided it would work out fine for him and said, "While I'm here I'm not just going to paint some pictures. I'm going to decorate your museum for you." Dor de la Souchère was thrilled.

After we had walked around the museum that day, we came to the little church next to it, on a lower level. Pablo started to steer me toward it. I asked him why he wanted to take me there. "You'll see," he said. He guided me around the interior and when he got to the back, near the holy-water stoup, he pulled me into a dark corner and said,

"You're going to swear here that you'll love me forever." I was a little surprised. "I can swear that anywhere, if I want to commit myself to that extent," I said. "But why here?"

"I think it's better done here than just anywhere," Pablo answered.

"Here or somewhere else, it's all the same," I said.

"No, no," Pablo said. "Well, yes, of course, it is all the same, but it's one of those things. You never know. There may be something to all that stuff about churches. It might make the whole thing a little surer. Who knows? I don't think we should throw away the chance. It might help." So I swore and he swore and he seemed satisfied.

Pablo had to order some of his painting equipment from Paris, because things like that were in very short supply at the moment. Meanwhile he went down to the harbor with Sima and laid in a supply of boat paint because, he said, that would stand up better in the environment in which it was going to live. Since boat paint is generally applied to wood, he decided he should paint on plywood. Then he ordered some large panels in fibrocement, saying that the boat paint would go well on that too. He bought some house-painter's brushes and started in to work the following day, when the things were delivered to the museum. He stayed there, working, during September and October and did almost all the paintings that are there now: all the fibrocement and plywood panels except the one called Ulysses and the Sirens, which was done a year later. The series of drawings surrounding the painting that is called La Joie de Vivre was not done at the museum but a month earlier at Monsieur Fort's. The pottery was done later and the tapestries and the lithographs were given by Madame Cuttoli.

Near the restaurant *Chez Marcel*, in Golfe-Juan, where we ate nearly every day, was a tiny café that specialized in local seafood. There was a stand outside displaying the different varieties to tempt people into buying, but it was October and almost everyone had left. The only person who was tempted by the display was the woman who ran the place. She was so wide and her café so narrow there was hardly room enough inside for her, so she stood outside trying to drum up trade. Since there was almost no one to buy from her, she kept dipping into the stock all day long. She was not quite five feet, a very sturdy little body as broad as she was tall, about forty-five or fifty years old with one of the coarsest faces imaginable, framed by a mass of corkscrew curls dyed mahogany and ending in a funny little pug nose that stuck out from under the visor of an outsize man's cap. Often as we were having our lunch, we saw her walking back and forth with a basket of sea urchins in front of her and a sharp, pointed knife, looking for a stray customer. Since almost no one ever showed up to lighten her load, from time to time she would dip into the basket, open up one of the sea urchins and suck in the contents so greedily that we would watch her, fascinated by the contrast between her soft, round, red face and the spiny, green-violet sea urchins she kept bringing up to it. Four of the paintings in the Musée d'Antibes were built around the figure of this woman and the sailors that hung around the harbor. There is a portrait of the woman herself, one of a sailor eating sea urchins and two other portraits of sailors, one dozing and the other yawning.

The Woman Eating Sea Urchins was begun one afternoon in a realistic manner. Everything about the portrait was a recognizable representation of the woman as we knew her: pug nose, corkscrew curls, man's cap, and the dirty apron in which she enveloped herself. Then, when it was finished, each day Pablo eliminated a few more naturalistic details until there remained only a very simplified form, almost vertical, with just the plate of sea urchins in the middle to remind one of what she looked like.

In the painting of the pale sailor eating sea urchins, since the sailor's eyes are lowered, there is only an indication of the lower eyelid and the shape of the eyeball covered by the upper lid. I noticed about three years ago when I visited the museum that someone had taken a blue crayon and drawn in the iris of the eyes in a particularly unpleasant shade of sky-blue. No one else appears to have noticed the addition. At least nothing had been done about it when I looked in on it again recently.

I noticed other changes, too, on my recent visit. In Ulysses and the Sirens, the blues had darkened and other surface painting had faded. The underpainting stood out more noticeably, perhaps because of the humidity. Some of the heads, which had been painted in bister, had paled down and the brown in the lower part of the painting was stronger and less grayish than it had been originally. The fauns in one of the small rooms, which had at first been very shiny, had dulled down and their blues and greens were paler. Pablo had done a portrait of Sabartés as a faun, painted on paper. The paper had yellowed and become foxed, I noticed, and the colors had grown flatter and more pale.

One day in 1948, Matisse came over with his secretary, Lydia, to look at the museum. He was particularly puzzled by the long plywood panel of the *Reclining Woman*. "I understand the way you've done the

head," Matisse said, "but not what you've done with her bottom. The two parts of it turn in a strange way. They don't follow the other planes of the body." It seemed to bother him. He took out a notebook and made a sketch of the painting to take home with him for further study and then sketched nine or ten others in a quick, approximate manner.

PABLO HAD ALWAYS LIKED to surround himself with writers and poets, beginning with the days of Guillaume Apollinaire and Max Jacob. That is one reason, I think, why he was always able to talk very articulately about his painting. At each period the poets created around him the language of painting. Afterwards Pablo, who—for things like that—was an extremely adaptable, supple person, always talked very perceptively about *his* painting because of his intimacy with those who had been able to discover the right words.

Pablo's most intimate friend among the poets of our time was Paul Eluard. I had met Eluard once or twice, but the first time I had a chance to see him at close range over an extended period was the week in 1946, at the time of the Cannes Film Festival, when he and his wife, Nusch, came to Golfe-Juan to see us and to watch the work-in-progress at the Musée d'Antibes. There was a complex kind of relationship between Paul and Pablo, because Nusch had been for some time one of Pablo's favorite models. Beginning in the mid-1930s he had done many drawings and portraits of her. In some of his paintings she was deformed in the manner of the portraits of Dora Maar. In others she was very close in spirit to the Blue Period. And Nusch was, essentially, a personage of the Blue Period. She was German and she and her father were wandering acrobats. Paul had met her one day as he was out walking with the poet René Char. He was captivated by the sight of this fragile seventeenyear-old girl going through her circus contortions right on the sidewalk. He fell in love with her and they were married very soon. There was a nostalgic element in that encounter that had touched Pablo, too, and recalled his Saltimbanques period of the early 1900s. That sort of evocation combined with her physical frailness made Nusch a very sensitive, poetic figure.

Paul and Pablo were at opposite poles in their personalities:

Pablo basically aggressive and changeable, and Paul a very harmonious being. I could see from the start that Paul was the kind of person who, without demanding anything of anyone, obtained the best from everyone. He brought into any group he frequented a kind of over-all harmony, not so much by what he said as by his simple presence. When Paul and Nusch left for Paris after the festival, we never saw Nusch again. Paul went to Switzerland and while he was there, Nusch died suddenly one night. Paul was shattered by her death. The poems he wrote about her later, under another name, are among the most moving in all modern French literature.

The following winter we saw Paul often. He lived meagerly from his poetry, but he was such a fine bibliophile that by buying and selling certain types of books that he knew so well he was able to fill in the gaps. But he always lived on a very modest scale. From time to time Pablo would give him a drawing or a painting or decorate his copy of an illustrated book so that when times were too difficult, Paul could sell something and resolve the crisis.

Paul and Nusch had "discovered" Mougins in the thirties and induced Pablo, he told me, to spend a part of his vacation there in 1936, 1937 and 1938. From that period date Pablo's studies of Nusch. Pablo had had a vague affair with Nusch at that period, he told me, and Paul he was certain—had turned a blind eye to it: the ultimate test of friendship.

"But it was a gesture of friendship on my part, too," Pablo said. "I only did it to make him happy. I didn't want him to think I didn't like his wife." Pablo had tender memories, too, of a girl named Rosemarie, who, he said, had a "magnificent" bosom and used to drive them all to the beach, bare from the waist up. Dora Maar was there, too. It was their first summer together.

A NOTHER POET who had been a good friend of Pablo's, André Breton, had spent the Occupation years in America and arrived back in France in June 1946, very shortly after I went to live with Pablo. We had heard that he was back in Paris but he didn't come to see Pablo. One morning in August, as we were leaning over the balcony of the Villa

Pour Toi in Golfe-Juan, Pablo pointed down toward *Chez Marcel* and said, "Look, there's André Breton." We went right downstairs since Pablo assumed that Breton was probably trying to find out where we lived. When Breton saw us approaching, he turned aside and it was obvious that he wasn't sure whether he wanted to see Pablo or not. Our going out to meet him apparently had jarred somewhat the timing and presentation he had been planning to give to their first postwar meeting.

Pablo stretched out his hand in a spontaneous, friendly way, since he had been Breton's friend almost as much as Eluard's. Breton hesitated, then said, "I don't know whether I'm going to shake hands with you or not."

"Why not?" Pablo asked him. Breton, with his characteristic dogmatic manner, said, "Because I'm not at all in agreement with your politics since the Occupation. I don't approve of your joining the Communist Party nor with the stand you have taken concerning the purges of intellectuals after the Liberation."

Pablo said, "You didn't choose to stay on in France with us during the Occupation. And you haven't lived through the events we lived through here. My stand is based on those experiences. I don't criticize your position since your understanding of those events was acquired at a different angle from mine. My friendship for you is unchanged. Your friendship for me, I think, should remain on the same basis. After all, friendship should be above any differences in our ways of understanding historical reality," and he put out his hand again.

Breton apparently couldn't see his way clear to retracting what he had just said. "No," he said, "there are principles that have no room for compromise. I stand on mine and I don't imagine you plan to change yours, either."

"No, I don't," Pablo said. "If I hold those opinions, it is because my experience has brought me to them. I can't very well change that. But I'm not asking you to change yours, either. And I don't see why we can't shake hands and remain friends."

Breton shook his head. "As long as you defend those opinions, I won't shake your hand," he said.

"That's too bad," Pablo said, "because I place friendship above any differences of political opinion. In Spain during the 1930s, there was quite a group of us that used to meet in the same café even though we held diametrically opposed political views. Sometimes we had very stormy discussions and we knew that on the day war broke out we would find ourselves in different camps, but no one saw any reason to stop being friends just because of that. All the more reason, if we don't think alike, for keeping the discussion open."

Breton shook his head again. "It's too bad you ever allowed yourself to be drawn into that political alliance by Eluard."

"I'm an adult," Pablo said. "I'm afraid those are my own opinions, not Eluard's."

"Well, then," Breton said, "I'm afraid you've lost a friend, because I'll never see you again."

ONE OF PABLO'S OLDEST FRIENDS was the painter Georges Braque. A few weeks after I went to live with Pablo, he had decided it would be pleasant for me to meet Braque and see his atelier. Also, he had let me understand that he wanted to see Braque's reaction to me. When we arrived one morning at Braque's house in the Rue du Douanier, across from the Parc Montsouris, Braque was very courteous. He showed us the paintings he had been doing recently, and after a brief visit we left. When we got outside I could see that Pablo was upset.

"Now you see the difference between Braque and Matisse," he said. "When we went to call on Matisse he was very warm-hearted and kind and called you Françoise right from the start. He even wanted to paint your portrait. I introduced you to Braque in such a way as to make him understand you weren't somebody I just happened to bring by chance, but he called you *Mademoiselle* all along. I don't know whether that was directed against you or against me but he acted as though he didn't get the point at all." Pablo began to sulk, then burst out with, "Besides, he didn't even invite us to stay for lunch."

At that period Pablo and Braque exchanged pictures from time to time. One of the fruits of those exchanges was a still life of Braque's, with a teapot, lemons, and apples, a handsome wide picture that Pablo was very fond of and used to keep prominently displayed in the atelier among the canvases of Matisse and others whose work he particularly liked. I noticed that the day we returned from our first visit to Braque, the still life disappeared.

The relationship between Pablo and Braque had been exceed-

ingly intimate when they were young painters. The fact that their intimacy was no longer as close troubled Pablo from time to time. He felt that this situation was partly attributable to Braque's reserve but not wholly. He would try to rationalize it, get nowhere, and often wind up with the announcement, "I don't like my old friends." Once when I pressed him for an explanation he told me, "All they do is reproach you for things they don't approve of. They have no indulgence." He didn't make it any clearer than that, but it was evident that for Pablo friendship had no value unless it was being actively demonstrated.

Soon after that first visit we left for Ménerbes and the Midi but when we got back to Paris late in the fall, Pablo suddenly thought one day of that meeting with Braque.

"I'm going to give Braque one more chance," he said. "I'm going to take you back there and we're going to arrive a little before noon. If this time he doesn't invite us to stay for lunch I'll understand that he doesn't like me any more and I'll have nothing further to do with him."

So one morning that fall, just before noon, we went to Braque's house-without any advance warning, of course. One of Braque's nephews was there, a tall man of about forty who was even more reserved than Braque. The house was filled with the aromatic bouquet of roasting lamb. I could see Pablo mentally adding up the presence of the nephew plus the very appetizing kitchen odors plus his lifelong friendship with Braque to get the desired result: an invitation to lunch. But if Pablo knew his Braque by heart, Braque knew his Picasso just as well. And I am sure-since I came to know Braque much better after thatthat for Braque, Pablo's black plot was sewn with white thread. Had he made the gesture and invited us for lunch, he could well imagine Pablo having a good laugh about it later, telling everyone, "Oh, you know Braque has no mind of his own. I get there at noon, he knows I want lunch so he sits me down and serves me. I push him around and he only smiles." The only course open to a man like Braque, who had a mind of his own, was to demonstrate the fact. Especially inasmuch as Pablo was very fond of saying, when Braque's name came up, "Oh, Braque is only Madame Picasso." Somewhere along the line someone must have reported that mot of Pablo's to Braque.

We went up to the atelier, and Mariette, Braque's secretary, pulled out his latest things and showed them to us. There were some large sunflowers, beach scenes at Varengeville, wheatfields, and one canvas that showed a bench with just a spot of sun over it. In all these paintings, form seemed to count a good deal less for Braque than it had in his earlier work and it was clear that his main interest now was in the study of the effects of light. There was no deformation or transposition of form; the essential feeling was of a desire to find an atmosphere that could express his thought. The paintings were very handsome.

"Well," Pablo said, "I see you're returning to French painting. But you know, I never would have thought you would turn out to be the Vuillard of Cubism." Braque looked as though he thought Pablo might have been more flattering but he continued to show us his work goodnaturedly.

Near one o'clock, Pablo started to sniff very loud and said, "Oh, that smells good, that roast lamb."

Braque paid no attention. "I'd like to show you my sculpture, too," he said.

"Please do," Pablo said. "Françoise will enjoy that." Braque showed us some bas-reliefs he had done of horses' heads, one of them very large, and some small reliefs of a woman driving a chariot. I found them all very interesting, but finally we came to the end of the sculpture.

"That lamb smells to me as though it were done," Pablo said. "Overdone, in fact."

Braque said, "I think Françoise might like to see my new lithographs." He began to show me his lithographs and a number of drawings. From time to time, Marcelle, Braque's wife, came into the atelier, smiled, then went downstairs again without having said a word. After her third trip, Pablo said, "You know, you've never shown your paintings of the Fauve period to Françoise." The Fauve paintings, as he knew, were hung in the dining room. We went downstairs, first into the large room before the dining room. We went downstairs, first into the large room before the dining room. The table was laid for three: Braque, Madame Braque, and Braque's nephew, obviously. I began to admire Braque's Fauve paintings.

"That lamb smells burnt to me now," Pablo said. "It's a shame." Braque said nothing. I continued to admire the Fauve paintings, but there were only six of them and that couldn't go on forever, so at the end of a half hour Pablo said, "There's one of your recent paintings up in the atelier that I didn't really get a good look at. I'd like to go upstairs and see it again." At this point Braque's nephew said good-bye. He had to get back to work. We went upstairs and spent the next hour reviewing the new paintings we had already seen. Pablo discovered one we

hadn't seen and Braque brought out several others he hadn't shown us earlier. Finally we left. It was 4:30. Pablo was bristling. But after he cooled off, it became very clear that Braque had risen considerably in his esteem. And it was only a day or two later that I noticed that the Braque still life with teapot, lemons, and apples had mysteriously reappeared and was once more in its usual place in Pablo's atelier. I was amazed at the number of times, from then on, that I heard Pablo say, "You know, I like Braque."

It would be a mistake to think that Braque was insensitive to the nuances of this situation. He realized how important it was, in all one's relations with Pablo, to be constantly on guard, because life for Pablo was always a game one played with no holds barred. When I first saw them together I realized that Braque was very fond of Pablo but that he didn't trust him, knowing that Pablo was capable of any ruse or wile in order to come out on top. His lowest tricks were reserved for those he liked best, and he never passed up an opportunity to play one if you gave him the chance. And if you did give him the chance, he had no respect for you. And so I learned very early that no matter how fond you might be of Pablo, the only way to keep his respect was to be prepared for the worst and take action before he did.

Braque had a great deal of affection for Pablo and he wanted Pablo to think well of him, at least; therefore, he felt obliged to be rather austere in all his dealings with him, knowing that if he dropped his guard even for a moment. Pablo would take full advantage of it in some way that would make Braque feel or look ridiculous, and then crow about it to all their mutual friends. At first I thought Braque acted like that because it was his nature: stiff, aloof, unbending. As time went on, I was able to see that he was especially that way when he was with Pablo, less so when Pablo was not around. And finally, when I came to know him better and saw him alone or with his wife, I realized he was not at all on guard when he felt he had no reason to be, and that he often talked a great deal. But when Pablo was around, Braque would say next to nothing. Later Pablo would say to me, "You see he never says a word. He's probably afraid I'll pick up one of his lines and try to pass it off as my own. Actually, it's more likely to be the other way around. He picks up my pearls and tries to peddle them as his."

After he had put Pablo in his place the day of the roast lamb, Braque seemed a lot freer. Several times while we were in the Midi, he came to St.-Paul-de-Vence and wasn't at all backward about coming to call on us first, even though he doubtless knew that the result would be —as indeed it was—that Pablo would strut around afterward saying, "You see, Braque came to me first; he realizes I'm more important than he is." And yet, if Braque hadn't come to us, Pablo would have fussed about it for days, saying that Braque needn't think that by staying away he would induce Pablo to make the first call.

That intense spirit of competition did not come out in the presence of Matisse, who was twelve years older than Pablo. Pablo did not, oddly enough, consider him a painter of his generation, and therefore a direct rival. But with Braque, it was always like two brothers, within a year of each other's age and with the same background, each striving to demonstrate his independence and autonomy and—in Pablo's case, at least—superiority. The rivalry was all the stronger because underneath it they were linked by a real bond of affection and their consciousness of having worked almost as one during the Cubist period before going their separate ways.

That sense of rivalry came out in other ways, too. Naturally, Braque and Pablo had many friends in common. They were both very fond of the poet Pierre Reverdy, for example, and Reverdy used to see them both. But if he had ever said to Pablo, "I'll have to leave now because I have a date with Braque," even though that was often the case, he would have made Pablo very unhappy. If Pablo arrived at Braque's house and found Reverdy there, trouble was brewing. After we got home, he would storm, "Reverdy doesn't give a damn about me any more. He prefers Braque." That made things very difficult for Reverdy.

Toward the end of his life Reverdy published *Le Chant des Morts*, which Pablo illustrated, and another book, illustrated by Braque. When the Reverdy-Braque book came out, there was a lot of sulking in Pablo's tent. Pablo went to incredible lengths, whenever Reverdy came to Paris, to find out, after he had left, whether he had spent more time at Braque's house than at his. If it turned out he had, Pablo would tell everybody, "I don't like Reverdy any more. Besides, he's Braque's best friend, so he's no friend of mine."

Braque never called on Pablo in Paris and he didn't like to have Pablo call on him without warning. If Pablo phoned in advance to say he was coming, then Braque would see to it that none of Pablo's friends were there when he arrived. One day we went to Braque's without having phoned first and found Zervos, René Char, and the Catalan sculptor Fenosa, all looking very embarrassed. If, the day before, they had been at Pablo's, Pablo wouldn't have taken it so badly, but it had been at least

two weeks, if not a month, since any of them had called at the Rue des Grands-Augustins. When we got outside, Pablo said, "You see how it is, don't you? I drop in, just by chance, to see Braque, and what do I find? My best friends. It's obvious they spend their life there. But they never come to see me." The next day he was telling everyone who came to see him, "You know, Braque is really a bastard. He finds ways of getting all my friends away from me. I don't know what he does for them, but he must do something-something I can't do. The result is, I don't have any friends any more. The only people who come to see me are a bunch of imbeciles who want something from me. Oh, well, that's life." Which wasn't very flattering to the caller to whom Pablo was unburdening himself. And if Zervos came to call the next day, Pablo would have Sabartés tell him he was out, and would repeat the process the next two or three times Zervos called. Pablo even went so far as to send spies to call on Braque periodically and report back to him who was there. And when the reports included repeatedly the names of people like Zervos, Reverdy, or René Char, he would go into a rage that would last for a whole day. I used to try to calm him down by saying that he chased people away and did his best to discourage visitors, so he had no right to complain if he was alone and only those who had something definite to ask him for dared brave his wrath by coming.

"If they really loved me," he said, "they'd come anyway, even if they had to wait at the door for three days until I felt like letting them in."

PABLO LOVED TO SURROUND HIMSELF with birds and animals. In general they were exempt from the suspicion with which he regarded his other friends. While Pablo was still working at the Musée d'Antibes, Sima had come to us one day with a little owl he had found in a corner of the museum. One of his claws had been injured. We bandaged it and gradually it healed. We bought a cage for him and when we returned to Paris we brought him back with us and put him in the kitchen with the canaries, the pigeons, and the turtledoves. We were very nice to him but he only glared at us. Any time we went into the kitchen, the canaries

chirped, the pigeons cooed and the turtledoves laughed but the owl remained stolidly silent or, at best, snorted. He smelled awful and ate nothing but mice. Since Pablo's atelier was overrun with them, I set several traps. Whenever I caught one, I brought it to the owl. As long as I was in the kitchen he ignored the mouse and me. He saw perfectly well in the daytime, of course, in spite of the popular legend about owls, but he apparently preferred to remain aloof. As soon as I left the kitchen, even if only for a minute, the mouse disappeared. The only trace would be a little ball of hair which the owl would regurgitate hours later.

Every time the owl snorted at Pablo he would shout, "Cochon, Merde," and a few other obscenities, just to show the owl that he was even worse mannered than he was. He used to stick his fingers between the bars of the cage and the owl would bite him, but Pablo's fingers, though small, were tough and the owl didn't hurt him. Finally the owl would let him scratch his head and gradually he came to perch on his finger instead of biting it, but even so, he still looked very unhappy. Pablo did a number of drawings and paintings of him and several lithographs as well.

The pigeons cooed but the two turtledoves really laughed. They were small and grayish-pink with a darker ruff around the neck. Every time we went into the kitchen to eat and Pablo launched into one of his characteristic long semiphilosophical monologues, the turtledoves would be all attention. Just at the moment he made his point, they would start to laugh.

"These are really birds for a philosopher," Pablo said. "All human utterance has its stupid side. Fortunately I have the turtledoves to make fun of me. Each time I think I'm saying something particularly intelligent, they remind me of the vanity of it all."

The two turtledoves were in the same cage and they often went through what seemed to be the act of mating but there was never any egg as a result. Finally Pablo decided there had been a mistake and they were both males.

"Everyone speaks so well of animals," he said. "Nature in its purest state, and all that. What nonsense! Just look at those turtledoves: as wholeheartedly pederast as any two bad boys."

He made two lithographs of them in action, one printed in purplish red, the other in yellow. Then he made a third by superimposing one lithograph on the other to give the effect of the shaking and fluttering they went through while they were, more or less, mating.

ONE MORNING THAT WINTER, when the sun was shining into the bedroom and making me feel as though it might be possible, after all, to hold on until spring in spite of the chill of Paris and the dampness of the studio and the uneasy moments of my pregnancy, Pablo said to me, "Now that you're part of my life, I want you to know all about it. You've already seen the Rue Ravignan and the *Bateau Lavoir*. I took you there first because that is the most poetic memory I have and you were already part of my poetry of the present. Now you're part of my reality so I want you to see the rest. Today I have an errand at the bank. We'll start there."

Pablo's bank was the main office of the B.N.C.I. on the Boulevard des Italiens and it was in their subterranean vaults that he kept many of his paintings. I found the place rather ugly from the outside, in a 1930-ish *Arts Décoratifs* style, massive and heavy. We went inside and took the elevator down into the depths. There were two circular levels, one below the other, arranged around an interior gallery so that the guards could survey easily up and down as they patrolled around a big hole like a snake pit in the center. I was pale that day and not feeling my best. I said it corresponded to my idea of what Sing Sing must look like.

"I guess you don't like it here," Pablo said. I told him I was allergic to banks.

"Fine," he said. "If you dislike that sort of thing, I'm going to have you handle my papers and money matters. People who don't like things like that generally do them very well. Since they're never sure of doing the job properly, they pay more attention to what they do." I protested but he remained firm and from the moment we went to live much of the time in the Midi a little later on, I replaced Sabartés in handling a good deal of the paperwork, much against my will.

That day, the guard looked us over when we came in and smiled broadly. "What's the joke?" Pablo asked him. The guard said, "You're lucky. Most of the customers I've seen here in my time come in year after year with the same woman, always looking a little older. Every time you come in, you have a different woman and each one is younger than the last."

Pablo's vaults were two good-sized rooms. He showed me first, in one of them, paintings by Renoir, the Douanier Rousseau, Cézanne,

138

Matisse, Miró, Derain and others. His own work was divided into two groups: in one room, everything up to about 1935, and in the other, the work of the past ten years. All his pictures were signed. I had noticed that he kept only unsigned canvases in the atelier. I asked him about that. "As long as a picture isn't signed," he said, "it's harder to dispose of if it's stolen. And there are other reasons, too. A signature is often an ugly blob that distracts from the composition once it's there. That's why I generally sign a picture only when it's sold. Some of these are paintings that I sold years ago and have bought back. The rest—well, as long as a painting hangs around the atelier unsigned, I feel I can always do something about it if I'm not completely satisfied. But when I've said everything I had to say in it and it's ready to start a life of its own, then I sign it and send it over here."

Several of the pictures he showed me that day had been painted either at Boisgeloup, an eighteenth-century château he had bought about fifteen years earlier when he was living with Olga, or in the Paris apartment they had occupied in the Rue La Boétie.

He had already told me the story of their difficult life together. He had married her in 1918, when she was a dancer with the *Ballets Russes* of Diaghilev. She wasn't one of the better dancers in the troupe, he said, but she was pretty and she had another asset that he had found very appealing: she came from a family that belonged to the lower echelons of Russian nobility. Diaghilev, Pablo said, had an original way of choosing his dancers: half of them had to be very good dancers; the other half, pretty girls of good social background. The first group drew people to the ballet because of their dancing. The others attracted people from their own social set or because of their looks.

The Ballets Russes had become a kind of diversion for Pablo during World War I, when many of his friends, such as Apollinaire and Braque, had been mobilized. While he was alone one day in his atelier, Jean Cocteau, dressed as Harlequin, had come to tell him he felt it was time Pablo came down out of his ivory tower and took Cubism out onto the street, or at least into the theater, by designing sets and costumes for a ballet. That was the basis for his collaboration in the ballet *Parade*. He went first to Rome, then to Madrid and Barcelona, and later on to London with the *Ballets*. He worked with Larionov and Gontcharova and with Bakst and Benois.

"Of course, what they did had nothing to do with what I was trying to work out," he told me, "but at that time I had had no experience of the theater. For example, there are some colors that look very

nice in a maquette but amount to nothing transferred to the stage. That was something that Bakst and Benois, on the other hand, had had a lot of experience with. So in that sense I learned much from them. They were good friends and gave me many pointers. They didn't influence my conceptions in any way but they gave practical advice when it came to translating those conceptions into working theater."

Pablo's association with Larionov and Gontcharova was much closer, since their aesthetic outlook was more closely related to his than was that of Bakst or Benois. Pablo struck up a friendship with Massine, the choreographer, and with Stravinsky, people he would not otherwise have had the occasion to know, probably. Until then his horizon had been limited to the other painters who were searching for new solutions, to the few collector-critics, like Gertrude Stein and Wilhelm Uhde, who were interested in such painters, and to a small circle of bohemian poets and writers like Apollinaire and Max Jacob. With Diaghilev he was introduced to another world. Even though basically he disliked that kind of social nonsense, it tempted him for a time and his marriage with Olga corresponded, in a sense, to that momentary temptation.

I could see from the way he spoke of their beginnings that Pablo had thought this well-born young woman would make a very effective partner in a social stratum a good deal higher than the one he had occupied until then. They were married in the usual civil ceremony at the *mairie*, and also, as a concession to Olga, at the Russian church in the Rue Daru, wearing crowns on their heads in the customary Orthodox ritual.

According to Pablo, Olga didn't have the sacred fire of her art. She knew nothing about painting or about much else for that matter, he told me. She married thinking she was going to lead a soft, pampered, upper-crust life. Pablo figured he would continue to lead the life of a *bohème*—on a loftier, grander scale, to be sure, but still remain independent. He told me that when he went to Barcelona with Olga before their marriage and introduced her to his mother, his mother had said, "You poor girl, you don't know what you're letting yourself in for. If I were a friend I would tell you not to do it under any conditions. I don't believe any woman could be happy with my son. He's available for himself but for no one else." Later, Olga tried to enlist Pablo's family's help in convincing him to lead a more normal—this is, more bourgeois —way of life. She had one idea in her head, not twenty, and she was capable of repeating that one idea until something happened.

Paul Rosenberg, who became Pablo's principal dealer about

that time, found him an apartment in the Rue La Boétie-number 23near the Champs-Elysées. That seemed an ideal place to Olga, so they moved in. Because there was no atelier there, Pablo began to work in a large room in the apartment but it had none of the advantages of a real studio. Since he found it very inconvenient and also, as he told me, almost from the start he and Olga did not get along, he rented an apartment on the seventh floor, just above theirs, and turned that into a suite of ateliers.

Olga's social ambitions made increasingly greater demands on his time. In 1921 their son Paulo was born and then began his period of what the French call *le high-life*, with nurse, chambermaid, cook, chauffeur, and all the rest, expensive and at the same time distracting. In spring and summer they went to Juan-les-Pins, Cap d'Antibes, and Monte Carlo, where—as in Paris—Pablo found himself more and more involved with fancy dress balls, masquerades, and all the other highjinks of the 1920s, often in company with Scott and Zelda Fitzgerald, the Gerald Murphys, the Count and Countess Etienne de Beaumont, and other international birds of paradise.

In 1935, a little while before the birth of Maya, his daughter by Marie-Thérèse Walter, Pablo and Olga separated. He wanted to divorce her because their life together had become unbearable. She screamed at him all day long, he told me. Olga didn't want a divorce so their separation negotiations were long and involved. Then, too, they had been married on a community-property basis, which meant that if he had divorced her, he would have been obliged to give her half of his paintings, and he was not at all eager to do that. So he, too, although in one sense he wanted a divorce, was dragging his heels to see if things couldn't be arranged in some other way. According to French law, a marriage ceremony involving two foreigners could be dissolved only in accordance with the laws of the husband's country. While the discussions were going on, the Spanish Civil War flared up, the government was overthrown and General Franco came to power. Under the new regime, divorce was no longer allowed for a Spanish subject who had been married in a church. They had already separated but were never able to be divorced. He turned over to her the Château de Boisgeloup. He continued to live in the apartment in the Rue La Boétie but he stopped working there in 1937 when he acquired the ateliers in the Rue des Grands-Augustins. In 1942 he began to live at the Rue des Grands-Augustins.

One winter morning soon after our first visit to the bank, he took me to the apartment in the Rue La Boétie. I saw the whole story, which

he had told me in all its detail, come to life again. And yet I wasn't at all prepared for what I saw. We entered the reception hall of the sixthfloor apartment. All the rooms were shuttered and everything was covered with dust. The place had been closed from 1942 until that day. We went into the bedroom on the left, which had been Pablo's and Olga's. The two twin beds were made up, one of them in the way one sometimes makes up a bed that is going to be slept in right away: the bedspread pulled back, the sheet and blanket turned down. On those sheets and pillowcases lay five years' dust. Beside each bed was a night table and on one of them still lay the remnants of the last breakfast: something that looked like Melba toast and some sugar. In that room were six or seven small Corots Pablo had bought from Paul Rosenberg or taken in exchange for works of his own. In addition to the Corots there were two paintings in a post-Impressionist manner. "Who is it?" he asked me. I looked carefully at one of them. It was a mountain landscape. "It must be Matisse," I said, "judging from the way the pink and the green are keyed in together." "That's right," he said. "They're both early Matisse." The other was a still life: flowers in a pewter pot, very colorful and perhaps more recognizable as Matisse, but very early also, before the Fauve period.

We went into the bedroom next to that one. It had been Paulo's room. The walls were covered with photographs of bicycle-racing champions and the floor was littered with toy cars, just as though the room had been occupied recently by a boy about eight. Yet when Paulo left that room he had been fourteen. From there we went into the salon, on the front of the house. It was a very impersonal room with a concert grand piano on which Paulo had been obliged to practice his scales under the supervision of Marcelle Meyer, regardless of the fact that he had, according to Pablo, neither taste nor talent for the piano. Everything was covered with loose slip covers and they, in turn, with five years' dust. Pablo went from one piece of furniture to the next, pulling off the covers to show me that every chair was upholstered in satin of a different color. Everywhere newspapers were piled up, and sticking out from between them, here and there, drawings of his.

We opened a door with difficulty and found ourselves on the threshold of another room, which was, I should guess, about sixteen feet square. It was impossible to tell exactly because, with the exception of a small open area just inside the door, it was full from the floor almost to the ceiling. This was Pablo's storeroom, where he kept everything that was to be saved. But since Pablo had never thrown anything away—whether an empty matchbox or a little watercolor by Seurat the range of its contents was enormous. Old newspapers and magazines, notebooks of drawings he had made, and copies by the dozen of various books he had illustrated formed a wall almost to the ceiling. I picked up a group of letters and saw that they included some from friends like Guillaume Apollinaire and Max Jacob as well as a note from the laundress that he had once found amusing. Suspended on the face of this wall was a charming seventeenth-century Italian puppet, strung together with wires and dressed as Harlequin, about four feet high. Behind it here and there, wedged into the mass, I saw paintings. I looked into a box. It was full of gold pieces.

After that room, the others were an anticlimax: the dining room with only a normal amount of disorder and then another room whose chief feature was a large round table, vaguely Second Empire in style, laden with the same kind of pack-rat accumulation. It was the table one sees in many of the mildly Cubist paintings and gouaches of the early 1920s, standing before an open window, sometimes with the dome of Saint-Augustin in the distance. Many of those pictures show the table pretty well crowded with objects. Since then nothing had been removed but a good deal had been added.

The main rooms of the apartment were laid out in the form of a semicircle around the entrance. From there a long corridor led to the service quarters: the linen room, the laundry, the bedroom where Inès, the chambermaid, and her sister slept and, at the very end, the kitchen. In the linen room Pablo opened one of the closets. Five or six suits of his hung there, like dead leaves that had become entirely transparent, with only the tracery of their fibres remaining. Moths had eaten away everything woolen. There remained only the buckram and the threads around the lapels and pockets, wherever the tailor's needle had passed. In the skeleton breast pocket of one was a crumpled, dusty, yellowed handkerchief. Some of the doors of the wardrobe were missing.

"I thought they'd be good to paint on so I had them removed and taken upstairs to the studio," Pablo said.

We went into the kitchen. The dishes and pots and pans were all in place. I looked in the pantry and saw jams and jellies all turned to sugar.

On the floor above, the disorder was about the same but the accumulation less. There were paintings of all sizes stacked against the walls, tables loaded with brushes, hundreds of empty, split-open tubes of paint all over the floor. Pablo showed me the rush-seated wooden

armchairs and canapé from the Spanish pavilion at the Paris World's Fair of 1937 where he had exhibited *Guernica*. They were Catalan peasant work and he had liked them so much that after the exhibition was dismantled they were given to him as a present. There was what remained of the gaunt frame of a philodendron onto which Pablo had hung all sorts of odd objects: a brightly colored feather duster, the horny beak of a bird, and a number of different-colored empty cigarette boxes. The chance accumulation of so many unrelated objects, end to end, had achieved a result that was more Picasso than anything one could have put together consciously. In fact all these objects seemed so obviously and intimately related to his work that I had the impression of having entered the cave of a very familiar Ali Baba, but an Ali Baba who would have preferred looting an alchemist's shop rather than Cartier's or van Cleef and Arpels.

"One summer I went on vacation and left one window halfopen," Pablo said. "When I returned, I found that a whole family of pigeons had established residence in the atelier. I never wanted to chase them away. Of course they left droppings everywhere and it would have been too much to expect that the paintings should have been spared." I saw several paintings of the period that had been decorated in that way by the pigeons. Pablo had never seen any point to removing their droppings. "It makes an interesting unpremeditated effect," he said.

I told him it looked to me as though his painting gloried in the most common-ordinary things. "You're absolutely right," he said. "If anyone could go broke for things that don't cost any money, I'd have been bankrupt years ago."

Not long after that, Pablo said that since I had seen the other houses, I ought to see Boisgeloup. If the apartment of the Rue La Boétie was the cave of Ali Baba, Boisgeloup was the house of Bluebeard. It is a very handsome eighteenth-century country estate but the day we visited it that winter, it seemed especially forbidding. It is built around a square courtyard. On the right, as we entered, was a rose arbor, and behind that, a lovely small thirteenth-century chapel. Beyond the chapel was a circular pigeon house, very large but in bad condition. There were seven or eight acres of land with the place and a caretaker-gardener to look after it.

The day we were there the sculptor Adam was working in the studio where Pablo had once worked and was living in the little apartment that had been used by the concierge in the days when Pablo had lived there with Olga. The main residence was not open to us, strictly speaking, since it was the domicile assigned by the court to Olga at the time of her separation from Pablo. However, Olga lived most of the year in Paris, in the Hotel California, just off the Champs-Elysées in the Rue de Berri, and went to Boisgeloup only occasionally. Since Paulo—her son and Pablo's—was with us, Pablo decided to go in anyway. It was very dreary and cold that day and the house had neither heat nor electricity.

"Just because I bought it, that's no reason to modernize it," Pablo said. So in spite of its appealing architecture, the interior was not very presentable. Since Olga was hardly ever there, the town had requisitioned it—under French law it was considered "insufficiently occupied"—and used the ground floor as an annex to the village school. Some of the rooms were filled with wooden school benches. In one of them there was a very pretty Delft faïence stove. Resting on top of that was the skeleton of a rhinoceros head with two large horns. The kitchen was huge, with a dirty long black stove.

Upstairs the place took on a sinister aspect. There was a long series of rooms, one after another, empty but for a few trunks scattered about. Pablo opened them up. They contained Olga's old ballet costumes. On the next floor above, we went into just one of the rooms. There was nothing in it but a chair, the one that appears in the rather Ingresque 1917 portrait of Olga sitting in a chair, holding a fan. I began to have the feeling that if I looked into a closet, I would find half a dozen exwives hanging by their necks. The atmosphere was all dust, decay, and desertion, and it gave me a chill.

ONE OF THE HARDEST of the jobs that fell to me was getting Pablo out of bed mornings. He always woke up submerged in pessimism and there was a definite ritual to be followed, a litany that had to be repeated every day, sometimes more insistently than others.

The bedroom, long and narrow with an uneven, sloping red-tile floor, was entered through the bathroom. At the far end was a high Louis XIII secretary and, along the left-hand wall, a chest of the same period, both completely covered with papers, books, magazines and mail that Pablo hadn't answered and never would, drawings piled up helter-

skelter, and packages of cigarettes. Between the two, in the middle of a large brass bed, lay-or sat-Pablo, looking more than ever the Egyptian scribe. Above the bed was a naked electric-light bulb. Behind the bed were drawings Pablo was particularly fond of, attached by clothespins to nails driven into the wall. The so-called more important letters, which he didn't answer either but kept before him as a permanent reminder and reproach, were pinned up. also with clothespins, onto wires that stretched from the electric-light wire to the stovepipe. The stove, a little wood-burning Mirus, stood in the center of the room. Even when the central heating was working. Pablo always made a wood fire because at that period he used to enjoy making drawings of the flames. The stovepipe was so long and took up so much space, it was the most important decorative element in the room. With its letters waving in the draft it was a hazard to almost everyone but Pablo, Sabartés and Inès, who were short enough to find their way through the maze without getting caught in the wires. Pablo always insisted on keeping the stovepipe, even though, after my first years there, the stove wasn't used any more. There was almost no other furniture except a Swedish chair in laminated wood completely out of character with the rest of the room.

Inès, the chambermaid, went in first, carrying Pablo's breakfast tray-café au lait and two pieces of salt-free dried toast-followed by Sabartés with the papers and mail. I brought up the rear. Pablo would always start to grumble, first about the way his breakfast was laid out on the tray. Inès would rearrange it-differently every day-to suit him, curtsy, and leave. Then Sabartés would set down the papers and hand him the mail. Pablo would flip through it indifferently until he came to a letter from Olga. Olga wrote him almost every day long tirades in Spanish, so that I wouldn't understand, mixed with Russian, which no one understood, and French, which she wrote so badly that it wasn't very understandable either. She would write in every direction: horizontally, vertically, and in the margins. She would often enclose a postcard photograph of Beethoven in one pose or another, frequently one that showed him conducting an orchestra. Sometimes she would send a picture of Rembrandt on which she had written, "If you were like him, you would be a great artist." Pablo read these letters through to the end and was tremendously bothered by them. I suggested to him that he just put them aside but he couldn't; he had to know what she said.

Then he would groan and begin his lamentations. One day typical of many they went this way: "You have no idea how unhappy I am. Nobody could be more unhappy. In the first place I'm a sick man.

My God, if you only knew what sicknesses I have." Of course, he had had trouble with an ulcer off and on since 1920, but when he started to list all the diseases he was suffering from, that was only a point of departure. "I've got stomach trouble. I suppose it's a cancer. And nobody cares. Least of all Doctor Gutmann, who's supposed to be looking after my stomach. If he cared at all about me he'd be here now. He'd find a way of coming every day. But no. When I go to see him he says, 'My friend, you're not so badly off as all that,' and then what does he do? He shows me some first editions. Do I need to see his first editions? What I need is a doctor who is interested in me. But he's only interested in my painting. How do you think I can be well under conditions like that? My soul itches. No wonder I'm unhappy. Nobody understands me. How can you expect them to? Most people are so stupid. Who is there to talk to? I can't talk with anybody. Under those conditions life is a terrible burden. Well, there's always painting, I suppose. But my painting! It's going very badly. Every day I work worse than the day before. Is it any wonder, with all the troubles I have with my family? Here's another letter from Olga. She doesn't miss a day. Paulo is in trouble again. And tomorrow it will be worse. Somebody else will show up to make life miserable for me. When I think that it's like that day after day, going from bad to worse, do you wonder I despair about going on? Well, I do despair. I'm pretty nearly desperate. I wonder, really, why I bother to get up. Well, I won't get up. Why should I paint? Why should I continue to exist like this? A life like mine is unbearable."

Then it was my turn. "But no," I said, "you're not so sick as all that. Of course, you've got a little stomach trouble but it isn't really very serious. Besides, your doctor is very fond of you."

"Yes," Pablo shouted, "and he says I can drink whiskey. That's how fond he is of me. He ought to be ashamed. He doesn't give a damn about me."

"Not at all," I explained. "He says that because he thinks perhaps that might make you happy."

"Oh, I see," Pablo said. "Well, I won't take it, anyway. It would probably make things worse." And so I had to go on reassuring him, telling him no, he didn't really have such terrible troubles. Given a little time, things would straighten themselves out. Life would become more agreeable. All his friends loved him dearly. His painting was something absolutely marvelous and everybody was completely in accord with that opinion. Finally, after an hour or so, as I was beginning to run out of all the reasons he might have for living—or I either—he began to

stir in his bed vaguely, as though he were making his peace with the world, and said, "Well, maybe you're right. Perhaps it's not so bad as I thought. But are you *sure* of what you say? You're absolutely certain?" So at that point I could only reach for a second wind and say, "Yes, yes, of course it's going to be better. It's not possible for it to be any other way. At least you can take action. Through your painting you can be sure that something is going to change. You're going to do something extraordinary today, I feel sure. You'll see this evening after your work is done. You'll be in a completely different frame of mind."

He sat up, more hopeful now. "Yes? You're very sure?" Then he got up and began his usual movements, complaining first to one friend, then to another, among those who had come before lunch, waiting for him outside in the studio. After lunch he forgot completely about his pessimism. By two o'clock he thought of only one thing: to get down to painting. And then, with a brief stop for dinner, nothing but painting until two in the morning. At two in the morning he was as fresh as a rose. But the next morning it would begin all over again.

Of course, Pablo did suffer from some kind of disease of the will, which made it impossible for him to make the slightest domestic decision. A little later on, because the weather in Paris had been rather bad, we had decided to go down south for a while. We had made our plans a week before and were going to take Michel and Zette Leiris with us. It had been decided that we would get up very early in order to leave by six, which was not at all the way we were accustomed to doing things. Marcel the chauffeur would come to pick us up and the Leirises would be there, ready to go with us at six.

The night before we were supposed to leave, beginning about ten o'clock while we were having dinner at Lipp's, Pablo began to twist and turn in his seat and then said, "Well, after all, why are we going to the Midi?" I said we were going because we were tired and had decided it would be a good idea to go to the Midi for a rest.

"Yes," he said, "but we said that a week ago and now I'm not sure I want to go any more." I said that was all right with me. It was really to make him happy that we were supposed to go in the first place but, I said, it wasn't absolutely necessary.

He began to squirm a little, not sure which horn of the dilemma to reach for.

"Yes," he said tentatively, "but all the same, I don't see why we have to go down there. I never can do what I want to." I said that

PART III

if he didn't want to go, it was very simple: we'd call up Marcel and call up the Leirises and we wouldn't go.

"Well, yes," Pablo said, "but what will it make me look like if I change my mind?" I said he needn't worry about that. We could telephone them that we weren't going and that would end it.

"Ah, yes," he said, "but I'm not sure that I won't go. Just because I don't *want* to go doesn't necessarily mean that I *won't* go. After all, tomorrow I may feel differently about it."

I said, "Let's think it over. There's plenty of time. It's only ten o'clock. Up until midnight we can reasonably telephone Marcel and the Leirises and tell them not to show up at six o'clock because we don't want to leave."

Then Pablo started off on a long philosophical monologue in which he quoted Kierkegaard, Heraclitus, St. John of the Cross, and Santa Teresa, building up to a disquisition based on two of his favorite themes: *Todo es nada* and *Je meurs de ne pas mourir*—what in a more amiable frame of mind he often referred to as his *philosophie merdeuse*. He went into all the reasons there were for taking action or for remaining passive in general, in particular, in this or that hypothetical case, and wound up by saying that since every action carried within it the seeds of its own degeneration, one was better off, in principle, not to act rather than to act, whenever there was a choice.

I agreed with everything he said. I said it was absolutely true that whenever anyone made a gesture or a move in any direction, very often one found he had occasion to regret it; that it wasn't at all a necessity to go to the Midi; that if we went, we might well wish we hadn't. I told him I didn't want to bring any pressure to bear on his wishes, whatever they might be; therefore, he should make the decision he felt happiest about.

"Ah, yes," he said, "but that's exactly what's so difficult about it—making the decision."

I said, "All right. Since we've already made one, perhaps we should just follow it through."

He looked uncertain. "Yes," he said, "but getting up at six o'clock in the morning is not very gay. I understand why they execute condemned men at dawn. I just have to see the dawn in order to have my head roll all by itself."

This went on for four hours. Although normally I could carry on this type of discussion without getting wrought up, or without making

him wrought up, which was even more difficult. I was now so tired that I burst into tears. He brightened up immediately.

"Ah," he said, "I knew very well you had an exact idea of what you wanted to do." I had no idea at all. I was simply so tired that I was crying because it was a thoroughly useless discussion and, after four hours, no further advanced than it had been at the start. It was completely enervating to be there from ten o'clock until two in the morning discussing a matter of no importance. So I told him, "I'm crying from exhaustion."

"No," he said, "you're crying because you want something." I saw it was useless. I was so worn out I preferred to make the decision, because it was just too painful to stay there any longer and still not be able to get one out of him. I said, "All right, if you insist. I want something."

"Fine, fine," he said. Then he put on a bland air and added, very sweetly, "Now then, what is it you want, exactly?" "I'd like to go to the Midi," I said.

"You see?" he said. "I knew very well it was that. You should have told me in the beginning if you had a little idea like that in the back of your head. Since you've finally told me, we'll go. But I'm going, understand, only to please you. If I don't like it down there, it's your fault." After that he was completely happy, because I had taken upon myself the full responsibility for our departure and if the trip was a fiasco, he would be able to chalk it up to my account.

HE BABY WAS DUE IN MAY. In February I received a letter from my grandmother, asking me to come see her. I hadn't seen her since I went to live with Pablo but she had learned where I was through a newspaper article someone had shown her. She was calm and loving, as always, and before I left she said to me, "You mustn't think that just because you've changed your way of life, you're not going to take me to the Midi for my winter vacation any longer. I'm not going to reproach you for what you've done but I don't expect it's going to alter our way of doing things."

When I was a child, she had taken me south with her every year from the time I was five years old. Later on the situation was reversed

150

and it was I who took her. I explained all that to Pablo and he agreed that I should go with her. He came along to see us off at the Gare de Lyon. He settled us into our compartment and then went back outside onto the platform. As the train started to pull away, Pablo's eyes seemed to soften with emotion and they were no longer just black and piercing but very beautiful. I had rarely seen him moved or affected emotionally in that manner and it gave me a real tug at the heart to see him receding into the distance.

When my grandmother and I returned to Paris after three or four weeks, I discovered that while we were away Pablo was convinced I wasn't coming back. He had been certain that the trip was a ruse to cover up my desire to get away from him, and that my family was going to pull me back into the fold. When he saw me return and learned that I had never intended anything else, he seemed so relieved and sweet, I could hardly believe it was Pablo, and the look he lavished on me then, too, was one I shan't forget in a long time.

Although the baby was due in a little over two months, I hadn't yet seen a doctor about my pregnancy. Pablo was against the idea because he felt that if one looked after such things too carefully, it might bring bad luck. The only medical person I had seen during that winter was the psychoanalyst Doctor Lacan. Pablo always felt you should use people for things that lay outside their area of specialization. Since Lacan was a psychoanalyst, Pablo had adopted him as his general medical practitioner. He took his troubles to him and Lacan prescribed very little, saying, as a rule, that everything was fine. One time, a little earlier, I had had what seemed to be a bad grippe and was coughing a great deal. Doctor Lacan said it was a combination of fatigue and nervousness and simply gave me some pills to make me sleep and I did, in fact, sleep for most of two days and two nights as a result. When I got up, the grippe was gone and the cough with it.

About a week before the baby was to be born I was beginning to be quite excited and I decided it was time to do something. I kept talking about it until Pablo finally agreed we should think about an obstetrician and a clinic. He called Doctor Lacan, who was astounded to learn that I hadn't been seeing an obstetrican. He got Doctor Lamaze for me and he, even more flabbergasted, arranged for a bed in a clinic in Boulogne called *Le Belvédere*.

A year or two before I met Pablo I had begun to note down the details of any dreams I had that seemed out of the ordinary. Just before we met I dreamed one night that I was taking a bus trip, the sort of thing

organized to show tourists famous monuments. In my dream we stopped at a museum. When we got out they herded us into a goatshed. It was very dark inside but I could see there were no goats. I was beginning to wonder why they had brought us there when I saw, right in the middle of the shed, a baby carriage. In it and hanging from it were two paintings: the portrait of Mademoiselle Rivière by Ingres, and a small painting by the Douanier Rousseau called *Les Representants des puissances étrangères venant saluer la République en signe de paix*. Both of them were smaller than their actual size; the Ingres was dangling from the handle of the baby carriage and the Douanier Rousseau was nestling inside it.

A few months after I met Pablo I had shown him the notebook in which I wrote about my dreams. He had thought that one particularly interesting; all the more so since the Douanier Rousseau painting I had dreamed about belonged to him, although I hadn't known it at the time. The day I went to the clinic for the delivery, Doctor Lamaze was delayed in arriving and when I got there, instead of finding him, I had a nurse and a midwife waiting for me. One of them was named Mademoiselle Ingres and the other, Madame Rousseau. Mademoiselle Ingres had black hair parted in the middle and pulled down severely on each side, like so many of Monsieur Ingres's female sitters. Pablo remembered reading what I had written about the dream and when Lacan arrived he asked him the meaning, in analysis, of a goatshed. Lacan told him it was a symbol for the birth of a child.

The baby—a boy—was born without difficulty on May 15, 1947. Pablo wanted him to be named Pablo but since his first son had been named Paul—the French equivalent—I thought we should try something different. I remembered that Watteau's teacher had been called Claude Gillot, and that he had done many paintings of harlequins, just as Pablo himself had, even before the Blue Period and long after, so we named the baby Claude.

152

PART IV

A SIDE FROM THE FACT that Pablo's studios in the Rue des Grands-Augustins were not designed to accommodate children, even one child, very adequately, there were two other reasons why it soon began to seem uncomfortable there after Claude was born. Their names were Inès and Sabartés.

Pablo had met Inès and her older sister one summer at Mougins while he was vacationing there with Paul Eluard and Nusch. The girls were fifteen and seventeen at the time. Inès was a jasmin picker for one of the perfume factories. He brought them back to the apartment in the Rue La Boétie, Inès as chambermaid and her sister as cook. When war broke out, he didn't want the responsibility of having the two young girls with him so he sent them home to Mougins. Not long after, Inès met Gustave Sassier, a young fellow from Paris who was taking part in a bicycle race in that region. Gustave fell in love with Inès, married her, and brought her back to Paris with him. Pablo rented a small apartment of three rooms for them on the second floor of his building in the Rue des Grands-Augustins, leading off the same little circular staircase that he used for reaching his studios. That took care of the newlyweds and at the same time provided him with a kind of caretaker for the studios.

Almost no one knew of Inès. If Sabartés was absent and Pablo too, a visitor might ring at Inès's door but that was rare. If one had thought about it, walking into the entrance hall of Pablo's studios, full of plants and disorder, one might have imagined her existence; no one would assume that either Sabartés or Marcel the chauffeur took care of

watering the plants or dusting the clutter. That's what I thought, anyway, the first time I went there. But she remained hidden for a long time. When I began visiting Pablo afternoons, I got to know Inès because that was when she came to do the housework.

She was very pretty at that time. She had an oval face with a small nose, black hair and eyes, and olive-brown skin. I could well understand why Paul Eluard had been led to write his poem about Inès and her sister-"like two dark doors to summer." Every year, for her birthday, around Christmastime, Pablo had her come to pose one afternoon for a portrait sketch and gave it to her, so that by now she must have twenty or more portraits by Picasso. She knew nothing about painting but she was very proud of the fact that every afternoon when she came to the atelier to clean, Pablo would show her what he had done the day before and ask her what she thought of it. Naturally, she got in the habit of expressing her opinions and Pablo seemed to take a good deal of interest in them. And so Inès was understandably proud of her prerogatives. She dressed very carefully and saw to it that her feather duster and her apron harmonized very noticeably, and she changed the combination each day. She was chambermaid to a great painter, not to just anybody.

In the spring of 1946 Inès had a baby. She wasn't very well for a time after that. When I first saw her she had seemed very much like the chambermaid in classic Italian comedy, a bit of a flirt yet at the same time rather shy, at least on the surface, speaking generally in monosyllables, running in and out with tiny steps. But with the birth of her child and her illness, plus the fact that in May 1946 I came to live there, her manner and her disposition changed. Pablo had always had women but not women who lived with him. Inès first arrived on the scene after he had broken with Olga and although he saw Marie-Thérèse Walter regularly, it was at her house. When Dora Maar entered his life, she lived in her own apartment, in the Rue de Savoie, around the corner from Pablo, and seldom came to the studios in the Rue des Grands-Augustins. As the woman entrusted with the care of Pablo's studio, Inès had come to feel, innocently and perhaps unconsciously, that Pablo belonged to her, in a certain sense. She felt that she filled a role in his life that no one else could duplicate exactly, and she considered herself a kind of priestess. But with the birth of her child and the constant presence of another woman, her life changed. The result was, she didn't like me very much. I sympathized with her, and did everything I could to put her at ease, but got nowhere. Whatever I did seemed to antagonize her further.

When Claude was born and occasionally she had to take care of him as well as of her own child, she complained of being tired and ill and soon found herself unable to make the slightest exertion in Claude's behalf. We had no room for anyone else and Pablo didn't like the idea, anyway, of having someone new around. And so family life in the Rue des Grands-Augustins became difficult.

After her child was born, whenever Inès came to pose for her annual portrait she posed with the baby in her lap, and so seriously, you would have thought it was the Virgin Mary with the Infant Jesus. Pablo made two lithographs of her with the baby. Once, after she had posed, Pablo's nephew Javier came and we decided to go out and have dinner in a restaurant. Inès had apparently planned, in honor of the occasion, to serve dinner there and when Pablo told her we were eating out, she burst into tears. "It's not the way it used to be around here," she said. "Now anything goes. In the old days I took good care of Monsieur but he's forgotten all about that." She loved to cry and did it with great art. Pablo calmed her down and agreed with everything she said, as in all such situations, but since he wanted to eat out, we ate out. But Inès became more and more of a problem.

The other courtier who was troubled by Claude's arrival was Sabartés. Sabartés was Catalan. He was, in fact, a distant cousin of Miró. Their point of encounter was Sabartés's grandfather. The grandfather was completely illiterate but he had made a fortune. Pablo told me, first as a scrap-metal dealer and then, later on, in some more respectable business. He could neither read nor write nor even count beyond the most rudimentary level, but no one could ever cheat him. If he was to receive one hundred iron pots and only ninety-nine showed up, he knew it, even without being able to count that high. He took an interest in Sabartés from his very early childhood and decided to educate him, with the idea that when Sabartés knew how to read and write and especially to count, he would take him into the business and from then on have no worries about being robbed by wily competitors. By the time Sabartés was nine years old he was handling all his grandfather's correspondence. Soon after, though, he had a very serious eve illness which resulted in his becoming nearly blind. That ended his usefulness to his grandfather.

In 1899 he met Picasso, who also was living in Barcelona, as his father had become professor of painting at the Barcelona School of Fine Arts. At that time there was a kind of regional fervor in Barcelona. There was an active group interested in reviving the Catalan language, which up until then had had only an oral tradition, and making it the

spearhead of a literary renaissance. They had put out a Catalan grammar and a number of young writers were beginning to write in Catalan. It was an intellectual surge that carried over into other domains. Sabartés was part of that group. Although he began as a poet, he once had ambitions of becoming a sculptor. He never did, though. He told me once, "When I discovered Egyptian sculpture, I knew that was what I would have wanted to do, but I could never have hoped to do it that well. So I gave up the idea."

From the beginning he was a kind of scapegoat for Pablo. Once when Pablo was annoyed with Sabartés, he told me the following story:

Back in their early starvation period in Paris. Pablo and Max Jacob once gave Sabartés the last few coins they could scrape up and told him to go buy an egg and whatever else he could get the most of for that money. Sabartés shopped around and wound up with a piece of bread, two sausages and, of course, an egg. Since he saw very poorly, he fell on the stairs on his way back. The egg broke and ran in all directions. He picked up the other things and continued up to the room where Pablo and Max were waiting. They were planning to cook the egg over a candle, since there was no other heat. He told them what had happened. Pablo was furious. "You'll never amount to anything," he told him. "We give you our last penny and you can't even get back here with a whole egg. You'll be a failure all your life." He grabbed up a fork and plunged it into one of the sausages. The sausage burst. He tried the other one. The same thing happened. Sabartés with his weak eyesight had bought two sausages so old and so rotten that they exploded like a pair of balloons as soon as the tines of the fork penetrated the skin. Pablo and Max divided between the two of them the bread Sabartés had bought. All Sabartés got for his trouble was the bawling-out.

Sabartés went back to Barcelona not long after that and married a distant cousin of his. Pablo said that they had a child and a bit later they went to Guatemala, where Sabartés worked as a journalist. After twenty-five years they returned to Spain. At that point the thread grows tangled. I only know what Pablo told me about this period of Sabartés's life and since Pablo had a rather malicious tongue at times, I never got a clear story on what happened to Sabartés's wife and child. In any case, shortly after his return to Spain he married again and it was with his second wife, a childhood sweetheart, that he landed in Paris. Pablo was now separated from Olga and so he had Sabartés and his wife come to live with him in the Rue La Boétie. The wife supervised the household and Sabartés began his long service as Pablo's secretary, front man, errand boy and, not least, scapegoat.

Sabartés had exactly the right temperament to be useful to Pablo. To begin with, he had the kind of devotion for Pablo that a Trappist has for his God. Day after day and year after year he was subjected to the bad moods and the good, he was the butt of Pablo's ribbing and the patient dupe of his practical jokes. He did all the legwork, the correspondence, the organization of exhibitions, and took the blame for anything that went wrong. There was Marcel, of course, but he was shrewd and thus knew how to protect himself in advance against any sudden squalls, and besides, he was only the chauffeur and could hardly be blamed for something he took no real part in. And so Sabartés held the honor of being the official whipping-boy. In all his life with Picasso he never made a decision on his own. Pablo didn't allow him to. He carried out instructions to the best of his ability. If things went well, he heard no more; if they went wrong, he reaped all the blame.

Aside from his devotion to Pablo, Sabartés's only interest was his wife. His whole life was built around those two figures. I saw her once or twice but it was only because I went to call on her in their tiny apartment in the fifteenth *arrondissement*. Otherwise I would never have met her. She never set foot in the atelier of the Rue des Grands-Augustins during the years I was there.

Sabartés was very fussy and cautious in everything he did and quick to take offense. But he was totally disinterested. He certainly had no selfish or ulterior motive in anything he did, and for all his devotion he was repaid by the skimpiest of livings. During the eleven years I knew him, his pay—like that of Inès, the chambermaid, and Marcel, the chauffeur—never exceeded eighty-five dollars a month, and for a long time it was less. He and his wife lived in a noisy, tiny flatlet not much bigger than a monk's cell, situated on top of an ugly block of worker's flats. One took the elevator as far as it went and climbed the rest of the way on foot.

Sabartés was a curious combination of pride and self-abnegation. People sometimes got into difficulty in their relations with him because either they thought he was completely negligible, in which case he would go to great pains to prove to them that this was not so by refusing their request for whatever it was they wanted; or else they buttressed their requests with the assurance that they knew he had great influence over Picasso. These were met with a cold, "I carry out only what he tells me to do." Almost no one found favor in his eyes. He always disliked

Claude because when Claude was a baby he was frightened of anyone who was strange-looking. Whenever Sabartés tried to pick him up or play with him, he began to howl. Sabartés never forgave him. Years later he asked me if Claude still had the same bad disposition. "Is he as odious as ever?" he wanted to know. In plain fact, Claude was never "odious" with anyone but he was terrified, as a baby, of Sabartés, and since Sabartés had no understanding of children, he took it badly.

Sabartés had the Spanish habit of affecting sadness to a far greater degree than he really felt. One might almost say that the Spanish are a nation in mourning. Ever since the time of Philip II they have never gotten over the fact that at court one always dressed in black. However little royal blood he may have in him, once be begins to feel himself in any degree a personage, the Spaniard will dress in black, at least metaphorically, for the rest of his days. And in my mind's eye that is the way I always see Sabartés. He loved mystery, even where there was none. He had a cloak-and-dagger imagination, and mentally shadowed everyone who came near him. He never talked of anything in plain terms like everyone else. He would never pronounce anyone's name in front of an outsider for fear of giving away a secret. Of course Pablo loved that. When I first went to live there, with my uninhibited free-speech temperament I shocked both of them terribly. "How do you dare say such a thing right out? Everyone will understand," Sabartés would whisper, and Pablo would look daggers at me. Once when Brassaï came in, I said to him, "Ah, you've come to photograph all the sculptures?" Sabartés whispered to me later, "It's nobody's business how long he's here or what he's doing." I said I had known Brassaï long before I came there. "Then see him outside and ask him," Sabartés answered.

Before the Liberation he was always certain that the Germans were all spies. After the war, it was the English: he was sure they were all from the Secret Service. When the GI's began to come see Pablo after the Liberation, and occasionally I would do something to make them comfortable, Sabartés would say, "Americans are puppies. Let them sleep on the floor and use the threshold for a pillow." One day he noticed a GI with an unfamiliar shoulder patch. He decided he was a member of the Intelligence Service. He warned Pablo not to say anything to him. "He might understand something," he said. Pablo pooh-poohed him. "Since Americans are like puppies," he said, "why worry about them?"

All this puzzled me. I asked Pablo, "What is there to understand --except your painting?" Sabartés grew very excited. "That's just the point," he said. "There are things in that painting that you don't understand. Perhaps most Americans don't, either. But this man, just like the English, might see through it. You know, the British Secret Service collects all possible information on intellectual activities; up until now, they probably don't know what to do with it, but if they ever find out, you'll see the trouble they'll make." When I began to roll my eyes skyward, Sabartés said, "You don't believe me? You want proof? Go one day to the British chancellery. Look at all the people they have working there. What do you think they all do?" He nodded ominously.

Finally I learned the secret code of the palace guard. One never mentioned a proper name. One never referred directly to an event or a situation; one spoke of it only by allusion to something else. Pablo and Sabartés wrote to each other almost every day to impart information of no value and even less interest, but to impart it in the most artfully recondite fashion imaginable. It would have taken an outsider days, weeks, to fathom one of their arcane notes. It might be something relating to Monsieur Pellequer, who handled Pablo's business affairs. Pablo would write (since Monsieur Pellequer had a country house in Touraine) of the man in the tower (tour) of the château having suffered a wound in the groin (aine) and so on and on, playing on words, splitting them up, recombining them into unlikely and suspicious-looking neologisms, like the pirates' torn map that must be pieced together to show the location of the treasure. He would sometimes use up three pages writing about a spade in such a way as not to be obliged to refer to it as a spade. lest the letter fall into the hands of Inès or Madame Sabartés and reveal something to one or the other. He worked so hard at being hermetic that sometimes even Sabartés didn't understand and they would have to exchange several more letters to untangle the mystery.

Of course, there was a feeling for the theatrical mixed up in all this, too. Whenever Sabartés admitted callers to the waiting room, some part of his sad, lugubrious air was certainly laid on to give added importance to the whole procedure. It was part of the stage setting. And since the building in the Rue des Grands-Augustins had once been—at least according to Pablo—part of the Spanish Embassy, I'm sure that whenever Pablo or Sabartés thought of that, they redoubled their private security measures. In the big reception room Pablo had even arranged some Spanish chairs and a large divan dating from the beginning of the seventeenth century and covered in very dusty crimson and yellow velvet, on which reposed a few guitars, all carefully contrived to make you realize that there you were in Spain. Then there are the portraits

he has done of Sabartés in the habit of a Dominican of the time of Philip II or dressed as an alguacil. So in spite of his deliberate self-effacement, Sabartés played to the hilt his role of Minister of the Interior.

At the beginning I understood why Sabartés accepted me so grudgingly. In the same way that he opened the door, the first time I called, just a crack, so every time after that he seemed to want to shut me out; but since Pablo was very frank about the pleasure it gave him to see me, Sabartés was obliged to go along. He was extremely severe and aloof but no more so with me than with others. In fact less so than with many. Later, when he saw that I was coming much more frequently, he began to predict doom, not only to me but to Pablo as well. "You'll see," he warned us. "This will end badly. It's madness. It will bring you to the edge of catastrophe."

Sabartés simply couldn't stand the idea that Pablo should have a new woman in his life. He thought Pablo was already overloaded, with Olga, with Marie-Thérèse Walter and her daughter, and with Dora Maar. But he was rather fond of Marie-Thérèse and hence had no use for Dora Maar. So after his first negative reaction, he put up no great objection to my presence, on the grounds, no doubt, that he felt I might be useful in getting rid of Dora. By that time, he must have assumed, Pablo would have lost interest in me as well. But after putting up with me for three years, instead of finding me gone he found me living there.

After I went to live with Pablo, Sabartés soon saw that I lightened the workload for him and I carried out my duties conscientiously enough to satisfy him. Gradually he began to lose his pessimism concerning my presence and decided that after all, perhaps it wasn't such a bad thing. He felt I had brought stability to Pablo's life and since he was the seismograph that recorded all the quakes and tremors from Pablo's direction, he could only benefit from the new equilibrium. He even went so far as to say it was nice to have someone so young around the place, that it had made Pablo more lighthearted.

During my first year there, Sabartés was a good friend to me. What broke down our good entente was the birth of Claude. It quite clearly put an end to his illusions that I would be a temporary preoccupation of Pablo's. After 1947 Pablo and I spent less and less time in Paris and when we came back we were all there together, as a family. And Sabartés's great decorum was sadly undermined by the presence of an active, exuberant child. Sabartès might have just finished impressing those who had come to seek audience with Pablo that their chances were very slim, that the Master was hard at work, really too busy to see any-

PART IV

body, when Claude would toddle in, say hello to everybody, climb up into a few laps, and announce, "My daddy's going to see you very soon. Just as soon as he gets out of bed and gets dressed." Everybody would begin to laugh and all Sabartés's stage-setting had gone for naught. Claude had turned a Greek tragedy into a film by René Clair.

Later Claude got into the habit of hiding himself in some out-ofthe-way place in the big atelier just before eleven o'clock, when the pilgrims began to file in. He was waiting for Mourlot, for whom he had developed an abiding affection. He called Mourlot "Colombe." He knew that it was in Mourlot's shop that his father had done the lithograph of the dove, and since the French word for dove is colombe, he had made up his mind that must be Mourlot's name. Mourlot came often, though not every day. As soon as he arrived, Claude would pop out of his hiding place, saying, "I'm looking for Colombe. I want to see Colombe." He made straight for Mourlot, saying, "Well, at last, here you are. Wonderful! Come give me a kiss. My daddy's going to see you right away. He won't make you sit around and wait like the rest of these people." By that time Sabartés's protocol was sagging badly. He would call for Inès and have Claude carried offstage but he could not undo the damage Claude had done. In addition to that, the presence of a child made it obvious that somewhere there was a woman, and for one reason or another. Sabartés would have preferred to keep that fact quiet.

The only time I ever saw Sabartés come close to doing anything on his own initiative he got his fingers so badly burned I doubt that he ever felt tempted to try again. It was the summer after Claude was born. The innocent cause of the trouble was the New York picture dealer Sam Kootz. But the story really begins before Claude was born and before Kootz arrived on the scene.

For quite a time Pablo had been trying, unsuccessfully, to get Kahnweiler to raise the unit price—the purchase as well as the selling price—of his paintings. Many American collectors were still being put off by Pablo's having joined the Communist Party and Kahnweiler told Pablo that he was having enough difficulty selling Picassos at the old price without worrying about trying to sell them at the price Pablo was suggesting. He refused to go higher. It wasn't so much greed that kept Pablo after Kahnweiler as it was pride. He had recently heard reports that canvases of Braque's had changed hands for sums higher than what Kahnweiler was asking for paintings of his that could be considered comparable in size, period, and so on, and Pablo had great difficulty in accepting that. Of course, Braque painted far fewer pictures in a year

than Pablo and for that reason alone there was a certain logical basis for a canvas of Braque's to sell at a higher price. But every time Pablo heard about such a sale, there was always a storm. He kept at Kahnweiler but Kahnweiler wouldn't budge, and since Pablo had made up his mind not to sell at the old price, no paintings were sold.

Louis Carré had bought a good many paintings in the years just preceding and had started a gallery in New York but it didn't seem to be thriving at the moment. As a result he was oversaturated with Picassos of recent vintage and hence, temporarily at least, out of the market. And if Kahnweiler wasn't willing to pay Pablo's price, Paul Rosenberg certainly wasn't going to.

It was at this point that Kootz showed up for the first time. He had been dealing in the works of some of the avant-garde American painters—Gottlieb, Motherwell, Baziotes, and others—and Gottlieb, he told us, had given him the idea that his position would be strengthened if he had paintings by Picasso along with those of his regular painters. He had been making enough money so that he felt he could take that step. So Kootz came along as an outsider, but an outsider with a completely different motivation for buying: unlike the other dealers Pablo was in the habit of doing business with, he had no stock of Picassos, and he wanted Picasso as a kind of moral backing for his Americans. And so for both those reasons he could afford to pay Pablo's price. But Pablo didn't sell him a thing at the moment. He told him to come back in June and in the meantime he would think over what he wanted him to have.

When Kootz had gone, Pablo decided to use his offer as a lever with Kahnweiler. He told him, "Now I've got a dealer who's happy to pay my prices, even if you're not." Kahnweiler said, "That's all right with me. Maybe he can afford to. I can't." And he remained adamant. He did, however, arrange with Pablo to handle all the lithographs he was making at Mourlot's. Until now Pablo had pulled only a few artist's proofs of each zinc or stone. The print market was beginning to boom, especially in America, and under the terms of their contract Kahnweiler agreed to purchase the entire edition of fifty proofs of each of Pablo's lithographs. That represented a lot of prints and a lot of money. As a result, Pablo had less reason to think about selling paintings. He quite forgot about Kootz, in fact. But Kootz returned in June, as Pablo had suggested, and came to the Rue des Grands-Augustins. He saw a number of canvases that appealed to him. Pablo told him, in a general way, the new price structure-so much per point, according to size. Kootz was agreeable and would have liked to close a deal on the spot, but Pablo was

in no hurry. He said, "You come see us in the Midi a little later on and we'll talk about pictures down there. There's plenty of time." Soon after that, Kootz and his wife came to Golfe-Juan. He wanted to buy pictures, but Pablo was more interested in swimming. After a week or so, when Kootz must have begun to think he had come on a wild goose chase, Pablo said to him, "You go back to Paris and see Sabartés at my studio. He'll show you some canvases and you pick out the ones you want." Pablo then wrote to Sabartés, authorizing him to let Kootz into the atelier for the purpose of selecting the pictures he was interested in buying. Kootz went there and picked out a portrait of Dora Maar, rather tortured in form, from 1943; a very appealing still life with a teapot and some cherries, done in May 1943, just at the time Pablo and I met; another still life with a glass and a lemon; one of the series of the Bridges of Paris; a small, very graphic portrait of the daughter of the concierge at the Rue des Grands-Augustins, and two portraits of me, one of them in the spirit of La Femme-Fleur, but showing only the head.

Since Pablo's instructions were not very precise, Sabartés returned to Golfe-Juan with the Kootzes in their car and with the canvases. When they reached the house and Pablo saw the Kootzes with the canvases under their arms, he said to Sabartés, "But I didn't tell you to bring back the paintings. I meant that they could look at them and pick out what they liked—nothing more than that. The deal hasn't been completed. What are you trying to do, anyway?" All this in front of the Kootzes, whom we hardly knew. He went on to say things like, "My God, those pictures aren't even insured. Suppose they'd been stolen en route or you'd been in a smashup and they were ruined." And he continued to rave for what seemed a very long time, saying any number of mean and humiliating things.

Pablo had it figured out that Kootz would see the pictures, then come back to Golfe-Juan and discuss the price more in detail with him. Also, having seen Pablo operate with other dealers, I knew he would have preferred to hold out one or two of the pictures until the very end in order to make the transaction as difficult as possible. To have the Kootzes return with the pictures made it look as though the affair were practically sealed. Pablo didn't care to be put in that position; so for the time being, he refused to sell the paintings and kept them in Golfe-Juan.

In front of the Kootzes I kept silent, but after they left, while Pablo and Sabartés and I were eating I told Pablo I thought he had acted badly. By way of answering, he told this story:

"Max Jacob once asked me why I was so nice with people who didn't really matter and so hard on my friends. I told him I didn't care about the first group, but since I cared very much about my friends, it seemed to me I ought to put our friendship to the test every once in a while, just to make sure it was as strong as it needed to be."

Sabartés was not comforted. He left for Paris soon afterward. I don't think that ever in his life he was as badly treated as he was that day.

Later on, Pablo finally did sell some paintings to Kootz, and he crowed about it to Kahnweiler. That got Kahnweiler off the fence. He decided to start buying again and drew up a contract—at Pablo's price —by which Pablo agreed not to sell direct to any dealer other than Kahnweiler. But Pablo had grown rather fond of Kootz and from time to time he would say, "I'd like Kootz to have that painting." When Kootz came to call, Pablo would tell him to go to Kahnweiler and pick up the painting he had earmarked for him. He even made him a special price.

Occasionally Pablo even gave Kootz pictures directly, in return for some favor. One year he had Kootz ship to him, just before coming to France in June, a white Oldsmobile convertible, in exchange for a painting. That way he was able to tell Kahnweiler, "Oh, I gave him a picture because he sent me an automobile." I remember the Oldsmobile was exchanged for a large still life with a table on which lay a cock whose throat had been cut, the knife that did him in, and a dish containing the blood.

DURING THE SUMMER OF 1946, while we were sitting on the beach at Golfe-Juan one day with a group of people, someone had suggested to Pablo that he try his hand at ceramics, and told us about a pottery called Madoura, in Vallauris, run by a couple named Ramié. I don't remember whose idea it was. It was almost an anonymous suggestion, dropped on the sand during a conversation with a number of people, none of them particularly intimate friends. More out of curiosity than for any other reason, we drove over to the pottery one afternoon, and Pablo decorated two or three plates made of red clay that had already been fired—what is called biscuit—with a few drawings of fish, eels and

PART IV

sea urchins. He didn't take much of an interest in it because he didn't find the forms and materials they gave him to work with that day very appealing. He spent the afternoon there, just fooling around, and then we left. It was all very casual, almost like making a drawing on a tablecloth in a restaurant and then walking off and leaving it. He thought no more about it.

The following summer, 1947, we were again living at Monsieur Fort's house in Golfe-Juan, but this time, with a baby and a nursemaid under foot. Pablo was even less able than he had been the year before to settle down to any sustained work. He went back to the Musée d'Antibes for three or four days to make the triptych, Ulysses and the Sirens. But now that it was full of his work and beginning to function as a kind of Picasso museum, he couldn't very well go on working there any more; that chapter was finished. He went to all the bullfights within reach-always a sign of restlessness with him. Then, in August, Monsieur and Madame Ramié came onto the beach one day and asked him to drop over to the pottery and see the results of what he had done the year before. We went-again, mostly out of curiosity-and Pablo wasn't greatly impressed by what he saw. But he was so bored with his lack of consequential activity that before we left that afternoon he told the Ramiés, "If you'll give me a workman to help out with the technical side, I'll come back and work seriously." They were delighted.

The Ramiés were about forty and had come to Vallauris from Lyons. They had worked in one of the silk factories there, she as a designer, until the war finished off the silk industry. Life in Lyons was hard after that and food was scarce. Marshal Pétain's government had been encouraging urban people in such situations to go back to the land or into small trades or handcrafts. When the Ramiés came to Vallauris and opened their pottery, Madame Ramié applied her design experience to the new field and Monsieur Ramié handled the business details and worked on production with the help of three or four local people.

Monsieur Ramié was a quiet man, tall but slightly stooped. Madame Ramié was thin, of medium height, with chestnut hair and brown eyes. Monsieur Ramié seemed to fade into the background, content to let his wife run things. Although he was by no means unfriendly, he didn't appear to be making the slightest effort to influence or impress Pablo. Madame Ramié, on the other hand, seemed very enterprising. On our way home that day, Pablo asked me what I thought of them. I told him that I had no opinion of Monsieur Ramié—he was quiet and inoffensive—but that I didn't feel at all attracted to his wife.

The next day Pablo went to the L'Hospied chemical works in Golfe-Juan and talked with Mr. Cox, the head chemist, and found out all he needed to know about the properties of the enamels he was going to use. The next time he went to the Madoura pottery, he undertook his work in the medium as an artistic experiment.

He decided first of all that the forms of the vessels needed renewing and he set about redesigning them. He tried to create form by taking the amphora as his point of departure. Whenever you turn a form in pottery, that form is cylindrical. It can be made into an amphora, with convex and concave forms, but it is always symmetrical and each cut is a circular one. If you want to come up with forms that are not circular, that first form must be cut in some way other than parallel to its base. Either that or you have to make incisions on each side and afterwards fold them over. At first the potter who was helping Pablo made the folds but Pablo wasn't satisfied with them. He realized that the complex forms he wanted were difficult to achieve. The potter didn't know exactly what proportions to give them in order to execute Pablo's idea, which even Pablo could not always explain very well. After Pablo had had more experience, he decided to do the folds himself. When he did, the most wonderful things began to take shape in his hands. He would let the amphorae prepared for him by the potter dry overnight. The next morning the clay was still very plastic and could be twisted in every direction without being broken. With it Pablo began doing little statuettes of women as delicate as Tanagra. One didn't have the impression that these were water jars with arms added to make them look like women. He rekneaded the amphora completely and molded that hollow form, with its thickness of three millimeters, until it had been reinvented and emerged as one of his sculptures. He worked along with his material as far as its possibilities allowed him and then invented his own means from that point on. He then painted and partially glazed a number of pieces. Some of them are at the Musée d'Antibes. Many of them have the refinement of Chinese figurines.

At the beginning Pablo worked mostly with the forms before they had hardened, just as they came freshly molded or turned from the form or wheel. In that way he was able to incise them and paint them before they were fired at all—at least when he used engobes. An engobe is a clay of a different color from that of the form to which it is applied. It is thinned down with water and a kind of gum and then painted on. It always looks mat but it can be covered with a transparent or a colored glaze. But engobes limit the palette, as compared to enamels. The engobe is generally applied the day after the supporting form is made. In any case it can't be done after that form has dried. The drying, as a rule, takes from three to four weeks.

Enamels, on the other hand can only be applied to clay that has already been fired—biscuit. Enamels are powdered colored glass reduced to the consistency of a paste. When they are fired, they become glass again; therefore, they don't need a transparent glaze over them.

Before firing, none of the colors has the appearance it will have afterward. The local red clay, as you work it before the firing, is very dark; white clay, which the Ramiés had to order from Provins, is grayish. The colors as you apply them are gray, too. You know in an abstract sense what you are doing but you have no visual evidence of it. Mixtures of colors are just not done in pottery but Pablo, naturally, wanted to mix his. And in mixing colors, you have even less of a guide to the outcome than with pure colors. Also, he asked Mr. Cox at the chemical works if he could make him other colors beyond the range of those in common use. They experimented and Pablo wound up with a broader palette than had ever been used before. Some turned out well; others, not so well.

During the first two or three months Pablo worked every day, late morning and all afternoon, at the Ramiés. All during this period he worked on raw clay, without seeing any of the results. At the end of a month they were able to fire the first lot, to produce the biscuit, but that didn't show him very much because the true color doesn't appear until the transparent enamel-the glaze-has been added. The second firing, for the glaze, has to be done in an electric kiln, since the glazes are much more demanding than the clay. At that time the Ramiés had, I believe, only one electric kiln, about three feet square, and it couldn't accommodate many pieces at a time. It took about six weeks before Pablo was able to see for the first time the things he had done the very first day. Naturally he was disappointed. "Is that it?" he said. "That isn't at all what I was hoping for." He kept on experimenting but the results continued to disappoint him for about six months, until, working almost like a blind man feeling his way around, he found himself in the new medium.

The traditional wood-burning kilns require careful supervision. You have to begin with a small fire, heating the objects bit by bit, because if they lose too much moisture all at once, their forms become distorted, or even break. The low fire goes on for about twelve hours, followed by twenty-four hours of high fire. The experienced workers can

tell the temperature by the color of the flame. The kiln, which is as big as an average-sized room, is filled with the pieces to be fired, arranged on shelves one above another, and then the door is blocked with large earthenware pots, which, being hollow, provide a double wall. There are evenly spaced holes top and bottom. The flame comes up from beneath, is sucked through the holes, licks the pottery as it goes through, and moves out as smoke through the holes in the top. The flame is guite beautiful to watch. It moves like a person's breathing. The workers throw in four-foot boards to feed the fire through a small opening in the bottom. When the high fire takes over, the draft sets up a respiration that belches out flame through the little hole and then sucks it back inside again. The fire is red at first, then it turns orange and finally, at its maximum, it becomes white. When it has held its top heat for about twenty-four hours. the workers feed it less and gradually the temperature falls back. With the electric kilns, which are much smaller, the firing takes less time but they, too, have to be watched carefully, often all during the night.

The engobe doesn't run, in firing, but enamels do, of course; as a result. the forms the enamel will take can't be clearly foreseen. Each of the two techniques has its own advantages and drawbacks so Pablo combined them in order to draw the best from each of them and, insofar as possible, eliminate the disadvantages. He decided that when he put a glaze over the whole form or plate, it gave the work a very impersonal appearance and cheapened the composition beneath it, just as though you placed a handsome drawing under a sheet of glistening plastic. He tried to find glazes that would be more mat but when he did, they were less transparent. Then he tried putting the glaze on more thinly but that made it look as though something were missing, so he finally decided to put it on in some places and not in others. He made his drawings on the forms in such a way that they didn't cover the whole surface of the objects and he began to apply his glaze in a manner that gave added form to certain parts of the piece but not to others. The parts underneath the glaze were protected by it and at the same time it gave them added form. The other parts remained nude. When the plate was fired a second time, he colored the nude parts with black and earth tones and waxed the mat area. You can't wash pottery treated in that way but the results were a lot more pleasing than the standardized appearance of the all-over glazes. Since then a great many potters have taken up that method.

It occurred to me one day that it might be a good idea to polish the pottery with milk. Pablo dipped a rag in milk and rubbed some of his unglazed plates for hours until he finally got the effect he was after, the case in in the milk taking the place of the wax. Time and patience play such a large role in pottery that finally Pablo grew impatient with it. His main interest was in enlarging its borders and inventing what he needed in order to make it work for him. If he had had artisans of high competence at his disposal, he could have made pottery more beautiful than any we know but, unfortunately, he did not.

Then, too, the materials he had to work with were not really worthy of the decoration he was adding. After all, those clays were the ones that up until then had been used for ordinary, low-priced kitchen dishes. In China and Japan, pottery has always been considered one of the high arts; elsewhere, too. But to produce such pottery requires noble materials. There was nothing wrong with the clay itself, but it hadn't been given the treatment it should have had. Not only in China but even in the Midi a generation or two earlier, potters wouldn't have made so much as a casserole without-as they call it-"rotting" their clay for at least three years before using it. "Rotting" clay means exposing it to the open sky. Falling rain, running through the clay, drains any impurities toward the bottom, including the bits of limestone that are mixed in with raw clay. It is especially important to eliminate limestone because, once the pottery is fired, the clay doesn't expand further but whatever limestone remains in it does and, as a result, the pottery cracks after a few years. The tiny bits of limestone can't always be seen with the naked eye, and the only way to get rid of them is to expose the clay to the elements for at least three years. Ten years would be even better. The longer it is treated in that way, the finer it is. And not only porcelain is fine; ordinary pottery can be fine too. Instead of having four millimeters of thickness, it can have only two if it is properly made. But it can be worked in such thin forms only if it has lost all its impurities. Potters have to knead the clay, too, just as bakers knead their bread, and there again one must have time and patience. I wonder whether collectors will ever take to Pablo's pottery in the same measure that they have taken to his work in other media. After all, if he paints on a bad piece of canvas, it can always be rebacked. Even a fresco that is beginning to come away from its wall because of dampness can be applied to another surface. But with pottery there is no way of separating the decoration from the form to which it is applied. Many people have told me that although they admired the forms of some of his pottery, they have refrained from buying it for this reason.

But one way or the other, Vallauris has remained a boom town ever since. It was a pottery town even before Roman times, because of

its deposits of red clay. Wooden galleys setting out from Golfe-Juanthe nearest harbor to Vallauris—used to furnish the whole Mediterranean basin with cooking utensils. The natives claimed that in the red clay there was a bit of gold; hence the town's name, which means valley of gold. But nobody ever saw any of that gold; the chances are, the term was used in a metaphorical sense and referred to the thriving trade that resulted from the conversion of the local clays into pottery designed for some utilitarian purpose—what they call *la culinaire*, the sort of terracotta dishes that used to go into the ovens and onto the tables of most of the kitchens of France.

During the German Occupation Vallauris had a bit of a boom because the shortage of aluminum forced people to make more use of the old-time earthenware casseroles. After the war, business slacked off and where there had been one hundred or more potteries in the town's heyday, the number dwindled to about twenty and very few of those kept busy. The old business had fallen off to almost nothing as a result of technical advances in the field. That was the state of things when Pablo began working there. There were a few potters-no more than ten, perhaps-who had recently settled there, hoping to bring about some kind of artistic revival. Another ten, of the old guard, not knowing any other trade, continued to struggle along turning out the traditional cooking vessels. After Pablo had been working at the Madoura pottery for two years, there was such a revival of interest in the town and its industry that potters came from all over the country to set up shop there and Vallauris became one of the principal pottery centers of France. That brought in a good many changes, not all for the better. Before the boom all the potters had used wood-burning kilns, which limited the color range and based their effects on restraint and skill of handling. If they produced no great masterpieces, at least they produced no horrors either. The new crowd installed electric kilns, brought in the white clay from Provins instead of continuing to use the local red clay, and began turning out the horrors that line most streets in Vallauris today. Pablo's presence brought the town prosperity but his examples served no use whatever. Vallauris is today a citadel of bad taste.

"The thing that annoys me most," Pablo said one day, as we returned to *La Galloise* after a walk through the center of the town, "is not that so many people try to imitate my pottery. It's the fact that they feel called upon to do portraits of women that resemble you. It's bad enough having to look at these horrors all over town without having them covered with portraits of you that don't quite come off." BY THE END OF OCTOBER, Pablo had become so interested in pottery that he kept on working long after he had intended to stop. With the exception of a short trip to Paris we spent nearly the entire winter of 1947–1948 in the Midi so he could keep at it. Almost the only change of pace he had during that period was the work he did for the illustration of two books. The first was an edition of twenty poems of Góngora, for a Monte Carlo publisher. Pablo wrote out by hand the Spanish text. This was reproduced on copper by his engraver, Roger Lacourière, and then Pablo illuminated the margins with small drawings and etched twenty full-page plates. The etching process he used is called sugar aquatint and is a particularly interesting one, I discovered, as I watched him working on the plates Lacourière had sent down from Paris. First he melted a lump of sugar in a little hot water, then mixed into it a tube of black gouache and two tubes of gamboge.

"You've tried your hand at the ordinary etching process," he said. "You've seen how it's a fairly uniform procedure. You cover the copperplate with a layer of varnish. With your point you make furrows in the varnish in certain places, according to your composition, and then you submerge the plate in acid. The acid eats into the copperplate wherever it's been uncovered by the point. *The Metamorphoses* of Ovid that I did for Skira was done in that way. Then, when the varnish is removed, you apply the ink and wipe it off but some of it remains in the furrows eaten by the acid. When you print from the plate, you get your impression from the areas beneath the surface where the ink has remained.

"But with sugar aquatint everything is more direct and at the same time more sensitive. In the first place you paint with the brush directly on the copperplate. It's a tremendous advantage in that it brings you a richer, more pictorial effect with a good deal more variety to the touch. The important thing is to use a new brush, washed thoroughly with soap and water first. This process gives you more freedom too. You can even use fingers." And when he came to do portraits of the poet and of one of the women, his thumb went in, right behind the brush, to finish them off. One of the plates was a woman with a veil-like scarf around her neck. Pablo took a bit of lace, dipped it into his solution, and impressed it directly onto the copperplate to achieve that effect. From time to time the mixture ran out of bounds, and he had to clean it away with alcohol and Spanish white, followed by a bit of the sugar and water. He

worked on several plates at a time and when he had finished his drawing, he set them aside to dry.

"That's only the first stage," he said. "If we were in Paris, once the drawing was thoroughly dry, let's say in a couple of hours, I would varnish the plates and when the varnish dried, put each one into the acid. Here I don't have all the equipment I need, so I'll let Lacourière take care of that. If I had varnished them, you would have noticed that the sugar prevents the varnish from adhering; so wherever the sugar has passed, those areas are exposed and the acid eats into them. Then when you ink the plate and print, you get that impression in black, just as in any other kind of etching. That's the second step. After that, I sometimes find that here and there I haven't produced the effect I wanted. In that case, I sprinkle on resin in powdered form and, holding the plate with pincers and applying a candle under the surface, heat it until the little grains of resin burst.

"You can hold it over a little gas fire or an electric heater," he said, "but with a candle you can vary your effect from area to area much better. When you dip the plate into the acid bath again, all the little burst bubbles of resin protect those areas and the acid eats in between them where there is no resin. In that way you can bring out certain areas more clearly, and cause others to fall back into shadow, just as you protect others with varnish so that the acid doesn't penetrate. This technique has a far wider range of subtlety than ordinary etching. This is how Goya, in his Desastres de la Guerra, obtained those marvelous blacks which are never opaque. He used a great deal of acid, but each time he applied his resin. As a result, the black has a granulated, speckled effect, never flat and uniform but full of tiny white holes. This, you see, is why they refer to the engraver's cuisine. Etching is a lot of fun if you get deep enough into it. There are a thousand little ways of varying your effects. For example, you don't have to plunge the plate into an acid bath; you can brush in the acid where you want it and control it even more subtly that way."

He finished sliding his plates back into their carrying case. "I mentioned my illustrations for *The Metamorphoses* of Ovid a minute ago. I guess I never told you how that book came about, did I?" I said no, he hadn't. Pablo laughed. "When Skira was a young fellow he made his mother rather unhappy because he hadn't done very well in school. By the time he was twenty-two or twenty-three he didn't seem to be getting anywhere and his mother, who was a widow, didn't know what to do with him. He grew tired of having her ask him constantly what he was going to do with his life, so one day he blithely told her he was 174 going to be a publisher. She was surprised and asked him what he was going to publish. To quiet her down he said, 'I'm going to publish a book illustrated by Picasso.' Apparently that impressed his mother, especially since it was the first inkling she had had of his intention of doing any kind of work at all. She didn't want to discourage him so she suggested he go talk to me. He came to the Rue La Boétie and introduced himself. I asked him what he wanted. 'I want to publish a book with you,' he told me. 'What book?' I asked him. Apparently he hadn't reached that point and for the moment, in addition to Picasso, he could think of only one name. 'A book about Napoleon,' he said. I said, 'Look, I appreciate your good intentions, and I'm reasonably well disposed toward you, but I'll never illustrate a book about Napoleon because he's one person I have absolutely no use for. I might go along with you and illustrate some book-provided you've got enough money to foot the bills-but I won't go so far as to illustrate a book about Napoleon. Furthermore,' I told him, 'it sounds to me as though you know nothing about the publishing business. It might be a good idea for you to pick up a few notions of how such things are done. When you have, come back and see me.'

"I didn't see him again for a long time. I figured I had frightened him away. The next thing I heard from his direction came while I was spending the summer in Juan-les-Pins. One morning when I went outside the villa to take a walk, an old lady sitting on a bench across the street came over and introduced herself to me. It was Skira's mother. She said, 'Monsieur, my son has his heart set on becoming a publisher and he's made up his mind to publish a book illustrated by you. You've got to say yes.' I asked her what he had done since the last time I saw him. 'He hasn't done anything,' she said. 'He's only twenty-three.' I couldn't feel very optimistic about her son's prospects so I put her off but she kept up the vigil and finally she wore down my resistance. I began to feel sorry for that naïve old woman lying in wait for me to broach such a ridiculous idea. Finally I told her to send her son around and I'd talk with him again. But I warned her I didn't want to hear any more about Napoleon. I told her he should try a classical author-perhaps something mythological.

"The next time Skira showed up at the Rue La Boétie, he had the money to launch his affair and had set about familiarizing himself with what was involved in it. He said he had just the text for me—*The Metamorphoses* of Ovid. I said I thought he was right. So I did it. And that was the beginning of Skira."

That was Pablo's version of it, at any rate.

LOWARD THE END of the year Pablo had finished his Góngora and we returned to Paris, to stay a few weeks. One day he said, "Matisse has come back from Vence for a few days. We'll go see him." When we reached Matisse's apartment in the Boulevard Montparnasse, we found the door leading from the hall into the apartment partly open. It looked as though Lydia, Matisse's secretary, had gone to the floor above to fetch something and left the door open, perhaps planning to return almost immediately. We walked into the apartment. The first room, a kind of entrance hall, was rather dark. As we walked from there into the salon, out from behind a wall hanging popped Matisse, shouting, "Coo coo!" When he saw it wasn't Lydia, he looked so embarrassed that I felt sorry for him. Not Pablo, though. He looked Matisse up and down with a satisfied smile and said, "Well, I didn't know you played hideand-seek with Lydia. We're used to hearing Lydia call you Monsieur Matisse." Matisse tried a laugh, rather weakly. Pablo didn't let him off that easily.

"The last time we saw you, in the Midi, you were so taken with the fact that Françoise's eyebrows reminded you of circumflex accents, you wanted her to pose for you," he said. "It looks to me as though you were doing all right with Lydia's." It seemed hardly the moment to make an extended visit so in a few minutes we left. Going down in the elevator Pablo said, "It's unbelievable, catching Matisse at a thing like that."

Lydia, according to Pablo, had first come to Matisse in 1932 or 1933. "Matisse didn't need anyone full-time," he said, "but she told him she'd make herself useful by sharpening his pencils. He found that a practical suggestion so he told her she could stay, for a while anyway, on that basis. Finally Madame Matisse found it a little tiresome to have that young girl coming around every day. She gave him his choice: 'Choose between that girl and me.' Matisse thought it over carefully and after two days of sober reflection told Madame Matisse, 'I've decided to keep her. She's a big help to me in preparing my income-tax returns.'

"After a great deal of wailing and gnashing of teeth, Lydia was installed as the official secretary." Pablo shook his head. "There's a Frenchman for you—always practical." A BOUT TWO YEARS EARLIER Tériade had asked Pablo to illustrate Pierre Reverdy's poem *Le Chant des Morts*. Tériade knew that, in general, bibliophiles don't care much for the kind of book that is a facsimile of the author's manuscript, but Reverdy's handwriting was so distinctive they had decided to do it in that form anyway. Tériade submitted the idea to Pablo and asked him what kind of illustration would be most appropriate. Pablo asked him to send along some samples of Reverdy's handwriting. Studying them, he decided that he couldn't do any kind of figurative illustration because the handwriting was too curved and rhythmical. "It's almost a drawing in itself," he said. His idea then became to decorate that drawing—Reverdy's manuscript—in some appropriate manner. "In that way the illustration will be organic and the unity of the book that much more complete," he explained.

Several years before. I had gone to see the illuminated manuscripts in the library of the Medical School at Montpellier. The oldest ones date from the eighth century and have large ornamental initial letters in red, beautifully refined in their abstract form. I described them to Pablo and suggested he pattern his illustrations after them. He made a number of drawings and three lithographs at the time, exploring the idea, then did nothing more about it. One day that winter, two years after those first experiments, Lucien Scheler, a rare-book dealer in the Rue de Tournon, brought Pablo three large illuminated manuscripts. Two of them were music books dating from the fifteenth century. The third volume, a folio like the others, was much older. The body of the text was written in the usual black Gothic script but the initials were very large ornamental letters painted in red and abstract in form. It showed a definite Arabic influence and reminded me very much of some of the manuscripts I had seen at Montpellier. Pablo was quite taken with it and bought it. He went back to work almost at once on Le Chant des Morts, with the idea of utilizing the margins of Reverdy's manuscript for large abstract decorations in red, done in lithography.

We returned to the Midi soon after and Mourlot brought down the required number of zinc plates. At such a distance transfer paper would have been simpler, but the results are never quite so good, so Pablo had decided to do the illustrations on zinc, since it would have been practically impossible to transport that many stones. Mourlot had indicated on the plates the area taken up by Reverdy's text so Pablo

could see exactly how much space remained for him to illuminate each page. Since Pablo still had no atelier, Mourlot brought the plates to the Ramiés' and in the long room on the second floor which they used for drying the pottery, Pablo spread out all the plates on the floor and painted in lithographic ink directly on the zinc. All in all, it took him about two weeks. There were four plates left over and on those he drew a few fauns in black ink. Mourlot packed them all up and took them back to Paris.

Reverdy was spending a few days with Tériade at St.-Jean-Cap-Ferrat, and he came to the pottery one day. The Ramiés prepared a few forms for him and he inscribed them with some of his poems. After he had left, Pablo told me that, in a way, Reverdy was responsible for Tériade's fortune. Tériade was Greek, of course, and first of all he went to work for Zervos. He wrote art criticism for Zervos's magazine, Cahiers d'Art, and did a book on Léger. Because Zervos was Greek, too, they didn't get along very well, and Tériade was happy to leave Zervos and go with Skira at the time they founded the surrealist review Minotaure. He came to know all the surrealists, had much useful publishing experience and, in a measure, helped put the review across. Still, he wasn't his own boss. Not long before the war, Reverdy, who was very friendly with Coco Chanel, met, through her, some Americans who wanted to launch a luxurious art review. They were looking for someone with enough taste to do it properly, someone who had good contacts with the best poets and writers, painters and sculptors. Reverdy proposed Tériade. Through that contact Tériade found freedom of action and financial backing far greater than anything he had had until then. The result was Verve. He always felt very grateful to Reverdy. Le Chant des Morts was a kind of token of that gratitude; hence their indifference to its commercial handicaps.

SOON AFTER PABLO HAD COMPLETED Le Chant des Morts, Miró came to spend two weeks at Vallauris. He wanted to see Pablo and also to investigate the possibilities of working at the Madoura pottery. He worked a little at the pottery and whenever he was there we had lunch or dinner with him. I have always noticed that in general painters are great talkers in their off hours but I was surprised to see that Miró, in spite of a constant angelic smile and a jovial, attentive manner, was so reserved as to appear almost mysterious. He said nothing about himself or his plans and gave out no clear-cut opinions about anything or anybody. Pablo talked very freely and Miró seemed quite happy to let him talk for both of them. He confined his own intervention to a sort of oral punctuation—"Yes?" "Oh?" "Is that so?" "Really?"—around which Pablo's talk could flow, gently encouraged but totally unimpeded. After two weeks of visits, lunches, and dinners I knew no more about Miró than I had known on the day he arrived in Vallauris. I asked Pablo if Miró had always been that way or if he thought he had some particular reason now for not opening up, at least occasionally. It struck me as all the more puzzling, I told him, since Miró's general attitude seemed one not only of cordiality but of the warmest kind of friendship.

Pablo laughed. "If you went on seeing Miró every day for the next two years, you wouldn't know any more about him then than you do now," he said. "Like all Catalans, Miró is the most cautious of men. At the height of the surrealist movement, when the big demonstrations were going on, everyone was supposed to do something scandalous, to throw mud in the collective bourgeois eye. It was considered a major achievement to do something outrageous right out on the street, in sight of everyone and, as a result, be arrested and perhaps spend a day or two in jail for having committed an affront to the established order. Everybody was cudgeling his brain for some original way of setting himself up in opposition to the reign of triumphant bourgeoisie. Some of the group hit on the idea of having people go out onto the street with various kinds of subversive utterances. Robert Desnos, for example, was supposed to say, 'Bonjour, Madame,' to a priest down in the subway within hearing of as many people as possible. Michel Leiris, whose father or uncle or cousin was an official at the Prefecture of Police, was assigned to insult policemen until he succeeded in provoking one into arresting him. He got drunk first, then started out on his bicycle and when he came across a policeman on duty he shouted abusive names at him. He was soon taken to a police station and there he kept it up so courageously that he was given a thorough beating and held for forty-eight hours. Since he's rather frail, when he came out after his two days he was in terrible shape, but guite a hero. Eluard went around shouting. 'Down with the Army! Down with France!' in some public square. He got roughed up, too, and then dragged away to cool off in jail. Everyone carried out his assignment with exemplary zeal. Miró, too, was expected to justify his presence in

the group in some manner. So what did he do? He went around declaiming politely, 'Down with the Mediterranean.' The Mediterranean is a pretty big, indefinite area, with so many countries along its shores that no one of them could take it very much to heart if the Mediterranean itself was being attacked, and so politely, at that. As a result nobody rose to its defense and 'Down with the Mediterranean' was the only outrage that went unpunished. Everyone else in the group was pretty disgusted with Miró when the results were all in. 'Why did you say that?' he was asked. 'That doesn't mean anything.'

"'Oh, yes, it does,' he said. 'The Mediterranean was the cradle of our whole Greco-Roman culture. When I shouted "Down with the Mediterranean." I was saying, "Down with everything we are today."'"

Pablo had shown me several early Mirós the day we visited his vaults at the B.N.C.I.—the self-portrait that everyone knows, one version of *The Farm* (of which Hemingway had another), and a *Catalan Peasant Woman*. I told him that up to a certain point I admired Miró's work, especially what he had done between 1932 and 1940 but after that, his inspiration had seemed to me to run out. I said that even if one liked Miró, one couldn't pretend that his was the painting of a seer, like Klee's, for example.

Pablo laughed. "Miró's been running after a hoop, dressed up like a little boy, for too long now."

ONE MORNING, SOON AFTER Miró had left, a special-delivery letter arrived from Kahnweiler in Paris. Enclosed with Kahnweiler's letter was a cable from New York.

We had been hearing wildly fantastic stories about American congressmen fulminating against modern art as politically subversive the kind of rabble-rousing speech that Hitler used to make in the thirties and that the Russians go in for now—the only difference being that the American congressmen saw it all as part of a Communist plot and the Russians call it "bourgeois decadence." The resistance to the lunatic fringe on this American subcultural front apparently centered about the Museum of Modern Art in New York and the cable was a real *cri du coeur* from the stoutly pumping heart of that center of resistance. It was signed by the painter Stuart Davis, the sculptor Lipchitz, and James Johnson Sweeney, at that period director of painting and sculpture at the museum. It was addressed to Pablo in care of Kahnweiler's gallery and read:

SERIOUS WAVE OF ANIMOSITY TOWARDS FREE EXPRESSION PAINTING SCULPTURE MOUNTING IN AMERICAN PRESS AND MUSEUMS STOP GRAVE RENEWED PRESSURE FAVORING MEDIOCRE AND UTILITARIAN STOP ARTISTS WRITERS REAFFIRMING RIGHTS HOLD MEETING MUSEUM MODERN ART MAY FIFTH STOP YOUR SUPPORT WOULD MEAN MUCH TO ISSUE COULD YOU CABLE STATEMENT EMPHASIZING NECESSITY FOR TOLERATION OF INNOVATION IN ART TO SWEENEY 1775 BROADWAY

Attached to the message was a prepaid reply voucher. I translated the cable for Pablo and then read him Kahnweiler's letter. Kahnweiler had read the cable before forwarding it—"delirious" was his word for it. As far as the mounting wave of animosity toward free expression in art was concerned, Who cares? Kahnweiler asked; nobody worries about people like that, he said. On the other hand, maybe he was wrong and Pablo would feel it *was* necessary to emphasize the necessity for the toleration of innovation in art.

Pablo shook his head. "Kahnweiler's right," he said. "The point is, art is something subversive. It's something that should *not* be free. Art and liberty, like the fire of Prometheus, are things one must steal, to be used against the established order. Once art becomes official and open to everyone, then it becomes the new academicism." He tossed the cablegram down onto the table. "How can I support an idea like that? If art is ever given the keys to the city, it will be because it's been so watered down, rendered so impotent, that it's not worth fighting for."

I reminded him that Malherbe had said a poet is of no more use to the state than a man who spends his time playing ninepins. "Of course," Pablo said. "And why did Plato say poets should be chased out of the republic? Precisely because every poet and every artist is an antisocial being. He's not that way because he wants to be; he can't be any other way. Of *course* the state has the right to chase him away—from *its* point of view—and if he is really an artist it is in his nature not to want to be admitted, because if he is admitted it can only mean he is doing something which is understood, approved, and therefore old hat—worthless. Anything new, anything worth doing, can't be recognized. People just don't have that much vision. So this business about defending and freeing culture is absurd. One *can* defend culture in a broad, general sense, if you mean by that the heritage of the past, but the right to free expression is something one seizes, not something one is given. It isn't a principle one can lay down as something that should exist. The only

principle involved is that if it does exist, it exists to be used *against* the established order. Only the Russians are naïve enough to think that an artist can fit into society. That's because they don't know what an artist is. What can the state do with the real artists, the seers? Rimbaud in Russia is unthinkable. Even Mayakowsky committed suicide. There is absolute opposition between the creator and the state. So there's only one tactic for the state—kill the seers. If the idea of society is to dominate the idea of the individual, the individual must perish. Furthermore, there wouldn't be such a thing as a seer if there weren't a state trying to suppress him. It's only at that moment, under that pressure, that he becomes one. People reach the status of artist only after crossing the maximum number of barriers. So the arts should be *dis*couraged, not *enc*ouraged.

"The thing that's wrong with modern art right now," he said, "and we might as well say it—it's dying—is the fact that there isn't any longer a strong, powerful academic art worth fighting against. There has to be a rule even if it's a bad one because the evidence of art's power is in breaking down the barriers. But to do away with obstacles—that serves no purpose other than to make things completely wishy-washy, spineless, shapeless, meaningless—zero."

Pablo studied the prepaid answer form. "Well," he said, "they wasted their nine hundred and thirty-eight francs on me." He tossed it into the basket.

A NTHE FALL OF 1944, at the time of the big Picasso retrospective at the Musée d'Art Moderne in Paris, Jean Cassou, the museum's chief curator, had dropped several broad hints to Pablo that were obviously designed to stir him to an act of generosity. French museums had almost no Picassos, Cassou pointed out, whereas the Museum of Modern Art in New York had quite a few of his major works, including *Guernica*, which had been sent there originally for a temporary exhibition but now, years later, were still there. Pablo brushed him aside by saying that when war broke out, he had felt those paintings would be safer in New York than in Paris, and since then he just hadn't gotten around to doing anything about them. He wasn't in a giving mood, to begin with. Then, too, whenever anyone tried to influence him directly to do something, he generally preferred not to do it. And in that frame of mind he was just perverse enough to consider Cassou's left-wing political sympathies as one more strike against him, even though he himself had just joined the Communist Party. So nothing happened.

After Pablo had finished his work at the Musée d'Antibes, in the fall of 1946, and just walked away leaving it there behind him, the museum's curator, Dor de la Souchère, and Marie Cuttoli talked of organizing a fund-raising campaign to pay for restorations which would make the museum a more fitting home for its new treasures. As their plans advanced, they were told it would be easier to raise the money if Pablo would officially donate to the museum the works he had so ambiguously left there.

One evening the next summer as Pablo and I were dining with the Cuttolis at the restaurant *Chez Marcel* in Golfe-Juan, Monsieur Cuttoli explained the situation and suggested that Pablo make the gift official. Unfortunately he didn't stop there. "Furthermore," he said, "you've lived here so long now, you ought to take out French citizenship. If you did, you could get your divorce and marry Françoise. After all, you've got a child now."

Pablo exploded, "I invite you here as my guest and you dare say such things to me! Of course I left those paintings at the museum; but what gives anybody the right to start talking about gifts and donations? Since everybody is so fond of quoting that remark of mine, 'I don't seek; I find,' I'll give you a new one to put in circulation: 'I don't give; I take.' And as for your idea about changing my nationality, I represent Spain in exile. I'm sure Françoise wouldn't approve of my changing that any more than I do. I think she understands that she and our son come after republican Spain in my scale of values. And you ought to understand right now that I have no intention of submitting my life to the laws that govern the miserable little lives of you petits bourgeois."

The food we were eating seemed to have stuck in our throats. No one spoke. Pablo glared first at one, then at another.

"Well, why don't you eat?" he shouted. "This food isn't good enough for you? My God, the stuff I get at your house sometimes! But I eat it anyway, for friendship's sake. You'll have to do the same. You're my guest." Pablo was all out of control now, beating his feet up and down on the floor and rolling his eyes like a hysterical woman. No one answered him. He stood up, picked up his plate, and hurled it into the sea.

Marie Cuttoli may have seen him perform that way before, but her husband certainly had not. He was a Corsican lawyer, a French senator and, for all that, almost an English gentleman. Whereas Pablo was dressed in shorts and the usual sailor's jersey, Monsieur Cuttoli, in spite of the oppressive heat and his great bulk, was wearing an impeccable starched white suit. I think Marie feared that if Pablo was allowed to go on in that vein, her husband's collar—perhaps even a blood vessel —would suddenly pop. She reached over to Pablo and laid her hand on his arm.

"Cher ami," she said soothingly, "you mustn't let yourself get into such a state. We're all your friends—remember that." She pulled him down into his seat, leaned over, and kissed him. I knew that she didn't really feel all that tender toward him in the face of that kind of behavior but that she realized things would go from bad to worse if she didn't act quickly. And so for the same reason, I went over and kissed him, too. Pablo kissed us both perfunctorily and made an effort to smile. He got up, calmer now, and kissed Monsieur Cuttoli, who, fat and bald, had been growing redder and redder and looked about ready to explode, himself. Pablo's kiss slowed him down and we finished the dinner talking of other things than donations and divorce.

But Marie did not give up her plan that easily. She was a good friend of Georges Salles, the Director of French National Museums. He used to come see us fairly often and one day, primed by Marie, he came to talk with Pablo about formalizing his "gift" to the Musée d'Antibes. Pablo was very polite to him but just as categorical in his refusal. A little later on, Dor de la Souchère made an attempt to revive the discussion. Pablo closed it promptly.

Monsieur Cuttoli, being a lawyer, was finally able to satisfy the authorities and Pablo, too, by saying that since Pablo had left his works *in situ* and had even gone so far as to add to them a certain number of drawings and ceramics done later and elsewhere, he had "clearly manifested his intention" of making a gift. Pablo, always a good Jesuit, found that phrasing adequately ambiguous and agreed, orally only, that it stand as a statement of the case. Marie's out-and-out gift to the Musée d'Antibes of Picasso etchings, lithographs, and tapestries doubtless helped reinforce the general impression that everything had been given.

After a discreet interval, Georges Salles brought up again the question of pictures for the Musée d'Art Moderne. He was sorry that Picasso was so poorly represented in their new galleries. Of course, since French museums had such tiny allotments for purchases, there wasn't much *he* could do, he said. He didn't come right out and ask for anything but what he wanted was obvious. "It was certainly generous of you to give all those things to the Musée d'Antibes," he added.

Pablo looked surprised. "Give? I didn't give them anything. I just painted some things there, and I'm letting them use them, that's all."

"No matter," said Georges Salles. "The paintings are there. That's what counts. And think how badly off we are in Paris, by comparison. We have that early portrait of Gustave Coquiot and not much more. It's a pity but we just don't have the means to do anything about it."

Georges Salles was the grandson of Gustave Eiffel, the man who built the tower, and for all Pablo's railing against the petit bourgeois, he was generally very susceptible to the charm and class of a grand bourgeois. I could sense that his resistance was weakening. One day as he moved some things around in the atelier at the Rue des Grands-Augustins, he said, "I don't know what to do with these big canvases. There are too many of them here. They clutter up the studio and they're too big for the vault. Where can I put them?" He was particularly annoved with a large painting of 1942 called Serenade, which he kept on a big easel. Its presence there prevented him from getting at a new large canvas that he wanted to work on at that easel. In the apartment in the Rue la Boétie he kept another very large painting, of 1926, called The Milliner's Workshop, a rather abstract, rhythmical canvas, very baroque in its construction, situated almost at the frontier between the neo-Cubist period and the period which begins with the portraits of Marie-Thérèse Walter.

Pablo had heard rumors that his apartments in the Rue La Boétie might be requisitioned for nonoccupancy and he had been wondering what he would do with this large canvas in that event. I reminded him of Georges Salles's visit, and asked him why he didn't give at least those two big canvases to the museum. He was in a very receptive mood. He thought for a minute, then said, "I could give them those two, I suppose." Then he thought a minute more. "On the other hand," he said, "maybe what Georges Salles meant was that they would like to buy something if it wasn't too expensive, but I can't sell them things like that. They're too big. They'd never have enough money to buy them."

I pointed out to him that Braque and Matisse would be well represented in the rooms the museum was planning to devote to them, and that he'd be far better off, while he was at it, to do a complete job for himself: select a group of paintings which showed enough different aspects of his work so that he, too, would be properly represented. Besides, I reminded him, we had heard that Braque had arranged a deal

whereby he gave the museum some paintings and sold them others and in the end the tax collector had wound up with most of the cash involved, so wouldn't it be better, I suggested, for Pablo to give all of his?

"My, you've developed quite a head for business, haven't you?" he said half-admiringly; then suspiciously, "But why are you so interested in getting these pictures into the museum?" I told him that since he had set me such a splendid example of patriotism at that dinner with the Cuttolis *Chez Marcel*, I thought I ought to show him how much I thought of my country.

He pondered the idea over the next month and then decided he would give the museum ten paintings: the two large ones plus eight others. We went one day to his vault at the bank and selected the others.

To go with *The Milliner's Workshop* and *Serenade*, we picked out a gray-and-white seated figure from 1937–1938, the handsome *Blue Enamelled Casserole* of 1945, *The Rocking-Chair* of 1943, *The Muse* of 1935, a 1936 still life with a lemon and oranges, another still life, of 1943, with three glasses and a bowl of cherries, a 1944 portrait of Dora Maar in blue, and an earlier, very colorful portrait of her done in 1938.

Although the pictures would eventually go to the Musée d'Art Moderne, Georges Salles had them taken first to the Louvre, where his offices were. One morning he called and suggested we come there on Tuesday, the day it is closed to the public. He had an amusing experiment he wanted to try. He said he would have some of the guards carry Pablo's paintings around to various parts of the museum so that he could see how they looked next to some of the masterpieces of other times. "You'll be the first living painter to have seen his work hung in the Louvre," he said.

The next Tuesday morning Pablo was up very early for him, and by eleven o'clock we were ready for the Louvre. He seemed more serious than usual and talked little. Georges Salles took us high up in the Louvre to a huge storage room where Pablo's paintings were being held. There was almost nothing else in the room except a large piece of dirty, worn-looking cloth that covered most of the floor. The guards picked up Pablo's paintings, all except the two very large ones, and we set off across the cloth to try the experiment. All of a sudden, Georges Salles looked panic-stricken. "But you're walking on my Delacroix ceiling," he said. "Get off, for God's sake." Delacroix's immense canvas had become damp-stained and had been taken down for drying and restoration. It was upside down so that the painting wasn't visible. When we reached the picture galleries, Georges Salles asked Pablo what paintings he would like to see his own hung with.

"First of all, with the Zurbarán," Pablo said. We found our way to Saint Bonaventure on his Bier, which shows the dead saint surrounded by those who have come to pay their last respects. The saint's body cuts across the painting from lower left to upper right. Pablo had always been fascinated by this bold diagonal composition and the way in which Zurbarán had been able to balance that with the other lines of force in the painting. He had often taken me to the Louvre to study it with him. He watched attentively as the guards lifted up three or four of his pictures and held them beside the Zurbarán but he said nothing. He then asked to see some of his paintings beside Delacroix's Death of Sardanapalus, The Massacre of Chios, and The Women of Algiers. He had often spoken to me of making his own version of The Women of Algiers and had taken me to the Louvre on an average of once a month to study it. After we had watched the guards parade his pictures among the Delacroix paintings, they held up one or two against Courbet's The Studio and Burial at Ornans. Then Georges Salles asked Pablo if he wanted to see any of his paintings among the Italian School.

He thought for a moment. "The only one that would interest me." he said, "is the Uccello—*The Rout of San Romano*. And I'd like to see one of my Cubist paintings alongside that. Since we don't have one handy, I guess that's enough for today." As we walked away, he made no comment of any kind. When we got home again, he said only that he'd been particularly interested to see a painting of his next to a Zurbarán. He seemed satisfied with the experiment.

I asked him how he felt about the Delacroix. His eyes narrowed and he said, "That bastard. He's really good."

HEN WE WERE IN PARIS we often ate at the Brasserie Lipp at St.-Germain-des-Prés. If Pablo felt like relaxing, there were other artists who came there with whom we could sit and talk. The sculptor Giacometti was one of his favorites. Whenever we saw him at Lipp's in the evening, clay seemed to be sticking to him, and his clothing and his hair were generally covered with a gray dust.

"You ought to see Giacometti's atelier," Pablo said to me one evening. "We'll go call on him." As we were leaving, he asked Giacometti what would be a good time to find him in.

"If you come anytime before one in the afternoon, you'll be sure to find me," he said. "I don't get up much before then." A few days after that, on our way to lunch, we went to Giacometti's studio, in the Rue Hippolyte-Maindron, a pleasant little street in the Alésia district. It is a quiet, humble quarter with small bistros and craftsmen's shops and an air of timelessness and bonhomie that has been lost in many parts of Paris. To get to Giacometti's studio we passed through a door off the street into a little yard with small wooden ateliers up and down both sides. Pablo pointed out to me Giacometti's two adjoining rooms and, on the other side of them, another atelier where Giacometti's brother Diego was working. Diego, a very gifted artisan, devoted himself entirely to his brother's work. Giacometti often worked late at night, making clay studies for sculpture. The next morning he might be inclined to destroy them if they didn't satisfy him, but Diego would get up when his brother went to bed and start molding plaster casts and doing all the other technical jobs that his brother had little interest in, to advance and preserve the work. He was the intermediary between Giacometti and the bronze-caster.

Giacometti was well known and respected for many years before he ever managed to make a decent living. Diego did the work that one or two assistants would normally have done—assistants that Giacometti was in no position to afford. Diego also made very handsome objects designed by his brother—table-lamp bases, floor lamps, doorknobs, and chandeliers—which helped support them. When Giacometti began to do as much painting as sculpture, Diego became one of his principal models —almost a full-time job in itself because Giacometti always worked tirelessly through sketches from life and when he did a portrait, his model had to be there.

When we went into Giacometti's atelier, I was struck by the degree to which the physical aspect of the place recalled Giacometti's painting. The wooden walls seemed impregnated with the color of clay, almost to the point of being made out of clay. We were at the center of a world completely created by Giacometti, a world composed of clay and peopled by the statues he had made, some very elongated, others so tiny as to be hardly visible. There was never the slightest color accent anywhere to interfere with the endless uniform gray that covered everything. Seeing Giacometti now on his home ground, I realized that since every object in his atelier—brushes, armatures, bottles of turpentine had taken on that coloration, there was no way he could have escaped the same fate. The little room adjacent to the atelier was just like it, with the addition of a gray divan, gray because all its color had been drained out of it.

About a year after that first visit, a sweet young Swiss girl named Annette came to see us one day because she wanted to be Pablo's secretary. Pablo turned her request into a pun. "To be a good secretary you have to know how to keep people's secrets," he told her. "But why should anyone be foolish enough to tell his secrets? On the other hand, if he has no secrets, he doesn't need a secretary." He had no work for her and took that way to tell her. Not long after, she became Giacometti's wife. She fitted in beautifully with the tonalities of his atelier. Her face, which was already very white, became even whiter. But two features added black touches to the background: Annette's eyes and hair. With Annette, Giacometti acquired a second shadow. She became a second untiring model, capablc, like Diego, of working all night if Giacometti felt like working, and then sleeping in the daytime to make up for it.

With some couples one notices that after a number of years the partners begin to resemble each other. Physically Annette did not resemble Giacometti at all. She was slender and pale with regular features; he had a large head and a deeply furrowed face, with the strength and nobility of the head of a lion. But in spite of Annette's frail body she came to take on a rugged leonine quality in her bearing, along with the same proportions that Giacometti was giving to his delicate and slender statues: the perfect canon that Giacometti had imagined in his sculpture.

One of Giacometti's chief preoccupations, he explained to us, was to discover the particular accent or relationship that enables us to identify a person we know off in the distance—to realize that it isn't just a man or a woman, but one particular man or woman.

"A man far away has no more individuality than a pin if we don't know him," he said. "If he's someone we know, we recognize him and he assumes an identity for us. Why? It's the relationship between his masses and quantities. If he's hollow-eyed, the shadows on his cheeks are longer. If he has a large, bold nose, there's a stronger patch of light in that spot, and he's no longer the anonymous pin. So it's the sculptor's job to make those humps and hollows create an identity by highlighting the essential points that tell us this is one person rather than another."

Giacometti's statues are generally quite static, in the sense that their arms are alongside the body and the legs touch without a suggestion of walking, as a rule. But whenever I saw them there, in that claygray studio, perhaps because of their widely varying dimensions. I had the impression that they were all in movement, all coming toward me or going away from me. A little later on, Giacometti began to think more of the street, he told us, and to make statues of a man on a bronze plaque seeming to walk forward between two other bronze plagues representing houses. One can't speak of arrested movement in connection with those pieces because it is really the contrary. It is almost something static in process of becoming dynamic through its intention. One gets the feeling of life or movement because of the exceptional acuity of Giacometti's sense of proportion. He makes us feel that his people are in motion, not by imitating any kind of gesture, but by the proportion itself and by the elongation of the material. One of his sculptures portrayed a person entirely static but on a chariot with wheels. It was movement and at the same time the opposite of movement.

Whenever Giacometti came to the Rue des Grands-Augustins to see Pablo, they would discuss in the minutest detail whatever sculpture Pablo might be working on at the moment. One day Pablo seemed particularly pleased with a sculpture he had completed by incorporating in it a separate object with a life and identity of its own: the five-foot-fourinch female figure, one of whose forearms had been formed by the addition of an Easter Island sculpture ending in a hand. Giacometti studied it and said, "Well, the head is good, but perhaps you shouldn't leave the rest of it like that. Is that really what you intended to do? It seems to me it's more important for the work to exemplify the principle that's behind it than to benefit from some lucky accident. Better to get rid of the lucky accident, which is nothing more than that, and work up to the point where you can see that you've finished the thing in accordance with its generating force."

Of all those who came to the Rue des Grands-Augustins I think Giacometti was the one with whom Pablo felt most inclined to discuss such matters, because Giacometti's preoccupations were never exclusively aesthetic. As Pablo pointed out, Giacometti was always asking himself fundamental questions to clarify the real point of what he was doing.

"Most sculptors are concerned with questions of style," Pablo said, "something that doesn't change radically the heart of the problem." Giacometti, he felt, often did succeed in changing something at the heart of the problem, something basic to sculpture as a whole, and that gave his work the unity Pablo admired in it.

"When he makes those sculptures like people crossing the street, going from one house to another, you can't help saying that these are people who are walking in the street and that you're at a certain distance from them," Pablo said. "Sculpture with Giacometti is the residual part, what remains when the mind has forgotten all the details. He's concerned with a certain illusion of space that is far from my own approach but it's something no one ever thought of before in just that way. It's really a new spirit in sculpture."

DURING THE SUMMER OF 1947, I had a new view at first hand of Pablo's wife, Olga. I had met Olga for the first time about a month after I went to live with Pablo in the Rue des Grands-Augustins, shortly before we left Paris for Ménerbes. He and I had gone to see an exhibition of Dora Maar's paintings at Pierre Loeb's gallery. We had just left the gallery and were turning from the Rue de Seine into the Rue Mazarine when a small, middle-aged woman with red hair and a thin, tight mouth, walked up to us. It was Olga. Pablo introduced me to her. I had noticed, as she approached, that she walked with short, stiff steps like a little circus pony. Her face was freckled and crinkly and her bright brownish-green eyes darted everywhere as she spoke but never looked at you directly. She repeated everything she said, like a broken record, and when she paused, you realized she hadn't really said anything. As soon as I saw her, I could tell she was extremely neurotic, at the very least.

I didn't figure out until later that she must have been waiting outside the gallery, angry at the idea that Dora Maar, whom she still considered her most serious rival—although Pablo had left Olga more than ten years before and not because of Dora Maar but for Marie-Thérèse Walter—was having an exhibition and that Pablo was probably there. When she saw him leaving the gallery with someone other than Dora Maar, she must have felt relieved, because she made a certain amount of small talk with us, was fairly pleasant, and gave little indication of living up to Pablo's descriptions of her. But once she had had

a chance to make inquiries about me and learned that I was, in fact, the one who had taken Dora Maar's place, she changed her tactics radically. The obsessive hatred she had been bearing Dora Maar quite unjustly, she transferred to me.

Although she hadn't lived with Pablo since 1935, she had formed the habit of moving around France in his wake. When he was in Paris, she came to Paris. When he went to the Midi, she followed him there, always living in a hotel not very far from wherever he might be staving. I didn't see her in the Midi in the summer of 1946. I think that she was not yet aware of my role. But as soon as Claude was born she became very familiar with all the details of our life together and from then on she didn't let us rest for a minute. In the summer of 1947, whenever we went to the beach-and Paulo, her son, was often with us-she would come sit down close by. First she would start talking to Pablo. He would ignore her or even turn his back. Then she would start in on Paulo: "Well, Paulo, you see that I'm here and I want to talk to your father. I must talk to him. I have something of the highest importance to tell him. I don't know how he can go on pretending I'm not here because I am here. For God's sake, get up and go tell your father I'm here and I must talk to him." Paulo would ignore her. Then she would move closer to Pablo and say, "I must speak to you about your son." Getting no reply, she would turn again to Paulo and say, "I have to talk to you about your father. It's very urgent." Often it was that her hotel bill hadn't been paid and she would threaten Pablo with bodily harm if he didn't take care of it at once.

She began to follow us in the street. One day she became so violent in her language as she pulled at Pablo's arm for attention that he turned around and slapped her face. At that she began to scream. The only way he could get her to calm down was to say, "If you keep this up, I'm going for the police." Then she quieted down and dropped back to a distance of three or four yards but kept on following us wherever we went. I found her behavior most unpleasant but I could never feel antagonistic toward her. She was a very unhappy, unfortunate creature, incapable of coping with the situation in which she found herself. I have never seen a more solitary person than she. Everyone avoided her. People were afraid to stop and speak to her, knowing what they would be letting themselves in for.

The first year or so, Olga made no direct attack on me. She limited herself to following us wherever we went and threatening Pablo with whatever came into her head. She wrote him daily letters, mostly in Spanish, thinking I wouldn't understand, but her Spanish was pretty elementary and therefore easy to decipher: "You aren't any longer what you used to be. Your son doesn't amount to much, either, and he's going from bad to worse. Like you." As long as we were in Paris, we were relatively free from her attentions, other than the daily threats by mail. But when we were in the Midi, we spent more time outdoors than in and we couldn't step outside without having her attach herself to us.

In the winter of 1947–1948, we returned to Paris in December. When we went back to the Midi in February, I left the nurse in Paris and whenever I took Claude out in his carriage, Olga followed me. My grandmother had come down to the Midi and was staying three or four houses away from Monsieur Fort's. Sometimes she would accompany me when I took Claude out for his airing. Olga was never far behind, shouting her threats and accusing me of stealing her husband away from her. I never answered her because I felt that would only enrage her more. My grandmother's hearing was not good, but she would say, occasionally, "I don't understand why that woman keeps following us." She wasn't at all happy about the situation I was in, so I couldn't very well explain that this was Pablo's wife.

The weeks went on and Olga's fury showed no sign of diminishing. If I was out with Claude and she hadn't followed me, she would wait outside Monsieur Fort's house until I returned. While I was finding my keys and unlocking the door, all the while holding Claude in my arms, Olga would come up behind me and start to pinch, scratch, and pull, and finally squeeze into the house before me, saying, "This is myhouse. My husband lives here," and pushing at me so that I couldn't go in. Even if I had wanted to struggle against her, I couldn't very well do so with a baby in my arms.

Monsieur Fort, the old printer in whose house we were staying, was about eighty-five at the time. His wife was about fifty. She had never been very nice to me and one day when she heard that scene going on at the door, she came to the window and called out to Olga, "I remember you. You're Picasso's wife, aren't you? We met years ago when my husband was Vollard's printer."

Olga, delighted by this windfall, said, "Of course. And I'm coming in to have tea with you." From that day on, Olga came every day to call on Madame Fort. She would sit at the window and whenever anyone came looking for Pablo, call out, "No, my husband isn't here. He's away for the afternoon. And I'm back living with him, as you see."

I told Pablo this couldn't go on, that we must find another house

immediately. He wasn't very stirred up about it because he went to Vallauris to make pottery every afternoon and I was the one who was left to handle Olga. Every time I met her in the hall or on the stairway she would slap me. I didn't have the heart to fight with her but I didn't intend to put up with the situation any longer. I told Pablo I thought we should rent another place temporarily and then look around for something more permanent. He asked the Ramiés to find something for us.

Meanwhile the Cuttolis came down to the Midi and I spoke to Monsieur Cuttoli to see if, as a senator, he could do something about Olga. I thought that if he wrote her a letter on official stationery, full of official-sounding phrases, that might slow her down, even if it had no real authority behind it. He had the police commissioner of the district call on her and tell her that if she continued she would find herself in a very unpleasant situation. That made her more cautious. But she had been carrying on for two months by then and although after that she no longer came to the house. I had had guite enough of Madame Fort and her house. It was clear, however, that Pablo would do nothing unless he was forced and so I drummed into him, day after day, my dissatisfaction. Finally, in May, he announced that the Ramiés had told him about a place in Vallauris that we could buy and get into at once, called La Galloise. We went to look at it. It was a rather ugly little villa with almost nothing to recommend it, but rather than stay any longer with the Forts I would have settled for less than that, bad as it was. Within a week we had whitewashed the interior, brought in two beds, two unpainted tables, two unpainted chairs and four stools, and we were ready to move in.

The morning we were to move, Pablo was in a bad mood. "I don't know why I should go through with this," he said. "If I had had to move every time women started fighting over me, I wouldn't have had time for much else in my life." I told him I had no interest in fighting with anybody over him.

"Maybe you should have," he said. "I generally find that amusing. I remember one day while I was painting *Guernica* in the big studio in the Rue des Grands-Augustins, Dora Maar was with me. Marie-Thérèse dropped in and when she found Dora there, she grew angry and said to her, 'I have a child by this man. It's my place to be here with him. You can leave right now.' Dora said, 'I have as much reason as you have to be here. I haven't borne him a child but I don't see what difference that makes.' I kept on painting and they kept on arguing. Finally Marie-Thérèse turned to me and said, 'Make up your mind. Which one of us goes?' It was a hard decision to make. I liked them both, for different reasons: Marie-Thérèse because she was sweet and gentle and did whatever I wanted her to, and Dora because she was intelligent. I decided I had no interest in making a decision. I was satisfied with things as they were. I told them they'd have to fight it out themselves. So they began to wrestle. It's one of my choicest memories." And to judge from the way he laughed, it was. I didn't see anything funny in it. Finally he sobered down and we got back to the question of moving.

"Look," Pablo said, "I don't want to be disturbed by this move. It breaks into my work. It may be unpleasant for you here at the Forts' but it doesn't bother me at all. So, if we have to move, we're moving for you and it's up to you to see that my life isn't changed one bit. You can have Marcel and Paulo for the day but by tonight I want everything in order. Tomorrow I'll go through all my things and if I see you've lost so much as one scrap of paper, you'll hear from me. Anyway, you've got the day. Go to it."

Marcel, Paulo, and I spent the day going back and forth between the Forts' house and the new place. *La Galloise* is set in a garden of about two acres but it is at the top of a hill which you reach by a long flight of steps. By the time we had struggled up and down, fully loaded, perhaps forty times, they had come to seem the steps to Calvary. By nighttime we were ready to collapse.

Even though, from then on, we were living in Vallauris, we were often in Golfe-Juan. After a while, Olga again began to follow us in the street, but from a distance now, and without accosting us. Soon she came back onto the beach. One day I was sitting there, with my arms behind me, holding myself up that way, when Olga came up in back of me and with her high heels began walking over my hands. Pablo saw what she was up to and roared with laughter. Every time I put my hands back onto the sand, Olga would walk on them. Finally, when I had taken all I cared to, I grabbed Olga's foot and gave it a twist and she went flat on her face in the sand. It was the only time I ever tried to pay her back in kind and it must have worked, for after that day I never saw her close to me again.

The new house didn't improve my disposition all at once, however. In one of the photographs taken of us sitting on the beach at that period, I have a long face—brooding, if not actually sulky. One day Pablo asked me what was the matter with me. "I've gone through all the annoyance of moving," he said, "and nothing is changed."

That was true, I said, but the problems of moving were nothing

compared with the difficulty of trying to shake off that heavy load of his far-from-dead past, which was beginning to seem like an albatross around my neck.

"I know just what you need," he told me. "The best prescription for a discontented female is to have a child." I told him I wasn't impressed by his reasoning.

"There's more logic to it than you think," he said. "Having a child brings new problems and they take the focus off the old ones." At first that remark sounded merely cynical, but as I thought about it, it began to make sense to me, although not at all for *his* reason. I had been an only child and I hadn't liked it a bit; I wanted my son to have a brother or sister. And so I didn't raise any objections to Pablo's panacaea. As I began to think back on our life together, I realized that the only time I ever saw him in a sustained good mood—apart from the period between 1943 and 1946, before I went to live with him—was when I was carrying Claude. It was the only time he was cheerful, relaxed, and happy, with no problems. That had been very nice, I reflected, and I hoped it would work again, for both our sakes. I knew I couldn't have ten children just to keep him that way, but I could try once more at least, and I did. PART V

PABLO AND I WERE SEPARATED for the first time about three months after moving into La Galloise. The Russian writer Ilya Ehrenburg wrote asking Pablo to take part in the Peace Congress to be held in Wroclaw, Poland. A few days later, people from the Polish embassy in Paris came to see him about it. Because of East-West cold-war tensions and Pablo's particular passport problem, the trip had to be made by plane. Although Pablo was a Spanish subject, he had never asked the Franco government to issue him a passport. They would certainly have done so had he asked, but that would have been a way of recognizing their authority and he didn't care to go that far. His movements in France were covered by a French carte de séjour of a "privileged resident," but foreign travel was more complicated. The Poles, however, were quite willing to issue him a visa even without a passport but the trip had to be made direct from Paris to Warsaw in one of their planes. Pablo disliked travel in any form and had a great fear of flying. He had never been up in an airplane before but in accordance with his customary practice he said yes, thinking that would quiet them down and then later they would forget about it and he could, too.

It seemed to be working out just that way until about three days before the date scheduled for leaving, when the Polish embassy sent a woman down from Paris to Golfe-Juan. She kept after him morning, noon, and night until, from sheer desperation, he began actively preparing to leave.

"If I don't go, I'll never be able to get rid of her," he said. He

had Marcel drive him to Paris and took the plane from there, along with Paul Eluard. Eluard had heart trouble and the trip was a rough one for both of them. To ease the shocks, Pablo took Marcel along. He had nothing to drive but he served as a kind of charm. Marcel's last name was Boudin, which means "pork sausage," and Marcel was just that kind of fellow. Pablo wasn't sure what he was heading into but with Marcel along, he carried with him a little bit of French soil; that way he didn't feel completely uprooted. They expected to be gone no more than three or four days but they had such a good time, they stayed away three weeks, with nearly a week in Paris after returning from Warsaw.

By the time Pablo got back to Vallauris I was thoroughly put out with him. Not only was it the first time we had been separated, but I was in my first month of pregnancy when he left and although he had promised to write to me every day, in all that time he hadn't written once. Every day I had received a telegram, but the messages were very strange indeed. In the first place they were never signed "Pablo" but always "Picasso." My name, on the other hand, had great variety. One day it was "Gillot," the next "Gilot," and after that, "Gillo." One thing remained constant. They all ended with the salutation "Bons baisers," an expression used mostly by concierges, street-sweepers, and people of similar background. It certainly was not in Pablo's repertoire; even less in Eluard's. That left only Marcel. I realized that Pablo was not only not finding time to write, but that he had given Marcel the job of composing, as well as sending, the pacifying daily telegrams. When he returned, I was in a black mood.

When he arrived at *La Galloise*, I was standing on the terrace. He climbed the long stairway, smiling broadly.

"Well," he said, still grinning. "Glad to see me?" I slapped his face.

"That's for the *Bons baisers*," I told him. And the next time he left for three days and returned in three weeks without writing a single letter, I wouldn't be there to greet him, I said. I ran into Claude's room and locked the door.

The next morning Pablo banged on the door until I opened it. When I came out, he inquired very solicitously for Claude. He had brought me a coat from Poland. It was brown leather decorated with peasant embroidery in red, blue, and yellow and was lined with black sheep's wool. There was a similar one, lined with white wool, for Claude. Neither of us mentioned the previous evening's scene, but after that, whenever Pablo went away, he made it a point to write to me at least once a day.

The slap certainly had a salutary effect. Pablo trotted out rather often his formula about there being only two kinds of women—goddesses and doormats—and it was clear that, for the moment at least, I was a goddess.

One of the things Pablo had enjoyed most was meeting in Warsaw the five or six architects in charge of rebuilding the city and hearing them explain their plans and methods. Building materials were scarce. What particularly pleased him was the fact that nothing was lost: all the rubble was collected and crushed and mixed with cement and other materials to form the material out of which the new Warsaw was built. And just as when concrete is reinforced with small stones it gains strength, amalgamating the old materials with the new strengthened the whole.

The Congress itself included people from all over the world, and the atmosphere, Pablo told me, was warm and friendly.

"There was just one incident, an embassy dinner, that was a catastrophe," he said. "The Poles have always been broad-minded and independent and it didn't occur to them that anyone would attempt to criticize my painting for political reasons. At the end of the dinner, when toasts were being proposed, one of the Russian delegation stood up and said he was pleased to see I had come to the Congress but he went right on to say it was unfortunate that I continued to paint in such a decadent manner representative of the worst in the bourgeois culture of the West. He referred to my 'impressionist-surrealist style.' As soon as he sat down I stood up and told them I didn't care to be talked to like that by some party hack and that in any case his description of me as an 'impressionist-surrealist' painter was not very impressive. If he wanted to insult me, at least he should get his terminology straight and damn me for being the inventor of Cubism. I told him that I had been reviled in Germany by the Nazis and in France during the German Occupation as a Judeo-Marxist painter, and that that kind of talk, whatever the exact terms, always cropped up at bad moments in history and came from people nobody had much respect for. Then everybody began to get excited and protest in one direction or the other. The Poles tried to calm down the Soviets by agreeing that perhaps some of my painting was decadent, but in any case, they said, the Russians couldn't be allowed to insult their guests."

FTER HIS RETURN FROM POLAND, Pablo went back to work at the Ramiés' pottery but that didn't satisfy him. He was beginning to be tired of ceramics. In his lithography he had made a tremendous effort and had renewed the whole lithographic process. He had discovered new technical possibilities that no one had hit on before him which resulted in work of really unique quality. Even in the sculpture that he created out of bits and pieces of next to nothing, once the whole was cast in bronze, it had an identity and a permanence that he found very satisfying. But he felt that the basic materials of pottery limited its possibilities for him and that it never quite gave him what he was looking for.

"It's always an object but not always an objet d'art," he said. "I have the feeling that the material itself can't carry the weight of the creative effort I put into it. It's a little as though I'd made a whole series of drawings on cheap wrapping paper and then realized that's the kind of paper that frays to pieces if it's exposed to the air very long and that those things are destined to be lost, sooner rather than later." He came back to pottery later on, for a number of reasons, but that was his reason for stopping at that period.

We returned to Paris in October and Pablo exhibited at Kahnweiler's a group of drawings he had done in the summer of 1946 while we were living at Monsieur Fort's, similar in theme to the ones now in the Musée d'Antibes. At the end of the year he held his first exhibition of pottery, at the *Maison de la Pensée Française*. Artistically it made something of a sensation because it was the first time this new aspect of his creativity had been shown. That series was the finest—at least the most inventive—of all his pottery because that was the time of discovery, the period of the amphora in the form of a woman and the combined forms he put together in the first surge of his inspiration. Later on his pottery was often more anecdotal or, at best, the mastery of a style he had experimented with and knew well.

The preparation for the exhibition was chaotic right up to the last minute. Trucks had been sent down to Vallauris to bring the pottery but they were late in arriving in Paris. The glass cases weren't ready on time, either. Everything arrived just a few hours before the *vernissage*. We had selected for the exhibition only those pieces which seemed completely successful artistically and technically. When we saw them at the *Maison de la Pensée Française*, we ourselves were surprised at the effect they made. Those who understood to what degree Pablo had renewed the potter's art were very excited by what they saw but people in general took it rather mildly. It wasn't really what they expected of him.

"They expect to be shocked and terrorized," Pablo said wryly. "If the monster only smiles, then they're disappointed."

After the exhibition Pablo started painting again and the winter was a busy one. He worked often at Mourlot's, drawing on the lithographic stone, and he was always in a good mood. And since he could never stand skinny women, even slender ones, and at that period I was beginning—for the second time—to be less slender that usual, I found added grace in his eyes. It was a happy and idyllic period. Pablo was very attentive and, most of the time, quite calm.

He did the series of lithographs of me called *Portrait with* the Polish Coat and many portraits in oils. None of them were very naturalistic and some seemed a continuation of the rhythms he had explored in his illustration of Reverdy's *Chant des Morts*: long, linear signs, rounded at the ends. In the paintings the face often appeared as a kind of papiér collé in black and white in a completely different manner from the rest of the painting, which was rhythmical with broad areas of very free color crossed by lines of rhythm and stress, indications of movement, rather than the more usual contour lines.

One day while Pablo was painting my breasts in one of those portraits, he said to me, "If one occupies oneself with what is full: that is, the object as positive form, the space around it is reduced to almost nothing. If one occupies oneself primarily with the space that surrounds the object, the object is reduced to almost nothing. What interests us most—what is outside or what is inside a form? When you look at Cézanne's apples, you see that he hasn't really painted apples, as such. What he did was to paint terribly well the weight of space on that circular form. The form itself is only a hollow area with sufficient pressure applied to it by the space surrounding it to make the apple *seem* to appear, even though in reality it doesn't exist. It's the rhythmic thrust of space on the form that counts."

With that in mind, Pablo made a first version of a large painting he called *La Cuisine*. It was based on the kitchen in the Rue des Grands-Augustins, where we sometimes ate our evening meal. The kitchen was painted white, and in addition to the usual equipment there were the

birdcages. Aside from the birds the only touches of color were three Spanish plates on the wall. So, essentially, the kitchen was an empty white cube, with only the birds and the three Spanish plates to stand out from the whiteness. One night Pablo said, "I'm going to make a canvas out of that—that is, out of nothing." And that is exactly what he did. He put into it all the lines of force that build the space, and a few concentric circles that look like targets—the Spanish plates. In the background, vaguely, are the owl and the turtledoves.

After he had finished it, he looked it over and said, "Now I see two possible directions for this canvas. I want another one just like it, to start from. You make a second version up to this point and I'll work on it from there. I want it tomorrow." I started to grumble about the rush but he said, "That's all right. Just do it in charcoal. Since this is all in black and white, it will make things simpler for you." I pointed out to him that it was too big for me to be able to trace out a copy but that didn't discourage him, either. "Any way you want to do it is all right," he said. "Square it and work it that way; I don't care. But I don't want it to be one millimeter off from the original. And I want it tomorrow night."

I knew I could never get it done by the next night working by myself—it was over eight feet long and nearly six feet high—so the next morning I called Pablo's nephew Javier Vilato, who was also a painter, and asked him to help me. We worked from lunchtime until eight in the evening and then we went to fetch Pablo. He took one look, drew back, and started to roar.

"I told you to make it *exactly* like the other one," he said. "Up in the right-hand corner there's something that's not quite exact." I was convinced we had done our work to perfection. If it wasn't exact, it was probably because the stretcher wasn't perfectly rectangular, I told him. Pablo smirked. "That's a real Françoise answer, all right. You make a mistake in your draftsmanship and then try to lay it onto the stretcher. That's ridiculous. Well, measure it, anyway."

We did. The opposite sides were not quite parallel. It was an inch and a quarter short in the upper-right-hand corner. Pablo ran to the telephone and called Castelucho in Montparnasse, who furnished most of his canvases, and roared at *them*. The next morning we took the canvas off the stretcher, measured it, straightened the stretcher and then replaced the canvas, having picked up the inch and a quarter in the process.

From time to time Pablo gave me the job of painting a copy like

that; painting it up to a certain point, that is. It was generally, as in the case of *La Cuisine*, because he had followed one course of action to its logical conclusion and after the picture was completed he was haunted by the thought of what it might have been if, at the fork in the road, so to speak, he had branched off onto the other path. To avoid having to do over again everything he had done to reach that point, he would have me do an exact copy of it. Sometimes I would make a tracing, lightly, first in pencil, then with the brush, of the lines of force in the first painting, with color indications, to give him a jumping-off point from which to launch into the variant. That gave him a chance to get to the main point quickly and work over it longer.

That winter I did three or four other jobs like that one. Most of them were portraits of me, in a linear manner, ending in a round ball shape with green hair. For Pablo my collaboration was a practical demonstration of the truth of one of his favorite aphorisms: "If I telegraph one of my canvases to New York," he said, "any house-painter should be able to do it properly. A painting is a sign—just like the sign that indicates a one-way street."

THE MONTHS LEADING UP TO the birth of our second child were, in many ways, a lot less burdensome for me than those that preceded Claude's. While I was carrying Claude, the idea of having a child was a great worry to me and I was painfully wrought up. But this time I had quite accepted the idea of having another child, and the obstetrician I had acquired only a week before Claude was born, I had now throughout my pregnancy. Then, too, during the first pregnancy I knew almost no one in Pablo's entourage well, but in the interim I had made my own corner in his world and things seemed much less black as a result.

Physically, though, I had begun to feel weaker. Pablo and I always went to bed very late and since I was working hard at my painting all that winter and getting up early in the morning with Claude, I was very tired. When I slept, I didn't rest well. Claude was nearly two years old and wouldn't stay in his carriage. Sometimes I would walk him in a pair of reins but that wasn't ideal, either, so as a rule when I went out into the Rue des Grands-Augustins I used to carry him in my

arms, and that may not have been a very good idea. About two months before the second baby was expected, the doctor told me he was concerned about my condition. When I went to see him a month later, he examined me and told me to come back again in three days. That time he looked me over and told me to go home, get my things together, and leave for the clinic at once. Since it was the day of the opening of the Peace Congress at the Salle Pleyel—April 19, 1949—and Pablo, as one of the prize exhibits, was quite taken up with that, I objected, a little feebly, and asked the doctor if it was really necessary. He assured me it was. "I'm going to give you injections to get this over with," he said. I told him it wasn't very convenient and that Pablo had a lot to do. "I don't care about that," he said. "That's the way it's going to be, so let's not waste time talking about it."

I went home and told Pablo what the doctor had said. I asked him if Marcel could drive me to the clinic. He looked annoyed.

"I need Marcel today," he said. "You know I have to go to the Peace Congress. Besides I've got to pick up Paul Robeson." I told him I realized it was inconvenient for him but it was inconvenient for me, too.

"Well," he said, "if you need a car, you'll have to find another solution. Why don't you call an ambulance?"

Marcel, who was sitting over against the wall reading his newspaper, looked up. "We could drive her around to the clinic on the way to the Congress, couldn't we?" he asked Pablo. They discussed it with the thoroughness due a major tactical decision. Finally Pablo shrugged. "You drive me there first," he said, "and then come back for her. I don't want to be late." Three days before that, he had been having labor pains for me; now, apparently, he had transferred his anxiety to the Congress.

When I reached the clinic it was nearly five o'clock. The doctor was waiting because I had been expected at two. Toward eight that evening, the baby—a girl—was born. Pablo had been calling from time to time from the Salle Pleyel to inquire about my progress. He had lost his anxiety over the Congress and shifted into the role of nervous father-to-be. His famous dove was plastered all over Paris on posters advertising the opening of the Peace Congress and when he heard he had a daughter he decided she should be named Paloma. He rushed to the clinic for a quick look at his new dove. He found her "lovely," "beautiful," "marvelous" and all the other words excited fathers fall back on. He was most apologetic for his "preoccupation" earlier in the day.

206

The next morning I heard people arguing outside in the corridor. I had a feeling they must be journalists trying to force their way in. I called the office. The supervisor arrived just as they were about to break into my room. They had reached my corridor after giving false names and pretending they were there as visitors. Just outside my room they were headed off by a nurse, whom they tried to bribe to let them take a picture of Paloma. The nurse told me they offered her a hundred thousand francs to bring Paloma out. When she refused, they were ready to burst in and take what photographs they could. At that point the supervisor arrived and ordered them away.

FOR MONTHS BEFORE PALOMA WAS BORN I had been after Pablo to buy a new suit, but for him it was as difficult to buy something new as it was to throw away something old. For three months he had been alternating between two old suits that were worn to the point of exhaustion. The day Paloma was born, he was wearing the older of the two. The cloth was so thin that in getting into the car to have Marcel drive him to the clinic he tore it wide open at the knee. The Belvedere Clinic is a rather snobbish place and when Pablo arrived that evening, I noticed he was holding his trench coat in front of him at an awkward angle. When he set it down I saw that his kneecap was fully exposed. I suggested this would be a good time to get a new suit.

"Oh, that takes time," he said. "It has to be custom-tailored." I told him that even a ready-to-wear would be better than the one he had on. Finally he capitulated and ordered a suit from his tailor, which he received about a month later. But during the week I stayed at the clinic, he showed up every day in the same old suit. He had to wear his old trench coat over it, even though we were in the midst of an early heat wave.

Pablo had no problem in buying shirts or shoes, but buying a suit caused him a great deal of trouble. He was fairly broad in the chest and shoulders and had the proportions in that area of a much larger man, but since he was very small otherwise, he couldn't buy a suit off the rack that fit him. With a ready-made suit, you could stuff two men his size into the trousers that went with a coat that would fit Pablo, and if

he got a suit with trousers that fit him, he was all arms and neck, bursting out of the coat. And he dreaded going through two or three fittings at a tailor's: it was just too much of an ordeal.

"It turns my life upside down," he explained to me. "I can't paint when I know I have to go for a fitting." I always wondered why, since he could go to the dentist's and lots of other places hardly more amusing. When I began to go to the tailor's with him, I understood. Every time he had to go through a fitting, the tailor would say something like, "You understand, Monsieur, it's a very complicated affair to dress you. You have a long, sturdy upper torso, but you're really a very small man." Every time Pablo heard that, it made him squirm. So whenever I managed to get him into a tailor shop and he gritted his teeth for the fittings, he always ordered three or four suits from that fitting so he wouldn't have to return for a long time. When he got them home, he shut them up in a closet along with his old, worn-out moth-eaten suits so that as a rule the new ones, too, were moth-eaten before he ever got around to putting them on. But since I wasn't allowed to throw away the old ones, the ones he had never even put on were condemned in advance and the whole process had to be started over again six months later.

When I went to live with Pablo, I had neither clothes nor money to buy any with, and for all kinds of reasons I didn't want to ask Pablo for money. While I was carrying Claude, I was reduced to borrowing an old pair of gray flannel trousers that Pablo had long since stopped wearing. For years afterward he kept throwing that up in my face, and he stored it away as one of the most wicked things I had ever done. He moaned about it often and each time with greater pain: "All you had to do was go out and buy something of your own, instead of which you took the only pair of pants that really fit me and now I'll never be able to wear them because you've stretched them all out of shape." I hadn't stretched them a bit, really, because even when I went into the clinic, they were still too loose for me. I must admit, though, there wasn't much wear left in them then, because they were practically worn out when I first put them on.

Finally the old clothes lying around everywhere began to get on my nerves. After Paloma was born, there was no room to store anything. In Paris, aside from the ateliers, we had only two rooms. I decided to throw away some of the old suits. I knew that since Pablo refused to discard anything he had ever owned, if I tried it in Paris it wouldn't work. I had once thrown out a suit in the rubbish, and Inès, the chambermaid, had picked it out and brought it to Pablo, saying very innocently, "Look what Madame has thrown away. A mistake, no?" Pablo was furious with me for weeks afterward. So I packed up all the old clothes and took them along the next time we went to Vallauris. But the first time I threw out something down there, the gardener found it, took it home, and one day showed up for work in it. It was almost like having a body one had neatly disposed of float up to the surface of the water. I told him Pablo wouldn't like to see him wearing that old suit; he had strange feelings about that sort of thing. It was crime enough for me to have thrown it away. For someone else to be wearing it—that, Pablo would never abide.

"But it's still good, Madame," he protested.

It just wouldn't do, I told him. To pacify him I gave him a bundle of my old sweaters since he was about my size. One afternoon, he was quietly working in the garden wearing a particularly outlandishlooking sweater I had given him. Back to and from a distance one might have thought it was I. Pablo, coming up the steps, saw him and then, almost simultaneously, saw me come out of the house. He began to curse.

"Damn you! I hope you realize that one day you'll begin to look like him and that you'll be all bent over just the way he is. That will teach you to give your clothes away to anyone who happens to pop into your head."

The next time it happened, we almost broke up over it. I had unwittingly given the gardener an old imitation-suede jacket of Pablo's, mixed in with the bundle of my sweaters. When Pablo came back from his atelier and saw the gardener wearing *his* old jacket, he flew into a rage.

"That's too much," he shouted. "This time I'm the one who'll be transformed into that ugly old man." (The gardener was twenty years younger than Pablo.) "It's dreadful. It's monstrous. You'd do that to me, would you? Well, if that's your intention, I'm leaving immediately." We had quite a struggle before he calmed down. Finally I was reduced to burning Pablo's worn-out, moth-eaten old clothes. I felt almost like Landru or Monsieur Verdoux burning the corpses of his successive wives. I had to poke around in the ashes afterward to pick up any odd buttons that might have survived and given me away.

One time at Vallauris we won a goat in a lottery. They had told us it was a nanny goat but it turned out to be a billy goat. He manifested his presence in several different ways, all equally undesirable. First of all he smelled bad. He wandered around through all the rooms

in the house, because Pablo-who often seemed more concerned over his animal family than over his human one-had told me, "If I have a little goat I want her to be able to run around everywhere. I love her like one of my children." If he felt very disagreeable he would say, "I love her more than you." Once he went so far as to say, "I love only my little she-goat because she alone is always adorable." The plain fact was, this adorable little she-goat was a horrible he-goat that stank as only an old he-goat can and he waddled around all over the house and did all kinds of dirty things whenever and wherever he felt like it. Furthermore, he took a dislike to Claude, who was about three at the time, and would charge him from behind and with his horns, like a pintsized bull, send him sprawling. At the end of two months I had had enough. One day some gypsies came to the house. They asked me if I didn't want them to forage around in the garden and see whether there were any snakes or harmful animals to get rid of. I told them I had a harmful goat to get rid of-would they take it along? They were delighted. They led him away and from that moment on I felt a sense of peace such as I hadn't known for months.

At noon when Pablo came home from the pottery, the first thing he said was, "Where is my little white she-goat that I love so much?"

I said, "I've given your little white she-goat that you love so much to a band of gypsies that passed by."

"You're the lowest form of human existence," he screamed. "I've never seen a woman like you." He turned to Marcel and said, "Can you imagine a woman like that? Have you ever seen anyone in your life so completely unnatural? Imagine! Giving away the treasure of my heart to some filthy gypsies! I'm *sure* they've carried my luck away with them." He was crushed.

Thanks to Pablo I became acquainted with a field of knowledge of which I had been completely ignorant except for a slight brush I had had with it during a stay in England. There, friends had taught me that when you spill salt on the table you have to pick some up in your right hand and throw it over your left shoulder; otherwise you have bad luck. Beginning on the day I went to live with Pablo, I got my indoctrination in how to live—with superstition. If I threw his hat on the bed, as I often did, it wasn't just that his hat was not in its place; it meant that someone in that house was going to die before the year was over. One day during the course of a little joke we were carrying on, a kind of playlet, I opened an umbrella in the house. What a crisis that precipitated! We had to go around the room, the third finger of each hand crossed over the index finger, waving our arms and shouting, "*¡Lagarto!*" is chase the bad luck away quickly before it could reach one of us. I was never allowed to put the bread on the table in any other way than with the rounded part on top; otherwise something disastrous would descend on us.

In addition to these typically Spanish superstitions, Pablo had adopted all the Russian ones—and heaven knows how many of those there are—from Olga. Every time we left on a trip, however short it might be, we had to carry out the Russian custom of having all members of the family sit down in the room from which we were going to leave, without speaking a word for at least two minutes. After that we were allowed to start out on our trip, with complete assurance that nothing bad would befall us. We did that in the most serious fashion and if one of the children laughed or spoke before the time was up, we had to begin all over again; otherwise Pablo would refuse to leave. He used to laugh, saying, "Oh, I just do it for the fun of it. I know it doesn't amount to anything, mais enfin . . ."

In the same way, Pablo was an atheist—in principle. From time to time I would receive a letter from my mother or my grandmother in which I was told that they were praying for me. Pablo always said, "But they ought to pray for me, too. It's not nice to leave me out." I asked him why he should care whether they prayed for him or not, since he wasn't a believer. He said, "Oh, but I do care. I want them to pray for me. People like that believe in something and their prayers certainly do something for them. So there's no reason why they shouldn't give me the benefit, too."

There is a primitive belief that one person can assume power over another through the possession of his fingernail or hair trimmings; hence they should never be allowed to fall into the hands of someone else. But if they were burned to remove them from an enemy's reach, the person himself might die. The true believers often carried the trimmings in little bags until they found a place secret enough to dispose of them with complete assurance. Pablo always had a great distaste for having his hair cut. He would go for months needing a haircut but unable to bring himself to walk into a barbershop. If anyone mentioned the subject, it was high drama. I'm sure that mixed in with his other fears on this subject was the old notion of hair as a symbol of male vigor, as in the Biblical story of Samson and Delilah. The beard presented no difficulties because he shaved himself every day and the problem of disposal was automatically taken care of. But the hairs of his

head were another matter. And the longer they grew, the more anguished he became at the thought of having to face up to the dilemma. Generally, in the end, he would let me cut them or sometimes, in privacy, cut them himself, with most unsightly results. One day in Vallauris he made the acquaintance of a Spanish barber named Arias. For some reason he felt Arias was a man who could be trusted. From then on, Arias used to come to *La Galloise* whenever a haircut could be postponed no longer. I never knew what happened to the hair, and don't to this day. It just disappeared. Arias, being Spanish, became, at least momentarily, Pablo's alter ego and Pablo lost his fear completely. Over the years since then, with Pablo's moves to *La Californie* in Cannes, and to *Notre-Damede-Vie* in Mougins, Arias has continued, one of the lone survivors of the passage of time, to go to the house at Pablo's call and cut his hair.

And there are other fetishistic addictions which Pablo has followed in the most systematic manner. Even now, whenever Claude and Paloma have gone to spend their holidays with their father, Pablo has never let Claude return without taking at least one, sometimes more than one, article of clothing from his luggage. The first thing his father took was a new Tyrolean hat. After that there was a whole series of other hats. It could be argued that Pablo just liked hats. But he gave others to Claude afterwards, in exchange. Another time it was a light-blue poplin raincoat, very pretty on a young boy, less so on an old man. But Pablo insisted on taking it. Every time Claude returned from the Midi, I noticed that his father had taken his pajamas and very often one or more neckties.

I finally became convinced that Pablo hoped by this method that some of Claude's youth would enter into his own body. It was a metaphorical way of appropriating someone else's substance, and in that way, I believe, he hoped to prolong his own life.

BEFORE WE MOVED INTO *La Galloise* it had belonged to two very old ladies. Several years earlier they had rented the apartment up over the garage at the entrance to the property to an elderly woman named Madame Boissière. Madame Boissière was at least seventy-five herself and was officially listed as an *artiste-peintre* but she had other talents as well, such as teaching a class of young female dancers from Vallauris who performed their rites in the garden behind the garage, clad in billowing Isadora Duncan-style drapery. She was tiny, with the bluest eyes I have ever seen and with frizzy gray hair that hung in ringlets all around her face. She used to dress in 1925 high style, with broadbrimmed picture hats, the kind of slacks worn at that period with floppy bell bottoms, and a long jacket faced with dulled gold-lamé inserts, all very showy and quite dirty.

The first day Pablo and I called to inspect *La Galloise*, Madame Boissière, in her faded finery, was sitting on her balcony facing the road. She greeted us effusively. She had heard, of course, who it was that was interested in buying the property and she said, "I'm so happy that artists are going to buy this place. I'm an artist, too, you know." I was a little taken aback by her appearance and her theatrical manner but she was very cordial and kept repeating how delighted she was that someone was coming to live there.

After we moved in, I noticed that Madame Boissière walked with great difficulty. I offered to find her a house in the town so she could get around easily to do her marketing without having to climb the narrow curving roads that led from the town up into the hills where La Galloise was situated. That would have been a convenience to us, too, because then we could have had Marcel, the chauffeur, living up over the garage rather than in a hotel down in Golfe-Juan. But Madame Boissière would have none of it. "I live here and I want to die here," she kept repeating every time I brought up the subject. Once I took her in the car to show her a very comfortable, roomy place I had found for her overlooking the market place in Vallauris but she wasn't in the least interested in its advantages. "You'll never get me out," she said. "I plan on dying right where I am." I could see there was no point in going any further so I dropped the subject. From that day on she began to detest-not me, but Pablo. She tacked up signs on the front of the garage proclaiming, "This is where Madame Boissière lives. This is not where Monsieur Picasso lives. Furthermore, Monsieur Picasso is a terrible painter," and other things of that kind. Everyone enjoyed them. Anyone who came to call on us was treated to a harangue from Madame Boissière. As soon as she saw someone reading the signs, she would come out onto the balcony and say something like, "Monsieur Picasso is a very bad painter. Don't waste your time with him."

Her own painting was in a symbolic religious vein, influenced perhaps by Maurice Denis. She had made up her mind that Pablo was

the Antichrist. Whenever he passed by, she made cabalistic signs to exorcise the evil spirit. That delighted Pablo. We both felt sorry for her so we let her have her fun and figured that sooner or later, as she apparently desired, she would die there. That's just about what happened.

Years later I drove down from Paris with a few friends to spend the Christmas holidays at La Galloise. We arrived around noon on the day before Christmas. When we drove into the garage I could hear noises coming from up above. By now Madame Boissière was about eighty-five and still lived there all alone in filth and disorder. I had tried to have the place cleaned up and painted for her but she wouldn't allow anyone to come in. At first I thought from the noise that she was reviling Pablo, since she had never lost that habit, but as we listened it became clear that the noises were groans. She kept a vicious dog, an enormous mongrel, and I wasn't at all eager to go into the house and have him bite me. I went across the street to fetch the gardener. We climbed up onto the balcony and looked inside. The dog was barking and clawing at the big bay window. Behind him I saw Madame Boissière lying on the floor. We climbed down again and I went up to the house to telephone the hospital at Antibes for an ambulance. When I warned them about the dog, they told me I'd have to arrange to have him taken care of; otherwise their men wouldn't go in. I drove to the veterinarian's in Cannes. He gave me double the usual quantity of pills to put the dog to sleep, I bought some ground beef to mix them into and drove back to La Galloise. I unlocked the garden door of the apartment and threw the meat in the dog's direction. And sure enough, he soon went to sleep.

Madame Boissière was happier to see me than I, or no doubt she, had ever imagined she could be. She had fallen only that morning as she got out of bed and had broken her thigh bone. But now that I was there she could die happy in my arms, she told me. She made me promise to see that her dog got a good home and was not put out of the way. After the ambulance had left, I called the local S.P.C.A. and they came for the dog, still sleeping peacefully. Madame Boissière died at the hospital about three weeks later. I paid to have the dog taken care of for several weeks until they found a home for him that I felt Madame Boissière would have been satisfied with. I quieted my conscience about the bad turn I might be doing the new owner by reflecting that at least I was honoring Madame Boissière's last request. A FTER THE MOVE TO La Galloise I tried to keep my thought from dwelling too much on Pablo's "other women" and their present condition but it wasn't always easy. There were occasional bulletins from Dora Maar, but on the whole she seemed rather remote. Olga, too, had been removed from the scene, but her barrage of vituperation continued to show up in the mailbox. Marie-Thérèse was an equally untiring correspondent but her letters, of course, were written in an entirely different vein from Olga's. Pablo found them gratifying; I didn't. For their holidays Marie-Thérèse and Maya came to Juan-les-Pins, less than ten miles from La Galloise, and so, in spite of their theoretical and historical distance they continued to seem very much a part of our life together. Pablo talked often about all my predecessors and, as a result, by the summer of 1949 I had come to understand Marie-Thérèse's role much better than I had when I first went to live with him in May 1946.

He had met Marie-Thérèse on the street one day near the Galeries Lafavette when she was seventeen, he told me. She became the luminous dream of youth, always in the background but always within reach, that nourished his work. She was interested only in sports and didn't enter in any way into his public or intellectual life. When he went out socially it was with Olga; when he came back bored and exasperated. Marie-Thérèse was always available as a solace. Often when he was at Boisgeloup with Olga and family friends, he pictured Marie-Thérèse bathing in the Seine near Paris. The next day he might return to Paris to see her, only to learn that she had bicycled out to Gisors to be near where he was. She haunted his life, just out of reach poetically, but available in the practical sense whenever his dreams were troubled by her absence. She had no inconvenient reality; she was a reflection of the cosmos. If it was a beautiful day, the clear blue sky reminded him of her eyes. The flight of a bird symbolized for him the freedom of their relationship. And over a period of eight or nine years her image found its way into a great body of his work in painting, drawing, sculpture, and engraving. Hers was the privileged body on which the light fell to perfection.

Marie-Thérèse, then, was very important to him as long as he was living with Olga because she was the dream when the reality was someone else. He continued to love her because he hadn't really taken

possession of her: she lived somewhere else and was the escape hatch from a reality he found unpleasant. But once he had, in order to take fuller possession of that form of hers for which he had such an insistent desire, sent Olga away, then reality suddenly changed sides. What had been fantasy and dream became reality, and absence became presence a double presence, since Marie-Thérèse was expecting a child. Then Marie-Thérèse replaced Olga as the one to escape from, in accordance with Pablo's form of logic. Along came Dora Maar to take photographs of Pablo, and Pablo became very interested in *her*.

Pablo always told me that he had a great deal of affection for Marie-Thérèse, and that he didn't care so much for Dora Maar but she was a very intelligent woman.

"It wasn't at all that I was so greatly attracted by Dora," he said. "I just felt that finally, here was somebody I could carry on a conversation with."

Dora Maar wanted, apparently, to play a part in Pablo's intellectual life and in that role she didn't see Marie-Thérèse as a serious rival since Pablo never brought her among his friends. Pablo told me that every time he left on vacation, it was with Marie-Thérèse and Maya, not with Dora Maar. But Dora would sooner or later show up in the same general area, having understood that was what Pablo wanted her to do, and then Pablo would have the best of both worlds. He spent more time in Dora's company because it was more amusing that way, but he always had Marie-Thérèse to return to when his mood changed.

The constant drama that this conflict between Marie-Thérèse and Dora brought up didn't bother Pablo at all. On the contrary, it was the source of a good deal of creative stimulation to him. The two women were completely opposite by nature and temperament. Marie-Thérèse was a sweet, gentle woman, very feminine, and very fully formed-all joy, light, and peace. Dora, by nature, was nervous, anxious, and tormented. Marie-Thérèse had no problems. With her, Pablo could throw off his intellectual life and follow his instinct. With Dora, he lived a life of the mind. This contrast crops up in a number of paintings and in many drawings of the period: one woman watching over another woman sleeping; two women of very contrasting types watching each other, and so on. His best work of those years is really a series of variants on two portraits: one very joyous, the other very dramatic. Marie-Thérèse and Dora were almost inseparable as plastic ingredients. Even though Marie-Thérèse entered his work before Dora, this phase of his painting, which seems to alternate between happiness and unhappiness, needed them

both for completeness. In *Guernica*, for example, the woman whose large head leans out of the window and whose hand holds a lamp, is clearly based on Marie-Thérèse. The rest of the painting, together with its preparatory sketches, is focused about the figure of a weeping woman. And Pablo often told me that for him Dora Maar was essentially "the weeping woman."

Pablo knew it meant a great deal to both Dora and Marie-Thérèse to be painted by him. They were both very conscious, he told me, of the fact that they were assuring their own immortality by becoming an integral part of his painting. That feeling intensified the rivalry between them but at the same time made each of them willing to overlook aspects of the situation that might otherwise have troubled them more.

When Marie-Thérèse and Maya came to the Midi, Pablo continued to visit them twice a week. In the summer of 1949 I asked him, since they were at Juan-les-Pins, why he didn't have them come to the house. I wasn't being naïve in suggesting this. I saw no reason why Maya shouldn't be brought together with her half-brothers, Paulo and Claude, and half-sister, Paloma. Since she saw her father only two days a week and Pablo never went anywhere with her and her mother, she had been brought up on the fiction that it was her father's work that made him unavailable. Now, at the age of thirteen, all she had to do was pick up a copy of *Match* or one of the papers to see her father rolling around on the sand at Golfe-Juan with his present family. Also, I had an idea that Pablo was probably giving Marie-Thérèse to understand that if he couldn't see her as often as she wanted him to, it was because I didn't allow it.

Pablo didn't like my suggestion at first but a few weeks later he agreed to it. When he finally brought them to *La Galloise*, it seemed clear to me that I had indeed been a convenient scapegoat. But when Marie-Thérèse saw that I was glad to have her come with Maya from time to time, my relations with her became more relaxed. Pablo was a little owlish at first, but he got over it.

I found Marie-Thérèse fascinating to look at. I could see that she was certainly the woman who had inspired Pablo plastically more than any other. She had a very arresting face with a Grecian profile. The whole series of portraits of blonde women Pablo painted between 1927 and 1935 are almost exact replicas of her. She might not have qualified as a fashion mannequin but since she was very athletic, she had that high-color look of glowing good health one sees often in Swedish women. Her forms were handsomely sculptural, with a fullness of vol-

ume and a purity of line that gave her body and her face an extraordinary perfection.

To the extent that nature offers ideas or stimuli to an artist, there are some forms that are closer than others to any artist's own aesthetic and thus serve as a springboard for his imagination. Marie-Thérèse brought a great deal to Pablo in the sense that her physical form demanded recognition. She was a magnificent model. Pablo didn't work from the model in the usual sense of the term but the mere fact of seeing her gave him a part of nature that was particularly suited to him. Whether she was intelligent or not could only be a very secondary consideration to the artist inspired by her form.

Maya was blonde with turquoise-blue eyes like her mother, and a physique like her father, whom she resembled strongly. The composition of her face was that of a man although she was very pretty. She was already well developed like her mother but her wrists were very small and her hands very feminine, like Pablo's.

During their first visit to La Galloise, while Pablo took Claude and Maya outside to show Maya a big turtle that lived in our garden, Marie-Thérèse said to me, coolly but not unpleasantly, "Don't imagine you could ever take my place." I told her I had never wanted to; I only wanted to occupy the one that was empty.

Pablo's many stories and reminiscences about Olga and Marie-Thérèse and Dora Maar, as well as their continuing presence just offstage in our own life together, gradually made me realize that he had a kind of Bluebeard complex that made him want to cut off the heads of all the women he had collected in his little private museum. But he didn't cut the heads entirely off. He preferred to have life go on and to have all those women who had shared his life at one moment or another still letting out little peeps and cries of joy or pain and making a few gestures like disjointed dolls, just to prove there was some life left in them, that it hung by a thread, and that he held the other end of the thread. From time to time they would provide a humorous or dramatic or sometimes tragic side to things, and that was all grist to his mill.

I had seen how Pablo refused to throw away anything, even an old matchbox that had served its purpose. Gradually I came to understand that he pursued the same policy with human beings. Even though he no longer had any feeling for this one or that one, he could not bear the idea that any of his women should ever again have a life of her own. And so each had to be maintained, with the minimum gift of himself, inside his orbit and not outside. As I thought about it, I realized that in Pablo's life things went on just about the way they do in a bullfight. Pablo was the toreador and he waved the red flag, the *muleta*. For a picture dealer, the *muleta* was another picture dealer; for a woman, another woman. The result was, the person playing the bull stuck his horns into the red flag instead of goring the real adversary—Pablo. And that is why Pablo was always able, at the right moment, to have his sword free to stick *you* where it hurt. I came to be very suspicious of this tactic and any time I saw a big red flag waving around me, I would look to one side of it. There, I always found Pablo.

PABLO'S DEFINITION of a perfect Sunday, according to Spanish standards, was "mass in the morning, bullfight in the afternoon, whorehouse in the evening." He had no trouble getting along without the first and the last of these, but one of the major joys of his life was the bullfight, and we went often, mostly to those at Nîmes and at Arles. Whenever we went we had to reserve our seats about a week in advance, generally through a friend of Pablo's named Castel, in Nîmes, who had a passion for Spain and all things Spanish.

Long before the first corrida of the season, which is around Eastertime, Pablo was full of good cheer, thinking of all the pleasures to come. That state lasted right up until the moment when we had to reserve the tickets by telephoning to Castel in Nîmes. On that day Paulo would come up from Golfe-Juan in the morning to play his role in the inevitable ritual. Since he didn't want to face his father alone, he would make me go in first and he would follow me. Pablo would be sitting up in bed surrounded by the papers, the mail, and his boxer, Yan. "Well, it's time to order the tickets for the corrida, Papa. How many of us will there be?" Paulo would ask.

"Ha, naturally," Pablo would say. "You all want to martyrize me. You want me to go to the bullfights. Well, you're not going to martyrize me. Not any longer. We're not going."

"No, we don't want to martyrize you," Paulo would answer. "We don't care whether you go or not. But if you do want to go, we must order the tickets today. Anyway, we can order them today and if you

want, cancel them afterward if we don't go. But how many should I order? Will we have friends with us or not?"

Pablo would throw up his arms, and scatter his mail all over the floor. "Ah, yes, now I have to take friends."

"No, Papa," Paulo would say, "I don't mean that you *have* to take friends, but if we don't order any tickets for friends and then afterwards we take some, there won't be any seats for them." This went on all morning long. Finally, after the tickets had been decided upon, with a carefully counted number of spares for selected friends, and the order telephoned to Castel, the first person Pablo ran into walking along the street—his barber, Arias, or even one of the workers at the pottery, someone of no interest to him at all—he would invite to go with us. When he got back to the house and thought over what he had done he was furious with us for "letting" him hand out the invitation.

The next day would be just as turbulent. We would telephone to Nîmes and change the order, taking two or three additional tickets as a precaution, and then go on stoically, head lowered, shoulders squared, ready for anything, because from that day on Pablo was in a dreadful humor, harping relentlessly on the old theme that we were the ones who were obliging him to go to the bullfight. Of course, if we had ever dared *not* to order the seats, he would have been in a worse humor and claimed that we were trying to prevent him from going. All during the time that remained we would telephone twice a day to Nîmes: once to cancel the tickets, once to reorder them, or to add more tickets to the order or take away some. During this period, Pablo's work was all topsy-turvy, because this put him, just as it put us, in a terrible state.

The morning of the corrida, Pablo wouldn't get up. That was an ordeal that Paulo and I had to face up to regularly. We would enter the bedroom and give him, once more, all the good reasons why he ought to participate in what was, for him, really a fiesta. We would plead with him not to take the line of least resistance. We told him it was, after all, an incomparable spectacle, very important for his work, and that we all loved it. Paulo did like it but I went along mostly to please Pablo. Aesthetically it is very impressive but it always gave me a frightful anguish, and I didn't have to go very often to have had enough. Furthermore, I was often carsick en route in those days, because my health had been less steady ever since Paloma was born. One could hardly say I had a passion for bullfights, and that I dragged Pablo to see them.

Finally, slowly, in order to please us, Pablo would get up and we would leave, way behind schedule. After that, Marcel had to drive

PART V

like mad because it's about a hundred and fifty miles to Nîmes, and only a little less to Arles, and we had to get there early enough for Pablo to inspect the bulls in the *toril* before lunch, greet the nervous matadors in their rooms, and very important, discuss with the *mayoral de la ganadería*, the breeder, the traits of each bull.

The mayoral always accompanies the bulls. He stands at the barrera directly behind the matadors so that he can see everything that happens during the corrida and thus know to what extent his bulls live up to his expectations. They call a bull "tame" (manso) when he refuses to fight and, instead of charging the cape, paws the earth and then backs up. They used to send in dogs to tear at him, but now they simply withdraw him from the fight. That is considered a great blow for the breeder. But when the bull has fought "sublimely," in the terminology of the aficionado, he is given full honors in the arena in defeat—in death. For the breeder, that is an indication that he has brought together the right stock in the right way to produce the best combination of fighting qualities.

So between inspecting the bulls, greeting the matadors, and talking shop with the *mayoral*, Pablo had a busy morning before him. These are all characteristically Spanish rites without which a bullfight is not a bullfight, and we had to get there well before noon; otherwise the whole day was spoiled for him. So we always tried to leave early, but since we never could, we had to rush and get there just under the wire. And then there was another rite. We had to sit down to a huge lunch of *paella* with all the friends who would come to Castel's house—the writers Michel Leiris and Georges Bataille, Pablo's nephews Javier and Fin Vilato, and a dozen more. By that time Pablo was radiant. We were at the bullfight and everything was fine.

One day we went to a bullfight in Arles, not only to see the usual three matadors kill their six bulls but also to see Conchita Cintrón, a Chilean girl about eighteen or twenty years old, who was a *rejoneadora*, fight two bulls from horseback. When the matador is on horseback, there are no *picas* or *banderillas*. All those first phases of the *corrida* are replaced by the maneuvers that the matador makes from his horse. When the bull tries to charge the horse, the matador pulls away from him and plants in his back wooden lances about five feet long with an eight-inch steel tip. These lances are called *rejones*. If he is skillful enough, he kills the bull. If not, at the end of ten or fifteen minutes, he gets down off his horse, takes a sword and a red *muleta* and goes in for the kill in the usual manner. That was the way it happened with Conchita Cintrón that day:

she got down off her horse and killed the bulls with her sword and she did it well. She was about my size, and had brown hair, and green eves. We had met her before the corrida because, as usual, we had gone to speak to the matadors. After the corrida, some of us were sitting around in a little café-Pablo and I, Javier, Castel, and the mayoral who had brought the eight bulls from Spain to Arles. The mayoral was wearing the costume of his function-narrow trousers, boots, a kind of leather apron, a short Andalusian jacket, and the Andalusian hat. Since he spoke only Spanish we were all speaking Spanish with him. I was wearing the hip-length Polish coat Pablo had brought back for me from his trip to the Peace Congress in Wroclaw. A group of people came over to me and asked me for my autograph. I thought that strange. I pointed to Pablo and said, "He's the one who signs the autographs.' They said, "No, no. It's you we want." Pablo said, "Don't argue. If they want your autograph, sign." So I signed, all around. Everyone seemed happy and they left. Almost immediately another group came in and we went through the same routine. This time even Pablo was astonished. I asked the people why they wanted my autograph. One of the men, looking very wise, said, "Whether you want to admit it or not, and even if you sign with another name, we know you're Conchita Cintrón." Pablo was delighted that I could be mistaken for a bullfighter and told the story to everybody.

That day the painter Domínguez and Marie-Laure de Noailles came to the *corrida*. For Pablo the bullfight was just as sacred—perhaps more so—as mass for a Catholic. We were seated in the first row in the shade, as usual, so that we had the best possible view and we were observing, as always, the religious silence that Pablo imposed on us. When he saw Domínguez and Marie-Laure come in and take their seats just behind us, he began to curse. Domínguez was weaving tipsily and they were laden down with bottles of wine, sausages, and a huge loaf of bread. Pablo remained friendly on the surface but inside he was seething. He muttered to me, "You know I don't like any distractions at a *corrida*. It looked like a decent program for a change, and now they're going to spoil everything, those two back there. It's disgusting. And I can't say anything. What a life I lead! Everybody spoils everything for me. No pleasure without the taste of ashes."

And in fact that afternoon Domínguez outdid himself and everyone else in shouting, cheering, hissing, at the most inappropriate moments. When the time came for the matador to receive his tribute from the crowd, Domínguez, amid the *olés*, threw down the loaf of bread and

PART V

then a sausage and finally the wine bottles, now more or less empty. But he did it with such brio that Pablo couldn't stay angry, despite the sacrilege.

Domínguez suffered from acromegaly, which made his skull swell and press against his brain and turned him half-mad and led him, eventually, to suicide. He had an enormous nightmare head right out of Goya. Marie-Laure, her hair parted in the middle with long bangs and falling in waves on each side, looked a bit like Queen Marie-Louise. She was wearing a very Goyaesque black lace dress with layers of ruffles and Spanish pompons. Since she had put on a bit of weight that summer, there was a space between the bodice and the skirt where you could see a generous patch of Marie-Laure. That cheered up Pablo somewhat, and he decided that, in spite of his earlier pessimism, their presence had actually added zest to the afternoon's other pleasures.

CABLO'S SON PAULO caused him a good deal of anguish on occasion, but I always felt he had more genuine affection for his father than many of those whose actions were more carefully calculated to please. My first view of Paulo came by way of a large photograph of him that hung in the long room where Sabartés worked at the Rue des Grands-Augustins. He had a straightforward, direct look that I liked and that shed a different light on him than the scrapes he sometimes got into and the angry reactions they aroused in Pablo. Whenever I asked Pablo about him, he was thoroughly out of patience with him: he said he was lazy, had no ambition, couldn't hold a decent job, and he made various other reproaches bourgeois parents often make about their slow-starting, twentyish sons. Then he would launch into a bitter diatribe against Olga, Paulo's mother, to show me that Paulo couldn't possibly amount to anything with a background like that.

Soon after I went to live with Pablo in June 1946, Paulo, who had been living in Switzerland, came to Paris and dropped into the atelier one day. He was over six feet tall, had red hair, looked no more Spanish than I, and had a likeable, easy manner that corresponded to the impression I had received from the photograph. Pablo introduced us and told him I had come to live there. Paulo scemed pleased, talked in

a friendly fashion for a while, then closeted himself with Pablo for some private matter and took off as quickly as he had arrived, back to Switzerland on his motorcycle.

A few weeks later, just as we were leaving Ménerbes to go visit Marie Cuttoli, Paulo and motorcycle arrived again. He decided to accompany us to Cap d'Antibes. All the way down he served as a combination escort and entertainer. There was almost no traffic a good part of the way and whenever the road was visibly free for several miles ahead, he would weave back and forth in an exhibition of fancy riding, sometimes far ahead, sometimes just behind us. It seemed to me to be intended not just as a proof of his skill in handling his motorcycle, but his way of trying to demonstrate an exuberant affection for his father and his goodwill toward me. Pablo didn't take it in that light, however, and by the time we reached Cap d'Antibes, he was thoroughly exasperated with his daredevil son.

Paulo was often in Golfe-Juan and once Pablo and I began spending much of our time in the Midi he was frequently with us. He did give his father a good bit of concern in the process of growing up and sometimes it seemed like a very long process indeed—but in any of his dealings with Pablo it was always very clear that it was never self-interest that motivated him but a genuine and spontaneous affection.

Paulo's spontaneity was evident in other ways, too. One evening after making the rounds of the bars of Juan-les-Pins, Paulo and a friend brought back to the *Hotel du Golfe*, otherwise known as *Chez Marcel*, a couple of girls of the kind one meets in the late bars. In French we call this kind of girl "light," and these two were so light that about two in the morning, having exhausted all the other possibilities, Paulo and his friend decided it would be easy to throw them out the window. At any rate, they managed to scare them half to death. The girls shouted and screamed so much—and the hotel was just across from the police station —that it ended with the intervention of the local police commissioner, a fellow named Isnard.

Isnard was fond of Pablo, and we used to see him often. He had got into the habit of dropping by, periodically, just as Pablo was getting up in the morning, to tell him what had happened the night before. Even when Paulo had not been misbehaving, we were treated to frequent briefings about everything that went on along the Riviera. He would tell us the whole story about such things as the theft of the Begum's jewels, who had taken them, and whether or not they would be given back. We knew, often before the newspapers did, the latest sordid stories that had crossed the police blotter. Isnard loved to spin out all the gossip. As for Pablo, it wasn't just that he liked gossip; he adored it. If we wanted to see him in a good mood all day long, all we had to do was to get Commissioner Isnard up to the house in the morning to tell him about the latest burglaries along the coast. Obviously, though, it was not quite so funny the days when he came to tell us of Paulo's carryings-on. That would put Pablo in a bad mood for the whole day.

That morning Isnard came in with a long face and said mournfully, "I don't like to have to bring it up, but do you know what happened last night? That son of yours, how he carried on! Talk about disturbing the peace! I've never seen anything like it. It's a good thing he's your son and that we can take that into consideration. Otherwise well, all I can say is, you've got to put a stop to it somehow. It's just out of the question that this kind of thing should go on. Imagine, trying to throw women out of the window!" By now Pablo was sitting up straight in his bed looking very glum, and Isnard, sensing that he had his audience, launched into his story. Being a true son of Marseilles, he loved to embroider the facts. By the time he had finished, Pablo looked like a thundercloud. "You go get Paulo and bring him in here," he said to me.

I went out to look for Paulo. He hadn't arrived yet, but when he showed up at eleven o'clock I saw that he was pretty badly hung over. I told him about Isnard.

"I'm not going in there alone," Paulo said. "You walk in front of me." Since Paulo was six feet one, I couldn't hide him entirely, even though he was crouching down behind me. Pablo began to bellow, "You worthless creature. You carried on again last night just like the lowest form of animal existence." He grabbed his shoes from the floor and threw them at us, then the books from his night table, and anything else he could lay his hands on. One of the books bounced off my head. I protested that I had nothing to do with this.

"Never mind trying to pass the buck," Pablo said. "He's my son. You're my wife. So he's yours, too. It amounts to that, anyway. Besides, you're the one who's here. I can't go out looking for his mother. You've got to stand up and take your share of the responsibility." Paulo and I burst out laughing at this brand of logic but that only made Pablo angrier. He looked around for something else to throw but he had run out of ammunition so he began to shout again.

"Good God, I don't understand how you can carry on like that. It's unbelievable. Trying to throw a woman out of the window. It's absolutely mad. I never heard of such a thing." With an angelic look on

his face, Paulo said, "But Papa, you amaze me. I would have thought you had more imagination. You, of all people, ought to understand that sort of thing very well. Haven't you read the Marquis de Sade?

At that Pablo exploded. "You're the son of a White Russian, all right. I've got the most disgusting son in the world. You're nothing but a bourgeois anarchist. And besides, you spend too much money. The only thing you do is pile up debts. What good are you?"

"I'm sure Aly Khan spends more of his father's money than I do of yours," Paulo said piously.

Pablo pounded his pillow. "You're disgraceful. Now you're comparing me to the Aga Khan. What a lack of respect! You have the crust to talk about me in the same breath with that repulsive old Buddha." I couldn't stop laughing and I was chased out of the room for impertinence. For the rest of the day Pablo didn't speak to us. He didn't even get out of bed.

Soon after that, tired of hearing his father say he couldn't do anything, Paulo told him there was one thing, at least, that he *could* do —ride a motorcycle. He entered a motorcycle race that started from Monte Carlo and wound over the curves of the Grande Corniche and the Moyenne Corniche and he came in second in competition with professional racers. Pablo was very impressed, but he was so afraid Paulo would kill himself if he kept it up that he never again reproached him for not being able to do anything.

I think Paulo would have done lots of things if his mother hadn't held him back. He lacked neither intelligence nor a sense of humor. One morning, Baron Philippe de Rothschild arrived at *La Galloise*. Since he knew that Pablo had already done *L'Homme au Mouton*, the statue of the man holding a sheep in his arms that now stands in the market square at Vallauris, he wanted Pablo to make a sheep for him as an emblem for his Mouton Rothschild wine, to be cast in bronze and placed at the entrance to his château and vineyards near Bordeaux.

"What I want," Philippe de Rothschild specified, "is a sheep holding a bunch of grapes in his mouth."

"Oh, I see," said Pablo. "That's a very natural desire on your part. But you think that just because I've made a goat and a sheep, I'm going into that business? If you asked me to do Bacchus holding a bunch of grapes in his mouth, I'd say, 'Go see Michelangelo. He's your man.' But a *sheep* with a mouthful of grapes—you must be out of your mind. I never heard of such a thing. I wouldn't consider it. And I don't know anybody who would."

Feeling a bit at a loss, no doubt, and looking for something to ease away the awkward moment, Philippe de Rothschild turned toward me and said, "Oh, Madame, it's marvelous how youthful you look." I asked him why. He said, "Well, I had heard that you had been paralyzed." I realized he thought I was Olga, who was then in a hospital in Cannes, partially paralyzed. Not content with one faux pas, he said, "It's unbelievable that you should have a son so big," and he pointed at Paulo. Paulo burst out laughing. Then he said to Philippe de Rothschild, "You know, I was born a bit prematurely. Quite a bit. As a matter of fact"-pointing to me-"I was born before she was." Then Rothschild realized he'd made the most beautiful gaffe of his life. Paulo rolled up his trouser legs as far as his knees, crouched down near the floor and began to run around the room, waving his arms and shouting, "Ma-ma, Ma-ma." Claude, who was then about three years old, was so delighted with this that he began to follow him around crying "Mama," too, and Philippe de Rothschild was obliged to leave, but without a sheep.

NICOLE VÉDRÈS had studied philosophy at Heidelberg, taken her doctorate, and after writing several novels, turned to film making. She had had a good deal of success with a film called Paris 1900, which she had made by taking bits of old films and running them together in a panorama of the period between 1900 and 1914. It was done with a good deal of wit, the script was excellent, and the music, composed by a friend of ours named Guy Bernard, added just the right accompaniment. Pablo went to see it and liked it very much. One day Nicole came to Vallauris to tell us she wanted to do another film, this one turned not toward the past but toward the future. She wanted to include in it a number of outstanding contemporary figures who might be considered to have importance for posterity, and to give some indication of what lay ahead. Among others, she had Joliot-Curie lined up for a discussion relating to nuclear physics, Jean Rostand for biology, Sartre for philosophy, and André Gide for literature. For painting she wanted Picasso. She had been friendly with Gide for a long time. Picasso and Gide, on the other hand, had not only always stayed away from each other, but

had held to a certain mutual antipathy. Pablo reproached Gide with a complete lack of taste in painting, since Gide's choice, based on his friendships, always ran to painters like Jacques-Emile Blanche. Gide, for his part, had felt that Pablo neither understood nor cared much about "things of the spirit."

In spite of his coolness toward Gide, Pablo agreed to take part in the film. Gide was then over eighty and Pablo was sixty-eight. Although each was perfectly satisfied that the other should be in the film, neither suspected that Nicole Védrès would bring them face to face. But that is what happened and the two Achilles came out of their tents and met on what was both more and less than neutral ground: the Musée d'Antibes. There was an entire sequence at the Musée d'Antibes in which Gide asked Pablo about the ceramics of his that were displayed there and Pablo explained to him the mysteries of the potter's art. There was nothing very exciting about the script. What was historic was the meeting itself and the fact that each of them should have accepted it.

Gide's face looked like a Chinese theater mask, with a fixed grimace. The only animation was in the eyes, which were still exceptionally bright. We had lunch with him one day on the harbor at Antibes. He had with him Pierre Herbart, who was then collecting the material about Gide which soon after began appearing in print, and another young man, dark and very handsome. During the luncheon, Gide said to Pablo, "Both of us have reached the age of serenity," adding, with a nod to his young man and then to me, "and we have also our charming Arcadian shepherds."

Naturally Pablo rejected that aesthetic interpretation of life. "There's absolutely no serenity for me," he said, "and furthermore, no face is charming."

Another day, Gide came to the house to visit us. Gide and I got along fine and that helped relax Pablo's antagonism. As we walked down the steps from the house to the road, Gide turned to Pablo and said, "There's one thing about Françoise I like very much. She's the kind of person who may always have remorse, but will never have regrets." Pablo said, "I haven't any idea what that means. I suppose Françoise has no acquaintance with regrets but she knows even less about remorse." Gide said, "It's easy to see there's a dimension to her inner life which has escaped you." That was the end of the friendship, because Pablo could never admit that Gide had found something in me that he himself hadn't seen. They never met again.

During the filming, I had to go meet Pablo as he left the Musée

d'Antibes, and perform other conventional banalities that were totally artificial. They had to shoot scenes like that a dozen times or more because both of us roared with laughter every time we had to go through them. Ordinarily we either stayed together all day long or we went our separate ways, but I had never been in the habit of running to meet him at the door of the museum, like the little woman who waits for her husband at the door of the factory or the office after his hard day's work. There was another scene showing Pablo at work in the pottery. It was almost impossible to shoot that scene since there were at least fifteen people who had nothing to do that day and had come to watch. Jacques Prévert had us all in stitches because he kept picking up some of Pablo's plates and holding them over his face as though he were wearing a mask. They had to do the scene over many times. Then the fuses kept blowing out and there was no more light. Everyone had a wonderful time except the technicians.

There was a sequence on the beach in which the director insisted on showing us going through all the usual beach stunts. Everyone on the beach was watching us, plus all the film crew, plus all our friends who had dropped by for the occasion, so there wasn't very much possibility of being natural. We romped into the water and out again and Pablo drew in the sand, just as though we were all alone on a desert island, although the beach had never been so full as it was that day. It was bad enough to have to go through all that nonsense, but to have to look at it from a seat in a movie house would have been too much; as a result I never saw the film.

UNTIL THE SUMMER OF 1949, Pablo had been satisfied to spend two or three afternoons a week doing pottery at the Ramiés', but now, suddenly, he had had enough of ceramics and he began to look for a place where he could paint. We looked first for a larger house so that he would have room to work at home, but we found nothing that seemed suitable at a price that Pablo didn't consider exorbitant. Then he got the idea of taking an old factory in the Rue du Fournas that had once been a perfumery. It was L-shaped and had good north light. Above the large ground-floor rooms were some small ones we might have been able to

live in if they hadn't been in such bad shape. Pablo made the right-hand wing into his sculpture studio and the left-hand area he used for painting. In the little rooms above he stored pottery. It took us about two months to put things in shape and in October Pablo began to work there. He generally went there after lunch and worked late into the evening.

The building was of very rudimentary construction. There was no central heating and we had to install a huge stove in each room. The sculpture studio was large and high-vaulted, about thirty-five feet by twenty-five. It required a stove to match, with pipes running all around. And since the tile roof was far from tight, the heat kept moving on up and out, so the fire had to be pushed all morning long. Then there were the two painting ateliers, each with its big stove. All these stoves had to be started by eight in the morning; otherwise it wasn't warm enough for Pablo to work there in the afternoon.

He had very suavely made the point that it was only when I built the fires that the place ever got warm enough to work in over the long hours he kept, so after I got through coaxing the heating system back to life at *La Galloise* in the morning, I would pedal down to the atelier and start the stoves there. Of course, they all had to be cleared of yesterday's debris before new fires could be built. That was my setting-up exercise every morning from the beginning of November to the end of April.

I wouldn't have minded this routine, even in the winter, except that, as usual, I was generally up with Pablo until very late and I didn't get much sleep: never more than five or six hours a night. Pablo slept until noon, as a rule, but I had to get the household and his day organized. Stoking the furnace at La Galloise and building the fires at the atelier were only the prelude. I went through the mail, sorting out the things that required immediate action. Since Pablo never answered letters, that meant letters for me to write. And then, since we had no telephone at La Galloise, I had to go to the pottery to see what needed taking care of there. Sometimes I had to show people the work he was doing at the pottery. But before any of that, there were the children to be dressed, washed, and, as soon as they were old enough, gotten ready for Marcel to drive to the école maternelle. And both of them gave Pablo reason to cut my ration of sleep even further. After Claude was born, Pablo began to make a Freudian slip that was quite amusing: whenever he wanted to speak of the child, l'enfant, he would say l'argent, the money. At the Rue des Grands-Augustins Claude slept in the room next to ours. We went to bed about one or two in the morning, after Pablo had finished his work. One morning about three o'clock Pablo

suddenly sat up in bed and said, "The money is dead. I don't hear him breathing any more." I had no idea what he was talking about. I saw he was awake, not dreaming, so I asked him what he meant.

"You know very well what I mean. I mean the child," he said. I told him that was the most peculiar mix-up I'd ever heard.

"You don't know what you're talking about," he said. "It's the most natural thing in the world. Freud even says so. After all, the child is his mother's riches. Money is another form of riches. You just don't understand those things." I told him I could hear breathing sounds very clearly from the next room.

"That's the wind," he said. "My money is dead. You go see." I went in to look at Claude. He was sleeping peacefully. I returned to our bedroom and reported to Pablo that the child was not dead. That happened about twice a week. Often Claude would wake up while I attended to him; that meant a half-hour or so before he got back to sleep again. Of course, looking after him like that gave him the habit of repeating his demands.

Later on, when we were living mostly in Vallauris and Claude slept farther away from us, I had to go through the same routine almost every night, because Pablo would begin to worry, about three in the morning, whether Claude hadn't smothered in his pillow. Sometimes, after my first inspection, he would be satisfied. Other times, in ten minutes he would begin again. And some nights, depending on the state of his anxiety, I would have to get up half a dozen times. It happened rarely in the summer, when he had plenty of activity at the beach, but in winter, without it, that became his favorite distraction. After Paloma was born, he swung into another cycle of the same, just as seriously and insistently as though we hadn't gone through it all before. And he was very thorough: all doors between all rooms had to be left open so that he could hear. Since there was a lot of wind in the winter, we slept in very drafty bedrooms and we all had plenty of colds.

During the day his anxiety continued. Often when he got home he would say, "Where's the money?" Sometimes I would say, "In the trunk," because Pablo always carried around with him an old red-leather trunk from Hermès in which he kept five or six million francs so that he'd always "have the price of a package of cigarettes," as he put it. But if I assumed he was referring to one of the children and said, "In the garden," then he would often say, "No, I mean the money in the trunk. I want to count it." There was never any real point in counting it because the trunk was always locked, Pablo had the only key and he

kept it with him at all times. "You're going to count it," he'd say, "and I'll help you." He'd pull out all the money, pinned together at the bank in small sheaves of ten bills, and make little piles of it. He'd count one sheaf and it might turn out to be eleven. He'd pass it over to me and I'd count ten. So he'd try it again and this time come up with nine. This made him very suspicious, so each of us had to check again all the sheaves. He had much admired the way Chaplin had counted money in *Monsieur Verdoux* and he tried to do it fast like that. As a result, he made more and more mistakes and there were more and more recounts. Sometimes we spent as much as an hour on this ritual. Finally, when Pablo was tired of playing with the bills, he would give up and say he was satisfied, whether the books balanced or not.

BETWEEN AND AROUND MY VARIOUS JOBS, I managed to find time to paint on my own. When I went to live in the Rue des Grands-Augustins, I had stopped painting for about three years and spent whatever free time I had drawing. It had seemed to me that if I were to go on painting, it would be impossible to work next to Pablo without reflecting his presence. I felt, though, that if I concentrated on the structural qualities in my drawing, I would be more likely to make progress in line with my own natural development, and that if I was being influenced by Pablo's work, I would become aware of it more easily since fewer elements were involved than there would be in painting. In 1948 I began working in gouache and in 1949 I went back to oil painting.

It would not have been feasible for me to work at Pablo's atelier, even though he had ample room. Working at home I was more subject to interruptions but I could keep an eye on other things—the children, for example. Paloma rarely bothered me. She was, as Pablo often pointed out, an ideal girl-child. She slept almost around the clock, ate everything she was supposed to and behaved like a model for her kind.

"She'll be a perfect woman," Pablo said. "Passive and submissive. That's the way all girls should be. They ought to stay asleep just like that until they're twenty-one." He spent many hours sketching and painting her as she slept. She was so passive, in fact, that she rarely talked to either one of us. And yet during some of her waking periods,

PART V

we used to hear her chattering endlessly to Claude. Afterward Claude would speak to us for both of them. She seemed to want to remain a baby. She would bring us flowers and present them, in baby talk, long after she was talking normally to Claude. She was never rebellious, but she never obeyed. Claude, on the other hand, argued about everything. After one drawn-out session with him, Pablo told him, "You're the son of the woman who says 'no.' There's no doubt about that."

It must have been lonely for them much of the time: they almost never saw their father, and their mother barricaded herself behind her studio door whenever she could see a spare hour or two before her.

Once as I was working at a painting that had been giving me a great deal of trouble, I heard a small, timid knock at the door.

"Yes," I called out and kept on working. I heard Claude's voice, softly, from the other side of the door.

"Mama, I love you."

I wanted to go out, but I couldn't put down my brushes, not just then. "I love you too, my darling," I said, and kept at my work.

A few minutes passed. Then I heard him again, "Mama, I like your painting."

"Thank you, darling," I said. "You're an angel."

In another minute, he spoke out again. "Mama, what you do is very nice. It's got fantasy in it but it's not fantastic."

That stayed my hand, but I said nothing. He must have felt me hesitate. He spoke up, louder now. "It's better than Papa's," he said. I went to the door and let him in.

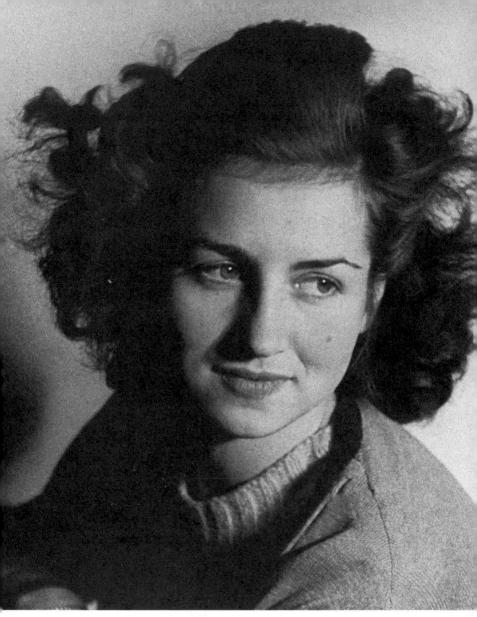

1. Françoise in 1942; photograph by Endre Rozsda

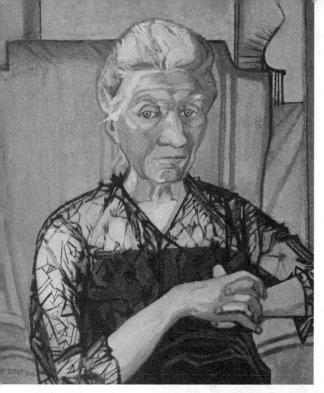

2. Françoise Gilot, *My Grandmother Anne Renoult*, 1943

3. Françoise at her family home, shortly after the liberation of France, 1944

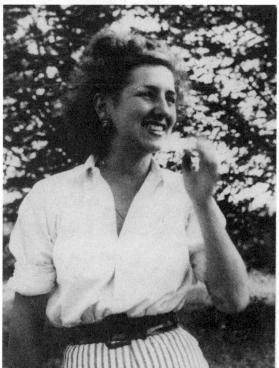

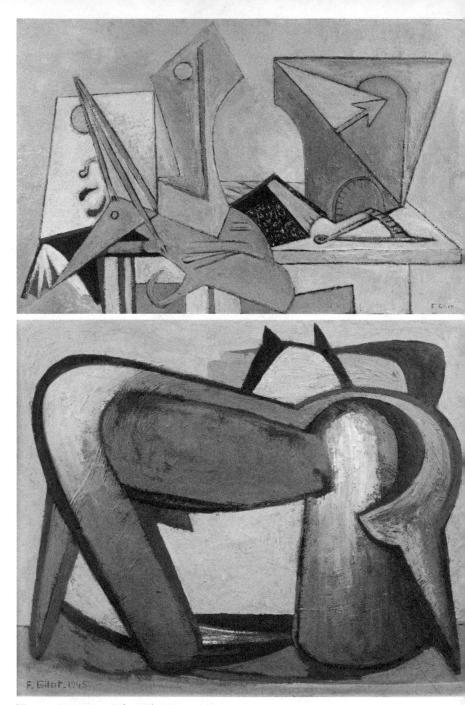

Top: 4. Françoise Gilot, *The Constructor*, 1944 Bottom: 5. Françoise Gilot, *Horse Abstraction*, 1945

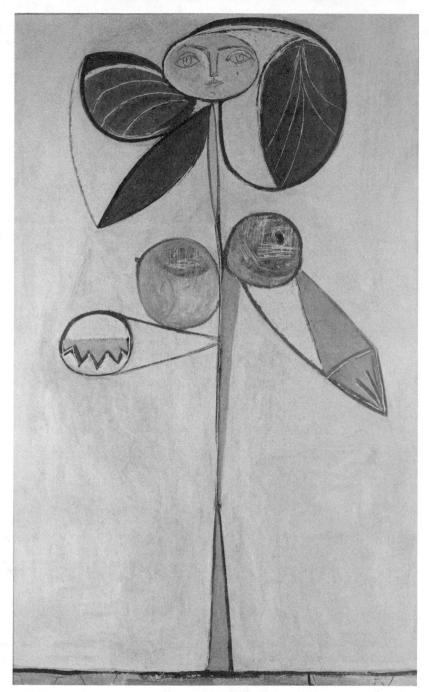

6. Pablo Picasso, *La Femme-Fleur* (portrait of Françoise Gilot), 1946

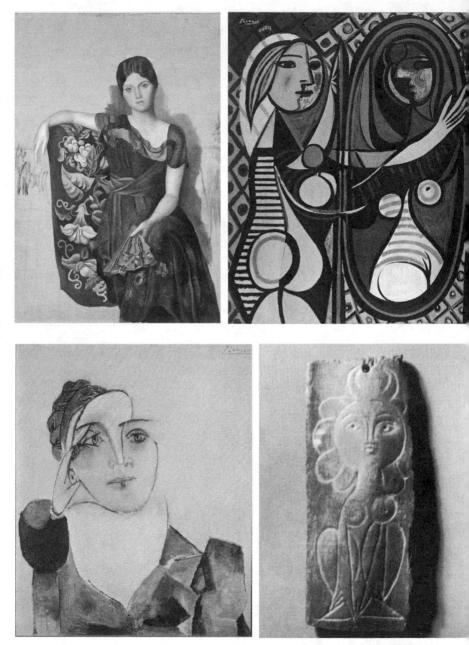

Four portraits by Pablo Picasso, clockwise from top left: 7. *Olga*, 1917; 8. *Girl Before a Mirror* (portrait of Marie-Thérèse Walter), 1932; 9. *Eve on Adam's Rib* (portrait of Françoise Gilot), 1946; 10. *Dora Maar*, 1936

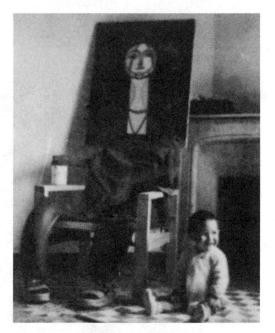

11. The first day at La Galloise; Claude and his mother, arrangement by Picasso, 1948

12. Claude with Françoise's grandmother in Golfe-Juan, 1948

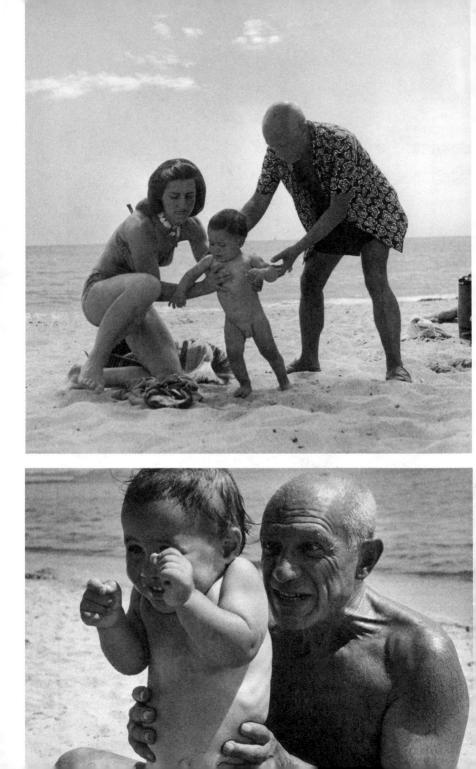

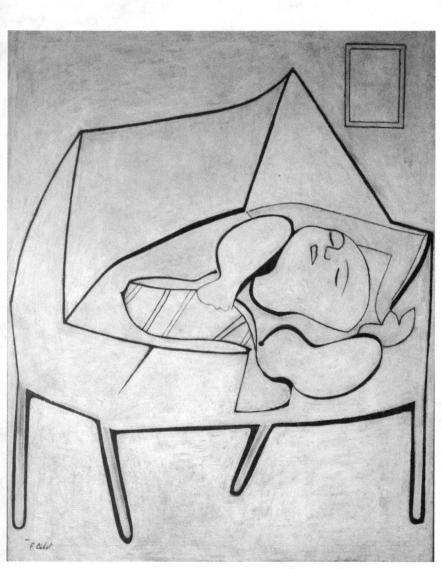

15. Françoise Gilot, Paloma Asleep in Her Crib, 1950

Opposite, photographs by Robert Capa: top: 13. Picasso and Françoise with their son, Claude, in Golfe-Juan, 1948; 14. Picasso with Claude, 1948

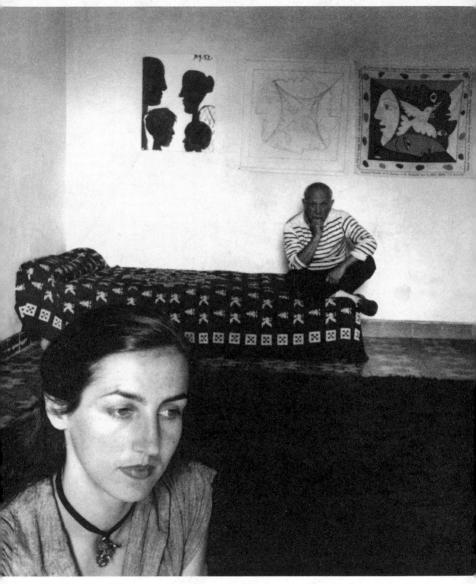

16. Françoise and Picasso at La Galloise, 1952, photograph by Robert Doisneau

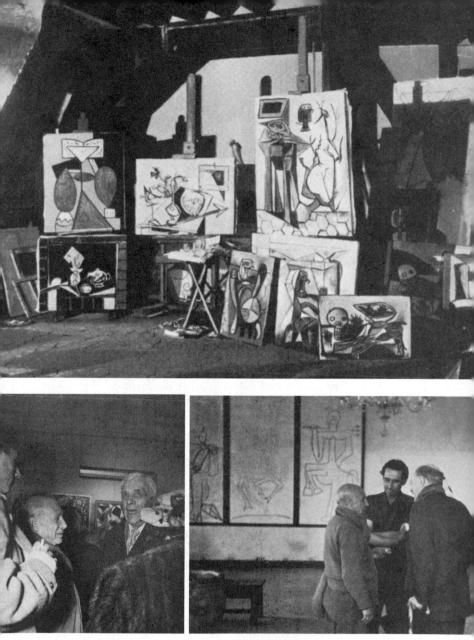

lockwise from top: 17. Picasso's studio, rue des Grands-Augustins, 1947, photograph by mil Schulthess; 18. Picasso with Messieurs Lachenal (father and son), in front of his iptych at Musée d'Antibes, photograph by Felix H. Man; 19. Paulo Picasso, Picasso, nd Georges Braque in front of Matisse posters at Mourlot's poster exhibition, 1952, hotograph by Hélène Adant

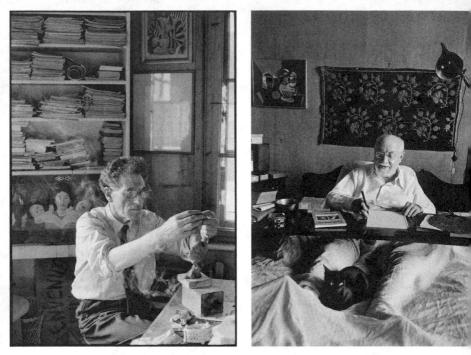

Clockwise from top left: 20. Alberto Giacometti, 1961, photograph by Henri Cartier-Bresson; 21. Henri Matisse, 1949, photograph by Robert Capa; 22. Pablo Picasso, *Pencil Drawing of Jaime Sabartés in Monk's Habit*, 1938; 23. Georges Braque, 1962

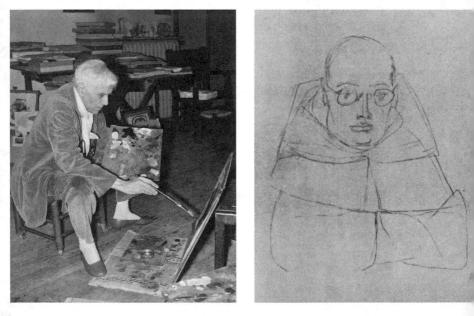

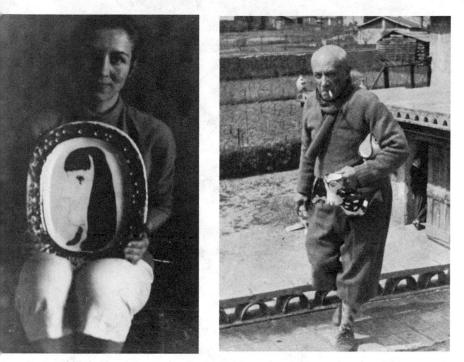

Clockwise from top left: 24. Françoise holding a painted plate, photograph by Picasso; 25. Picasso at the pottery, Vallauris, photograph by Felix H. Man; 26. Françoise and two sculptured portraits by Picasso, Vallauris, 1951, photograph by Claude Roy; 27. Picasso and Roger Lacourière at the pottery

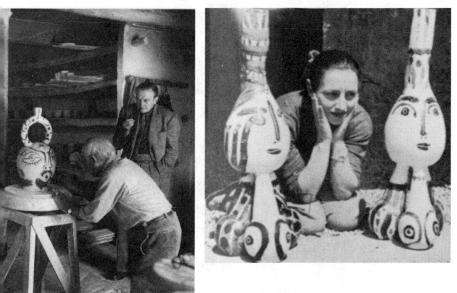

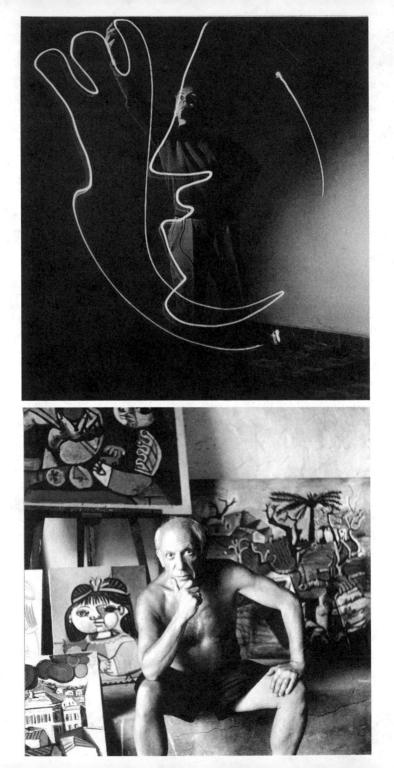

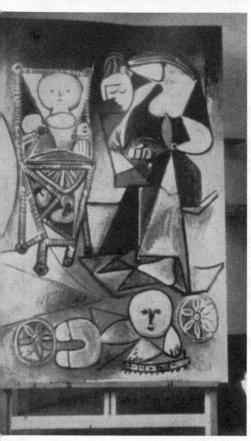

Opposite, top: 28. Françoise drawing with light, 1948, photograph by Gjon Mili; bottom: 29. Picasso with his paintings of Vallauris, Paloma, and La Galloise, photograph by Douglas Glass

Top: 30. Pablo Picasso, *Paloma*, *Françoise, and Claude*; bottom: 31. Pablo Picasso, *Françoise*, *Paloma, Claude, Yan*, India-ink wash drawing, 1951

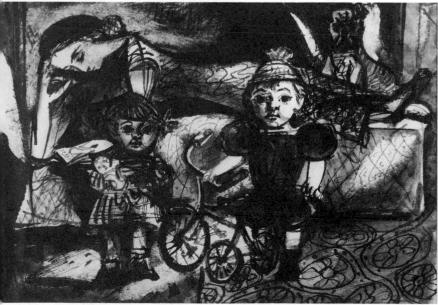

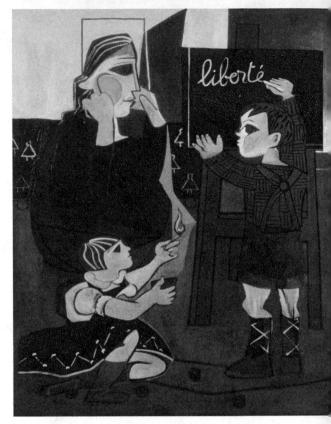

32. Françoise Gilot, *Freedom*, 1952

33. Françoise Gilot, *Earthenware*, 1951

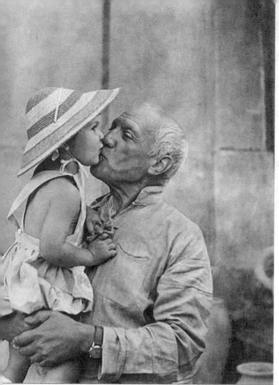

34. Paloma and Picasso, 1951, photograph by Edward Quinn

35. Françoise and Paloma, ca. 1951, photograph by Marianne Hederström Greenwood

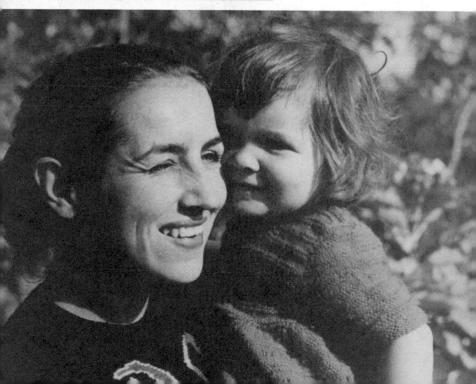

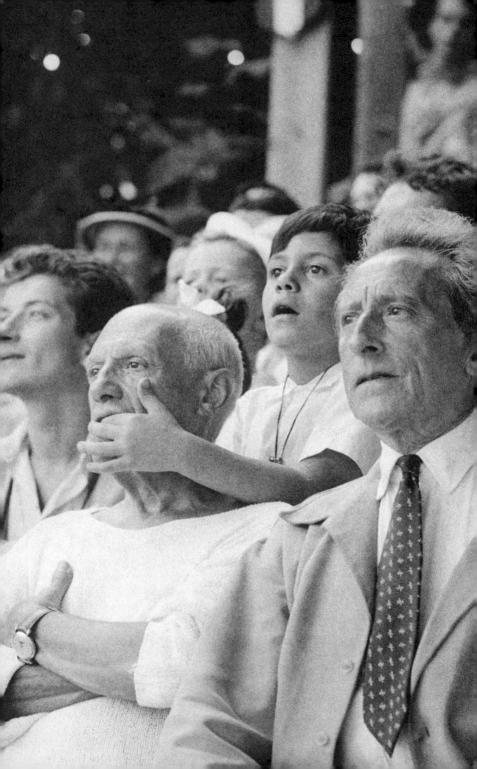

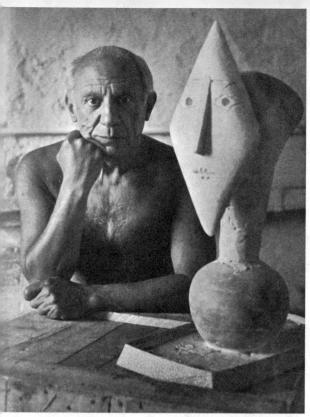

Opposite: 36. Picasso, Claude, and Jean Cocteau watching a bullfight, 1955, photograph by Brian Brake

37. Picasso with *Tête de Femme*, a sculptured portrait of Françoise, 1951, photograph by Douglas Glass

38. Pablo Picasso, *Goat Skull, Bottle, and Candle,* 1951–1952

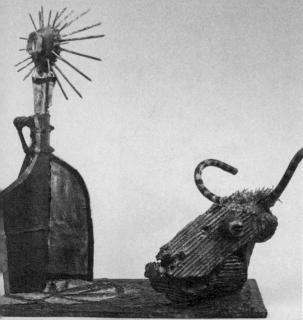

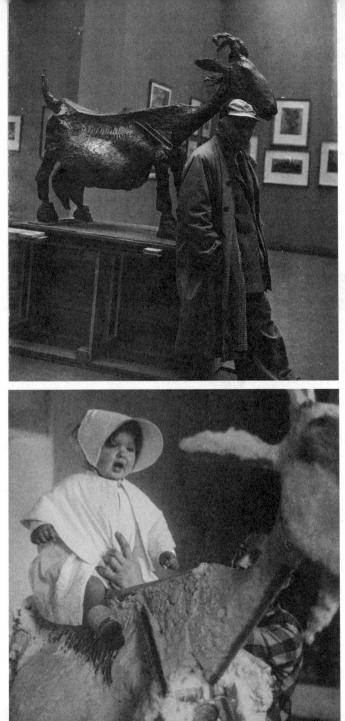

39. Picasso with *The Goat*, at the Salon de Mai, 1952, photograph by Michel Sima

40. Paloma and Françoise with *The Goat*, 1950, photograph by Clair Batigne

41. Paulo with the Kootz Oldsmobile, Vallauris, 1949, photograph by Robert Capa

42. Paloma, Paulo, and Claude, photograph by Alexander Liberman

43. Françoise and the children, Paris, after her last visit to Picasso, 1955

44. Françoise Gilot, *Theseus*, 1963

PART VI

FALL THE ARTISTS Pablo knew and visited during the years I spent with him, no one meant guite as much to him as Matisse. At the time we made our first call on Matisse in February 1946 (when Pablo came to visit me at Monsieur Fort's house in Golfe-Juan), he was living in a villa called Le Rêve in Vence. He had moved there from Cimiez. up in the hills above Nice, where he had gone to convalesce following two very serious operations he had undergone in Lyons in the spring of 1941. The nurse who took care of him in Cimiez had her heart set on becoming a nun. She was young and pretty and it was she who posed for all the drawings he made to illustrate Tériade's edition of Letters of a Portuguese Nun. In 1943 Matisse moved to Vence. Across the street from his villa was a Dominican convent. Later on, his former nurse-now Soeur Jacques—came there as a novice, and often visited him. On one of her calls she brought him a design she had made for a stained-glass window to decorate a new oratory the order was planning to build. As a result of their discussions and of others Matisse had with a Dominican novice named Brother Raysséguier and with Father Couturier, also a Dominican and the leading exponent of modern art in religious circles, Matisse found himself a prime mover in the construction and decoration of the Dominican chapel in Vence.

Matisse was confined to his bed for three-quarters of the day but that didn't dampen his enthusiasm for the project. He had paper fixed to the ceiling over his bed, and at night, since he didn't sleep much, he would draw on it with a piece of charcoal attached to the end of a long

237

bamboo stick, sketching out the portrait of St. Dominic and other elements of the decoration. Later, he would roll around in his wheel-chair and transfer his drawings to large ceramic squares covered with a semimat enamel on which he could draw in black.

Matisse's idea was that there should be no color inside the chapel, other than what came in with the light shining through the stained-glass windows. He laid out the maquettes for the glass in much the same manner he used for the papiers découpés on which he spent a good part of his last years. He had Lydia paint large pieces of paper in various tones for background and pin them against the wall in the areas he indicated to her. He then showed her, with his stick, where to place the cut-out pieces in other colors with which he formed his composition. He did three series of maquettes. The first was extremely geometric and very successful on its own terms but he decided not to use it because it did not create just the effect he wanted. The next was very much in the spirit of Tahitian foliage, akin to the one he finally used, but with different proportions. The color range he was working with included ultramarine, a deep yellow, and a green. He wanted each element to have about the same dimensions as the others so that the light entering through them would be uniformly divided. And so he asked for something that had not been done until then: that the glass should be frosted on the outside. He reasoned that if it were not frosted, the blue, for example, would give a great deal less luminosity than the yellow and wouldn't remain on the same plane. With the glass frosted, the luminosity would be uniform throughout. But once the windows were placed in the chapel, they gave a kind of uniform pink-mauve light. And when it reflected on the forty ceramic squares which Matisse had ordered to be semi-mat but which were actually rather shiny, it left a mauve reflection, which wasn't a very pleasing effect; certainly not what he had intended.

Pablo thought it wasn't successful. "If Matisse had realized that the light inside the chapel was going to become this pinkish mauve," he said after one of our visits to the chapel, "he would have been better off to have used some other colors inside the chapel to counteract that effect. If the chapel was supposed to be white and black, there should have been no color except maybe a spot of red or something very clear-cut, but not that pink-mauve. That makes the place look like a bathroom."

One afternoon we went to call on Matisse while he was working on his projects for the stained glass, the chasubles, and all the ornaments to decorate the chapel. Father Couturier, the principal intermediary whom Matisse saw in connection with his work, was there that day. He

PART VI

was no stranger to me. At the Dominican college which I had attended in my teens, I was looked upon as one of the leading rebellious spirits, and they had often been obliged to send me to have discussions on a high theological plane with several priests who, they hoped, might be able to satisfy somehow my perverse questions—I always had a great deal of trouble accepting certain notions they put forward as fact, such as the idea that there is no salvation outside the Church. In that connection, I had met Father Couturier.

On our previous visit Pablo had said to Matisse, "You're crazy to make a chapel for those people. Do you believe in that stuff or not? If not, do you think you ought to do something for an idea that you don't believe in?" Matisse was telling this to Father Couturier as we arrived that day and Father Couturier replied, "You can say what you want to about Picasso, but he paints with his blood." Obviously that was designed to please Pablo, but Pablo wasn't in the mood to be seduced by a phrase, however flattering it might be, and he began to repeat what he had said to Matisse on our earlier visit. "But why are you doing these things? I'd approve of your doing them if you believed in what they represent, but if you don't, I don't think you have any moral right to do them."

"As far as I'm concerned," Matisse said, "this is essentially a work of art. It's just that I put myself in the state of mind of what I'm working on. I don't know whether I believe in God or not. I think, really, I'm some kind of Buddhist. But the essential thing is to put oneself in a frame of mind which is close to that of prayer."

Father Couturier was clearly determined to draw out of this whatever spiritual advantage he could, however much it might exude an odor of Buddhism. He turned toward me and said, "But you know very well, don't you, that we are open to all ideas. We don't attempt to make everyone conform to us. We are more interested in opening ourselves up to all kinds of spiritual possibilities." And then, as evidence of their intellectual broad-mindedness, he referred to the discussions he had had with me when I was at college.

I smiled and told him I remembered them well. But if the Dominicans were that way now, I said, it was because they were relatively weak. "With all the charm at your disposal you'll do anything—even to going into the theater and the movie world—to fish for whatever few poor souls are still available. You're ready to make all kinds of concessions," I said. "But when you had the power with you, what did you do? It was the Dominicans in Spain who were at the head of the Inquisition. Your weapons vary according to your strength or weakness."

Pablo was rubbing his hands together, pleased to see me react, for a change, in the kind of aggressive manner that he frequently reproached me for lacking. I noticed often that he seemed to be giving me plenty of rein in situations like this one and whenever I rose to the occasion, he began to beam like the proud owner of a filly that has turned in a promising performance.

As for Matisse, whether Buddhist or Christian, he radiated a serenity that I found very moving. I told him so one day.

He said to me, "I didn't expect to recover from my second operation but since I did, I consider that I'm living on borrowed time. Every day that dawns is a gift to me and I take it in that way. I accept it gratefully without looking beyond it. I completely forget my physical suffering and all the unpleasantness of my present condition and I think only of the joy of seeing the sun rise once more and of being able to work a little bit, even under difficult conditions."

Before the operation Matisse had been a rather bourgeois person in temperament and habits. Pablo told me. He said he had never liked Matisse very much when they were younger, and had found it impossible to spend much time with him then. But from the time we started living in the Midi, they saw each other more and more. Pablo had almost a reverence for Matisse because Matisse's manner reflected an inner balance, a calm that brought peace even to a man like Pablo. Also, I think that Matisse had eliminated from his thinking any sense of rivalry, and this made their friendship possible. His detachment from self was certainly the positive element in their relations. Matisse could afford the luxury of being Pablo's friend. It was more important for him to see Pablo, even with the sarcastic remarks and occasional ill temper that Pablo indulged in than not to see him. He had a kind of paternal attitude toward Pablo and that, too, helped, because in friendship it was always Pablo who took and the others who gave. In their meetings, the active side was Pablo; the passive, Matisse. Pablo always sought to charm Matisse, like a dancer, but in the end it was Matisse who conquered Pablo.

"We must talk to each other as much as we can," he told Pablo one day. "When one of us dies, there will be some things the other will never be able to talk of with anyone else."

Later, when Matisse was again living in his apartment at the Hôtel Régina in Cimiez, we used to go see him about every two weeks. Very often Pablo would bring him his latest paintings or drawings, and sometimes I would bring canvases and drawings of mine. Matisse would have Lydia show us things he had just done, or if he had been working on *papiers découpés*, we would see them pinned up on the walls.

One day when we called, Matisse had just bought a Chinese mandarin's mauve-pink silk robe, very long and lined with the fur of a Gobi desert tiger. It stood up all by itself, and Matisse had posed it in front of a pale mauve Arab wall hanging. The robe was very thick, with a high white collar that flared up on each side of the face.

"I'm going to have my new model pose in it," Matisse said, "but first I'd like to see what it looks like on Françoise." Pablo didn't like the idea but Matisse insisted, so I tried on the Chinese robe. It came right up to the top of my head and I was completely engulfed in its triangular form. Matisse said, "Oh, I could do something very good with that."

"If you do," Pablo said, "you'll have to give me the painting and give her the coat."

Matisse began to back down. "Well," he said, "the robe looks nice on Françoise, but it wouldn't be at all right for your painting."

"I don't mind," Pablo said.

"No," Matisse said, "I've got something that's much better suited to you. It's from New Guinea. It's a full-sized human figure that's completely savage. It's just right for you." Lydia went out to get it. It was carved in arborescent fern, streaked with violent tones of blue, yellow, and red, very barbaric looking and not really old. It was larger than life-size, rather battered, its legs attached by strings—just bits and pieces barely hanging together, topped by a feathered head. It was much less handsome than many things of New Guinea I had seen. Pablo looked at it and said that we didn't have room in the car to carry it away. He promised Matisse he'd send for it another day.

Matisse acquiesced. "But before you go, I want you to see my plane tree," he said. I wondered how he had managed to bring a plane tree into his hotel apartment. At that point a giant of a girl, who looked about twenty years old and was surely six feet tall, walked in.

"This is my plane tree," Matisse said, beaming.

After we had left, Pablo said, "Did you notice how Lydia's nose was out of joint? Something's going on there, you may be sure. But don't you find that a little exaggerated, for him to be carrying on like that with women, at his age? He ought to be a little more serious than that."

I told Pablo I was surprised he could be such a puritan for others as long as he indulged in whatever he wanted himself. Moreover, I said,

I didn't see any harm in the fact that a man as old and as ill as Matisse should find joy and warmth in letting his eyes and spirit follow, appreciatively, the curves of a young girl's body.

"I hate that aesthetic game of the eye and the mind," Pablo said, "played by these connoisseurs, these mandarins who 'appreciate' beauty. What *is* beauty, anyway? There's no such thing. I never 'appreciate,' any more than I 'like.' I love or I hate. When I love a woman, that tears everything apart—especially my painting. Everybody criticizes me because I've had the courage to live my life in broad daylight—with more destruction than most others, perhaps, but certainly with more integrity and truth, also.

"What annoys me even more is the fact that because I'm uninhibited and live that way, everybody thinks I don't like refined things. When I became interested, forty years ago, in Negro art and I made what they refer to as the Negro Period in my painting, it was because at that time I was against what was called beauty in the museums. At that time, for most people a Negro mask was an ethnographic object. When I went for the first time, at Derain's urging, to the Trocadéro museum, the smell of dampness and rot there stuck in my throat. It depressed me so much I wanted to get out fast, but I stayed and studied. Men had made those masks and other objects for a sacred purpose, a magic purpose, as a kind of mediation between themselves and the unknown hostile forces that surrounded them, in order to overcome their fear and horror by giving it a form and an image. At that moment I realized that this was what painting was all about. Painting isn't an aesthetic operation; it's a form of magic designed as a mediator between this strange, hostile world and us, a way of seizing the power by giving form to our terrors as well as our desires. When I came to that realization, I knew I had found my way.

"Then people began looking at those objects in terms of aesthetics, and now that everybody says there's nothing handsomer, they don't interest me any longer. If they're just another kind of aesthetic object, then I prefer something Chinese. Besides," he said, "that New Guinea thing frightens me. I think it probably frightens Matisse too and that's why he's so eager to get rid of it. He thinks I'll be able to exorcise it better than he can."

Shortly after that visit, Pablo went back to Paris and stayed there a while, but all during the time he was away Matisse held fast to his idea. He called up the Ramiés at the pottery, not knowing that Pablo had left for Paris, and said that the object was still there waiting for him. Then he wrote to him twice reminding him that his gift was still uncalled for. He obviously had his heart set on transferring it to Pablo's possession. "It's not something you can remain indifferent to," he wrote. "And it's not sad, either." But Pablo was still put out to think that Matisse believed it was better adapted to his temperament than something Chinese. He didn't like the idea of Matisse thinking that *he* was the intelligent painter and Pablo just a creature of instinct. Finally, Matisse had it sent over to Vallauris. Once Pablo had it, he was rather happy about it and we made a special trip to Cimiez just so he could thank Matisse.

PABLO HAD AT LEAST eight paintings by Matisse, of which he had bought perhaps three. The others he got from Matisse in exchange for paintings of his. One of these exchanges was a characteristic Matisse still life of white tulips and a plate of oysters on a brick-red table against a black background scratched with small white checks. Also from that period he took a painting of a woman seated in a brown armchair. The woman is in mauve and the background is green. Those two canvases were very successful in their color harmonies and very free and spontaneous. Matisse told us that sometimes in the evening he used to wipe out with cotton and turpentine whatever he had done during the day if it didn't please him completely. He would start the same painting again the next morning, from scratch, always with a completely spontaneous approach. He did that because, he said, "When I have a feeling for something, my feeling for it doesn't change. That feeling is at the center of my conception of the painting and I try all possible expressions of it until I find one that satisfies me completely." In the same spirit he had made all sorts of trials for the illustrations he did for the Letters of a Portuguese Nun. From his model, the future Soeur Jacques, he made about eighty drawings exploiting all the plastic possibilities of her face: in one, he accentuated it in the form of a square; in another, all the round features were strongly exaggerated; in another, the eyes were small and very close together; another was sharply linear; another, very softly modeled with charcoal. And yet those eighty drawings, which were all very different, one from another, expressed complete unity; throughout, one had the sense of art embroidered on the same feeling. As Matisse

said, "When I look at a fig tree, every leaf has a different design. They all have their own manner of moving in space; yet in their own separate ways, they all cry, 'Fig tree.'"

From Pablo's work, Matisse had chosen a head of Dora Maar and a 1943 still life with a pitcher and a glass. The still life was very austere with little color and with somber harmonies, stressing his way of constructing the objects in the composition. The head of Dora Maar had its planes brought over from the profile onto the front view, in blue and the black-gray-white gamut with ochre that is one of Pablo's typical combinations. Each one had chosen what was most characteristic of the other.

During the winter of 1951, Pablo showed Matisse a picture he had painted of a dead tree, a very sad landscape, rather like Cranach, with a gray sky and a black-gray-white color harmony with just a bit of ochre and a touch of green. It had a strong, clear-cut design. It pleased Matisse tremendously. There was some talk of making an exchange but Matisse was already rather ill and the swap never came about. Matisse was frequently rather tired. At one time they would talk about making the exchange, then later on, when we would go back, Matisse would have been ill and everything would have to be started all over again. Pablo didn't really want to let go of the painting anyway because, as he said, "Every now and then one paints a picture that seems to have opened a door and serves as a stepping-stone to other things. One doesn't like to part with those pictures, as a rule." That, for him, was one of those pictures.

ONE DAY WHEN WE WERE VISITING MATISSE, he showed us some catalogs he had received from his son Pierre, an art dealer in New York. They contained reproductions of paintings by Jackson Pollock and others of that persuasion.

"I have the impression that I'm incapable of judging painting like that," Matisse said after we had finished looking at the catalogs, "for the simple reason that one is always unable to judge fairly what follows one's own work. One can judge what has happened before and what comes along at the same time. And even among those who follow, when a painter hasn't completely forgotten me I understand him a little bit, even though he goes beyond me. But when he gets to the point where he no longer makes any reference to what for me is painting, I can no longer understand him. I can't judge him either. It's completely over my head.

"When I was young, I was very fond of Renoir's painting. Toward the end of the First World War, I found myself in the Midi. Renoir was still living, but very old. I still admired him and I decided to call on him at Les Collettes, his place at Cagnes. He received me in very friendly fashion and so, after a few more visits, I brought him a few of my paintings, to find out what he thought of them. He looked them over with a somewhat disapproving air. Finally he said, 'Well, I must speak the truth. I must say I don't like what you do, for various reasons. I should almost like to say that you're not really a good painter, or even that you're a very bad painter. But there's one thing that prevents me from telling you that. When you put on some black, it stays right there on the canvas. All my life I have been saying that one can't any longer use black without making a hole in the canvas. It's not a color. Now, you speak the language of color. Yet you put on black and you make it stick. So even though I don't like at all what you do, and my inclination would be to tell you you're a bad painter, I suppose you are a painter, after all.""

Matisse smiled. "You see, it's very difficult to understand and appreciate the generation that follows. Little by little, as one goes through life, one creates not only a language for himself, but an aesthetic doctrine along with it. That is, at the same time one establishes for himself the values that he creates, he establishes them, at least to a degree, in an absolute sense. And so it becomes all the more difficult for one to understand a kind of painting whose point of departure lies beyond one's own point of arrival. It's something that's based on completely different foundations. When we arrive on the scene, the movement of painting for a moment contains us, swallows us up, and we add, perhaps, a little link to the chain. Then the movement continues on past us and we are outside it and we don't understand it any longer."

Pablo said, with a sarcastic air, "Ah, well, then we pretend to be Buddhists—some of us, at least." He shook his head. "I don't agree with you at all," he said. "And I don't *care* whether I'm in a good position to judge what comes after me. I'm against that sort of stuff. As far as these new painters are concerned, I think it is a mistake to let oneself go completely and lose oneself in the gesture. Giving oncself up entirely

to the action of painting—there's something in that which displeases me enormously. It's not at all that I hold to a rational conception of painting—I have nothing in common, for example, with a man like Poussin —but in any case the unconscious is so strong in us that it expresses itself in one fashion or another. Those are the roots through which the whole human substratum communicates itself from one being to another. Whatever we may do, it expresses itself in spite of us. So why should we deliberately hand ourselves over to it?

"During the surrealist period, everyone was doing automatic writing. That was a bit of a joke, at least in part, because when you want to be completely automatic, you never can be. There's always a moment when you 'arrange' things just a little. Even the surrealists' automatic texts were sometimes corrected. Therefore, since there's no such thing as complete automatism, why not admit frankly that one is making use of all that substratum of the unconscious but keeping one's hand on it? That doesn't mean I'm promoting the idea of a rational line of thought, one which goes from deduction to deduction, from one principle to its inevitable consequences. My own thought in doing a painting is often a continuous non sequitur, a series of jumps from one mountain peak to another. It's what you might call a somnambulist's thought. That doesn't mean it can't be a kind of directed dream, but that's just as far from pure automatism as it is from rational thought.

"Whatever the source of the emotion that drives me to create, I want to give it a form which has some connection with the visible world, even if it is only to wage war on that world. Otherwise a painting is just an old grab bag for everyone to reach into and pull out what he himself has put in. I want my paintings to be able to defend themselves, to resist the invader, just as though there were razor blades on all surfaces so no one could touch them without cutting his hands. A painting isn't a market basket or a woman's handbag, full of combs, hairpins, lipstick, old love letters, and the keys to the garage. Valéry used to say, 'I write half the poem. The reader writes the other half.' That's all right for him, maybe, but I don't want there to be three or four or a thousand possibilities of interpreting $m\gamma$ canvas. I want there to be only one and in that one, to some extent, the possibility of recognizing nature, even distorted nature, which is, after all, a kind of struggle between my interior life and the external world as it exists for most people. As I've often said, I don't try to express nature; rather, as the Chinese put it, to work like nature. And I want that internal surge-my creative dynamism-to propose itself to the viewer in the form of traditional painting violated."

ON OUR WAY BACK FROM ONE of our visits to Matisse, Pablo said, laughing, "Matisse has such good lungs." I asked him what he meant.

"It's the way he uses color," he said. "In Matisse's work, when you find three tones that are put on close to one another-let's say a green, a mauve, and a turquoise-their relationship evokes another color which one might call the color. That is the language of color. You've heard Matisse say, 'You need to leave each color its zone of expansion.' On that point I'm in complete agreement with him; that is, color is something which goes beyond itself. If you limit a color to the interior, let's say, of some particular black curved line, you annihilate it, at least from the point of view of the language of color, because you destroy its power of extension. It's not necessary for a color to have a determined form. It's not even desirable. What is important is its power of expansion. When it reaches a point a little beyond itself, this force of expansion takes over and you get a kind of neutral zone to which the other color must come as it reaches the end of its course. At that moment you can say that color breathes. That's the way Matisse paints and that's why I said, 'Matisse has such good lungs.'

"As a rule, in my own work I don't use that language. I use the language of construction, and in a fairly traditional manner, the manner of painters like Tintoretto or El Greco who painted entirely in *camaïeu*, and then, once their painting was about finished would add transparent glazes of red or blue to brighten it up and make it stand out more. The fact that in one of my paintings there is a certain spot of red isn't the essential part of the painting. The painting was done independently of that. You could take the red away and there would always be the painting; but with Matisse it is unthinkable that one could suppress a spot of red, however small, without having the painting immediately fall apart."

I asked Pablo how he would classify one of my favorite colorists ---Bonnard.

"Don't talk to me about Bonnard," he said. "That's not painting, what he does. He never goes beyond his own sensibility. He doesn't know how to choose. When Bonnard paints a sky, perhaps he first paints it blue, more or less the way it looks. Then he looks a little longer and sees some mauve in it, so he adds a touch or two of mauve, just to hedge. Then he decides that maybe it's a little pink too, so there's no reason not

to add some pink. The result is a potpourri of indecision. If he looks long enough, he winds up adding a little vellow, instead of making up his mind what color the sky really ought to be. Painting can't be done that way. Painting isn't a question of sensibility; it's a matter of seizing the power, taking over from nature, not expecting her to supply you with information and good advice. That's why I like Matisse. Matisse is always able to make an intellectual choice about colors. Whether it's close to nature or far away, he's always able to fill an area completely with one color, simply because it goes with the other colors on the canvas, and not because of being more or less sensitive to reality. If Matisse decided the sky should be red, it would be a real cadmium red and nothing else and it would be all right because the degree of transposition in the other colors would be at the same level. He would transpose all the other elements of the canvas into a sufficiently high color range so that the mutual relationships of those tones made possible the intensity of that first red. In that way it's the whole color range of the composition which permits that eccentricity. Van Gogh was the first one to find the key to that tension. He wrote, 'I'm building up to a yellow.' You look at a wheatfield, for example; you can't say it's a real cadmium yellow. But once the painter takes it into his head to arrive at an arbitrary determination of color, and uses one color that is not within nature's range but beyond it, he will then choose, for all the rest, colors and relationships which burst out of nature's straitjacket. That's the way he asserts his freedom from nature. And that's what makes what he does interesting. And that's what I hold against Bonnard. I don't want to be moved by him. He's not really a modern painter: he obeys nature; he doesn't transcend it. That method of going beyond nature is actively accomplished in Matisse's work. Bonnard is just another neo-impressionist, a decadent; the end of an old idea, not the beginning of a new one. The fact that he might have had a little more sensibility than some other painter is just one more defect as far as I'm concerned. That extra dose of sensibility makes him like things one shouldn't like.

"Another thing I hold against Bonnard is the way he fills up the whole picture surface, to form a continuous field, with a kind of imperceptible quivering, touch by touch, centimeter by centimeter, but with a total absence of contrast. There's never a juxtaposition of black and white, of square and circle, sharp point and curve. It's an extremely orchestrated surface developed like an organic whole, but you never once get the big clash of the cymbals which that kind of strong contrast provides."

IN HIS AVIARY, IN COMPANY with many exotic birds, Matisse had four large Milanese pigeons. Their feet were not bare like most pigeons. They had feathers right down to the ground covering their claws; it was just as though the feet had white gaiters on them. One day he said to Pablo, "I ought to give these to you because they look like some you've already painted." We took them back to Vallauris with us. One of them had a very distinguished artistic and political career. Early in 1949 Pablo made a lithograph of it which turned out to be a brilliant technical success. In lithography one can get an absolute black quite easily, but since lithographic ink has wax in it, when you dilute it with water to make a light-gray wash, the lithographic stone does not take the wash very evenly. That makes what is called in French, la peau de crapaud, a surface mottled like a toad's skin. But in this lithograph Pablo had succeeded in making a wash that gave the impression of an extremely transparent gray, with gradations that were an amazing tour de force.

About a month later, the poet and novelist Louis Aragon, who served as a kind of intellectual wheelhorse for the French Communist Party, came to the studio in the Rue des Grands-Augustins to prod Pablo into giving him a sketch he had promised him for the poster advertising the Communist-sponsored World Peace Congress soon to be held at the Salle Pleyel. Aragon looked through a folder of recent lithographs, and when he saw that one, the pigeon looked so much like a dove to him that he had the idea of making it the symbol of the congress. Pablo agreed and by the end of the day, the poster and the "dove" had already begun to appear on Paris walls. In its countless printings and reprintings, first as an original lithograph and later in reproduction, the poster went around the world in the cause—or at least in the name —of peace.

After Aragon had "discovered" the peace dove that day, he continued to look through the lithographs Pablo had done recently and he came across a series of portraits of me in the coat Pablo had brought me back from Poland. They were very stylized, with small heads. They had started as an attempt at color lithography but they hadn't worked out very well because the register marks had not been made accurately. Pablo had pulled a few proofs but they hadn't satisfied him and so he had reworked the five original plates—one for each of the colors—and

made of them five different compositions. From each of these he had pulled several states. Afterward, since they had been so much worked over and almost spoiled as a result, he made another one, very spontaneously. When Aragon saw it he said, "That one you must give to me. It's completely successful." Pablo seemed on the point of complying. Then Aragon had the misfortune to add, "I like it especially because for once you've shown Françoise to be as charming as she really is." At that Pablo looked very angry and said, "For me there's no difference between a charming woman and a frog."

"I'm very sorry for you, then," Aragon said, "but if you really don't know the difference, you've had a great deal of luck in your life, because so far, I've always seen you surrounded by rather pretty women —classical types, really—and not by little froglike monsters.

Pablo began to laugh and said, "That's like Braque. He once told me, 'In love, you still go along with the tradition.'" Then we all laughed and Aragon said, "Since you're laughing, you can't be angry any longer, so why don't you give me the lithograph?"

"No," Pablo said. "You've been impertinent. You don't get the lithograph. You'll have to be satisfied with lunch."

Aragon came often to see Pablo. Their friendship was a mordant, aggressive one, crossed with flashes of lightning, periods of sulking, and reconciliations. I think they were fond of each other and yet detested each other a little bit at the same time. Pablo, I know, never felt quite satisfied with Aragon as a friend.

"I can't have friends if they're not capable of sleeping with me," he said. "Not that I require it of the women or want it from the menbut there should at least be that feeling of warmth and intimacy one experiences in sleeping with someone."

If Aragon had come alone, that would have helped somewhat, because his wife, Elsa Triolet, and Pablo couldn't get along at all. Elsa was often sarcastic and rather mocking, and although Pablo liked making fun of people, he didn't like people to make fun of him.

The first time I saw Aragon at Pablo's atelier, I was quite taken with his physical presence. He looked like an eighteenth-century courtier. One almost expected to see him arrive dressed in silk, with knee breeches and a sword. But even without all that he produced almost the same effect. With his clear blue eyes, his pale skin, and his nearly white hair, he looked very youthful and handsome. Whenever he arrived he was in such a state of agitation he couldn't sit down and talk like anyone else; he had to stride back and forth from one end of the room to the other, speaking rapidly and continuously as he walked. It was an unsettling spectacle, almost like following the volleys at the Davis Cup matches, first to the left, then to the right, then to the left, then to the right. If by chance there was a mirror at either end, before turning he would look in it and carefully arrange his hair with his left hand. Anything he told you, however intelligent it might be, seemed of secondary importance to the fascination exerted by his perpetual motion, like that of a serpent charming a bird. The result of his marathon was that one wound up by agreeing with whatever he had come to say.

The only common denominator between Elsa and Aragon was their blue eyes—very blue, with a tiny pupil like a little black dot. He was tall and she petite but well proportioned, with remarkable legs. She, too, was still a great charmer. One couldn't say she was really beautiful, but there was no escaping the charm she exuded. I could well understand the influence she had as a young girl in Russia on the poet Mayakowsky, who was at one time the husband of Lili Brick, her older sister, and in Berlin, later, on the painters and poets there. When I met her she was fifty and still fascinating.

Pablo was always greatly intrigued by the continuing love affair between Elsa and Aragon. On Aragon's side particularly it seemed to be total devotion, almost a kind of cult or religion of which this unique woman was the reigning goddess. He discussed this with Aragon, sometimes, when he came without Elsa.

"How can you go on always loving the same woman?" Pablo asked him one day. "After all, she's going to change like everybody else and grow old."

"That's just it," Aragon said. "I like all those little changes. They nourish me. I like the autumn of a woman, too."

"Well, well," said Pablo, "I'll bet you also like lace panties and silk stockings. Are *you* decadent!"

Aragon laughed. "And you? You're an eternal adolescent, I'd say. I shouldn't talk to you about things like that. You're not mature enough to understand them."

After Aragon had gone that day, Pablo looked almost wistful and said to me, "He's lucky to be able to concentrate on one person. I'm afraid I'd find that monotonous. It would be all right for a while but then it would get pretty dull. . . ." He stopped. "No," he said, "that's not true. I'm just as particular as he is and I'd like to have my life exemplary, too." Then he sat up a little straighter and added, "And my life *is* exemplary."

I had to smile. "How right you are," I said, perhaps a bit too fervently.

Pablo looked out from his maligned virtue. "What do you expect," he said, "when I'm surrounded by sarcasm and critical analysis, instead of by the confidence and devotion that I ought to be receiving? It's not easy to hold oneself up there on the mountaintop with that kind of support."

I burst out laughing. Finally Pablo joined in. "Oh, well," he said, "what difference does it make? Life is only a bad novel, anyway."

Pablo was never very relaxed with Aragon. He and Aragon were always trying to score off each other. Their relationship was spicy and peppery, interspersed with little coquetries, flourishes, flatteries, hyperbole and paradoxes.

One day Aragon came in saying, "I have discovered a great writer, Maurice Barrès." Barrès, of course, was a bigoted nationalist and very academic, and neither of them had any respect for him. Or it might be Henri Bataille, a writer of popular melodramas. Or he would say, "I've written a brilliant study of the two great heroes of France— Jeanne d'Arc and Maurice Chevalier," just hoping to get a rise out of Pablo.

Aragon was a very gifted raconteur, whether relating his memories of childhood or his reminiscences of the Resistance, in which he underwent a good deal of danger passing manuscripts to the Resistance press. But when he read his own poems you began to grit your teeth because his manner of reading was completely unnatural. As long as he spoke in prose, he was fascinating.

Aragon, I could see, was a politician in the sense of a man like Talleyrand, a complex personage who played himself amid the complexities of politics. As Pablo often said, "Aragon is a saint, but perhaps not a hero." He would hate to have me compare him to Malraux but they do have something in common. Aragon, though, is more of a grand seigneur than Malraux.

One day, after Aragon had called on us, Pablo said, laughing, "All popular parties, like the Communists, need princes" and it was quite obvious that Aragon was a prince. If he had chosen the church instead of the Communist Party, one could easily imagine him as a cardinal. But the overlapping in his nature of the poet and writer with the actor was confusing, because at the superficial level he was primarily an actor and, in that sense, a complete fraud; yet within, he was deeply and authentically himself. He was a person of extreme contradictions, and he suffered enormously from them. He had every right to believe himself a grand seigneur of literature, and he always demanded his due: at first nights or in any gathering of the *Tout-Paris*, he must be accorded his exact place, as sensitive to rank and protocol as any of the dukes at the court of Louis XIV. And underneath it all lay a permanent suspicion of others, an anxiety, a basic unhappiness, I suppose, which resulted in an insatiable need to multiply himself, to give himself a thousand faces.

I think perhaps Pablo was right in saying that Aragon was a saint, because for a man like that to belong to the Communist Party was the greatest renunciation he could possibly achieve. Just as at the social and literary levels he was capable of demanding all the consideration he believed himself entitled to, at the other pole there was a form of masochism in his adherence to the Party that made him become more communist than all the others. As a result, he was more than once the martyr of the Party's aesthetic misjudgments.

One of the most absurd examples of this came up just after the death of Stalin. One morning in Vallauris I received a telegram from Aragon asking me to telephone him; he wanted Pablo to do a portrait of Stalin. It was very urgent because Aragon's paper, *Les Lettres Fran-qaises*, was a weekly and the portrait had to be ready by the next day in order to be in time for the next issue. I telephoned Aragon and told him it was impossible. Pablo had just left for his studio and I didn't want to disturb him by telling him that during the afternoon he must turn out a portrait of Stalin, which I felt sure he had no desire to do. Under those conditions he might not do a good job, I pointed out, and then what would Aragon do?

"That's all right," Aragon said. "Let him do a portrait of Stalin just the way he wants to do it and we'll publish it. It's an emergency. It's better to do it somehow than not to do it at all." I went off to Pablo's studio and explained the situation to him. Pablo's reaction was just what I had foreseen.

"How do you expect me to do a portrait of Stalin?" he said, irritably. "In the first place I've never seen him and I don't remember at all how he looks, except that he wears a uniform with big buttons down the front, has a military cap, and a large mustache." I had already looked around the studio and found an old newspaper photograph that might have been a picture of Stalin at the age of about forty. I gave it to Pablo.

"Oh, all right," he said. "Since it's Aragon and he needs it, I'll try to do it." Very resignedly he got down to work and tried to make

a portrait of Stalin. But when he had finished, it looked like my father. Pablo had never seen him, either, but the harder he tried to make it look like Stalin, the more it resembled my father. We laughed until Pablo began to hiccough.

"Maybe if I tried to do a portrait of your father, it might look more like Stalin," he said. We studied the photo a little more, then studied the drawings he had made, and finally he came up with one that was, more or less, Stalin at the age of forty.

"What do you think?" he asked me. I said I thought it was an interesting drawing in its own right and did resemble Stalin a little bit. Since neither one of us had seen him we couldn't say it didn't resemble him, anyway.

"But do you think I should send it?" Pablo asked. I said I did. Aragon knew his business. If he didn't think it proper he wouldn't publish it. I mailed the portrait and forgot all about it. Two or three days later, at the end of the morning, as we were leaving the house to go to the studio, we passed a group of journalists at the entrance to *La Galloise*. One of them asked Pablo, "Is it true that in doing the portrait of Stalin you wanted to make fun of him?" We didn't know what he was talking about. He explained that a great controversy had grown up around it within the Communist Party and that the Party had condemned Pablo for having drawn the portrait and Aragon for having published it.

Pablo took it philosophically. "I suppose it was the Party's right to condemn me," he said, "but it's certainly the result of a misunderstanding, because I had no bad intention. If my drawing shocked or displeased anybody, that's something else again. It's an aesthetic matter, which can't be judged from a political point of view." He shrugged. "You've got the same situation in the Party as in any big family: there's always some damn fool ready to stir up trouble, but you have to put up with him."

Later on, Aragon told us that when he opened the package the next morning he thought the drawing very interesting, just as I did. But as a result of all the protests from the literal-minded rank and file, he was obliged to open the columns of *Les Lettres Françaises* to those readers who felt it didn't resemble Stalin enough. That was absurd because if what they wanted was a speaking likeness, then all they had to do was publish a photograph. Since they had asked a painter for a drawing, they should have accepted a painter's interpretation.

The Party condemnation was published but at the end of a few days, when the whole world had begun to laugh, the Party leaders realized they had made fools of themselves. Laurent Casanova, who had been out of the country, returned to France and came to see us about it and everything quieted down. Pablo never said he was wrong to have made the drawing; that was unthinkable. All he said was, "I made a drawing. My drawing was good or not so good. Maybe it was bad. That's an affair between me and myself. My intention was very simple: to do what somebody had asked me to do." Two weeks later we were in Paris, and under Casanova's influence, the Party modified its original position by saying that the drawing had been done with the best of intentions. The only one who had to do public penance was Aragon, who was completely innocent. In the end, Thorez and several other Party bigwigs apologized to Pablo, but nobody apologized to Aragon. In addition they obliged him to make an autocritique. And that's the fate that tracks Aragon: a saint who follows the Party line right down to the point of being martyrized.

We were martyrized, too, occasionally—every time the Communists came to eat with us. Each one ate enough for four. Even old Marcel Cachin, dean of the Party hierarchy, scrawny as he was, would put away all kinds of appetizers, a fish, steak, salad, cheeses, a fancy dessert, and coffee, washed down with plenty of good wine. Pablo and I ate little and never lingered over a meal, so those banquets, which, together with the conversation, lasted for hours, were always an ordeal for us.

"What appetites those people have," Pablo said to me after one of their visits. "I suppose it's because they're materialists. But they're in more danger from their arteries than from the inequities inherent in the capitalistic system."

Maurice Thorez, the Party chief, was such a bore: he never knew what to say. The only civilized member of the Party politburo was Casanova. During the winter of 1949 he often came to see us. Once Pablo arranged for us to eat at the *Colombe d'Or*, a very worldly and expensive place in St.-Paul-de-Vence, just to see if Casanova would protest. While we were eating, we were photographed by a *Match* photographer. After that, Casanova said he didn't think we ought to put ourselves in that position again. "It's bad publicity for Communists," he said.

That annoyed Pablo. "You're above that," he said. "You're not a Boy Scout."

"You don't understand how people's minds work," Casanova said. "I don't mean just our people, but the general public. When Thorez was a cabinet minister he had a car at his disposal. He was criticized in all the papers for not using a bicycle and, on another occasion, for drinking champagne instead of plain red wine."

Sure enough, when the photograph was printed, Casanova had his knuckles rapped by some of the Party puritans.

MOST OF THE WRITERS AND PAINTERS who had left Paris to spend the war years in America returned to France as soon as they could after the Liberation. Chagall was one of the last to come back. Bella, his wife, had died in New York in 1944 and some time later he met an English girl named Virginia and had a son by her, born just a few months after Claude. Chagall wrote to Pablo from America saying that in a few months he would be back in Europe and was looking forward to seeing him, and he sent Pablo a picture of his son. Pablo was rather touched, I remember, because he pinned up the photograph of Chagall's son in our bedroom.

One day Tériade came to see Pablo about the illustrations for his edition of Reverdy's Chant des Morts, and Pablo mentioned Chagall's letter to him. "I'll be happy to see him," Pablo said. "It's been a long time." Tériade said that Chagall's daughter, Ida, was over at his place at the moment and that she would enjoy seeing Pablo. So a week later, along with Michel and Zette Leiris, we went over to Tériade's place in St.-Jean-Cap-Ferrat for lunch and there was Ida, who had prepared a sumptuous Russian meal for us. She knew Pablo's wife, Olga, was Russian and she must have thought he had a taste for Russian food. She put on all her charm for Pablo, and told him how much his work meant to her. That was music to his ears, of course. She was rather well set up, with curves everywhere, and she hung over Pablo almost adoringly. By the time she had finished, Pablo was in the palm of her hand, and he began telling her how much he liked Chagall. So Ida finished off what her father had begun: she made Pablo want to see Chagall even before he had returned.

Several months later, Chagall arrived in the Midi. One of the

PART VI

first things he did was send word that he wanted to make pottery at the Ramiés' and he came over, prepared to go to work. That was too much for Pablo. His fondness for Chagall wasn't built to withstand that and he showed it. Finally Chagall stopped coming. There was no quarrel; it was just that Pablo was much less enthusiastic once Chagall was back. But officially they were good friends.

About a year after that, Tériade invited us to lunch again. This time Chagall and Virginia were there. Virginia had a very pretty face, but was exceedingly thin and so tall as to tower over Chagall and Pablo and everyone else. Pablo, I could see, was aghast at her thinness. In addition she was, I believe, a theosophist and her principles prevented her from eating meat and about three-quarters of the rest of the food on the table. Her daughter, about ten, was there too, and followed the same dietary laws. Pablo found that so repugnant he could hardly bear to eat, either. I, too, was at the absolute limit of thinness for Pablo at that moment. Surrounded by skinny women he was in a bad mood and he decided to put it to good use. He started in on Chagall, very sarcastically.

"My dear friend," he said, "I can't understand why, as a loyal, even devoted, Russian, you never set foot in your own country any more. You go everywhere else. Even to America. But now that you're back again and since you've come this far, why not go a little farther and see what your own country is like after all these years?"

Chagall had been in Russia during the revolution, and had been a commissar of fine arts in Vitebsk at the beginning of the new regime. Later, things went sour and he returned to Paris. In the light of that experience, he never had any desire either to return to his country or to see the regime flourish anywhere else.

He gave Pablo a broad smile and said, "My dear Pablo, after you. But you must go first. According to all I hear, you are greatly beloved in Russia, but not your painting. But once you get there and try it a while, perhaps I could follow along after. I don't know; we'll see how you make out."

Then suddenly Pablo got nasty and said, "With you I suppose it's a question of business. There's no money to be made there." That finished the friendship, right there. The smiles stayed wide and bright but the innuendos got clearer and clearer and by the time we left, there were two corpses under the table. From that day on Pablo and Chagall never set eyes on each other again. When I saw Chagall quite recently, he was still smarting over that luncheon. "A bloody affair," he called it.

Not long after that visit at Tériade's, Virginia left Chagall. One evening soon after that, we were at the ballet and met Chagall's daughter, Ida. She was very upset about Virginia's leaving. "Papa is so unhappy," she said. Pablo started to laugh. "Don't laugh," Ida said. "It could happen to you." Pablo laughed even louder. "That's the most ridiculous thing I've ever heard," he said.

But in spite of his personal differences with Chagall, Pablo continued to have a great deal of respect for him as a painter. Once when we were discussing Chagall, Pablo said, "When Matisse dies, Chagall will be the only painter left who understands what color really is. I'm not crazy about those cocks and asses and flying violinists and all the folklore, but his canvases are really painted, not just thrown together. Some of the last things he's done in Vence convince me that there's never been anybody since Renoir who has the feeling for light that Chagall has."

Long after that, Chagall gave me his opinion of Pablo. "What a genius, that Picasso," he said. "It's a pity he doesn't paint."

PABLO HAD A GREAT DEAL LESS enthusiasm for the work of Fernand Léger, even though one might have thought that as ex-Cubists they had more in common. In 1951 Léger began coming to the Midi in the winter and spring because one of his pupils had set up a ceramics studio at Biot with the idea of bringing out editions of ceramic plaques designed by Léger, including some large pieces in bas-relief which could be joined together to form vast expanses of polychrome mural decoration.

Pablo would never have taken the trouble to go see Léger. Even in Paris they had almost no contact except for an occasional chance meeting at the Galerie Leiris if both of them happened to have dropped in to see a new exhibition or to chat with Kahnweiler. Pablo liked Léger's early painting, the more rigorously constructed canvases of his Cubist period, and to a lesser extent, what he did up to about 1930. But he liked much less what Léger had been doing since then.

Léger always considered himself one of the musketeers of Cubism, but it was not an opinion that was shared by Pablo or, according to what Pablo told me, by Braque or Juan Gris either. They were the Three Musketeers of Cubism, and Léger, as far as they were concerned, was just Léger. The three of them were originally Montmartre painters in the heroic period. Pablo and Juan Gris lived and worked at the *Bateau Lavoir* and Braque worked nearby in the Boulevard de Clichy. If there was a fourth Musketeer at the time, it would have been Derain, who was very friendly with Braque. Léger came later, brought over from Montparnasse by Max Jacob. Max was an insomniac and often spent his nights wandering from one end of Paris to the other; often he didn't have the price of a *métro* ticket. At that time Léger lived at *La Ruche*, a crumbling beehive of artists' studios near the Vaugirard abattoirs. In 1912, when Pablo went to live in Montparnasse, they saw a bit more of each other. But whenever Pablo and I went to the Galerie Leiris and Léger's paintings were on view, he always found them a bit outside the domain of great painting.

"There's not enough there for me," he told me. "It's open and frank, but it doesn't go beyond what it shows you at first glance. The harmony of two colors in a painting by Matisse or one by Braque covers an infinite distance, full of nuances. Léger puts down his colors in the required amounts and they all have the same degree of radiation. Perhaps there's nothing wrong with that, but you can stand in front of one of his paintings for an hour and nothing happens beyond the shock you register during the first two minutes. In Matisse's work the vibrations set up by a certain mauve and a certain green create a third color. That's painting. When Matisse draws a line on a piece of white paper, he draws so perceptively, it doesn't remain just that; it becomes something more. There's always a kind of metamorphosis of each part that creates the whole. If Léger draws a line, it does remain just that—a line on white paper."

There's an old story about Braque driving through Italy with his wife. In every town they came to, Braque would drive up in front of the museum, stop the car and say to his wife, "Marcelle, you go in and look around and then tell me what's good in there." He wouldn't go in himself for fear of spoiling his eye with "old" painting. But Braque was a very cultivated man, and the point of the story is simply to illustrate a certain attitude on his part. With Léger, things weren't quite the same. One day Kahnweiler came to see us in the Midi and said, in an awestruck voice, "Do you know what's happened?" Pablo said no. Kahnweiler said, "I've been to see the Caravaggio exhibition in Milan, you know."

"Oh, Caravaggio," Pablo said. "Very bad stuff. I don't like it at all. It's completely decadent and-"

Kahnweiler interrupted him. "Yes, I know you feel that way, but that's not the point. I'm not obliged to share your opinion and I don't. But at any rate, you know what Caravaggio's painting is like."

"Of course I do," said Pablo. "If I didn't I wouldn't be talking about it."

"But you can't imagine what I just heard in Paris," Kahnweiler said.

"Of course I can't," said Pablo. "So why don't you tell me without wasting so much time."

"Well," said Kahnweiler, "when I got back to Paris from Milan after seeing the Caravaggio exhibition, Léger came to the gallery one day and asked me where I'd been. I told him Milan. He asked me why I'd gone there. I told him I'd gone to see the Caravaggio exhibition. 'Oh,' said Léger, 'and what about it?' I told him I found it very good. Léger thought awhile and then he said, 'Tell me, Kahnweiler, did Caravaggio come before or after Velázquez?'"

Of course Pablo was delighted with that. It even made him feel very benevolent to see Léger in such a position. "Well," he said, "Léger always claimed, 'Painting is like a glass of red table wine,' and you know as well as I do that not all painters drink *le gros rouge*. And they paint their pictures with something other than that, too, fortunately. Leonardo came nearer the truth by saying that painting is something that takes place in your mind, but he was still only halfway there. Cézanne came closer than anybody else when he said, 'Painting is something you do with your balls.' I'm inclined to think it's a question of Leonardo *plus* Cézanne. In any case, *le gros rouge* just won't do."

Madame Léger, as Russian and as unsophisticated as could be, was very eager to have her "great man"—"Missié Léger," as she called him—get together with the other great man—Picasso. Since she knew Pablo often saw Matisse and Braque and from time to time Chagall, she saw no reason why he shouldn't see Léger too. And not at the gallery, but at home. She came to *La Galloise* to call on me. She explained her point of view in her picturesque French, winding up with "I hope you understand. Is absolutely necessary two great men get together." I said nothing of this to Pablo because I knew it would only annoy him. I had thought no more about it when, two or three months later, Madame Léger returned to *La Galloise*. Bubbling over with goodwill, she held out a package to me. "You, little body, not very developed, but I make for you pretty sweaters with magnificent design here, Missié Léger. You wear them, very handsome, in name of peace." She unwrapped her package and took out first one and then another heavy black sweater, each decorated across the chest with a full-blown white dove-a Léger dovewith highlights in several colors. I thanked her and invited her into the house. The sweaters were very well knitted but the doves-well, doves were not Missié Léger's dish, really. I could see myself walking around Vallauris being taken for a bicycle racer or a prize fighter's manager or perhaps a sandwichman heralding the arrival of the circus. She had hardly left when Pablo returned from the atelier. I showed him the sweaters. He burst out laughing. "You must wear them," he said. "C'est trop beau." So I wore them from time to time and at least once in the presence of Madame Léger, who beamed with pride when she saw me. That encouraged her in her project for a meeting at the summit between the great men, and finally she arranged with me for Missié Léger to call on Pablo. The Légers arrived toward the end of a May morning at Pablo's atelier in the Rue du Fournas. It was a very warm day with a clear blue sky untroubled by anything other than the smoke from the wood-burning potteries. Léger looked up at the sky and said, "I certainly miss my Normandy. It's so tiresome, this constant blue sky. There's not an honest-to-God cloud up there. When you need clouds you have to send up smoke. There aren't even any cows here."

"We're a Mediterranean country," Pablo said. "We don't have any cows; only bulls."

"I can't tell you how much I miss those Norman cows," Léger said. "They're so much better than bulls. Besides, they give milk."

"Ah, yes," Pablo said, "but a bull gives blood." I could see he wasn't in the mood to show his paintings that day but the Légers gave no sign of leaving. Finally we went inside, Pablo showed them his ateliers, and brought out a few pictures for them to look at. Nadia—Madame Léger—like all Soviet stalwarts, was interested in theorizing on "the new realism," abstract versus figurative, the problem of how much of the image to bring into the painting, and so on. "Painting must return to some kind of realism," she insisted. "Is absolutely necessary. The way of the future. I have the right to say that because I was pupil of Malevich," and she turned to me as though I were a Hottentot and said, "Malevich, little white square in big white square."

Pablo and I were trying our best to keep a straight face. Pablo couldn't resist the temptation to put in, "But it's unbelievable that you should have been a pupil of Malevich. How old were you at the time?"

Madame Léger thought over the implications carefully for a moment, then, realizing that from the point of view of age perhaps she

had worked herself into a corner, replied, "I was child prodigy. Pupil of Malevich twelve years old."

N HIS RELATIONS WITH HIS DEALERS, Pablo played a shrewd psychological game based on the idea, as he put it, that "the best calculation is the absence of calculation."

"Once you have attained a certain level of recognition," he explained to me, "others generally figure that when you do something, it's for a very intelligent reason. So it's really foolish to plot out your movements too carefully in advance. You're better off to act capriciously. It's amazing how easy it was for me to get Paul Rosenberg upset. I had only to act annoyed or disgusted and say, 'Oh, no, my friend, I'm not selling you a thing. It's out of the question for the moment.' Rosenberg would spend the next forty-eight hours trying to figure out why. Was I reserving things for some other dealer who had made overtures to me? I'd go on working and sleeping and Rosenberg would spend his time figuring. In two days he'd come back, nerves jangled, anxious, saying, 'After all, dear friend, you wouldn't turn me down if I offered you this much'—naming a substantially higher figure—'for those paintings rather than the price I've been accustomed to paying you, would you?'"

Pablo had been much impressed by the technique of Ambroise Vollard. A couple would come into Vollard's shop to see some Cézannes. Vollard would show them three paintings and pretend to fall asleep in his chair, so he could listen to the couple discuss the pictures and their preferences without being obviously interested. Up to that time, nothing had been said about price. Finally Vollard would stir in his chair and ask them which one they preferred. "It's so hard to decide," they would say. "We'll come back tomorrow." The next day they'd return and say, "We've come to make a decision about the picture, but first we'd like to have you show us a few others." Vollard would bring out three others and go back to his nap in the armchair. After the same little routine they would ask to see the first three. Then Vollard would tell them either that he couldn't find them, or that they had been sold, or perhaps even that he didn't remember anything about three others; he was old and tired, he'd say, and they'd have to forgive him. Each day this went on, the pictures got less and less interesting. Finally the couple would realize they'd better buy something—anything—quickly before things got even worse. And if they hadn't yet talked price, they discovered in the end that they had paid more than they ought to have for something a lot less interesting than what they had seen the first day. Pablo considered that the height of wisdom and always based his own maneuvers on Vollard's tactics.

"I never calculate," he told me. "That's why the others who do, calculate so much less accurately than I do." In a certain paradoxical sense he was telling the truth, and yet the whole truth was much more complex than that. He didn't make any calculations in the sense that if a picture dealer was to come see him the next morning he said to himself the night before, "I'm going to sell him such and such a canvas at such and such a price." He would think of the psychology of the meeting in terms of the amusement or the boredom it represented for him. And it was for that reason that the picture dealer was always at a loss, because he didn't know how to approach Pablo; he couldn't find out whether Pablo wanted a certain thing or not because Pablo hadn't figured it out for himself yet. What Pablo did do was to imagine in advance how the interview was going to go in general. Sometimes he would have us act out little playlets which prepared the routine of the next day if Rosenberg or Kahnweiler or, a little bit before their day, Louis Carré, was coming. Sometimes Pablo kept his own role and I would take the part of the dealer, or I would be Pablo and Pablo would be the dealer. Each question and each reply, even though it was slightly burlesqued and often turned into farce, still had to be a prefiguration of what was going to take place the next day. Each of us had to respect the psychology of the character he played even where the humor was exaggerated far beyond the actual facts. If Pablo played himself, he asked the most pointed and embarrassing questions of the "dealer." If I answered something which wasn't in character, Pablo would correct me and I had to find something else. The next day I was in on the meeting as a neutral observer. At certain moments I would have a little wink from Pablo because the dealer had given a reply which duplicated exactly one I had given for him the night before. This sort of playlet had its practical uses but it was put on principally, I think, for fun. In general it had to end with the triumph of Pablo. He had the last word because he had more wit, more fantasy, more imagination, more arms of all kinds, than his opponent.

There was one exception to this. Those whose triumph over him

he was able to foresee were the ones who would bore him to defeat. Kahnweiler was a master of that technique. Pablo would say, "Oh, that Kahnweiler. He's terrible. He's my friend and I'm very fond of him, but you'll see, he's going to take me over because he'll bore me night and day. I'll say, 'No' and he'll go on boring me for another day. I'll still say 'No' and he'll go on boring me for a third day. And I'll say to myself, 'When is he going to leave? I can't stand having him bore me a fourth day,' and he'll have such a terribly sad look on his face, look so bored himself, that I'll say, 'I can't bear it. I must get rid of him.' And in the end, since I know what he wants, I'll give him some pictures just to get him to go away."

In Paris when Kahnweiler wanted pictures, he would come and go and come again until he got them, but if we were in the Midi it was much more serious because in that case he would camp on our doorstep until he won out. Pablo would say, "Of course, he's a friend. I can't be too unpleasant with him. But even if I say the most insulting things to him, he won't go away." Sometimes Pablo would say dreadful things, hoping that Kahnweiler would get angry and react vigorously, but Kahnweiler wouldn't, because he knew that his strength lay in his inertia. Pablo could be pretty inert when he wanted to be, so the only way for Kahnweiler to triumph was to be still more inert than Pablo, to let Pablo say the most absurd things to him, such as, "You've never given a damn about me," or "When I think of how, in my early days, you exploited me in the most shameless fashion," and just reply, "No, no," but very calmly, without protesting too much, because if he did, then Pablo would come back at him more angrily, perhaps. Pablo sometimes continued by attributing to him all sorts of shameful activities, although Kahnweiler was, of course, a very gentle and virtuous man. Kahnweiler would say, "No, no, not at all," but not too excitedly. He knew enough not to allow himself to lock horns with Pablo on that ground, because there Pablo was a past master. And so he would come, armed with a will that was ready for any test, determined not to leave until he had the paintings.

Since Kahnweiler was a very intelligent man, Pablo would often begin to argue philosophy or literature with him. Whenever Kahnweiler answered, he would always leave the advantage to Pablo, because what counted was to get the pictures. If things became tense, he would go to sleep, or pretend to, because he didn't want to anger Pablo by giving an indication of any kind of superiority. If he had wished, he could have triumphed intellectually over Pablo during these conversations, but he

PART VI

knew that Pablo never would have given him the paintings. He would have said, "Ah, well, my friend, you've been victorious in our little arguments. You certainly don't expect to be victorious in our business dealings, too; you might as well forget about paintings."

Occasionally Pablo would ask Kahnweiler, "Have you made up your mind to join the Communist Party? That would make me very happy, you know." The question had a double edge and Kahnweiler knew it. If he had said yes, Pablo would have been unhappy because he would have known that Kahnweiler could not have done such a thing with any sincerity. If he had said no, Pablo would have been unhappy, also, to have his old friend turn him down flat. Since Kahnweiler didn't want to lose out on his paintings, he was generally very careful to make a reply that was neither yes nor no. But one time he answered quite wittily, "No, my dear friend, I don't believe I will join the Communist Party, because since the death of Stalin and the discovery of all his crimes. . . ."

"Ah," said Pablo, "I see what you're coming at. That gives you an easy out, doesn't it? You're going to claim you're disgusted with Stalin and that solves everything."

"Not at all," said Kahnweiler. "I've just come to realize something I never understood before, and that is, Stalin was a pessimist."

"What are you getting at?" Pablo asked him suspiciously.

"Just that," said Kahnweiler. "A pessimist. I suppose he must have picked it up in his early years at the seminary, when he was studying theology. Developed a kind of Manichaean dualism, apparently. He must have decided that evil is so well rooted in human nature that he could only eliminate it by wiping out human life. So, after studying the question very carefully, I have come to the conclusion that there's just too much of a contradiction there. On one hand, Marxism preaches the doctrine of endless possibilities of human progress: in other words, a doctrine based on optimism. Yet Stalin gives us the proof of just how false he thought that doctrine was. He was better placed than anyone to know whether optimism in that matter was possible, and he answered with a thumping negative by killing everyone within reach, apparently on the grounds that human nature was so bad, there was no other way of settling affairs. Under those conditions, how can you expect an intelligent man to become a Communist?"

I think Pablo rather admired the skill of that answer but he felt obliged to say that Kahnweiler had got out of his hole by "typical bourgeois sophistry." A little bit later on, in answer to the same question,

Kahnweiler said, "You wouldn't like me to have painters who are nothing more than Party hacks under contract at my gallery, would you? But that's probably what I'd be obliged to do if I ever joined the Party."

Pablo never asked him again-at least, not within my hearing.

KAHNWEILER HAD LOOKED at the first drawings I had done after I went to live with Pablo in 1946 and had been very much interested by what he called the "severity" of my research. He told me at the time that he saw in my work a state of mind very close to the one which had guided Juan Gris. After that, from time to time he would take a look at what I was doing when he came to call on us in the Midi or in Paris. In the spring of 1949 he came down to Vallauris to see Pablo and buy some paintings from him. He installed himself at a nearby hotel and we had him for lunch and dinner and the greater part of each day until the whole affair was ironed out. He stayed with Pablo if Pablo felt like tolerating his presence in the atelier; with me, if Pablo was in a bad mood and didn't want him around. One afternoon while he was waiting for Pablo, he asked me to show him what I had done that winter. He looked over everything I brought out and seemed to like it. After he had finished, he told me he wanted to give me a contract. He would take all I had done during that winter and agree to buy, from then on, twice a year, everything done in the previous six months. But I was not to sell to anyone else. I was very pleased but quite astonished because I had never imagined he would offer to place me under contract. I told him I would discuss it with Pablo and if Pablo agreed, I would accept. When I told Pablo that evening, he was as surprised as I had been. He told me he had once asked Kahnweiler to take Dora Maar on contract to his gallery and that Kahnweiler had not wanted to. As a result he had never thought of suggesting that he take me on. But since Kahnweiler had suggested it himself, Pablo was all for it, so I said yes to Kahnweiler's proposition.

He bought my paintings on the basis of eighteen hundred francs a point; the drawings at eighteen hundred francs each; those in color, at twenty-five hundred. He sold them, in general, as he did those of several other painters of his gallery, at three times what he paid for them. For example, a size-twenty canvas, which measures about two feet by two and a half, he bought for thirty-six thousand francs, about one hundred dollars at the time, and sold for one hundred thousand francs, or three hundred dollars. As André Beaudin remarked wryly one day when we were discussing Kahnweiler: "The Galerie Leiris is the Temple of Art and one of the best places for a painter to starve to death."

Dealers in other countries who wanted Picassos were obliged to take a certain number of the gallery's other painters—Masson, Beaudin, and others, including now, me. In that way, Kahnweiler moved the production of all his painters in and out with the rhythm and regularity of a Ford assembly line.

As it turned out, he did rather well with my work, and two years later he doubled the amount he was paying me. With painters who didn't produce a great deal, he took everything on the basis of so much a point. With those who turned out a lot, he took all they produced and paid them a fixed stipend of so much a month. At that time I was doing a lot of drawings but perhaps no more than twenty or twenty-five paintings a year, so he wasn't taking much of a risk in contracting for my entire production.

In the fall of 1951 I had a show of drawings at the La Hune Gallery in Paris, and the following spring, a full-scale exhibition at Kahnweiler's. The night before the Kahnweiler vernissage Pablo and I went to the gallery, then situated in the Rue d'Astorg, to watch them hang the pictures. Pablo was in a good mood. In addition to Kahnweiler and the Leirises, there were a few painters who were attached to the gallery, such as Masson and Beaudin, Marie-Laure de Noailles, and some other friends. When we left, Pablo said, "There's no point in my going tomorrow. In the first place I've seen it, and besides, if I'm there, that will take the attention away from you. People will come around asking my opinion on all sorts of things, so you'll be better off to go alone." But the next day, he couldn't quite make up his mind. He stalled and stalled to avoid having to make a decision. The vernissage was scheduled for four o'clock. He always hated to go to the movies, but he said, "You can't go to the gallery so early. Not before six, anyway. We'll go to a movie." He took me to see a film about the Flying Dutchman. There were some bullfight scenes in it, and that made him happy enough to make a decision. Around five-thirty he drove me to the gallery and left me there. Some of my friends said they thought it wasn't very nice of him to stay away the day of my vernissage but I thought, on the contrary, it was very thoughtful of him.

WHEN WE WERE STILL LIVING in Golfe-Juan at Monsieur Fort's, I had a nurse that I had brought from Paris to take care of Claude, and a local woman named Marcelle to do the cooking. Marcelle found it humiliating, in accordance with local standards, to have to serve the nurse, who ate with us. I had a good deal of trouble with these two, and one day came back to find them chasing each other around the house, the nurse armed with a frying-pan, and the cook with a heavy metal lid and a long-handled, two-tined fork. When I tried to separate the two furies I got both the frying-pan and the lid on my head.

After that, I decided to try to take care of Claude myself and let the nurse go back to Paris before any blood was shed. But as soon as the nurse had left, it developed that Marcelle wouldn't stand for any interference from anyone: she would take care of Claude, preside over the kitchen, and let no one, least of all me, interfere in her domain. So I desisted. Mornings I was busy with Pablo's work and afternoons with my own and I left Marcelle pretty much to herself. After a while, though, I began to pick up disturbing rumors that were circulating around Golfe-Juan. Pablo's son Paulo, when he wasn't racing his Norton motorcycle, spent a good deal of his time relaxing in the local cafés and bars. Whenever he showed up at one of his usual haunts, the bartender or a waitress would call out, "Here's Claude's brother," he told me. Since Claude was a youngster at the time, it struck me as odd that Paulo, a fully grown young man and well known around town for his exploits of various kinds, should have to be identified as "Claude's brother." On investigation it turned out that Marcelle, instead of taking Claude to the beach, was spending most of her afternoons in one or another of the local bistros. Having no other place to leave Claude, she was in the habit of sitting him up on the bar alongside her glass, I learned.

She was very fond of Claude, told him stories, made him laugh, and in general was fairly hard working. But aside from the bad air Claude was breathing and the questionable atmosphere he was soaking up along with it, I was afraid that Marcelle, weaving her way home at the end of the afternoon, would one day swerve into the path of an oncoming car and they would both be run over. From then on I kept her at home and took Claude out afternoons myself.

The move to La Galloise gave me a good excuse to get rid of her. There I engaged a couple who lived across the road, the husband as gardener, and the wife as cook and general factotum: Monsieur and Madame Michel. I found Madame Michel a great improvement over Marcelle. She applied herself to her job and did the heavy work well. I would have preferred to have someone look after Claude and nothing more but Pablo said he couldn't stand another strange face around the house, and when I mentioned it to Madame Michel she told me that if anyone else came in, she would leave at once. I let the matter drop.

Madame Michel was a model of French thrift. I had linen sheets for Claude's bed but she never put them on. She cut out squares from worn-out sheets and tablecloths and used those instead. When I told her to use the ones I had bought for the purpose, she told me it was a waste and quoted a local proverb to the effect that counts and barons were brought up with a minimum of fuss and feathers.

Claude had lots of playsuits and I used to change them often two or three times a day if necessary—so that he looked clean and fresh most of the time. When I tried to have her observe the same routine, she looked at me sternly and again recited her bit about counts and barons. She kept him in a drab, institutional-looking plaid romper suit. Every time Pablo saw him he'd say, "Well, here's the orphan." On Sundays at least I would have liked to see him in white, but nothing doing. Counts and barons.

One day Madame Michel told me she couldn't serve lunch that noon; she had to leave early, to "make grass" for the rabbits, which in the local phrase meant that she was going to cut some grass for them. I suggested that perhaps the rabbits could eat at another time, but she thought not. It happened so often and took such a long time I thought the Michels must keep at least two hundred rabbits. I found out later that they had only five or six.

It wasn't long before she was unable to serve dinner either, and for far stranger reasons than making grass. It was the beginning of winter when she approached me one evening about six o'clock, with a very tragic air, to say, "Madame, I must leave now. There's an agony in the Fournas quarter," which, translated, was her way of saying someone was dying in the section of Vallauris near Pablo's studio. I told her I was sorry to hear that, but why did it mean she had to leave?

"That's the way it is, Madame," she said. "In this part of the country nobody dies without me."

I had no idea what she was referring to but I began to laugh because it struck me as a very strange notion, whatever she meant by it. She looked at me disapprovingly. I stopped laughing and asked her why

it was nobody could die without her. After all, she wasn't the village priest.

"Madame doesn't know what she's talking about," she said. She had very little respect for either Pablo or me, and she generally talked to me as though I were her wayward daughter. I told her she was quite right; I certainly didn't know what I was talking about, and I'd be happy if she would explain it all to me so that I *would* know.

"Well, Madame," she said, "I'm a weeper; the best weeper in Vallauris." Old legends of Corsica surged up through my memory and I realized, then, that most of the local people were of Italian origin. "You don't just die, like a dog," she said. "Unless you're very poor, you bring in three weepers to help you get through." I told her I would give her the time to go to her agonies on condition that she tell me what went on, because I wanted to know how it was done. She needed no urging.

"Well," she said, "when we're called in, the first thing we do is to eat a good meal. Weepers work hard and you can't do that on an empty stomach. Then we draw up our chairs alongside the bed. The main thing is to prolong the agony so that before you leave, you've helped that poor soul recall everything important that happened to him all during his life. I might say, 'Do you remember, Ernest, the day of your First Communion, how little Mimi stood behind you and pulled your hair?' I grew up with him, you see, and I remember those things. 'Yes, yes, I remember,' he sobs, and all three of us weepers groan and wail with him. Then it's the next weeper's turn. 'Do you remember the day you left for your military service and how you felt when you had to say good-bye to the family?' If he says yes, then it's the third one's turn, but if he says no, we try it again and again and add more and more details until he does remember. Sometimes, it's a real sad memory, like 'Do you remember, Julie, the time you lost your little girl from the croup at the age of three?' When Julie cries her heart out, we follow along like a chorus. If it's a happy memory, we all laugh. And it goes on like that through the whole life of the one who's dying."

I said it seemed to me rather gruesome to put someone who was already suffering through an ordeal like that.

"Just the contrary," Madame Michel said. "If he can recall everything of importance that happened to him on earth, happy or sad, he can start his new life on the other side happy and free. But it's not as easy as you think. That's why I'm the best weeper around here, because I generally get it all out before they go. Sometimes we have to work fast. Other times, when we can, we take a longer way around, and make things go on like that for two or three days. But the main thing is to make it all come out even. Then, when the poor soul feels the end approaching, he doesn't answer any more; he turns his face to the wall." Madame Michel leaned closer to me and lowered her voice. "That's more important than extreme unction," she whispered. "Then we eat again and go home. The rest is up to the undertaker."

I had no choice but to let Madame Michel follow her vocation. Fortunately, in Vallauris people weren't dropping off like flies. One evening, after a calm period, she had to leave suddenly to weep for someone who was in a very bad way, over in the Fournas quarter. Pablo had bought the atelier there only recently and it hadn't been completely refurbished for his use. Since it had been used as a distillery for perfume essences, there were pipes that carried away the waste products into the sewer mains. In the middle of the front yard was a kind of shaft, blocked by a manhole cover, that led into this subterranean complex. When Madame Michel left the house, she told me she was going around by Pablo's studio in order to avoid passing in front of the house of a very poor Italian family known in the quarter simply as "Les Calabrais." Most of the Italians who had settled in Vallauris were from Piedmont, but a later wave came from a much poorer region, Calabria. The Piedmontese looked down on the Calabrese, whom they accused of eating cats and of having the evil eye. Whenever it was necessary to pass in front of the house of a Calabrese, they never failed to make the usual signs to exorcise the evil eye. But if there was a way to avoid the house. they took it.

"If I were like you people who speak pointed"—people from the North—"that wouldn't be necessary," she said, "but I have to take precautions."

The next morning at breakfast time she wasn't back. I didn't worry because by now I had grown accustomed to agonies that went on and on. Her husband, the gardener, didn't give it a second thought, either. After breakfast I went to the atelier, as usual, to start the fires for Pablo. I thought I heard groans coming out of the ground beneath my feet as I walked through the yard. I had been listening to too many of Madame Michel's stories, I told myself. Inside the atelier the groans seemed louder. I went out into the yard again, looked around and noticed that the manhole cover over the branch line of the sewer wasn't in place. I ran over to it and looked down inside. There, sitting against the wall, twelve feet below me, with no way of getting out, was Madame Michel. I ran for a ladder and when she had laboriously climbed out, stiff from

the cold and her bruises, but with nothing broken, fortunately, she explained that after a long evening of weeping, tired and distracted, she had cut across lots in the dark and without any warning suddenly found herself in what seemed a bottomless pit. After that her zeal for agonies was noticeably diminished.

One night while she was washing the dishes, I told her that we who talked pointed didn't like agonies a bit, that we didn't watch things like that unless it was someone in our own family, and that overindulgence in agonies would do her no good in the end. And since I felt in a sermonizing mood, I told her also that another thing she ought to slack off on was reading her favorite magazine, *Détective*, a very lurid crime sheet she was addicted to. She looked at me, scandalized.

"Madame," she said, "that's the only thing that's true. What you read in the other papers may have a little truth in it, but it's mostly a pack of lies. But when somebody pulls out a gun and kills somebody else, there's no two ways about it: it's real."

Détective was so real to Madame Michel that it put every other periodical in the shade. She knew, for example, that she worked for a man who was being written about constantly in all the papers and magazines. But he was never written about in *Détective* and she thought that very odd, she said. He couldn't really amount to very much. And she had reservations about other things, too.

"I don't understand why Madame and Monsieur don't dress like a lady and a gentleman," she said one day. I asked her how one ought to dress to win her approval. "Well," she said, "I know you have enough money to dress like the people in Paris, but you don't." I explained that since we were painting most of the time, it was a lot more convenient to wear blue jeans and sweaters than fancy clothes like the people in Paris. She admitted grudgingly that she understood, but it obviously made her unhappy. She had a niece, she said, who was a second maid at the Aga Khan's villa and there people dressed properly.

About two weeks later she came in one day looking very pleased. Someone had moved into the villa *Les Mimosas*, down the street, who dressed like a gentleman, she said. "I'd like to work for him," she added. I told her I had no objection to that. She stayed on, however, but from time to time she would point him out to me as he walked along the road, and he did look like a real dandy, right out of Savile Row.

A few weeks after that, Pablo's friend the police commissioner dropped by one morning to feed Pablo his weekly ration of gossip. He was walking on air. "We just picked up Pierrot le Fou No. 2"—a Marseilles gangster who was Public Enemy Number One in France at the moment. "We've been trying to get our hands on him for months," he said. "And you know, he's been living up here right under your nose in that villa *Les Mimosas*, which he bought through a straw a few months ago to use as a hideout. Everybody took him for a rich businessman from Paris. He certainly dressed the part."

Madame Michel took it rather hard. And since she was always rubbing my nose in one of her meridional proverbs, I decided it was time to teach her another one. "It's not the coat that makes the man," I reminded her. She didn't find it at all funny.

That wasn't the only thing that didn't amuse her. Pablo would have preferred, at least when it was warm, to have me walking nude around the house and the garden. For one thing, being at the beach so often, wearing the usual bikini, made me very tanned, but when I took off the bikini, there were white patches in one or two places and Pablo found that unattractive. He suggested that if at home I walked around in and out of the sun without even my bikini, the damage would soon be repaired.

"Besides," he said, "how do you expect me to put nudes in my paintings if I never see any?" I pointed out that on occasion he did. "Well, if I do, it's lying down, and if I want to paint a nude walking or standing, that's no help at all. Furthermore, it's important for me to see vou nude outside the house, in natural surroundings." I realized he had a point there, but it was difficult to carry out because of Monsieur and Madame Michel. Madame Michel was prudish, and if I had dared walk about like that while she was on the premises, she would have given me a week's notice and then covered her face with her apron and run out of the house screaming. So nothing of the sort was possible during the hours she was on the job. And for a different reason it was just as impracticable when Monsieur Michel was at work in the garden. If I ever tried to take a sunbath on the edge of the swimming pool, with a giantsized bath towel beside me for use in emergencies, that was always the moment Monsieur Michel chose to come consult with me about what flowers he should plant, although he never planted any, and whatever he did do, he did without consulting anybody. But at those times he wasn't able to do a thing without frequent and lengthy consultations. And although I always covered myself with the beach towel when he came, he looked disgusted and indignant as though the mere thought of our low ways was almost more than he could bear. Yet it was next to impossible

to get rid of him. Sometimes he would preach me a little sermon. "Madame can't stay here like this. What if the postman came?" If I pointed out to him that the postman had long since come and gone, he raised the possibility of an unexpected telegram. "And if the delivery boy saw Madame like that, what would they say in Vallauris?" If he was on the grounds there was no place I could go without having him search me out, so the only time I could sunbathe without drawing the fire of either one of the Michels was at noon when Madame Michel left to make grass for her rabbits, and Monsieur Michel had his midday siesta. That satisfied Pablo, too, because in spring and summer it was generally warm enough to have lunch outside. Since it wasn't his intention that anyone else should see me in that costume, we ate on the terrace, which was sheltered from the neighbors. So in theory, and especially if the Michels weren't around, there was no particular reason for me to be dressed. Occasionally that got me into trouble.

One afternoon I had just taken a shower and was coming out into the next room, when I heard a noise. I thought it was the children coming back from the beach. I walked through the door and found myself face to face with the matador Dominguín. I didn't know what to do. Should I stay and greet him, like a polite hostess, or should I turn and run for cover, however undignified that might make me appear? Then it suddenly occurred to me that neither one would do. He had already seen the front; it was too late to do anything about that, but there was no reason to show him the rear also. So I solemnly backed through the door, shut it, and then, when I had dressed, returned to the room. He was still waiting. I felt almost as embarrassed with my clothes as I had without them. He apologized for not knocking at the front door but explained that he had been walking around outside the house, thinking he might run into Pablo. He had seen the open door leading onto the terrace, had walked inside, et puis voilà. I accompanied him to Pablo's atelier in the Rue du Fournas. Later, when I told Pablo how Dominguín had walked in on me or vice versa, he laughed. "You weren't in any danger with him," he said. "After all, you're not a bull."

I THINK PABLO AND I were with Paul Eluard the day he first saw Dominique, who was to become his wife a year and a half later. We had gone to Paris for a few days just before Pablo's first exhibition of pottery at the *Maison de la Pensée Française*. Madame Ramié was with us and she wanted to call at a small pottery shop in the Rue de l'Arcade. With her and with Paul, we visited the shop. The woman who waited on us that day was Dominique.

Some months after that, Paul left for Mexico to give a series of lectures and also to see several refugee Spanish writers, Machado among them, who were then living in Mexico. At a meeting of one of the literary groups he spoke to he met Dominique for the second time. She had gone there on holiday. After that they traveled around Mexico together and a month or two later returned together to France. We knew nothing of all this at the time.

In February 1951, in Vallauris, we received a note from Paul one morning telling us that he was coming to call in a few days, "with my chauffeur." Pablo and I knew he had never driven a car because his hands shook as a result of an illness he had had when he was about sixteen, but we knew also his very meager income didn't allow him luxuries like a chauffeur. We thought it must be a joke. In a few days Paul called up the Ramiés to say he had arrived and to invite us to have lunch with him at *Chez Marcel* in Golfe-Juan. When we got there, we found him waiting for us with his chauffeur, who had driven him down from Paris. It was Dominique. We recognized her from our visit to the pottery shop in the Rue de l'Arcade, and then they told us about that second meeting in Mexico, and everything that had happened since. They went back to Paris soon after that but in June they returned to the Midi to get married and wrote asking us to come to St.-Tropez to stand up with them at the ceremony.

In June there is a fête at St.-Tropez called *La Bravade*. The local people go around shooting an antique rifle called a *tromblon*, which flares out at the muzzle like an old horn. They load them with gunpowder and make a terrible noise with them. The marriage took place right after *La Bravade*, at the town hall. The mayor's nerves must have been badly frayed by the festivities. He was surly and couldn't even bring himself to say the few friendly commonplaces generally handed out on such

occasions. We all signed the book and went out and that was it. A group of us, including Roland Penrose and his wife, Lee Miller, and Monsieur and Madame Ramié, went to lunch afterward at a small inn called *L'Auberge des Maures*.

Paul and Dominique settled down to married life in a pleasant apartment that Dominique had in St.-Tropez, up over a café called *Le Gorille* whose owner, a hairy, gorillalike fellow, served at his bar stripped to the waist. Paul would have liked us to visit them often at St.-Tropez, since we were rarely in Paris when they were. Their apartment was fairly good-sized and we could have stayed there if we had left the children in Vallauris, but Pablo never wanted to leave them alone, even for a day, so the only way we could get together was to invite Paul and Dominique to Vallauris. But at *La Galloise* there wasn't room to accommodate them properly so they had to stay at the hotel in Golfe-Juan.

On one of their visits, Dominique came down with a virus infection almost as soon as they reached the house. I had to put her to bed in a room on the garden level. She used to say afterward that she had understood from that point on that Pablo didn't like her because it seemed to her he was only too happy to see her ill in that damp, dark room, where no one would choose to be, even in the best of health.

They had brought their dog with them and before they left, the dog went mad. He kept running around in circles trying to catch his tail and was uncontrollable. That annoyed Pablo so much, we had to have the dog put out of the way. Paul took it rather hard, and Pablo made things no easier when he said to him, "You get married and your wife falls sick. You buy a dog and he goes mad. Everything you touch turns sour."

Dominique was a large woman with sculptural proportions—just the kind Pablo liked. He thought she would have made a good wife for him, but that she wasn't quite right for Paul, and that annoyed him.

"When I don't like the wife of a friend, that takes away all the pleasure I get out of seeing that friend," he said. "She's all right by herself, but the combination, no. She's not the wife Paul should have."

"She'd make a good wife for a sculptor," he told Paul one day, "but, my poor friend, she's much too solid for you. Besides, you're a poet. The best thing for a poet is absence. A woman who is there, under foot, looking as solid as the Rock of Gibraltar, isn't very appropriate for a poet. You'll wind up not being able to write a line. You should be sighing and suffering for a pale young girl, and one who isn't here, to boot." "I get the idea," Paul said. "You're the only one who has a right to be happy. You want everybody else to be unhappy, is that it?"

"Naturally," Pablo said. "A painter shouldn't suffer. Not in that way, at least. I suffer from people's presence, not from their absence."

When Dominique was better, both she and Paul would have preferred to return to St.-Tropez, but Pablo refused to allow them to leave. Staying there was a test of their love. "There's no such thing as love," Pablo was fond of saying. "There are only proofs of love." It wasn't enough for Dominique to love her husband; she must love Pablo too. And it couldn't be in the abstract. It had to be shown in a concrete way, and so if she had to suffer above and beyond the call of her illness by being confined to a dungeon—well, that proved that she did love Pablo, in the same perverse way that those who mortify the flesh prove their love for God.

That was the way Pablo figured things out. The first dress he ever bought for me after I went to live in the Rue des Grands-Augustins was bought quite by chance one day in a street market, and it would be hard to find an uglier one. But by my willingness to wear it, I proved, in Pablo's view, that I was above such petty considerations of feminine vanity as wanting to be well dressed or being afraid of ridicule. From time to time Pablo subjected all his friends to that kind of testing. Occasionally he made jewelry in gold and silver by the lost-wax process, with the help of a Vallauris dentist, Doctor Chatagnier. In that way he had made several necklaces. Dominique would have loved to have one of them. Realizing that, I suggested to Pablo that he give her one. He thought about it and finally decided he would.

"But first," he said, "I'll put her to the test." He went into one of the little shops in Vallauris that sell ceramic necklaces in the worst possible taste and bought two of the most hideous, made of three pieces of black ceramic with little green Buddhas painted on them. He gave one to me and one to Dominique. I put mine on and kept it on all day long. Dominique, on the other hand, was greatly disappointed and decided that this proved Pablo had no taste whatever. She put the necklace away without wearing it for as much as five minutes. The next day Pablo gave one of the silver necklaces to me, but none to Dominique.

In all, Pablo made about ten necklaces with the help of Doctor Chatagnier. Some of them were in hammered gold. Two of the others bore portraits of Claude and Paloma on silver and one was a sun in silver. One was a very striking woman's head surrounded by a dove. I thought they were all very nice except one, a rather heavy head of a

satyr, in silver. Pablo wanted to give them all to me, but I didn't like the satyr's head at all and I told him so.

He was shocked. "You dare find something I did ugly?" he said. I told him it wasn't that I thought it ugly; it was just that I liked it less than the others. Since I didn't have any desire to wear it, I suggested he give to it someone else. Zette Leiris was there at the moment and she said she'd be delighted to have it. So Pablo gave it to her.

A little while after that, Pablo's and Marie-Thérèse's daughter, Maya, came to visit and I let her try on the necklaces. I could see she wanted one badly, so I suggested to Pablo that he go back to Chatagnier's and make one for her.

"No," he said. "I don't want to do any more of that. I've had enough." I asked him if he objected, in that case, to my giving one of mine to Maya. He was aghast.

"You mean you'd give away something that I gave you? I find that monstrous." I told him it was all in the family; I ought to be able to give his daughter one of mine without offending him.

"Is there another one you don't like?" he asked me, sarcastically. On the contrary, I told him. I had thought of giving her the one I liked best—the woman and the dove—so that she would have something really nice. Maya was thrilled but her father stayed angry for a long time.

Occasionally when we were at St.-Tropez visiting Paul Eluard and Dominique, we would run into Jean Cocteau. Usually he stayed with Madame Weisweiller. Sometimes as the four of us were sitting at the café *Chez Sénéquié*, the Weisweiller yacht would cruise by, and Cocteau, seeing us there, would seek us out. Eluard had never liked Cocteau and would try to avoid him, but Cocteau generally wound up by pressing his hand into Paul's, whether Paul liked it or not. A little of Paul's coolness rubbed off on Pablo, and he was inclined to be rather short with Cocteau when Paul was around. Cocteau was always looking for reasons to come visit us but, since Paul disliked him so and Pablo was much more interested in Paul than he was in Cocteau, it wasn't until after Paul's death in November 1952 that Cocteau began to make much headway. He knew he wasn't very welcome all by himself so he often made it a point to attach himself to a group that was coming for some specific purpose. Just before Pablo's big exhibitions in Milan and Rome, we were overrun with Italians of all kinds. One of them was Luciano Emmer, who wanted to make a film about Picasso. Cocteau knew Emmer because Emmer had made a film on Carpaccio for which Cocteau had written the script. Cocteau came along with that group and since Italians are great talkers, he was in his element. They had brought a book which seemed to show that through his mother, whose family was from Genoa, Picasso was actually half-Italian; that further back there had been another Picasso, who was a painter and a full-blooded Italian, and, by some miraculous heraldic sleight-of-hand, at a given point the Picasso family merged with that of Christopher Columbus. They were ready to make Pablo an honorary Italian citizen. They even brought the mayor of Genoa along with them to tell the story, and Pietro Nenni carried the big book under his arm. No one really believed all this but it made a nice story and built up good will and smoothed the path for the business in hand the exhibitions in Rome and Milan.

Cocteau got into the spirit of the occasion by inventing wild tales about a mythical Madame Favini, the widow of a rich shoe manufacturer from Milan. According to Cocteau, she was a great art collector and lived the most exciting and improbable adventures. He wrote me letters about her, which I read to Pablo and which amused him greatly. She listened only to Schönberg and read only Rilke. She was so far left of left that after Stalin died, she went on a hunger strike until her daughter brought her back to her senses by squirting her with Fly-Tox. He once sent snapshots of her and her lover, a Milanese lawyer, so that Pablo would recognize them if they ever came to call on us. Later, when Pablo went to Italy for the exhibition, the Italians even produced some of these make-believe characters and introduced them to him.

But even without Cocteau, Paul and Pablo had a great deal of fun together much of the time. Paul always seemed to me a very harmonious person. One day when I said something to that effect to Pablo, he said, "Oh, you don't know him at all. He's terribly violent behind that gentle exterior. Some of his outbursts of temper I'll never forget. You remember that time I told you about, when Dora Maar got sick, how he became so angry he smashed a chair to bits?" I did remember but it had sounded so little like the Paul I knew, I had always wondered if Pablo hadn't exaggerated when he told me that story. One day in Antibes I had a chance to see for myself. Pablo and I were having lunch at the writer René Laporte's house, with Paul Eluard and Dominique and the writer Claude Roy and his wife. We had been talking of the way Fougeron, the painter of socialist realism, was being puffed by the French Communist Party as a great artist. Pablo wasn't at all pleased with that. In the beginning he had found it funny, then ridiculous, later absurd, and finally very unpleasant. Paul, in his normal state of good humor, could agree that Fougeron was a bad painter but that day he seemed politically very

committed, and had ready-made arbitrary opinions that he was handing out with a certain amount of sharpness. He said he had heard that Frédéric Rossif—who recently made that very fine film *Mourir* à *Madrid*, but who was on the staff of the French national film center in those days—might make a short film about Picasso and that Pablo and I had been seeing him from time to time in connection with the project.

"You haven't the slightest notion what you've let yourself in for," Paul said. "I don't like that fellow at all, and I don't want you to see him, either one of you." That seemed hard to square with Paul's usual moderate manner.

"Why should it bother you?" Pablo asked him.

"He has no use for me," Paul said, "and I see no reason for you to make a friend of him. You know nothing about him or his background."

"Calm yourself," Pablo said. "I think you're a little overheated."

"I think you're a bird-brain," Paul snapped back.

Pablo jumped up. "Nobody ever said that about me before." Paul saw at once that he had gone too far but his pride wouldn't let him apologize, so he kept talking in circles, trying to back down a bit without doing it directly. When he stopped, Pablo said, "I may be a bird-brain, but at least I paint a little better than Fougeron." Paul was so upset by now that he wasn't clear enough to realize that he couldn't successfully defend Fougeron anywhere but at a Communist Party meeting—where he would never have thought of doing such a thing.

"Well," he said, "let me tell you that Fougeron isn't such a bad painter as you think. If you want proof, I've just bought one of his drawings."

Pablo sat bolt upright. "You what? You bought a drawing by him?" Dominique decided it was time for somebody to step in between them. She explained to Pablo that Paul hadn't really had much choice in the matter; it was one of those Communist Party charity bazaars and he had been put in a position where he couldn't refuse. The drawing itself wasn't terribly ugly, she said. It was just a flower, and after all a flower couldn't be too ugly, no matter who drew it. But Paul was still boiling and wasn't having any of that.

"Not at all," he should. "The trouble with all of you is you're just a lot of bourgeois mentalities and you can't appreciate good art. I *like* Fougeron's painting." I knew very well that he didn't when he was in his right mind, and to hear him protesting that he did, at the top of his voice, set us all to laughing. Pablo was getting a great kick out of it by now, laughing and chanting, "I'm a bird-brain, I'm a bird-brain," with the others chiming in, like a chorus, "bird-brain, bird-brain." Poor Paul sat there, looking pale and tense and outraged, and every once in a while, when there was a temporary lull in the hooting, protesting "I *like* Fougeron," which was an outright lie and which, each time he said it, sounded less convincing and more ridiculous. Finally he got into such a rage, he picked up a side chair and smashed it against the floor. He was never a very strong man, physically, but he was so carried away by his anger that the chair broke up like an assemblage of match sticks.

WHEN PABLO'S LARGE SCULPTURE of the man carrying the sheep in his arms—*L'Homme au Mouton*—was finally cast in bronze six years after he had done it in clay, three casts were made. Pablo sold one, kept one in the atelier of the Rue des Grands-Augustins and, in a burst of generosity, decided to give the third one to the town of Vallauris.

Up in the square of Vallauris, next to the town hall, stands an old building called the Château de Vallauris. Like the Musée d'Antibes, it had once belonged to the Grimaldi family. For a long time some of the more enterprising townspeople had wanted to turn it into a museum. The trouble was, there were quite a few people living in it and it was difficult to move them anywhere else. But the Château had a little Cistercian chapel and they decided to make a museum out of that. At first L'Homme au Mouton was placed in the chapel, but it was too crowded and badly lighted, so after a year they moved it out onto the market square. Right across the square is a monument to those who were killed in World War I—like most war memorials, a pretty ugly affair. Pablo didn't like the juxtaposition but decided it was the lesser of two evils.

On August 6, 1950, the town inaugurated the statue. Laurent Casanova spoke, André Verdet read a long and windy poem, and Eluard sat quietly next to us. There was a big crowd, including quite a few Americans, and the dedication had the informal gayety of a village fête. Cocteau stood on a second-story balcony of one of the houses about

ten yards behind the speakers' stand, over a little restaurant called the Café de la Renaissance. After each one of the official speeches, he declaimed his own appreciation of the statue. He hadn't been invited to speak, but he wanted to be heard and took the only means at his disposal.

The first time I saw L'Homme au Mouton, it was a plaster cast of the clay original. On one of my first visits to the Rue des Grands-Augustins, Pablo had told me that the idea for it had been working in the back of his mind for a long time. He showed me preliminary drawings and also an etching of a frieze depicting a family group with a man carrying a sheep in the center.

"When I begin a series of drawings like that," Pablo explained, "I don't know whether they're going to remain just drawings, or become an etching or a lithograph, or even a sculpture. But when I had finally isolated that figure of the man carrying the sheep at the center of the frieze, I saw it in relief and then in space, in the round. Then I knew it couldn't be a painting; it had to be a sculpture. At that moment I had such a clear picture of it, it came forth just like Athena, fully armed from the brow of Zeus. The conception was a year or two in taking shape, but when I went to work, the sculpture was done almost immediately. I had a man come to make the iron armature. I showed him what proportions to give it, then I let it sit around for about two months without doing anything to it. I kept thinking about it, though. Then I had two large washtubs of clay brought up, and when I finally started to work, I did it all in two afternoons. There was such a heavy mass of clay on the armature, I knew it wouldn't hold together long in that form, so I had it cast in plaster as soon as I could, even before it was completely dry."

Between 1943 and 1949, when Pablo installed his sculpture atelier in the old perfumery in the Rue du Fournas, he did very little sculpture. But he had a great many pieces which he had done in plaster between 1936 and 1943 and which were still in that state when I first went to the Rue des Grands-Augustins. All during the Occupation it was impossible to have sculptures cast in bronze. All the available bronze, including many statues already set up in Paris parks and squares, went into feeding the German war machine. But as soon as restrictions were loosened after the war, Pablo began to talk about getting in touch again with his bronze-caster, Valsuani. He kept putting it off and two or three years went by. Finally one morning he took me with him to visit Valsuani's atelier, near the Parc Montsouris.

Valsuani was Italian, and like many bronze-casters he had

inherited his métier from his father, his grandfather, and countless generations behind them. He had clear blue eyes and an aquiline nose, which was made to appear even longer and sharper by his extremely emaciated frame. He looked more like a Trappist monk than a man whose life was spent among the scalding steam and black billowing smoke of forges and molten metals. At the time I met him he couldn't have been even forty, but he looked considerably older. He looked tubercular, too, but it was his métier, along with his passionate devotion to it, that gave him that look. It is a métier that wears men out early. As a result, bronze-casting is a dying craft.

Pablo brought nothing with him that morning; it was simply a reconnaissance mission. After we had chatted a while in Valsuani's office, Pablo asked him how he'd like to cast L'Homme au Mouton.

"Not a chance," Valsuani said. "I can't do a thing for you. It's just not possible these days. Besides, you're too hard to please. You pick up every little detail that's not just the way you want it. And your things present too many technical problems. They're almost Chinese puzzles. I'm already a sick man. I'm not going to make things worse by starting to work for you again. Later, maybe. We can think about it. Perhaps we can do those heads of women; they're more or less classical. Of course, they're pretty big."

It obviously wasn't the moment to carry that any further so Pablo began to talk of other things, and after a while we left Valsuani and went out into the atelier. Pablo walked around looking at all the work under way and discussing it with the workmen. Workmen always liked him because he was greatly interested in the craft side of any medium. They could see that he was interested in them and the problems they had to solve. In their eyes, that made him one of them. He began to grumble about the way Valsuani had been stalling him off. "Don't worry about that," one of the workmen said. "We'll take care of your pieces. They're not really too difficult. You'll see."

Valsuani came out of the office and joined us. Pablo pointed to a sculpture one of the men was finishing. It was a very academic study of a female nude. "Look at the stuff you're turning out here," he said, "in preference to mine."

"Yes," Valsuani said, "but it gives us a lot less trouble."

"Perhaps I ought to take my things to Susse," Pablo said. "They're a serious outfit."

Valsuani hesitated. "Well," he said, "perhaps we could do something with those big heads of women. As I said, they're more or less

classical in form and won't give us as much trouble as some of your other things."

"It's a deal," Pablo said. "And that will start you off on the right track. It will bring in the other good sculptors and get rid of the junk I see around here now." And it did. It wasn't long before Valsuani was doing the big sculptures of Matisse—the several versions of *Nude*, *Rear View*—and his heads of Jeannette, as well as the sculptures Renoir executed, with the help of an assistant, toward the end of his life.

Bit by bit Pablo's backlog of sculpture was taken care of. It was a long job. One of the large heads, for example, took over a year. Even when the casting is over, the work is still far from done. The irregularities have to be filed down after comparison with the original model, and then, when the bronze is an exact replica of the original, it has to be patinated. The bronze looks like a dirty penny when it first comes out. It's neither polished nor mat, and the color is very uneven. The patina is very important because the sculpture doesn't really reach its proper form until the right patina has been chosen for it and applied, sometimes over a very long period.

Pablo had made a small sculpture of the head of a woman during the Occupation. The patina had never satisfied him. He had changed it, I don't know how many times, from very dark to natural metal, then green in all its varying tones. Still it didn't seem right. He felt it should be oxydized, so he would dip it in various acids from time to time, but nothing satisfied him. He was complaining about it one day to one of the finishers at Valsuani's, a big burly fellow. "I'll tell you, Pablo," the fellow said. "When everything else fails, there's only one solution —piss on it." Pablo always had great respect for that particular workman, so when we got home that day he followed his advice, but the results—even with time and patience—were greatly disappointing. After a few more attempts he gave up. He rubbed down the head with a rough rag.

"Nothing works," he said. "It's just not a good piece, so the patina only makes it worse. I was a fool to have it cast." He stored it away in a dark corner.

A visit to Valsuani's was one of the few things that could get Pablo up in the morning. As a rule we had finished our business with Valsuani by noon and at that point Pablo was ready to go calling. The three friends who were geographically most exposed to his visits were Giacometti, Braque, and Laurens. We couldn't call on Giacometti, since he worked late into the night and didn't stir about much before one. As for Braque, ever since the time he had refused to invite us to stay for lunch, Pablo always felt a little backward about going there at noon. That left only Laurens. Laurens liked Pablo but better, I think, from a distance than at close range. He always greeted Pablo by saying something like "What a pleasure to see you," but he said it so uncertainly that we were persuaded he wasn't quite so pleased as he claimed. I think that Pablo's habit of picking up unkind gossip and spreading it around Paris may have made him uneasy, and so he was always on his guard. He showed us his work but didn't talk about it. That made Pablo a little reserved, too.

A year or two later, after Laurens had been ill with a pulmonary congestion, the doctor sent him for a vacation to Magagnosc, not far above Vallauris. While he was there we called on him, and for the first time he seemed delighted to see Pablo. I think it was because he wasn't in his studio. Most of the painters and sculptors Pablo called on were a little uneasy when Pablo was in their ateliers, perhaps because Pablo often said, "When there's anything to steal, I steal." So they all felt, I think, that if they showed him work they were doing and something caught his eye, he would take it over but do it much better and then everyone else would think that *they* had copied it from *him*.

A FTER WE SETTLED IN VALLAURIS, Pablo occasionally made small objects in plaster or terra cotta at Madame Ramié's, but it wasn't until after he had bought the atelier in the Rue du Fournas that he began to make sculpture of any consequence. Next to his new atelier was a field where some of the potters threw debris. It wasn't exactly a dump but it served as an excuse for one. In addition to their odds and ends of pottery, there were occasionally pieces of scrap metal. Often on his way to work, Pablo would stop by the dump to see what might have been added since his last inspection. He was generally in a cheerful mood, full of high expectations. It was very hard for Claude, who was only three or four at the time, to understand why his father should be so happy about finding an old fork or a broken shovel or a cracked pot or something equally unprepossessing, but a find like that was often the beginning of a creative adventure for Pablo. The object he found became the mainspring of a new sculpture. But with *The Goat* it was the

other way around. Pablo started with the idea of making a sculpture of a goat and then cast about for objects which might be useful for his purpose. Beginning then, he stopped being driven to work. He searched the dump daily and before he even got there, he rummaged around in any rubbish barrels we passed on our walk to the studio. I walked along with him, pushing an old baby carriage into which he threw whatever likely looking pieces of junk he found on the way. Or if it was something too big to fit into the carriage, he would send the car around for it afterward.

That was the way he picked up an old wicker wastebasket one morning. "That's just what I need for the goat's rib cage," he said. A day or two later at Madame Ramié's he came across two pottery milk pitchers that hadn't quite panned out. "They're rather peculiar forms for milk pitchers," he said, "but maybe if I knock out their bottoms and break off the handles, they'll be just about right for the goat's teats." Then he thought of a palm frond he had picked up as we were walking along the beach one morning at least two years before that. It had looked good to him at the time, but he hadn't found a use for it right away. Now he saw that a piece of it would fit into the goat's face. He carved it a bit to give the mouth and nose the proper proportions. Another part of it went into the backbone. The horns he fashioned of vinestalk and the ears were pieces of cardboard shaped like ears and filled with plaster. For the legs he used sticks of wood like thin logs, cut from the branch of a tree. The ones he used for the hind legs had knots that looked like joints and they "bent" at the knots. He stuck bits of metal strapping and ribbing from the junk pile into the haunches to emphasize them and give an effect of angularity and boniness.

Pablo never liked to overlook any anatomical detail, especially a sexual one. He wanted the goat's sex to be indicated in clear enough fashion so that no one could be in doubt. Of course, the two long teats hanging down gave a clue but that didn't satisfy him. He took the top of a tin can, bent it in the middle until it was three-quarters closed, and lodged it, open side out, into the plaster between the hind legs. The tail was formed by a double length of braided copper wire, which stuck up jauntily. Directly underneath that, Pablo inserted into the plaster a short length of pipe, about one inch in diameter, to represent the anus. He filled in the gaps with plaster and let it dry. *The Goat* was finished.

Pablo had always wanted to make a sculpture that didn't touch the ground. One day, watching a little girl jumping rope, he decided that would be the way to do it. He had the ironmonger in Vallauris make him a rectangular base from which rose, to a height of three or four feet, a curving iron tube in the shape the jump-rope would have as it reached the ground. The top ends of the "rope" provided the support for the little girl. The central part of her body was a shallow round wicker basket of the type used to gather orange blossoms for the perfume factories. From each end extended a wooden holder, which Pablo set into the open ends of the metal tube. To the bottom of the basket he attached folds of heavy paper. He set plaster into those and when it had dried and he had removed the paper, that made the skirt. Below that he hung little legs he had carved out of wood. He found in the dump two large shoes, both for the same foot. He filled them with plaster and attached them to the legs. For the face, he took the cover of an oval chocolate box and filled it with plaster. When the plaster had set and he had removed the box cover, he applied the face against a flat plaster form which had been grooved by pressing it against the ribs of a strip of corrugated paper and thus gave the effect of an elaborate coiffure. The ribbed rectangular piece had been trimmed out at the bottom to form a neck, and on each side, a slightly curved flaring gave the appearance of hair falling back from the head.

For Claude, toys were not something to play with, but something to break. From the age of three on, whenever a new toy came into the house, he would take a hammer and go to work on it, not to see what was inside, as most children want to do, but simply to reduce it to rubble as soon as possible. In 1951 Kahnweiler brought two small automobile models to him and they were miraculously still unbroken when Pablo decided they would be useful to him. Claude wasn't very happy about it, because they hadn't served their purpose as far as he was concerned. Pablo took them, anyway, and put them together, one right-side up, the other upside down, attached to the first. That made the head of his sculpture Monkey with Young. For the ears he used two handles from pitchers he found in the scrap heap near his studio. He took the handles from a large pottery bowl called a *pignate*, the most common variety in use in Vallauris, and made the shoulders with them. Under the right ear he set in a piece of plaster that had been premolded in a basin and grooved so that it had greater supporting strength than soft plaster. The bulging front was a pot which he incised with a knife to make the breast and nipple. The tail was a strip of metal ending in a curl. The baby in the monkey's arms was modeled wholly in plaster. And the legs, like the legs of the goat, were made from pieces of wood.

The Crane was very characteristic of Pablo's method in sculpture

in that it was finding the shovel which formed the tail-feathers that gave him the idea of making the sculpture of a crane. Then he found two roasting forks, a long one and another, much shorter and in bad condition, which he repaired by winding wire around it. These gave him the legs. The base he made, as he often did, by filling a candy box with plaster and when it had dried, tearing the box away to leave the block of hardened plaster. For the head he used a brass faucet fitting into which he inserted a pointed metal wedge for a beak. Once it was cast in bronze he painted it.

Every time we drove through Aix, Pablo always stopped to buy a kind of candy called *calissons*, made from almond paste baked onto a thin wafer and covered with glacé sugar. They were packed in a diamond-shaped box which he liked to use as a form to mold parts of his sculptures. He often used such a mold for the base, but in 1951, in doing a portrait of me called simply Woman's Head, he formed the face by molding plaster in the cover of one of these boxes. Once the form was dry, he filed the edges to give it a bit more relief and make it lose the strict angularity it originally had. He set into that a triangular piece of plaster he had previously molded between two pieces of cardboard. That became the nose. At that time I wore my hair drawn back tightly into a bun. To emphasize that feature, the face in the sculpture is projected forward onto a separate plane, and the head and hair are grouped in a mass behind. This secondary mass Pablo formed from a damaged pottery vase he had picked up in the scrap heap. The cylinder of the neck, below this mass, has no contact with the face. He modeled the neck from plaster and set it into a rounded jar. The base he made by molding plaster inside a rectangular candy box.

One of the first sculptures Pablo made in the perfume factory was the *Pregnant Woman*. He wanted me to have a third child. I didn't want to because I was still feeling very weakened even though a year had passed since Paloma was born. I think this sculpture was a form of wish fulfillment on his part. He worked over it a long time, I suppose from a composite mental image he had of the way I had looked while I was carrying Claude and Paloma. The breasts and distended abdomen were made with the help of three water pitchers: the belly from a portion of a large one, and the breasts from two small ones, all picked up from the scrap heap. The rest was modeled. The fact that the figure was only about half the normal size gave it a grotesque appearance. It had almost no feet, it swayed perilously, and the arms were too long. It always looked to me like a child-woman recently descended from the ape.

PART VI

One of the finest sculptures of that period was the Goat Skull and Bottle. Pablo had made at least five or six paintings in which he had explored all the spatial relationships that existed between these objects. The composition was a sort of graphic maze based on the inspiration that had guided the two versions of the large painting La Cuisine. I told him I thought he ought to explore it in sculpture, too.

About the time I first met Pablo, he had made a sculpture of a bull's head out of the seat and handlebars of a bicycle. He used to say that this sculpture was reversible. "I find a bicycle seat and handlebars in the street, and I say, 'Well, there's a bull,' " he explained to me. "Everybody who looks at it after I assemble it says. 'Well, there's a bull,' until a cyclist comes along and says, 'Well, there's a bicycle seat' and he makes a seat and a pair of handlebars out of it again. And that can go on, back and forth, for an eternity, according to the needs of the mind and the body."

One day in Vallauris he found another set of bicycle handlebars. "There are my horns for the goat skull," he announced. Between the horns, he filled in plaster sown with hundreds of tiny nails. The rest of the head was formed by plaster on which he had impressed corrugated paper to give that undulating form he used in so many of his sculptures of the period. He set in screws for the eyes. The bottle was formed with pieces of old terra-cotta tiles. The long, spiky forms representing the rays of light shed by the candle in the bottle were large nails that he stuck in plaster. The job of casting those nails in the flame of the candle was exasperating. Each one took a separate mold.

I asked Pablo one day why he gave himself so much trouble to incorporate all these bits and pieces of junk into his sculptures rather than simply starting from scratch in whatever material—plaster, for example—he wanted to use and building up his forms in that.

"There's a good reason for doing it this way," he told me. "The material itself, the form and texture of those pieces, often gives me the key to the whole sculpture. The shovel in which I saw the vision of the tail-feathers of the crane gave me the idea of doing a crane. Aside from that, it's not that I need that ready-made element, but I achieve reality through the use of metaphor. My sculptures are plastic metaphors. It's the same principle as in painting. I've said that a painting shouldn't be a *trompe-l'oeil* but a *trompe-l'esprit*. I'm out to fool the mind rather than the eye. And that goes for sculpture, too.

"People have said for ages that a woman's hips are shaped like a vase. It's no longer poetic; it's become a cliché. I take a vase and with

it I make a woman. I take the old metaphor, make it work in the opposite direction and give it a new lease on life. It was the same way, for example, with the thoracic cage of the goat. One could say the rib cage resembles a woven wicker basket. I move from the basket back to the rib cage: from the metaphor back to reality. I make you see reality because I used the metaphor. The form of the metaphor may be worn-out or broken, but I take it, however down-at-the-heel it may have become, and use it in such an unexpected way that it arouses a new emotion in the mind of the viewer, because it momentarily disturbs his customary way of identifying and defining what he sees. It would be very easy to do these things by traditional methods, but this way I can engage the mind of the viewer in a direction he hadn't foreseen and make him rediscover things he had forgotten."

Sometimes Pablo found objects that seemed exactly right and needed no intervention from him to make them works of art. These he called, like Marcel Duchamp, his "ready-mades." The outstanding example was the one he named *La Vénus du Gaz*. In a certain type of prewar gas stove there was one burner, different from the others, that looked as though it should have been a Picasso sculpture of a woman. To make it one, Pablo mounted it on a block of wood and christened it *La Vénus du Gaz*.

"In three or four thousand years they'll say, perhaps, that at our period, people worshiped Venus in that form," he said, "just the way we so confidently catalog old Egyptian things and say, 'Oh, it was a cult object, a ritual object used for libations to the gods."

His "Venus" pleased him immensely, just as everything he did —or adopted—pleased him. "We mustn't be afraid of inventing anything," he said one day when we were talking sculpture. "Everything that is in us exists in nature. After all, we're part of nature. If it resembles nature, that's fine. If it doesn't, what of it? When man wanted to invent something as useful as the human foot, he invented the wheel, which he used to transport himself and his burdens. The fact that the wheel doesn't have the slightest resemblance to the human foot is hardly a criticism of it."

290

Not EVERYONE PABLO talked sculpture with saw it through his eyes—or cared to. Every year after the Liberation, a committee of the friends of Guillaume Apollinaire would periodically revive their old project of a memorial monument to Apollinaire. Politics played its part because the project depended for its approval and financing on the Paris Municipal Council. Among the friends there were factions, too: some very left-wing, politically; others, right of right. So their deliberations were often stormy. After each session at which the Left had triumphed over the Right, a few of them would show up at the Rue des Grands-Augustins with the announcement that Pablo *must* do a monument in memory of Apollinaire. Pablo's answer was always the same: he was in favor of the project, but he insisted on having complete liberty. Some of the committee members were agreeable to this; others weren't very interested in having Picasso at all—even less so, in giving him carte blanche.

Pablo was adamant. "Either I do the job that way or you get someone else. If you want me, I'm going to do something that corresponds to the monument described in Le Poète Assassiné: that is. a space with a void, of a certain height, covered with a stone." The problem that interested him lay in creating an abstract sculpture which would give form to the void in such a way as to make people think about the existence of it. The people who didn't want Pablo to make the monument said, jesuitically, that they'd go along with the idea of having him do a portrait of Apollinaire but that the monument he proposed was impossible. They were hoping, of course, that he would back out, of his own accord. At that period the monument was scheduled for the intersection of the Boulevard St.-Germain and the Rue du Bac, which then had a statue dedicated to the memory of two men who, allegedly, had invented the telegraph. To take that down in favor of something entirely abstract and featuring, as its principal ingredient, empty space, would make the committee the laughingstock of Paris, they felt. After one stormy session the committee let it be known that they were thinking of turning the job over to a man like Zadkine, who would produce something more in keeping with their ideas. Pablo said that was all right with him. But Zadkine didn't like the idea of being called in as second choice. So there it hung, for several more years. The committee kept coming back, every time the wind changed, to sound out Pablo but he

remained intractable. Whenever it looked as though agreement was about to be reached, there would be a change in the constitution of the committee or of the Municipal Council and they would have to start all over again. From time to time Apollinaire's widow, Jacqueline, would come to see if she couldn't move Pablo to action.

"You really owe it to the memory of Apollinaire to do something," she told him. "It's not so important, in the end, whether it's something extraordinary or not." So Pablo decided on a compromise: a huge base, supported by four pillars about five feet high with the empty space beneath it that he couldn't bring himself to eliminate, and then, on top of the stone base, a massive head of Apollinaire, the head itself about three and a half feet high. He made a number of drawings, in some of which there was a laurel wreath on Apollinaire's head. But it became obvious that the conservative element in the Municipal Council didn't want Picasso in any form, because this new proposal, which was neither abstract nor revolutionary and shouldn't have shocked the most backward of municipal councillors, was met with total silence. Finally they decided the monument couldn't be placed in the spot they had originally assigned to it, but would have to be relegated to the little square behind the church of St.-Germain-des-Prés, at the corner of the Rue de l'Abbaye. By now Pablo was thoroughly disgusted and lost all interest in the project. The affair dragged on months more and when, in the end, the committee managed to get a weak, unenthusiastic OK from the Municipal Council, Pablo himself had so little enthusiasm left that he simply gave them a sculpture that was lying around the studio, a bronze head of Dora Maar that he had done in 1941.

In due time the committee had it set up in the little square under a tree particularly favored by the local sparrows. There it stands today, encrusted with their droppings, less a monument to the memory of Apollinaire than another ill-starred tribute from its maker to Dora Maar.

Aside from the question of the monument, there was a renewed interest in Apollinaire in general at that time because Gallimard was preparing the Pléiade edition of his complete works. Jacqueline Apollinaire and old friends such as André Billy were going to great pains to collect everything unpublished. Marcel Adéma, a fervent Apollinaire collector, was working on a biography. He knew, just as Jacqueline Apollinaire did, that Pablo had a number of unpublished letters and manuscripts, poems and drawings and many other souvenirs of their friendship. Some of these were in the Rue des Grands-Augustins; many more, in the Rue La Boétie. Pablo told me that Olga, in one of her tempery moments, had torn up some of them, along with some of his letters from Max Jacob. But since nothing had ever been thrown away there, one could even have found those pieces if one had had the patience. Everyone was greatly interested in having the new edition as complete as possible and it was suggested that if Sabartés supervised the operation, we might strike a major lode, but Pablo said no. He didn't even let them use the papers he had ready at hand in the Rue des Grands-Augustins.

"It's too much of a nuisance," he said. "Besides, Apollinaire's memory will be just as well off with the poems everyone knows already as it would be with the few additional ones you'd have if I gave you mine."

One of the first times Jacqueline Apollinaire came to the atelier, Pablo suggested she show me her apartment, and that very afternoon, after lunch, we went there. It was high up in an old building on the Boulevard St.-Germain, near the corner of the Rue St.-Guillaume. Before we arrived at the top floor, where the apartment was situated, I saw, halfway up the last flight of stairs, the small round window from which Apollinaire's secretary, the so-called Baron Mollet, looked out at whoever was approaching to see whether he should be admitted.

The apartment had been left in just the state it had been in during Apollinaire's lifetime. The layout resembled curiously the inside of a human body: an esophagus followed by a stomach followed by an intestine-a real labyrinth. We entered first a good-sized room, and went from that into a long corridor which led us to another room where there were many paintings: the large Marie Laurencin collective portrait of Apollinaire, Picasso, Marie Laurencin, and Fernande Olivier; other paintings by Marie Laurencin; several small Cubist paintings by Picasso, including the one he had given Apollinaire as a wedding present; and many small sketches of Apollinaire that Pablo had made at different periods, including the one of Apollinaire with a pear-shaped head. After that we went into a long second corridor which led to a tiny setback, perhaps five feet square, where Apollinaire did his writing. It was the smallest and most unlikely place in the apartment for anyone to do that kind of work. After that was the kitchen. A winding stairway led up to a single room above the rest of the apartment. It contained a small table and a chair and on the wall you faced as you sat there, were photographs, reproductions of paintings, and handwritten notes pinned up just as they had been at the time Apollinaire died. It had a terrace which looked out over the Faubourg St.-Germain.

I found the place a little sad, like a tiny provincial museum, everything covered with a slight layer of dust. Jacqueline Apollinaire told us she did, too. She had left it just the way it had been when Apollinaire was alive, but she found it difficult to live there for long periods and she spent most of her time away from Paris.

N PABLO'S ENTOURAGE SOME OF THOSE who filled what might seem like minor posts were the ones who had the greatest influence with him. Chief among the gray eminences was the chauffeur Marcel. When I first saw Marcel, he was about fifty years old, a Norman with the head of a Roman emperor: Norman in the characteristic mixture of peasant cunning and sly wit, but with the kind of head one finds on an old Roman coin-sharp features and a slightly arched nose. He had been Pablo's chauffeur since 1925 or thereabouts. If Pablo said he wanted to take a trip, in the end it was Marcel who decided whether or not that trip was necessary, and it was inevitably he who decided what time we should leave. If for one reason or another it suited Marcel better to have us stay home or to leave later, he always found some way of delaying the trip or having it called off entirely. It was generally something that mysteriously went wrong with the motor and occasioned countless trips to the garage. with Marcel supervising the work of the mechanics. But whenever Marcel had the urge to get rolling, the car responded magically. Marcel was in the driver's seat, in more ways than one.

He had other talents, too. Just as Molière used to read his comedies to his chambermaid first to see if they would go over with his audience, Marcel followed his master's output from day to day and commented on it in detail. In Pablo's view, Marcel hadn't been contaminated by a false veneer of culture and so his reactions could be counted on to be truer than those of most of the others. Marcel carried much more weight in this respect than did Sabartés, for example, even though Sabartés was officially Pablo's secretary and Boswell. When Marcel arrived in the morning, he first examined the pictures Pablo had done the night before. By the time Pablo got up, Marcel was ready with his opinions of them. Pablo gave out privately that Marcel's opinions didn't matter to him but he went on collecting them, all the same.

More important, Marcel had built up the reputation over the years of being the person who was most competent at detecting fakes. When Marcel pronounced a painting authentic, it was accepted as authentic. If he pronounced it a fake, no one dared take issue with him.

"You see?" Pablo would say, after Marcel had laid down a verdict that he agreed with. "My own dealer goes wrong. Everybody goes wrong. But Marcel is always right. At least *he* understands my painting. There's the proof: he's the only one who recognizes it. He can't explain it, perhaps, with all the glib eloquence of Monsieur Kahnweiler or Monsieur Zervos or Monsieur Rosenberg, but at least he knows it when he sees it."

Marcel's authority carried over into the rest of Pablo's life, as well. He was a little like Don Juan's valet, Leporello, griping about his hard lot and the blows he had to take from time to time but, all in all, very happy to participate in his master's adventures. He enjoyed running from one house to another carrying private notes to whoever was, for the moment, in his master's good graces, and I think it fair to say that Marcel's feelings of sympathy or antipathy were often reflected in Pablo's actions.

Whenever Pablo and I went anywhere in the car, he and I sat in the front seat with Marcel. Pablo sat next to Marcel and directed all the conversation to him. Since Pablo never drove, he was completely relaxed and when the conversation warmed up, Marcel did most of the talking and Pablo listened. With others—the poets, the painters, the acolytes—Pablo ran the conversation, but with Marcel, Pablo was content to listen. Marcel gave him a rundown on the news of the day with his own editorial judgments thrown in. He contradicted Pablo and even criticized him. Pablo generally sat back and took it.

When Marcel wasn't around, Pablo would say, "I have no confidence in that man. He's been robbing me for years. He never shows up if he has anything else to do. He does as he pleases." He complained about Marcel as chauffeur from morning till night, but for other things that had no connection with driving a car, Marcel had managed to acquire and maintain unlimited credit. When Pablo complained about the way Marcel handled his job as chauffeur, he didn't say he was a bad driver because that would have been ridiculous, but he claimed Marcel spent too much money on the car and that he diverted funds from that purpose to his own use. As far as I know, that was not true. But every time Marcel asked for any new equipment—even a new cap—Pablo

went into a rage. One day I heard him tell Pablo he needed a new uniform.

"He wants another uniform. He wears out more clothes than I do," Pablo lamented. "Next he'll be wanting to drive in a tuxedo." Then, turning to Marcel, he asked, "How many does that make in the last year?"

"Chauffeurs need new livery once in a while," Marcel protested. "The way I have to slide in and out behind the wheel so often, my uniform gets all shiny. You don't want me to look as though I polished it, do you? What will people think?"

"Who cares?" Pablo said. "Look at me. I'm not ashamed to wear old suits."

"That's all right for you," Marcel said. "You're the boss. It doesn't work that way with me. I'm only the chauffeur."

But for anything that had nothing to do with Marcel's real job, they were on the best of terms. In the antechamber where people waited to see whether they would be received, Marcel shared authority with Sabartés. Sabartés was such a sad-looking monk and was so disagreeable with women and looked so distrustingly at them that they generally appealed to Marcel to get them in. He was the kind of fellow one could always get along with.

Marcel's presence set the tone for Paulo's life, too. For a child, there's nothing much to admire in a father who is a painter; besides, a painter is always in the atelier and the child hardly ever sees him. When Paulo was four or five years old, the kind of pictures his father was painting couldn't have made much sense to him. But a chauffeur who drives cars is something different. Which is probably the explanation for the inordinate importance motorcycles and automobiles have always had for Paulo. Paulo used to imitate Marcel's way of speaking, and even his walk. Marcel wasn't fat but his stomach always stuck out noticeably like that of a self-confident politician, which is, in effect, what he was. Unconsciously Paulo assumed the same stance. When I first went to live with Pablo, relations between father and son were somewhat strained. Paulo didn't work and was interested in only one thing: racing motorcycles. He was dependent on Pablo for handouts. When things got too difficult, Paulo would seek out Marcel, who was very fond of him, and Marcel would serve as intermediary between him and his father.

Marcel had little formal education but he had shrewd psychological insight. And he had good sense and a good heart. With that peasant shrewdness that enabled him to size up people very quickly, he knew how to protect Pablo from time-wasting or self-seeking intruders. As long as he was there, he was able to ward off a number of persistent bores who, after he had gone, managed to worm their way in and establish themselves among the regulars. And he did it all with a goodnatured, witty approach that was quite a contrast to Pablo's other watchdog. Sabartés. When people arrived in the morning at the atelier of the Rue des Grands-Augustins and fell into Sabartés, peering out through his thick glasses, completely absorbed in his own melancholy, and from time to time very sadly dropping a word or two that eventually might add up to a whole sentence, that was enough to damp down the most buoyant enthusiasm. The poor fellow didn't see very well, to begin with, and that gave his most casual glance an almost inquisitorial air. Most people under his scrutiny began to feel very guilty and stumble over their words. As a rule, the mere sight of his mournful, almost tragic expression and manner could get rid of the more timid visitors. However, if Sabartés's gloom wasn't enough, and the visitor seemed undesirable, then Marcel finished him off. On the other hand, if the visitor seemed worth receiving but had been put off by Sabartés's manner, Marcel would spend a few minutes cheering him up and restoring his original enthusiasm.

Marcel was always good-natured. Even when Pablo was in his most savage moods, Marcel kept merry, laughed at his own jokes and got away with it. He was the only one who could. He called Pablo *Monsieur*, but their relations were much more relaxed and man-to-man than one would expect between a chauffeur and his employer. Every once in a while, though, on one of his black days Pablo would get fed up with Marcel's insouciance when everyone else was trembling and would blast out at him in a way that Marcel wasn't used to. Then for a while he would maintain a strictly formal relationship with him, and whenever Marcel drove him anywhere, ride in the back seat without conversation.

When we were living in Vallauris, since there wasn't room in the house for Marcel, he lived in the little hotel-restaurant *Chez Marcel*. The innkeeper, another Marcel, being a Provençal, spent most of his time bowling, and the chauffeur Marcel soon fell in with the routine, with the result that there was a marathon game of bowls going on most of the time. Since it was warm and the mild exertion warmed them even more, they would stop every little while to sip a *pastis*, the local anise-flavored liqueur, and then, refreshed, go back to their game. That

would continue most of the day with just time out for meals. Anytime we needed to go anywhere and called down for Marcel, he generally couldn't leave right away, either because the game wasn't quite finished or they had just settled down to cool off with a *pastis*. Pablo would put up with that, too, most of the time and then, periodically, blow up and stop talking to Marcel. Then Marcel would be crushed, begin to brood, and give up bowls and *pastis*. Finally he would start to make jokes again and ease Pablo out of that mood and everything would be all right once more.

Except for the days when we went to Nîmes or Arles for the bullfights, Marcel didn't have much to do when we were in the Midi. He would sit around waiting for us at the other Marcel's place and that meant more and more pastis. Sometimes Pablo would take it into his head at the end of the afternoon to return to Paris. Marcel would drive us back all through the night, we would spend the day in Paris and return the following night. It was about a fifteen-hour trip each way, with time out to eat, and we had never had an accident-Marcel had always been an excellent driver. But after a few years of being mostly in the Midi and consuming untold quantities of pastis, he began to drive faster and take more chances. One day, returning in Kootz's Oldsmobile from Nîmes, where there had been lunch and then, after the bullfights, a big dinner with buckets of wine, he was passing another car with the speedometer just under ninety miles an hour when he made a slight miscalculation of the distance between. The door handle of the other car etched a line the full length of the white Oldsmobile. That gave us something to think about.

Soon after that, Pablo and Marcel returned to Paris because Pablo was having trouble holding onto his apartments in the Rue La Boétie, from which the owner was trying to evict him. The car was at Pablo's disposal all day long and when he had no more use for it Marcel was supposed to put it into a garage for the night. Everybody knew he often used it in the evening to drive his wife and daughter, just as though it were his own, but nothing had ever been said about that. One evening he drove his family out into the country, about sixty miles from Paris, and smashed into a tree. No one was very badly injured but the car was a complete wreck. The next morning Marcel came to tell Pablo what had happened. Pablo was quite philosophical about it at first. But later, as he thought it over, all the complaints he had had against Marcel over the past twenty-five years surged up before him and he fired him. Poor Marcel was aghast.

PART VI

"You mean that in spite of everything I have been to you, you'd fire me for that?" he said. "If you're that heartless, I warn you the day will come when you won't have anybody left. Not even Françoise, because even she will walk out on you."

Pablo was unmoved. He bought a Hotchkiss and suggested I take Marcel's place as chauffeur. I took several lessons but didn't like driving. I suggested that Paulo take over since he was such a good driver. With Paulo at the wheel, the Hotchkiss served for ordinary driving and for trips to Paris. A little later, Pablo's treasure, his old Hispano-Suiza, was rehabilitated and brought to Vallauris. He kept it in the garage and used it only for bullfights. It had room for eight or nine people and resembled the cars the more idolized matadors used for their gala entrances.

THE WRECK OF THE Oldsmobile wasn't the only, or even the principal disaster that summer. Pablo's two apartments in the Rue La Boétie had been unoccupied for years. Because of the acute housing shortage since the war, they could have been requisitioned at any time, but in the case of people like Pablo the enforcement agencies took a lenient attitude based on the idea of the "importance to the nation" of such people. As long as Pablo had friends like André Dubois at the Prefecture, nothing was ever done. But when André Baylot, an archenemy of the Communists, became Prefect of Police, he decided to annoy Pablo by exercising his legitimate right in the case of Pablo's unoccupied apartments. Because of their size, they offered the possibility of housing at least half a dozen people, upstairs and down. If Pablo had owned the apartments, it might have been possible to put someone in there to "cover the law," but since he was only a tenant he could do little about it. And since the apartments were filled with all kinds of precious objects, he could not, on the other hand, let the housing authorities put just anyone in.

When Pablo received his eviction notice he was outraged, but he expected that, either through André Dubois or Madame Cuttoli, he would be able to straighten things out. They tried all possibilities, but the administration was more expert in such matters than any of Pablo's

influential friends, so in August 1951, after a year of litigation, Pablo had to give in. He turned the moving job over to Sabartés, who had to examine and classify every object, however important or humble, and pack each one of them in its proper case. At the end, he had filled seventy wooden packing cases.

After Pablo was evicted, he was obliged to store all his worldly goods here, there, and everywhere. The studios in the Rue des Grands-Augustins were very large but not large enough for all of Pablo's needs. And there was far from being enough room to accommodate the cases from the Rue La Boétie. So we bought two small apartments in the Rue Gay-Lussac, one above the other, and decided to store as much as we could in them. Of the rest, everything that could be fitted into the ateliers in the Rue des Grands-Augustins was sent there; what remained was put into a warehouse. But as soon as we returned to Vallauris, we had eviction notices served on us for nonoccupancy of the new apartments further proof, if one needed it, that the whole maneuver was political.

I had been feeling tired and not very energetic for a long time, but I left at once for Paris, hung curtains in the new apartments and brought in a minimum of furniture so that we could move in and forestall another eviction. We stayed there all through that winter, making our way around the packing cases as best we could. In the Midi we had gotten out of the habit of the damp Paris winters, and Pablo and the children came down with heavy chest colds. Pablo was barely able to drag around. The children's colds turned into pneumonia and they topped that off with the measles. Since Pablo wouldn't have anyone else around him, I nursed everybody and at the end was so weakened that I began to have fainting spells. Pablo had to put on mustard plasters every three hours, but he refused to take them if I didn't keep him company. I didn't have any chest complications—I was simply exhausted —but I had to go along with him, and apply just as many mustard plasters to my own chest as to his.

All this put Pablo in a very black mood and he couldn't work at all. I kept on working, whether I felt like it or not, because of my forthcoming exhibition at Kahnweiler's. Pablo just sat there day after day watching me work but not lifting a pencil or a brush himself. This went on for weeks and weeks and weeks.

PART VII

T THE TIME I WENT to live with Pablo, I had felt that he was a person to whom I could, and should, devote myself entirely, but from whom I should expect to receive nothing beyond what he had given the world by means of his art. I consented to make my life with him on those terms. At that time I was strong because I was alone. During the next five or six years I had given my life over to him completely, I had had the children, and as a result of all that I was perhaps less capable of satisfying myself with such a Spartan attitude. I felt the need of more human warmth. And I thought that we had been working toward the point where such a thing was possible. Until some time after Paloma was born I continued to hope for that, and then gradually came to realize that human warmth was something I would never get from Pablo; that I would get nothing more than what I had been willing to settle for at the beginning: whatever joy I might receive from devoting myself to him and his work. It took me a long time to work up to this realization, because I couldn't throw off all at once the hopes I had for something more, since I had come to love him much more than I had loved him at the outset.

But now that the children were regulating our lives to a great extent, it began to be clear that Pablo was chafing under so much domesticity. I could almost hear him thinking, "Well, I suppose now she figures she's won the game. She's taken over, with her two children, and I'm just one of the family. It's total stabilization." And if ever a human being was not cut out for total stabilization, that was Pablo. What he

himself had wanted so badly and at first had brought him such great pleasure began to rub him the wrong way. He seemed, at times, to look on the children as weapons I had forged to be used against him and he began to withdraw from me.

It began rather subtly. From the time I went to live with him in May 1946 until his trip to Poland with Eluard and Marcel, Pablo and I had never been apart a single day. After his return from Poland he began taking short trips to Paris without me. Another time he set off for a bullfight in Nîmes without me on the pretext that I wasn't well enough to stand the trip and the excitement. Whenever I went with him to Nîmes, we were generally back by midnight. This time, when he hadn't returned by three in the morning I began to fear that perhaps Marcel had drunk more than he should and had smashed up the car. I dragged a mattress out onto the balcony and stayed there, sleepless, until I saw the car pull up in front of the garage just before dawn.

When Pablo came up the stairs, he flew into a rage, accused me of spying on him and said he was free to come in whenever he wanted to —all this without my having said a word to him. The Ramiés had been in the car with him and since I had waved to them before Marcel drove them away, Pablo also accused me of embarrassing him in front of his friends. How, I asked him.

"Instead of being asleep in bed where you belong, you're out here waiting for me. It's obvious to anybody that you're trying to take my freedom away from me," he said.

In the weeks that followed, I saw that both spiritually and physically he was erecting a wall between us. At first I couldn't believe it possible that he should want to stay apart from me at the very moment I was making the greatest effort to come close to him. But I wasn't sufficiently extroverted to be able to ask for explanations for a thing like that, and my pride would not allow me to force myself on him in the ways that any woman can when she feels a man's interest is flagging. His attitude did not extend to the children: he was obviously very fond of them, as he always had been of all small children, but when he saw them in their relation to me, and me, as their mother, in my relation to him, his attitude hardened. He had me handle his affairs with Kahnweiler and others more and more, but our own relationship became increasingly impersonal. Before, it had been profound and satisfying. Now we had become working associates.

I realized, as I thought it over, that Pablo had never been able to stand the company of a woman for any sustained period. I had known from the start that what principally appealed to him in me was the intellectual side and my forthright, almost tomboy, way of actingmy very lack, in a sense, of what is called "femininity." And yet he had insisted that I have the children because I wasn't enough of a woman. Now that I had them, and presumably was more of a woman and a wife and a mother, it began to be clear that he didn't care a bit for it. He had directed this metamorphosis in my nature, and now that he had achieved it, he wanted no part of it. Up until then, I had never felt any form of bitterness. No matter how difficult he had made things at times. I may have regretted or disliked what I saw but I always felt it was less important than the thing that bound us together. But now I began to feel bitter because it seemed to me there was an ironic injustice in what had taken place. And I began to do something terribly feminine and-for me-most unusual: I cried a good part of the time. One of the few lithographs, among all those that Pablo made of me, for which I actually posed (and which is perhaps the most naturalistic of all of them), is the one listed in Mourlot's catalog as No. 195. I remember sitting there almost all of that dark November afternoon and crying steadily with only an occasional letup. Pablo found it very stimulating.

"Your face is wonderful today," he told me while he was drawing me. "It's a very grave kind of face." I told him it wasn't at all a grave face. It was a sad face.

Another time he was less flattering. "You were a Venus when I met you," he said. "Now you're a Christ—and a Romanesque Christ, at that, with all the ribs sticking out to be counted. I hope you realize you don't interest me like that."

I told him I realized I had grown rather thin, but, as he knew, I hadn't been feeling very well since Paloma was born.

"That's no excuse," he said. "It's not even a reason. You should be ashamed to let yourself go—your figure, your health—in the way that you have. Any other woman would improve after the birth of a baby, but not you. You look like a broom. Do you think brooms appeal to anybody? They don't to me."

It was pretty hard to take this kind of talk, especially since I was physically very much weakened at that time, but finally I was able to get myself out of the picture. I told myself that I could best express my feelings for Pablo by devoting myself more than ever to him and to the children, and that I might still be of some use to him in his painting; also, that I had work of my own to get on with, too, and on that basis life could be quite livable, even if our relationship had apparently

deteriorated to the point where the usual personal and emotional fulfillment a woman derives from a man's love was no longer possible. But it took me two full years, from 1949 to 1951, to reach this acceptance of the situation.

Whenever Pablo went to Paris, he always left me plenty of work to keep me busy until he came back. In February 1951, he made one of those trips. Tériade was planning to bring out a special number of his art review *Verve* devoted to Pablo's ceramics and his recent painting and sculpture. Pablo had given me the job of picking out the works that were to be photographed. He told me I was not to budge until the photographer had finished his work and left, so that nothing would be broken or stolen.

A few days after Pablo left for Paris, I received a wire from my mother, telling me that my grandmother had had a serious stroke, and that I should come at once, since the doctors didn't expect her to live much longer. She was the person I had always felt closest to and I had, in a sense, abandoned her to go live with Pablo. I decided that having to make photographs of pottery was no sufficient reason for not going to Paris—at least for a single day—to see my grandmother before she died. I knew that if I telephoned to Pablo in Paris he would forbid me to leave, since the only thing in the world that ever really mattered to him was his work. I decided to take the night train to Paris, spend a day there and return the following night. I told Tériade's photographer I would be absent the next day but back on the job the day after.

After an all-night train ride, I arrived in Paris the following morning. I went directly to the hospital and saw my grandmother. She was very badly off. As it happened, she rallied and I was to see her again because she managed to hold on for a few months longer, each relapse leaving her a little worse off than the previous one. I spent the day at her bedside and around six o'clock I left the hospital. My train wasn't due to leave for the Midi until 8:30 that evening, and the thought came to me that I had time to see Pablo and explain what I had done. But I knew so well that he would be unable to accept, or even to understand, my reason for coming to Paris that it would be better simply to return without adding all that unpleasantness to the sadness my grandmother's condition gave me.

At that moment I realized just what our relationship had become. When you are unhappy, the natural thing is to look for comfort from the one you love the most. I knew I would not only find no comfort there, but that I would be subjected to the stiffest kind of rebuke. I knew there would be more comfort in some anonymous spot that would not involve me in any kind of contact, so I returned to the Gare de Lyon, checked my suitcase, and went into a café close by. I had two hours before my train left and I decided to think over very carefully both my past and my future with Pablo. As I sat there, weary and burdened, it seemed to me that I was completely alone—worse off, actually, than if I were alone—except for the children. In that case why go on, I asked myself. The only answer I could find was that I had a certain usefulness for Pablo, however one-sided our relationship had become. I knew I could expect nothing further from him, and that if I did continue, it would have to be out of a sense of duty.

It was the closing hour for business offices. People were working their way in among the crowded tables and the café filled up. I felt a kind of solace in the movement of all these human lives crossing mine and flowing around me. They seemed to brush away a part of Pablo's hostility, which I felt even in his absence, and cover for a moment the vision of my grandmother lying helpless on her hospital bed. And as I studied them, their gestures and expressions, it came to me that, after all, most of them had burdens like mine, some far heavier, that we were all headed in the same direction with the same job to do in different forms, and that I was no more alone than they—just as much, but no more. Part of my burden dropped away. I got a very clear sense of the solitude of every human being, and of our complete interdependence, and that helped me in my determination to go on. After that I was much less unhappy than I had been in the previous two years.

As soon as I reached Vallauris I wrote Pablo a letter telling him what I had done. Zette Leiris wrote back saying that I had behaved in a silly way that Pablo was deeply hurt and was telling everyone that if I was in Paris it was my duty to come see him, that if I hadn't, it was because I had probably seen other people that I preferred to him, and that I cared nothing about him or his work. When he got back to Vallauris, he asked me why on earth I thought he would have scolded me if I let him know that I was in Paris and had gone to see my grandmother. I told him he had said so many things of that kind to me, I knew all his reactions by heart now.

"Of course I might have *said* something like that," he told me. "It's my nature to get angry. But I'm always saying things I don't mean. You should know that. When I shout at you and say disagreeable things, it's to toughen you up. I'd like *you* to get angry, shout, and carry on, but you don't. You go silent on me, become sarcastic, a little bitter,

aloof, and cold. I'd like just once to see you spill your guts out on the table, laugh, cry—play my game." He shook his head in disgust. "You northerners, I'll never understand you."

But I couldn't have played his game. At that period I hadn't wholly outgrown the effects of my early indoctrination. All my life I had been warned away from public displays of emotion. Growing angry, losing control, bursting into a storm of temperament in front of someone else, even a person one loved, were as unthinkable as parading nude before a thousand strangers; for that kind of emotion I was still locked within my shell. I have often wondered if all the lobsters and knights in armor Pablo was drawing and painting at that period weren't ironic symbols of his feelings about me in this respect.

Nearly two years later, when I told Pablo I felt I had to leave him, he brought up that incident and said, "That was when you decided to leave." That was far from true, because it was at that moment that I had decided to stay.

I think I loved Pablo as much as anyone can love someone else, but the thing he reproached me with later, and proof of which he saw in this incident, was that I never trusted him. He may have been right, but it would have been hard for me to feel otherwise, since I came onstage with an unavoidably clear vision of three other actresses who had tried to play the same role, all of whom had fallen into the prompter's box. Each of them had started out guite happy in the thought that she was unique. I didn't have that initial advantage because I knew, in general, what had gone on with Bluebeard's earlier wives and what I didn't know, he soon told me. It was almost impossible for me to be so confident of my own superiority to all the others that I could afford to laugh at the handwriting on the wall. After all, their fate didn't depend exclusively on themselves; it depended in large measure on Pablo. And mine did, too. They had all had different kinds of failures, for very different reasons. Olga, for example, went down to defeat because she demanded too much. One might assume on that basis that if she hadn't demanded too much and things that were basically stupid, she wouldn't have failed. And yet Marie-Thérèse Walter demanded nothing, she was very sweet, and she failed too. Then came Dora Maar, who was anything but stupid, an artist who understood him to a far greater degree than the others. But she, too, failed, although, like the others, she certainly believed in him. So it was hard for me to believe in him completely. He had left each of them, although each of them was so wrapped up in her own situation that she thought she was the only woman who had ever really counted

PART VII

for him, and that her life and his were inextricably intertwined. I saw it as a historical pattern: it had never worked before; certainly it was doomed this time, too. He himself had warned me that any love could last for only a predetermined period. Every day I felt that ours had one day less to go.

If Pablo was right in saying at times that I was cold, I suppose it was because I was chilled by the growing realization that whatever might come in the guise of good was only the shadow of something bad which was to follow; that whatever was pleasing would have to be paid for by its opposite immediately after. There was no means, ever, of coming really close to him for long. If for a brief moment he was gentle and tender with me, the next day he would be hard and cruel. He sometimes referred to that as "the high cost of living."

After Paloma was born, in the moments when I wanted to promote a real fusion between us he withdrew abruptly. When I, as a result, withdrew into my own solitude, that seemed to rekindle his interest. He began to reach out to me again, unwilling to see me serene so close to him yet without him. The heart of the problem, I soon came to understand, was that with Pablo there must always be a victor and a vanquished. I could not be satisfied with being the victor, nor, I think, could anyone who is emotionally mature. There was nothing gained by being vanquished, either, because with Pablo, the moment you were vanquished he lost all interest. Since I loved him, I couldn't afford to be vanquished. What does one do in a dilemma like that? The more I thought about it, the less clear the answer seemed.

DURING THE SUMMER OF 1951 I was obliged to return to Paris several times because my grandmother was gravely ill and also because I had to settle the new apartments in the Rue Gay-Lussac so that Pablo and I and the children could move in and avoid having them requisitioned. My grandmother had a series of strokes after her first one, and the last one left her paralyzed on one side. She was barely able to move and could hardly talk at all, but she was still lucid. I sensed she wanted to tell me something but she wasn't able to get it out. She grasped my hand and sank her nails into it. I could feel her desire to speak.

Finally she was able to break through the barrier and she said, "Let me bathe myself in your eyes." That was the last thing she said to me.

I returned to the Midi on the first of August. A few days later Pablo and I were at the pottery. Since our house wasn't in the center of Vallauris but up in the hills above the town, any telegrams that came for us were delivered to the post office. In France as elsewhere, southerners are never in a hurry and they often let such things gather dust for a while. When it began to be evident that my grandmother couldn't rally again, my mother had begun sending me telegrams to prepare me for the final news. Two or three of her wires had been received at the post office but since we had no telephone at the house, they were lying around undelivered. Finally, learning that we were at the pottery, the postal clerk called up there. When the telephone rang, I was standing beside it. Without thinking I picked it up and said, "Hello." The clerk was expecting Madame Ramié to answer so he simply announced, "Françoise's grandmother is dead." I hadn't received any of my mother's preparatory wires and when that sentence hit me, it knocked all the breath out of me, like a punch in the pit of the stomach. I returned to Paris at once knowing my mother would need me, since she worshiped her mother.

When I reached Paris, my mother told me that my father would be at the funeral, and that I had better be prepared to meet him. I hadn't seen him since I went to live with my grandmother in October 1943 because he had made it plain that he didn't wish to see me again. He hadn't seen my grandmother since then, either. Meeting him now was difficult, but I knew I must make the effort because it was a breach that, one day or another, had to be healed. And with his disposition it was certain that he would not take the first step.

We met in the clinic in Neuilly where my grandmother had died. My father shook hands with me rather coldly. I held his hand long enough to let him overcome his fear of appearing "soft," and finally he said, "After the ceremony is over, I'd like to have you come to the house." Then he added, "I'm not doing this for you, but for your mother."

After lunch he said to me, in a clear-cut businesslike fashion, "I haven't forgiven your grandmother for having supported you in this enterprise of yours, but I see no point in arguing about that now. I've decided to overlook it, so consider yourself at home here once again. I'll be happy to see you whenever you care to come, you and the children. We won't discuss it again." From that day until the day he died he was polite, and on occasion helpful, but no more. We were able to discuss literature, or anything he thought he had to teach me about money matters so that I would be able to look after my mother and the children properly if one day it fell to me to take over his role in the family, but there was nothing of father and daughter in our talks.

WHEN I WAS FIRST GOING TO SEE Pablo afternoons at the Rue des Grands-Augustins in the spring of 1944, he used to tease me about a girl that Paul Eluard had sent to him, who was beginning to write poetry. "You're not the only girl who comes to see me," he told me. "There are others." I didn't rise to the bait, so he went on, "For example, there's a girl who studies philosophy and writes poetry. She's very intelligent. What's more, she's very thoughtful. Very often when she comes to see me in the morning, she brings me cheese-Cantal cheese." I told him that if she was as nice as all that, he ought to invite me some morning when he knew she was coming, so that I could look her over and see if she measured up to his praise. He did, and when she arrived I saw a big bosomy girl, whose physical attributes bore a definite relation to the production of cheese. After that, any time Pablo referred to her, I would say, "Oh, yes, the Cantal cheese." Like most people who enjoy ridiculing others, Pablo never enjoyed being exposed to ridicule himself and he soon stopped talking about her.

The years passed and I had quite forgotten about the Cantal cheese when something arose to remind me of her in a very disagreeable way. Early in 1951, after a relatively quiet period, Pablo began making trips to Paris alone, leaving the children and me in Vallauris. I felt that something was going on, but it wasn't clear just what or with whom. In May, Paul Eluard and Dominique arrived at St.-Tropez. Pablo went over, without me, to spend two weeks with them. I sensed that he wasn't alone and that Paul wasn't the real reason for his trip.

One day soon after that, Madame Ramié confided to me that some journalists had told her Pablo was carrying on in St.-Tropez with another woman. She said they had even told her he was planning to go off to Tunisia with the girl, and she thought I ought to know about it before I read it in the papers or heard it from "an outsider." I thanked her but told her I'd have preferred to know nothing about it from any-

one. Even though I had suspected something of the sort, it wasn't very pleasant to have it confirmed, and in that fashion. There are times when one can take that sort of thing in one's stride; other times, when it's rather hard to stand up to it. At that moment it was very hard indeed. When Madame Ramié finished filling me in on Pablo's "new adventure," as she called it, I remember feeling just as though I had fallen from the sixth floor and had picked myself up and tried to walk away. There was more than one painful element in the situation. For one thing, I was very fond of Paul Eluard and I liked his new wife, Dominique. And although I didn't know exactly to what extent, it seemed evident that they were somehow involved and were helping make the difficult situation between Pablo and me become more so. All by itself, the matter of Pablo's becoming interested in someone else was hard enough to take; to know that people whom I had come to consider my closest friends were leading him into this "new adventure" was far harder.

I had no idea who the woman might be; I knew only that Pablo was very distracted and that his mind and his heart were elsewhere. When I thought over Madame Ramié's story afterward, I wondered for a moment if the woman might not be Dominique Eluard. Since I knew Paul very well and understood that masochistic nature of his which had led him, years before, to give tacit consent to an affair between his previous wife, Nusch, and Pablo, I thought the pattern might be repeating itself. In a certain sense, if it was Dominique, it seemed easier to accept.

When Pablo returned, I asked him if he wanted to tell me about the change in his feelings toward me. I said we had always been very frank with each other and I felt we should continue on that basis. Deciding, doubtless, that too much talk on the subject would complicate things for him or that I would react like a child, he said, "You must be crazy. Nothing at all is going on." He sounded so convincing, I believed him, preferring to think that perhaps the journalists had been badly informed. A few weeks later we spent the weekend with Paul and Dominique at St.-Tropez. They were very nice to me, thoughtful in the way one sometimes is with someone who is ill and needs special consideration. But as I studied them all and their relations with one another, I knew it couldn't be Dominique.

It was soon after our return from St.-Tropez that my grandmother died and I went to Paris for the funeral. Almost as soon as I got back, Pablo left for a bullfight in Arles. While he was gone, I went to the pottery one day. Madame Ramié, looking very conspiratorial, got me off into a corner.

"My dear, I know who it is," she said. "Of course, it's all over now; you can take comfort from that." If it was all over, I asked her, why did she need to bring it up again? She said she thought she should tell me for my own good. Finally, she got the name out. It was none other than the Cantal cheese. I was flabbergasted. At first I laughed, and then I felt rather sad that Pablo could have been willing to cause so much pain for so little in exchange. He had a proverb he was fond of quoting which translates to the effect that one look at a she-monkey's face tells you how much milk she's good for. One look at the Cantal's face had convinced me there was neither much fun nor profound feeling behind it. But that was my judgment, not his. Apparently I was a bad judge.

When Pablo returned from the bullfight, I told him that if he wanted to start a new life with someone else, I would make no objection to that, but I didn't want to share our life with that someone. What I was principally interested in, I said, was having him tell me the truth. And if he did, I would try to accept it cheerfully.

What I got was the usual wild rage. "I haven't any idea what you're talking about," he said. "Everything is exactly the way it always has been. There's no use talking about things that don't exist. Instead of probing continually to find out whether I have interests elsewhere, you should be more concerned to learn whether—if such a thing were true—it might be your fault. Whenever a couple runs into a storm, it's the fault of both of them. Nothing has happened, but if anything had, it would be because you allowed it to, fully as much as I did—at least passively."

Two or three times more I tried to raise the question. His answer was always in the same vein. And I soon began to see that having denied everything flatly, he was making an effort to have his attitude toward me correspond to what he had said. However, since he was unwilling to talk about it, it kept bothering me, because even if his little fling was finished, the fact that he couldn't any longer be frank and open with me hurt. But I said nothing more to him about the incident. My behavior toward him remained the same in that summer of 1951, but inwardly I began to move away from him. My grandmother's death had given me a heightened sense of individual solitude, of each one of us walking toward his own death, with no one able to help us or to hold us back.

Over the next year everyone had the impression that we had

never been so happy. Our life together was very calm, within and without. Sometimes when one does things without passion but with a sense of order, the results are the better for it. I had never before been so efficient in my work, Pablo told me. Our relations were constantly amiable. There was no real exchange, but each of us exerted himself more for the other than he had in years. There was no longer a real dialogue; each of us carried on a monologue in the direction of the other.

Toward the end of October 1952 Pablo went up to Paris. I asked him to take me with him. I told him that if he wanted us to remain together, he should take me with him when he went away for extended periods, because as soon as I was alone, I began to think the kind of dark thoughts that would lead me away from him. He shook his head. "Paris in winter is no place for you and the children," he said. "There isn't proper heat, for one thing. You're better off here. Besides, the sort of thing people can talk about like that, they never wind up by doing."

I told him I thought he must know me well enough to realize that I was not the kind of person who threatened to do something but never did it. If I told him even once that I felt that from now on we should be together all the time, that we should find a way of life that was adapted to us both and not just to him alone, it was because I would do something about it. But he left for Paris by himself. Three weeks later he telephoned to tell me that Paul Eluard had died. I was so broken up I was unable to go to Paris for the funeral. I asked him to get in touch with a friend of mine named Matsie Hadjilazaros, a Greek poet who was also a friend of his nephew Javier's, and ask her to come stay with me. I felt I needed to talk things out with someone. She was older than I and I had enough confidence in her objectivity to feel that she could help me make the right decision. She came at once. I told her that I couldn't see my way clear to staying with Pablo any longer. but his insistence that it was my duty to remain, that he needed me in his work, troubled me.

"No one is indispensable to anyone else," Matsie said. "You imagine that you're necessary to him or that he will be very unhappy if you leave him, but I'm sure that if you do, within three months he will have fitted another face into your role and you'll see that no one is suffering because of your absence. You must feel free to do whatever seems best for you. Being somebody's nurse is no way to live unless you're unable to do anything else. You have something to say on your own and you ought to be thinking, first and foremost, about that."

When Pablo returned, I told him I was convinced there was no

314

longer any deep meaning in our union and I saw no reason for staying. He asked me if there was anyone else in my life. I told him no.

"Then you must stay," he said. "If there were someone else, you'd at least have an excuse, but if there isn't, you stay. I need you." That autumn and winter we were preparing for the big exhibitions of his work in Milan and Rome, and there was a lot to be done. So I put out of my mind everything Matsie had said and I stayed. Until then I had dreaded Pablo's absences. Now I welcomed them. I worked as hard as ever, but the less I saw of him, the easier I found it.

It was obvious that Pablo realized how I felt and he was darting up and down the countryside like the headless horseman. He never traveled so much in his life as he did that winter. Every time he returned to Vallauris he asked me if I had changed my mind. My answer was always no. In the spring, he went from one bullfight to another, the intervals between sprinkled liberally with amorous intrigues. Each time he returned from one of these expeditions like a tired dog dragging his tail behind him, he would ask triumphantly if I *still* wanted to leave him. Always childish, he imagined that through jealousy I would do an about-face to keep him at all costs. But the effect was just the opposite.

For the first time I started taking into account the factor of Pablo's age. Until then, it had never seemed important. But when he began gamboling about so wildly, I suddenly came face to face with the fact that he was now over seventy years old. For the first time I saw him as an old man, and it seemed extraordinary to me that he should be the one to carry on in that fashion. I was the young one, lacking experience and the stability it brings, whereas he had had more than enough time to find his equilibrium. If, in spite of his years, he had no greater capacity for self-government than an inexperienced boy my own age, I might as well grow up with a boy rather than with an old man whose education, by now, should have been completed, but was actually far from it. That was the crack that let in the light. One day, after he had inventoried for an hour or two in his usual fashion all the things that were going so badly in his life, I was surprised to hear myself, instead of beginning the usual ritual of winding him up and starting him off in the other direction, say, "Yes, you're right. It's going very badly. It will probably be worse tomorrow." I went on, like Cassandra from her rampart, to say that things were dreadful, that there was no way out, but that the worst was yet to come, and that things would grow so black that one day he would look back on these days as happy ones. He was outraged. He went into a fit of anger and threatened to commit suicide. I

told him I didn't believe he would, but that if it would make him happier, I wouldn't attempt to stop him.

He was stunned. "You, who were so sweet and gentle, what have you become? You've lost the magic mountain," he said. "You used to be a kind of somnambulist, walking on the edge of the roof without realizing it, living in a dream or a spell."

I had been, but I wasn't any longer. I had waked up and I was disenchanted. From that moment on I saw him threatened by every wind and all kinds of distractions—the same things that threaten everybody else. One of the qualities I had admired most about him was his intense power of self-concentration to unite and direct his creative energies. He attached no importance to the façade of living. Any roof would have suited him, so long as he could work under it. He spent no time on "entertainment": we almost never went to the theater or the movies. Even our friends were kept within well-defined limits. His great strength had always been that in proportion to his expenditure for his creative work, he wasted little of himself on the assorted routines of day-to-day living. That was one of his guiding principles.

He had told me once, "Everybody has the same energy potential. The average person wastes his in a dozen little ways. I bring mine to bear on one thing only: my painting, and everything is sacrificed to it —you and everyone else, myself included."

Until now I had seen him, through his inner life, as a unique phenomenon. But now that I saw him spending his energies in the most frivolous and irresponsible ways, I saw him, for the first time, from outside. I realized that passing his seventieth birthday had made him feel a whole decade older and that the strength he ordinarily kept concentrated within him for his creative work, he was suddenly eager to spend in "living." And so all the standards he had set up and so carefully observed until now were completely thrown aside. His constant dread of death had moved into a critical phase and, as one of its effects, had apparently provoked a taste for "life" in a form which he had abandoned years earlier. He was anxious to appear youthful, whatever the cost, and he kept asking me if I wasn't afraid of death. He often said, "I'd give anything to be twenty years younger."

"What luck you have to be your age," he said. Before, he had told me, "If I live with someone young, that helps me to stay young." But now he complained that "seeing someone young around all the time is a constant reproach for being no longer young oneself." The idea that he was now past seventy was something he hurled against me as though I were responsible for it. I used to feel that the only way I could atome for it was by making an effort to become, suddenly, seventy years old myself.

I used to get up very early mornings. At night he would keep at me hammer and tongs with discussions and recriminations, often until three in the morning. Sometimes I would pass out from exhaustion. When he saw that I was very weak and even at my age didn't have the same kind of robust good health he had, that would cheer him up somewhat.

"You're not so well off, after all," he told me. "You won't last as long as I will." He couldn't seem to bear the idea that anyone who had been part of his life should survive him. I recalled how he had told me at the beginning, "Every time I change wives I should burn the last one. That way I'd be rid of them. They wouldn't be around now to complicate my existence. Maybe that would bring back my youth, too. You kill the woman and you wipe out the past she represents."

HILE PABLO WAS IN PARIS, about two weeks before Eluard's death, he met one of the few men he had always admired: Charlie Chaplin.

I had long realized that all his life Pablo had identified, in a symbolic way, his role—even his fate—with that of certain other solitary performers: the anonymous acrobats and tumblers whom he etched so poignantly in the *Saltimbanques* series; the matadors whose struggles he made his own and whose drama, whose technique even, seemed to carry over into almost every phase of his life and work.

The clown, too, with his ill-fitting costume, was for him one of the tragic and heroic figures. Almost every morning as Pablo lathered his face for shaving, he would trace with a finger in the billowing cream the enormous caricatured lips, the suggestion of a question mark over the eyebrows, and the path of tears oozing out of each eye—the stigmata of the professional clown. His makeup complete, he would begin to gesticulate and grimace with an intensity that made it clear that this was

not only a game he enjoyed but, at the same time, something more. Claude was always a good audience and soon I, too, would burst out laughing.

Pablo had told me that he had been an avid Chaplin fan during the silent-film days but that when the talkies came along he had lost interest in all movies. When Monsieur Verdoux was announced, he could hardly contain his impatience, curious to see how Chaplin would manage with a role outside his traditional one, because for Pablo, Chaplin's art lay essentially in the physical stylization of his "little man" role. After seeing Monsieur Verdoux Pablo felt a little disappointed with the film, but he cherished those scenes where Chaplin relied exclusively on mime to produce his effects. The scenes, for example, in which Chaplin so deftly flipped through the pages of the telephone directory and counted money were responsible, I'm sure, for the way in which Pablo, over and over again, counted, or miscounted, the banknotes in his old, red-leather trunk. In those scenes the direct force of the image seemed to him to duplicate the kind of shock that comes when you look at a painting. "It's the same thing, to the extent that you work on the senses to convey your meaning," he said. "Mime is the exact equivalent of the gesture in painting by which you transmit directly a state of mind -no description, no analysis, no words."

More than once he had expressed a desire to meet Chaplin. He never failed to add, very seriously, "He's a man who, like me, has suffered a great deal at the hands of women."

At the end of October 1952, Chaplin came from London to Paris for the French première of his film *Limelight*. Several days later, with Aragon and a few other friends, Pablo had dinner with him, and Chaplin visited his studios in the Rue des Grands-Augustins. Chaplin didn't speak French, nor Pablo English.

"The interpreters were doing their best but the thing was dragging badly," Pablo told me. "Then I had the idea of getting Chaplin alone and seeing if maybe all by ourselves we couldn't establish some kind of communication. I took him upstairs to my painting studio and showed him the pictures I had been working on recently. When I finished, I gave him a bow and a flourish to let him know it was his turn. He understood at once. He went into the bathroom and gave me the most wonderful pantomime of a man washing and shaving, with every one of those little involuntary reflexes like blowing the soapsuds out of his nose and digging them out of his ears. When he had finished that routine, he picked up two toothbrushes and performed that marvelous dance with the rolls, from the New Year's Eve dinner sequence in *The Gold Rush.* It was just like the old days."

Limelight, though, was another matter. The tragic—or at least melodramatic—aspects of the story troubled Pablo deeply. There were three separate levels to the effect the film had on him. One of them was simply and expectably a general protest against sentimentality in any form.

"I don't like that maudlin, sentimentalizing side of him," he said. "That's for shopgirls. When he starts reaching for the heartstrings, maybe he impresses Chagall but it doesn't go down with me. It's just bad literature."

The second layer of meaning the film had for him he explained in terms of the physical changes time had wrought in Chaplin and how these had modified the whole nature of his art.

"The real tragedy," he said, "lies in the fact that Chaplin can no longer assume the physical appearance of the clown because he's no longer slender, no longer young, and no longer has the face and expression of his 'little man' but that of a man who's grown old. His body isn't really him any more. Time has conquered him and turned him into another person. And now he's a lost soul—just another actor in search of his individuality, and he won't be able to make anybody laugh."

But beyond that—and far more disturbing to him—was the parallel he must have drawn, even if unconsciously, between our own precarious personal situation and the story of the film: the aging clown who not only brings the young dancer out of her paralysis so that she can dance once more and discover herself as an artist but is ready to sacrifice himself and turn her over to a younger man and thus allow her to embark on her life as a woman.

"That kind of altruism is ridiculous," he told me scornfully. "Just hand-me-down, threadbare romanticism. That's not my way of doing things, I'll tell you that. To claim that when you love somebody, you can accept the idea of seeing her go off with some young fellow is very unconvincing. I'd rather see a woman die, any day, than see her happy with someone else. I prefer to be honest and sincere and admit that I want to hold onto the person I love and not for anything in the world let her go. I'm not interested in these so-called Christian acts of nobility."

URING THE SPRING OF 1953 Pablo was intrigued by two silhouettes he used to see in an old pottery across from his studio in the Rue du Fournas. They belonged to a girl named Sylvette David and her fiancé, a young Englishman who designed and assembled very unusual chairs, with an iron framework filled out by rope and felt. The chairs were so impractical for sitting in that Pablo was delighted with them. Sylvette's fiancé made one up and brought it to us one evening as a gift. At the end of the arms were two round balls on which to rest one's hands. On the network of rope one could put a pillow and make the chair a little less uncomfortable. It was such an abstraction of the idea of a chair that it reminded Pablo of certain paintings he had done during the 1930s in which Dora Maar is shown sitting in a chair made up of a skeleton framework much like this one, ending in two balls. This resemblance pleased him, and since it was obvious that Sylvette and her fiancé were doing barely enough business to get by, he ordered two more chairs like the one they had given him and a third one somewhat smaller. As a result La Galloise was bulging with chairs that were amusing to look at but took up a disproportionate amount of room in view of the fact that no one could sit in them with any pleasure.

After this Pablo decided that Sylvette, with her blond pony tail and long bangs, had very pictorial features and he began to make portraits of her. Undoubtedly he wanted to make portraits of her, but I know, also, he hoped I might think twice about leaving if I realized there was someone else so close at hand who could step into at least one pair of my shoes. But I encouraged him to go on and make more portraits of her, for I found her as charming as he did, and I made it a point never to be around while she was posing for him. The first few portraits he did with enthusiasm, and then he began to drag his heels like a schoolboy doing homework on his vacation. The pleasure was shrinking. One day he reproached me: "You don't seem at all unhappy about it. You should refuse to admit another face into my painting. If you knew how Marie-Thérèse suffered when I began making portraits of Dora Maar and how unhappy Dora was when I went back to painting Marie-Thérèse. But you—you're a monster of indifference."

I told him it wasn't a question of that. For one thing, I had never had the ambition of being "the face" in his painting. Beyond that, the portraits I admired most were some of his Cubist portraits, along with

PART VII

some of Dora Maar, which seemed to me much more profound and inspired than anything he had done of me. I tried to explain to him that it was his work that held me, not the image of myself that I saw in it. What I did see in it, I told him, was him, not me.

One day while Pablo was working on one of his portraits of Sylvette David, Totote, the widow of his old friend the sculptor Manolo, and her adopted daughter, who lived near Barcelona, came to call on us, driven over by friends of Totote's who lived at Perpignan-the Count and Countess de Lazerme. Madame de Lazerme was tall and well built. with black eyes and hair and classic features. Except that she was taller, she resembled strongly my school friend Geneviève. She looked about thirty-five and was a very charming queen bee. She invited Pablo and me to visit her and her husband in Perpignan. They had a large house there, she told us, and she said she thought Pablo would be interested in seeing the library. Since Pablo was going to all the bullfights that were held at Nîmes, and Nîmes was right on the way to Perpignan, it was very easy for him to accept Madame de Lazerme's invitation. Once he had found his way there, he discovered that it was pleasant to spend the intervals between bullfights in this vast house with its intriguing library. I had now come to feel that my leaving him was only a question of time, and I thought it pointless to accompany him on these junkets. He confided to me that he was "paying court" to Madame de Lazerme. He was flattered to feel he was attractive to such a handsome young woman. He made several trips in her direction and then began to travel farther afield. In the center of France he was smitten by another married woman, a pregnant one this time, whose husband was only too delighted to be cuckolded by such a great and famous man. Pablo gave him a drawing now and again, inscribed from "his friend Picasso," and he became the most willing of accomplices. One day the entire family landed in Vallauris so that, in the seclusion and comfort of his own studio, Pablo could paint the wife's portrait. Life had become a permanent circus.

On his return from one of these expeditions, Pablo looked at me with his air of *enfant terrible*, and said. "Well, aren't you going to say anything? No protest to make? Don't you have any desire to hold me back so I don't do things like that?" I said it was too bad, but I didn't. Not any more.

The situation became even more difficult. I had never known Pablo to talk about his private business with anyone. Everything was a secret to him and when I first went to live with him, whenever I referred, in front of others, to anything concerning our activities, I was in

for a raking-over. Now, suddenly, he began sharing his private life with everyone. His reactions and attitudes were so changed, I felt I was dealing with a total stranger. We had discussed the idea of separation but hadn't settled on anything. And yet everyone who came to call was greeted with, "You know Françoise is leaving me." I knew I had to leave him because I had finally come to realize that I didn't have the strength to go on; on the other hand. I had a terrible sense of desperation at not being able to go on. I loved him and I felt that for the children's sake it would certainly be better if we stayed together. My hope, originally, was to make it a gradual and partial separation, helped, perhaps, by some intermediate step, toward a less painful final solution. At one moment I even thought that if I could regain my equilibrium through rest, I could make some adjustment that would enable me to stay. I asked Pablo to let me go to the mountains for three months. He refused. And since he talked about our separation with everyone and it was now the chief nourishment of all the gossips, it became inevitable.

He wrote countless letters to Sabartés, in a very hermetic Spanish: "I am not what I was. I am not loved," and so on, and then left them around for me to read. But that was nothing; Sabartés was as discreet as the tomb. Pablo broke the news to Kahnweiler and Madame Leiris, Dominique Eluard, Madame Ramié—everyone we met in Vallauris or in Paris. He was getting advice on all sides. People were rushing to me, telling me I mustn't leave him, then rushing back to him saying I wouldn't leave; it was only a maneuver on my part to obtain more freedom; all he had to do was remain firm and I would come around. By now Pablo's nerves were pretty frayed. He didn't know what to say to me, since nothing he did seemed to produce the desired effect. And he kept on piling up psychological errors, one on top of another.

"No woman leaves a man like me," he said. I told him maybe that was the way it looked to him, but I was one woman who would, and was about to. A man as famous and as rich as he? He couldn't believe it, he said. I could only laugh at his complete misunderstanding of a woman with whom he had lived for so many years.

A year or so earlier Pablo had asked me whether there was anyone else in my life. That had started me thinking about all the friends I had once had. It made me want to go back and pick up their traces, find out what the painters and writers of my own generation had been searching for, and where their efforts had led them. As I did so, I saw that even though they weren't widely known, most of them, they had sent off arrows into the future, and the efforts they were making gave real meaning to their lives. All that seemed much closer to me than the routine of someone who had arrived at the summit of life without me and for whom I existed as a physical form and a useful object but not a genuine necessity. So I began to tell Pablo that if I was leaving him, it was in order to live with my own generation and the problems of my time.

Now it was Pablo's turn to laugh at me. "You imagine people will be interested in you?" he said. "They won't ever, really, just for yourself. Even if you think people like you, it will only be a kind of curiosity they will have about a person whose life has touched mine so intimately. And you'll be left with only the taste of ashes in your mouth. For you, reality is finished; it ends right here. If you attempt to take a step outside my reality—which has become yours, inasmuch as I found you when you were young and unformed and I burned everything around you—you're headed straight for the desert. And if you go, that's exactly what I wish for you."

I told him I had no doubt that the majority of people who now bent over backward to please me acted that way for reasons that were neither pure nor sincere. But if I was destined to live in the desert, as he predicted, I wanted to make the effort to do just that, and to see if I could survive, if for no other reason than to find out what I was. For ten years now I had lived in his shadow, trying wholeheartedly most of the time to relieve the pain of his solitude. But since I now realized that he lived in a self-enclosed world and that his solitude was therefore total, I wanted to explore my own solitude.

"Your job is to remain by my side, to devote yourself to me and to the children," he said. "Whether it makes you happy or unhappy is no concern of mine. If your presence here provides happiness and stability for others, that's all you should ask." I told him it was quite clear from his recent performance that I couldn't do much about providing *him* with any stability, and as far as the children were concerned, I was no longer convinced that they would have less stability without him than they had with us together. He grew very angry.

"Of course," he said. "We're living in a disgustingly sentimental age. Everyone thinks in terms of 'happiness' and other concepts that don't really exist. What we need are Roman mothers; they were the only real ones." "Roman" was a term Pablo often used to imply people without feelings, since for him, sentiment was the equivalent of sentimentality. It was apparently pointless to try to make him see anything unrealistic in his notion that one of us should be motivated only by a sense of duty

and have no feelings whatever, while the other should react only in accordance with his feelings and have no sense of duty toward anyone but himself. Pablo always saw himself as a river sweeping everything before it. That was his nature and he must obey it. He used to refer to himself as "an ascetic of the plethora." His vision of my role was that of the unresisting saint, sitting quietly in her cave, sanctifying or at least neutralizing by an exemplary existence the worst aspects of his own way of life. At one time I had been able to accept that concept. But now the distance between us had grown too great.

In the summer of 1948, when Pablo's nephew Javier and Matsie Hadjilazaros had come to Vallauris to visit us, they had brought a friend named Kostas with them. Like Matsie he was Greek. He had left Greece in 1946 and had studied philosophy with Karl Jaspers in Basel. He was now settled in Paris, translating the writings of Heidegger and working on a book about Heraclitus. Together with Pablo, I had seen him perhaps six or seven times. When I went to Paris in the spring of 1953 to work on sets and costumes I had been commissioned to do for a ballet of Janine Charrat, I saw him with Javier and Matsie. Like everyone else, he realized that things were going badly between Pablo and me and he asked me what I planned to do. Probably nothing, I told him. There were the children to think of and besides that, I still felt I was more useful to Pablo than to anyone else. His answer stunned me. He loved me, he said, and I must end my relation with Pablo. I could see that he meant what he said. His declaration made me realize that in spite of all Pablo had said, it would be possible for me to have a valid human relationship within my own generation. I told him I was deeply moved by what he had said but I didn't think I loved him. He said that was of no importance, that there are times when one person can carry the burden of love for both. I told him I thought it would be impossible for me to begin another life with someone else. He said it was obvious, in any case, that my life with Pablo was finished; therefore, I should write an end to that. Whether I had confidence in a future with him or not, at least he would offer me moral support while I took that necessary step. I felt very uncertain of the rightness of the step, but over the next few months I gave it a great deal of thought. To strengthen my resolve I told myself that I loved him. And I told Pablo that now there was someone else. He discussed that with everyone, too.

The only comforting element in the situation that summer was the presence of Maya, the daughter of Pablo and Marie-Thérèse Walter. She came and stayed with us for about six weeks. She knew I was thinking of leaving and she was the only person who was helpful. While she was there we had a fairly pleasant, reasonably normal life and I began to feel it might be possible for me to stay on. Letters arrived daily from Kostas urging me not to falter. No one but Maya seemed to realize that I was in an extremely difficult situation and so exhausted as to be unable to handle it comfortably.

I had other problems, too. Ever since Paloma was born, things had not been quite right with me. Recently I had been having frequent, very heavy hemorrhages, which weakened me greatly and were a constant source of annoyance to Pablo. My doctor had told me I needed an operation. I had written to Inès asking her to come to Vallauris and look after the children while I was in the hospital. She replied that she couldn't leave Paris at the moment. When I spoke to Pablo about it, he said there was no question of my having the operation right away.

"I'm much too busy to let you take time off now," he said. "There's no need for women to be sick so often, anyway."

I decided there was only one thing to do: return to Paris with the children. I served notice on Pablo that as of September 30 I was moving with them to the apartment in the Rue Gay-Lussac and enrolling them at the Ecole Alsacienne for the fall term. The future could take care of itself. I made the train reservations. Right up to the last minute Pablo was convinced I would back down. When the taxi pulled up and I got into it with the children and our bags, he was so angry he didn't even say good-bye. He shouted "Merde!" and went back into the house.

In Paris, when I tried to make a go of things with Kostas, it didn't—it couldn't—last. I wasn't really ready. It was difficult enough to bring ten years of my life to an end in that manner without starting at once to take on something new. I was not yet free of my involvement with Pablo. Kostas couldn't stand that. In less than three months we had broken up.

FOR A LONG TIME BEFORE I LEFT Pablo, Madame Ramié had known that things were not going very well between Pablo and me. She had been virtually force-feeding me with whatever details she had access to concerning Pablo's outside activities and she found other ways, too,

of adding to the general confusion. During the fall of 1952 she imported a young cousin of hers named Jacqueline Roque to be a salesgirl at the pottery. In general, she used to let the salesgirls go in the fall; once the tourist season was over, there was no further need for them. Jacqueline, however, came at the end of the season, with her six-year-old daughter. She spoke a little Spanish and since very little pottery was sold in winter, her chief occupation appeared to be holding conversations in Spanish with Pablo. She was just over five feet tall, with a rather cute little head, high cheekbones, and blue eyes. She had a little house between Golfe-Juan and Juan-les-Pins, which she called *Le Ziquet*. In the Midi, that term means "the little goat," and Pablo often referred to her as "Madame Z." I wasn't with Pablo very often when he went to the pottery and he undoubtedly saw Jacqueline Roque and talked with her more often than I might have imagined at the time, had I given it any thought.

A week after I left Vallauris on September 30, Pablo came to Paris and stayed two weeks. Within a week of the time he got back to the Midi, Jacqueline Roque had taken over. "One can't leave that poor man alone like that, at his age. I must look after him." That was the substance of the quotations that were passed along to me at the time. Journalists literally camped on my doorstep. There was one period when I didn't go outside for a week because there was never a moment when the stairway was not obstructed with them. Our separation was the last thing I wanted to talk about. But I was soon reading in the newspapers declarations to the effect that I had left Picasso because I didn't care to live with "a historical monument." I never made such a statement to the press—or to anyone else.

At Christmastime I accompanied Claude and Paloma on the train to Cannes so they could spend the holidays with their father. Madame Ramié was waiting for me at the station. I asked her if she thought it would be a good idea for me to drop in to see Pablo. She told me it was much better that I didn't go near him, and that he had said he didn't want to see me. So I took the train back to Paris the same evening without going to *La Galloise*. When the Christmas vacation was over, I went down to Cannes to pick up the children. Madame Ramié brought them to the station and I returned to Paris with them, still not having seen Pablo.

As I thought it over, I began to understand that she was doing her best to keep Pablo and me apart. From the start, she had pretended that she felt I shouldn't leave, yet she did everything she could to make me want to. *La Galloise* belonged to me and I had taken away only the clothes that the children and I needed at once. I hadn't planned on moving out at all. In Paris one of the apartments in the Rue Gay-Lussac was mine and before I left, Pablo and I had agreed, in one of our calmer moments, that we would get together in Paris and in Vallauris from time to time. But it was quite apparent, now that I was no longer there, that his good friends on the spot had repeated to him so many times that I was a wicked and selfish woman to do such a thing to a man like him that Pablo, already in a very bad mood over my departure, was soon agreeing with them. After three months of that diet, he was saying that he never wanted to set eyes on me again, if one could believe Madame Ramié.

I decided that when I brought the children to the Midi for their Easter holidays, I would see him, and a few days before leaving Paris I wrote him to that effect. When we reached *La Galloise*, Jacqueline Roque was nowhere in sight, but it was apparent that she had left not long before. I went to my clothes closet to put my things away and noticed a number of changes. In my Spanish gypsy dress—the type worn during Holy Week—which Pablo had had someone bring me from Spain, all the hooks in the back had been pulled away as though it had been worn by someone heavier than I. There were other indications that my clothes had been worn in my absence. It gave me a strange feeling.

Pablo had heard that Kostas and I had broken up. "I knew you wouldn't be able to make out with anyone except me," he said, cheerfully. Then he grew more sober, as he added, "I'm going to talk to you now like the old philosopher talking to the young philosopher. Whatever you do from now on, your life will be lived before a mirror that will throw back at you everything you have lived through with me, because each one of us carries around with him the weight of his past experiences and that can't be set aside. You loved me, and since you came to me fresh from nowhere and you were completely available, it was easy for you to be generous. You haven't learned yet that little by little, as life forms us, it shapes us into a mold. That is why I have told you that you are headed for the desert, even though you think you're moving toward understanding and communication. You made your life with me, I passed my own brand of anxiety along to you and you assimilated it. So now, even a person who might be willing to dedicate himself completely to you, since he hasn't been tested in the same fire that you have, wouldn't be able to save you, any more than you were able to save me."

I told him I knew that deserts produced mirages but that they

also contained oases and that under certain circumstances a cup of water was the most precious of gifts. He brushed that—and its implications —aside. He said that we should begin again to live together, but "on another basis"—as friends, so that I could help him with his work and continue our conversations on painting which, he said, had become a necessity for him. He would "fill in the rest" elsewhere and wouldn't ask me to account for my outside activities, either. I could see that although the name had changed, it was the same old kingdom. I knew that my life with Pablo was over. If life was to become a desert or a long exile, I had to face it. I couldn't go back to where I had been before.

But for the moment there was no animosity between us. "The reward for love is friendship," Pablo said. We agreed that we had lived through many happy experiences together, that we had a great deal of affection and esteem for each other, and that there was no reason why that feeling couldn't be carried on as we went our separate ways, especially since it would be a stabilizing influence on the children.

Over the next two weeks we talked a great deal about painting. One day as he showed me the work he had done since I went away, he said, "It's terrible that you have to go away again. There's nobody I can talk with about the things that interest me most, the way I can with you. The solitude is so much greater since you left. We may have had our troubles living together, but it seems to me it's going to be even harder living apart." I let that opening pass.

A few days later Pablo said to me, "Since you're here, you ought to see Madame Ramié." I didn't want to argue with him about her so I went to the pottery. Madame Ramié acted much more coldly toward me than ever before.

"What are you doing here?" she asked me. "You can't possibly imagine how much that poor man has suffered because of you. You'll make him sick, coming back like this. It's plain to see you haven't got a heart. It's shameful, what you're doing. I hope he told you so." I said things hadn't taken that path at all. I told her I saw no reason why Pablo and I couldn't talk together.

"There's a very good reason," she said. "You may not know it but there's someone else in his life now." I said he hadn't spoken of that to me and it might be better if she let him tell me.

"I'm telling you right now," she said, "because it's the truth. And if you imagine you can come and go as you please, whenever you take it into your head, you're very wrong." I decided, in view of that conversation, that since I had no intention of going back to live with Pablo, perhaps it would be better if I went away while our casual relations were untroubled. In that way he could arrange his life in any manner he saw fit and we could see each other whenever the occasion demanded, just like any other friends. I said nothing to him about my conversation with Madame Ramié. I think that what she told me was basically true but that he was waiting to see my reaction before taking a step in any direction. When I left Vallauris, we agreed that I would come and stay for a month with the children at the beginning of the summer, leave him the children and their nurse for the rest of the vacation and then return at the end of the summer to take them back to school in Paris. La Galloise would remain common ground because of the children.

As agreed, I returned to *La Galloise* with the children in July. Again I found Pablo alone, but Jacqueline Roque came nearly every day. We had lunch with her at her house several times. It was clear from everything Pablo said that he considered her presence temporarily useful but that he didn't see it as a long-term arrangement. He and I picked up our old habit of talking while he worked and sometimes after, until two or three in the morning. Pablo, I could see, was very restless, but he was very nice toward me.

"Since we're together." he said. "we've got to take advantage of it and have some fun for a change." That amused me, because in all the years that we were together, the question of "having fun" had never come up. With one exception, I had never known him to go to a movietheater. And we had never set foot in a nightclub or anything of that kind. But for several weeks that July we spent whole nights in the clubs of Juan-les-Pins and other towns nearby. Pablo would hardly ever go home without seeing the dawn. And once he saw it, then he'd say, "There's no sense going to bed now," and the next day would start then and there. We went around the clock like that day after day. I was worn out, but Pablo was very gay and lively. There were always between twelve and twenty guests following us around, including Jacqueline Roque, some friends of hers from Bandol, and some Spaniards to whom Pablo had given the job of organizing the first bullfight in Vallauris. We went from Juan-les-Pins to Bandol and from Bandol to Nîmes, from bullfight to bullfight. In Vallauris I was living at La Galloise, and so was he, but we occupied different rooms. When we went to Bandol and stayed at a hotel, I had no intention of sleeping in the same room with him, but when I ordered a separate room for myself, he insisted

I share his as I had always done when we traveled. Jacqueline Roque was indignant and said that even the idea of it was "immoral."

I had intended to leave by the end of July but Pablo urged me to stay for the first Vallauris *corrida*, which was being held in his honor.

"If you want to do me one last favor," he said, "you can open the bullfight in Vallauris. You're going out of my life, and last year when you left I was in a pretty ugly mood. But you deserve to leave with the honors of war. For me the bull is the proudest symbol of all, and your symbol is the horse. I want our two symbols to face each other in that ritual way."

I agreed to go through with it. I was to enter the ring on horseback, execute a series of intricate movements and circle the arena several times, making the horse dance. Then there would be a proclamation to read stating that the bullfight was being held under the presidency of Pablo Picasso and in his honor. But it wasn't at all easy to find a horse that had the training to fit him for that role, nor was there enough time left before the *corrida* to train one very thoroughly. I finally found one in Nice that was somewhat above the average and after working him out over a period of two weeks, got him to the point where he could be counted on not to make too bad a job of it.

Madame Ramié made no secret of her disapproval. "Imagine this person, who has walked out on our great and dear Master, being given the honor of opening the first bullfight here in Vallauris—and in his honor!" That was the form in which her protest got back to me. When she said something to me about the "inappropriateness" of it all, I reminded her it was Pablo's idea, not mine. I said I would be glad to turn the job over to someone else, but it had to be someone who wasn't easily dismounted. Would she like to try it? Whereupon she grew all red and walked away.

Jacqueline Roque, meanwhile, had been behaving reasonably calmly. But the morning of the bullfight she drove up to *La Galloise* and burst into the house, tears streaming down her face. "I beg of you, don't do *that*," she said. "It's just too ridiculous for everybody." Pablo asked her what she was talking about.

"Françoise mustn't ride into the arena to open the bullfight," she said. "What will the newspapers say?"

Pablo laughed. "In all the years newspapers have been printing nonsense about me, if that were the worst thing they'd said! If Françoise and I want to do it that way, we'll do it. Let the newspapers make the most of it." "But it's like a circus," she protested.

"That's right," Pablo said. "It is like a circus. And what's wrong with the circus? Anyway, I like the idea. If others don't, *tant pis*."

When she saw he was intractable, she brushed the tears and hair out of her eyes and said, "Perhaps you're right. I didn't understand. You're always right." And she left.

That afternoon the program went off hilariously. Pablo's son Paulo shaved one side of his head and drove through the streets of Vallauris in an old car. Pablo, with a small jazz band, followed him in another. After the bullfight Pablo was in an expansive mood.

"You were wonderful," he told me. "Absolutely sublime. You've got to stay this time. You're the only one I have any fun with. You carry with you the right atmosphere. I'll die from boredom if you go." I told him I knew I would not be able to bear up under our old way of life and I left that evening. After I had gone, he got into one of his black moods again and couldn't stand being in Vallauris. He took the children and their nurse, Jacqueline Roque and her daughter, and all the others and went to Collioure, in the Pyrenees. There he spent the rest of the summer buzzing around Madame de Lazerme.

N PARIS THAT FALL, I was taken ill and had to have an emergency operation. After I came out of the hospital, Kahnweiler called to tell me Pablo wanted to have the children the next Sunday. He said Jacqueline Roque wouldn't be there, that there would be only Picasso, himself, and the children. Since the children were still rather young —five and seven—I told him it might be simpler for everybody if I accompanied them. Kahnweiler and Pablo called for us. They sat in the front seat and the children and I in back, and Kahnweiler drove us out to his country place at St.-Hilaire on the road to Orléans. In the middle of the dinner, Pablo said suddenly that he was very ill, that he knew his heart was giving out. I offered to look after him, but he said he didn't want anything to do with me. Kahnweiler, of course, became extremely agitated. Pablo left the table and went up into a bedroom to lie down. Kahnweiler and I sat downstairs while he rested.

After an hour or so, I went upstairs to look at him. He seemed

on the point of expiring quite dramatically, but he revived sufficiently to say, "You're a monster, the lowest form of human life. You see how your mere presence is enough to make me ill? If I see any more of you, I'll die. When I think of all you owe me!" Then, of course, I understood his frame of mind, so I nodded compassionately, and said he was quite right; he had found me lying in the gutter and had rescued me from all that and brought me to the castle to live like a princess. That made him all the angrier. He stormed on about middle-class morality and bourgeois values, cursed my parents for having brought me up in a life of ease, and said he wished he could have my father thrown in jail for being a successful businessman who had accustomed his daughter to a pampered life and educated her in sophistries.

"If I had found you in a gutter, we'd both be better off," he said. "Then you would owe me everything and you'd be smart enough to know it. If this were the ancien régime and I were king, I would put your father in jail. It's all his fault."

I had to laugh. I told him it sounded so funny to hear a Communist yearning for the *ancien régime*. And I reminded him that if it *were* the *ancien régime*, it would be more likely that my father would have *him* thrown into jail for having caused his only daughter to stray onto the primrose path at such an early age.

Pablo sat up in bed. "You can't look me in the face and tell me you consider you were pure." I looked and I told him.

"And you don't consider yourself enormously indebted to me?" he asked. I told him I did indeed. He had taught me a great deal. But I had given him a great deal throughout those years—at least as much as he had given me—and I felt, as a result, that my indebtedness had been amply paid off.

"Ah, so you think you've paid for your life with me by undergoing a bit of annoyance on occasion?" he asked. I told him it wasn't a question of annoyance. I had paid with my blood for everything I had got: from every point of view and far more than he realized. Finding me so hopelessly unrepentant, he gave up. He was too sick to argue further, he said. He had to return to Paris at once.

He stamped downstairs and faced a trembling Kahnweiler with the announcement, "This woman makes me ill. I never want to set eyes on her again. It was a terrible mistake on your part to bring her here." Kahnweiler grew even paler. I apologized but said I had felt it was my duty to be with the children, especially since there was no one else to look after them.

PART VII

All the way back to Paris no one spoke. *Livery* few minutes Pablo went through a little mime designed to convince us all he was passing out. I felt sure he was as strong and as well as ever: except when he was remembering to act out his little comedy, he certainly looked it.

In December, his son Paulo had to undergo a hernia operation. Doctor Blondin was the surgeon. After the operation, Paulo suffered a lung embolism. For several days he was between life and death. Blondin sent a telegram to Pablo, in the Midi, telling him that Paulo was very ill and urging him to come to Paris. He didn't come.

In January, while Paulo was still in the hospital, his mother, Olga, partially paralyzed and suffering from cancer in a hospital in Cannes, took a turn for the worse. Paulo couldn't move. I think he was greatly troubled, knowing that he was unable to be with her and that she would die alone. In a few days she did die. The *coup de grâce* posthumously—was that she was buried in Vallauris, a place she had despised once Pablo and I settled there. She had lived much in Cannes and it would have been more appropriate for her to be buried there. She was a communicant of the Russian Orthodox church and there is an Orthodox cemetery in Cannes, but it was decided Vallauris would be better.

About two weeks after that, now that Paulo was on the mend, Pablo came up to Paris, but for purely personal reasons. I wanted to stabilize my life, and had come to feel I could do that with Luc Simon, a young painter I had known since my teens. I hadn't seen Luc since then until one day about a year after I left Pablo, when I met him, quite by accident, in a bookshop on the Left Bank. After a year of seeing each other again, we had decided to marry and I wanted to tell Pablo my plans. I telephoned him at the Rue des Grands-Augustins and made an appointment with him. He received me after lunch in the long room on the third floor.

When I told him I was thinking of marrying, he grew angry and said, "It's monstrous. You think only of yourself." I told him I wasn't thinking only of myself. I was thinking of the children, too. He calmed down and said, "Well, let's not get into a quarrel right off. I'll get you something to eat." He went into the kitchen and returned with a tangerine. He gave me a piece of it.

"It's better not to get into a row about everything," he said, no doubt recalling our previous meeting at Kahnweiler's country place. I felt he wanted to put this conversation on a different plane, just as though this were our customary meeting-ground, as it had been. We sat

there, talking and eating our tangerine. The charm of the place put us both, I think, a bit under the spell of the old days and it seemed very pleasant to be sitting there together again where everything had begun. Pablo seemed quite relaxed and happy. Just then the door that led from that room into the sculpture atelier opened a crack. Behind it I could see someone listening to everything we said. Whenever we came to what must have seemed too personal a phase in our conversation the door would open wider as a warning to Pablo that he was treading on dangerous ground. He was soon back on formal terms.

"You owe me so much," he said, "this is your way of thanking me, I suppose. Well, I've got just one thing to say. Anybody else will have all of my faults but none of my virtues. I hope it's a fasco, you ungrateful creature." He was wearing a wristwatch I had given him. He pulled it off and threw it at me. "Your time is no longer mine," he said. Since the watch I was wearing was one he had given me, I took it off and handed it over to him. He began to laugh. At that point the door in the rear creaked open again, and he sobered down. I could see there was no point in continuing the discussion and I left.

That summer I sent Claude and Paloma, accompanied by the Martinique maid who took care of them at home in Paris, to visit Pablo, and I arranged with Maya to be there at the same time so that she could look after them, as well. Luc and I were married quietly early in July and left for Venice. I planned to be in Vallauris at the beginning of September.

While I was in Venice, Maya sent me information bulletins about the children and life at *La Californie*, Pablo's new home in Cannes. One day, just before I was to leave, she wrote that *La Galloise* had been emptied completely. I wrote immediately to a lifelong friend of mine, Christiane Bataille, and asked her to get in touch with a *huissier*—a kind of sheriff's officer, or bailiff. When I reached Vallauris, the *huissier* was there to go into the house before me and establish the fact that all my things had been removed. He took the testimony of Monsieur and Madame Michel, my caretakers, who said that everything of mine had been taken out of my house.

Not only the things Pablo had given me, like paintings and drawings, were gone, but my books—I had many and they meant more to me than anything else—my own drawings, and almost all other personal objects had disappeared, even the letters Matisse had written to me over the years. There were the beds and a few chairs, three boxes of papers stored in the attic-where no one, apparently, had thought of looking-and that's all.

After I returned to Paris, I never saw Pablo again. I did hear from him indirectly from time to time: for example, in the spring I was not invited to exhibit at the Salon de Mai. And the next fall, a week after I returned from the clinic with a new daughter, Aurélia, I had a letter from Kahnweiler terminating my contract with him. Occasionally —even today—a picture dealer will tell me that he would like to buy or exhibit my work, but that he doesn't dare to, for fear of losing Pablo's good will. And then there are all those people who showered me with attentions when I was with Pablo but who look the other way when our paths cross now.

Pablo had told me, that first afternoon I visited him alone, in February 1944, that he felt our relationship would bring light into both our lives. My coming to him, he said, seemed like a window that was opening up and he wanted it to remain open. I did, too, as long as it let in the light. When it no longer did, I closed it, much against my own desire. From that moment on, he burned all the bridges that connected me to the past I had shared with him. But in doing so he forced me to discover myself and thus to survive. I shall never cease being grateful to him for that.

INDEX

Adam, Henri-Georges, 144 Adéma, Marcel, 292 Aix, 64 America, 129, 256 Anderson, Sherwood, 61 Andromaque, 34 Antibes, 89, 124-125, 214, 279 Museé d', 124-125, 136, 167-168, 183, 184-185, 202, 228, 281 Apollinaire, Guillaume, 32, 71-72, 128, 139-140, 143, 291-292, 321 Apollinaire, Jacqueline, 393-394 Aragon, Louis, 55, 81, 249-255 Arias, 212, 220 Aristotle, 66 Arles, 64, 219, 221-222, 298, 312 Auberge des Maures, 276 Autobiography of Alice B. Toklas, The, 60 Bakst, Léon, 139-140 Ballets Russes, 139 Balthus, 133 Balzac, Honoré de, 18 Barcelona, 139, 158, 321 School of Fine Arts, 157 Barrault, Jean-Louis, 17 Barrès, Maurice, 252 Bartes, Maurice, 252 Bataille, Christiane, 334 Bataille, Georges, 221 Bataille, Henri, 252 Bâteau Lavoir, 70-91-259 Baudelaire, Charles, 27 Baylot, André, 299 Baziotes, William, 164 Baeudin, André, 29, 267 Beaudin, André, 78, 267 Beaumont, Count Etienne de, 141 Beaumont, Countess Etienne de, 141 Beauvoir, Simone de, 33 Belvédere, Le (clinic), 151, 207 Benois, Alexander, 139-140 Bernard, Guy, 227 Billy, André, 292 Blanche, Jacques-Emile, 228 Blue Enamelled Casserole, 186 B.N.C.I. (Banque Nationale pour le Commerce et l'Industrie), 36, 138, 180 Boisgeloup, 17, 139, 141, 144, 215 Boissière, Mme., 212-214 Boissière, Mme., 212-214 Bonnard, Pierre, 41, 247 Boudin, Marcel, 70, 88, 93-96, 122-123, 148, 152, 159, 195, 200, 206-208, 213, 230, 294-299, 303 Braque, Georges, 67-68, 131-136, 139, 163-164, 185, 250, 259-260, 284 Braque, Mme. Georges, 149

Brassaï, 35, 77, 160 Brasserie Lipp, 187 Brauner, Victor, 78 Breton, André, 37, 77, 82, 129-130 Bretonne, Restif de la, 25 Brière, 100 Brittany, 100 Bruant, Aristide, 70 Bucher, Jeanne, 78-79, 117 Bullfights, Picasso and, 219-220 Burial at Ornans (Courbet), 187 Cachin, Marcel, 255 Café de la Renaissance, 282 Café de l'Union, 120 Cahiers d'Art 14, 32, 178 Caldwell, Erskine, 61 Californie, La (Cannes), 212, 334 Cannes, 124, 214, 333-334 Film Festival, 128 Cap d'Antibes, 83, 124, 141, 224 Caravaggio, Michelangelo Merisi da, 259-260 Carpaccio, Vittore, 278 Carré, Louis, 58-59, 164, 263 Casanova, Danielle, 70 Casanova, Laurent, 70-71, 255-256, 281 Cassou, Jean, 53, 182-183 Castel, André, 219-222 Castelucho, 204 Catalan, Le, 13, 20, 60 Catalan Peasant Woman (Miró), 180 Catalan Feasant W oman (Miro), 180 Cézanne, Paul, 41, 51, 61, 116, 203, 260, 262 Chagall, Bella, 256 Chagall, Ida, 256, 258 Chagall, Marc, 256-258, 260, 319 Chanel, Coco, 178 Chant des Morts, Le (Reverdy), 135, 177-178, 203, 256 Chaplin, Charlie, 232, 317-319 Char, René, 128, 135-136 Charrat, Janine, 324 Chatagnier, Doctor, 277-278 Château de Vallauris, 281 Château Grimaldi, 124 Chef-d'Oeuvre Inconnu, Le (Balzac), 18 Chevalier, Maurice, 252 Chez Francis, 96 Chez Marcel, 89, 126, 130, 183, 275, 297 Chez Sénequie, 278 China, 31, 171 Chirico, Giorgio di, 77 Christ, Jesus, 66 Cintrón, Conchita, 221-222 Clair, René, 163 Cocteau, Jean, 34, 139, 278 279, 281

Collettes, Les (Cagnes), 245 Collioure, 331 Columbus, Christopher, 278 Communist Party, 54-55, 57, 163, 183, 249, 252-256, 265-266, 280 Conquerors, The (Malraux), 33 Coquiot, Gustave, 185 Corot, J.-B.-C., 142 Courbet, Gustave, 117, 187 Couturier, Father, 237-239 Cox, Mr., 168-169 *Crane, The*, 287-288 Cubism, 61, 67-70, 133, 138, 201 Cuisine, La, 203-205, 289 Cuny, Alain, 13-16 Cuttoli, M., 183-184 Cuttoli, Marie, 83, 118, 124, 183, 186, 194, 224, 299 Dante Alighieri, 33 Daumier, Honoré, 85 David, Sylvette, 320-321 Davis, Stuart, 180 Death of Sardanapalus (Delacroix), 187 Delacroix, Eugène, 186-187 Denis, Maurice, 213 Derain, André, 138, 259 Desastres de la Guerra (Goya), 174 Détective (magazine), 272 Deux Magots (café), 77 Diaghilev, Sergei Pavlovich, 139-140 Domínguez, Oscar, 222-223 Dominguín, Luís, 274, 277 Don Juan, 295 Dor de la Souchère, Jules-César Romuald, 125, 183-184 Dos Passos, John, 61 Dubois, André, 32, 33, 299 Duchamp, Marcel, 290 Ehrenberg, Ilya, 199 Eiffel, Gustave, 185 Eiffel Tower, 71 Eluard, Dominique, 275-280, 311, 322 Eluard, Nusch, 128-129, 155, 312 Eluard, Paul, 54-55, 77, 80-82, 128-131, 155-156, 179, 200, 275-280, 281, 303, 311-312, 314, 317 Emmer, Luciano, 278 Ernst, Max, 37, 84 Farm, The (Miró), 180 Faulkner, William, 61 Femme Couchée, 55 Femme-Fleur, La, 108-109, 165 Fenosa, Apelles, 135 Fitzgerald, F. Scott, 61, 141 Fitzgerald, Zelda, 141 Flore, Café de, 97

Giacometti, Alberto, 187-191, 284 Giacometti, Annette, 189 Giacometti, Diego, 188-189 Gide, André, 227-228 Cilles (Directo 152) Gillot, Claude, 152 Glass of Absinthe, A, 23 Goat, The, 286 Goat Skull and Bottle, 289 Goat Skull and Bottle, 289
Gogh, Vincent van, 20, 67-68, 248
Gold Rush, The, 319
Golfe-Juan, 82, 87-88, 124, 126, 128-129, 165-168, 172, 183, 195, 199, 213, 217, 219, 224, 237, 268, 275, 326
Góngora y Argote, Luís de, 173, 176
Gontcharova, Nathalie, 139-140 Gordes, 118 Gorille, Le, 276 Gottlieb, Adolph, 164 Goujon, Jean, 20 Goya, y Lucientes, Francisco, 174, 223 Greco, El, 247 Grimaldi family, 281 Gris, Juan, 51, 60, 62, 71, 259, 266 Guernica, 17, 143, 182, 195, 217 Gutmann, Doctor, 147 Hadjilazaros, Matsie, 314-315, 324 Hegel, Georg, 65-66 Heidegger, Martin, 324 Hemingway, Ernest, 53, 69, 180 Heraclitus, 324 Herbart, Pierre, 228 Homme au Mouton, L', 17, 226, 281-283 Hôtel California, 145 Hôtel du Golfe (Chez Marcel), 224 Hôtel Paradis, 71, 73 Hôtel Régina (Cimiez) 240 Impressionism, 67 Indo-China, 33 Inferno. L' (Dante), 34 Inès, see Sassier, Inès Ingres, J.-A.-D., 152 Isnard (police commissioner), 223-225, 272

Forain, Jean-Louis, 41

172, 201 Franco, Francisco, 36, 141

321

French National Museums, 184

Galerie Louise Leiris, 54, 267 Galerie La Hune, 267 Gallimard (publisher), 292

Fort, Louis, 82, 87-90, 124, 167, 193, 237

Fort, Mme. Louis, 193 Fougeron, André, 279-280, 281 France, Free Zone of, 26, 54 German Occupation of, 13, 54-55, 91, 130,

Galloise, La, 172, 194-195, 200, 212-215, 217-

218, 226, 230, 254, 260, 268, 276, 326-327 Geneviève, 13-16, 18-19, 21, 26, 28, 84, 89-91,

Fontès, 26

INDEX

Jacob, Max, 87-88, 127, 130, 142, 158, 166, 259, 293, 321 "Jacques," M. (picture dealer), 56-58 Jarry, Alfred, 59 Jaspers, Karl, 324 Jeanne d'Arc, 252 Joie de Vivre, La, 126 Joinville, Jean de, 27 Joliot-Curie, Frédéric, 227 Juan-les-Pins, 141, 175, 217, 224, 329 292, 296, 322, 331-335 Kasbek, 35 Khan, Aga, 226 Khan, Aly, 226 Khan, the Begum, 224 Kierkegaard, Sören, 149 Klee, Paul, 180 Kootz, Sam, 164-166, 290 Kostas, 324-325, 327 Kostrowitzky, Comtesse de, 72 Lacan, Doctor, 81-82, 151-152 Laclos, Choderlos de, 25 Lacourière, Roger, 173-174 Lamaze, Doctor, 151-152 Laporte, René, 279

Larjonov, Michel, 139-140 Larionov, Michel, 139-140 Laurencin, Marie, 71-72, 293 Laurens, Henri, 284-285 Lazerme, Count de, 321 Lazerme, Countes de, 321, 331 Léger, Fernand, 37, 178, 258-261 Léger, Mme. Nadia, 260-262 Leiris, Louise ("Zette"), 16, 54, 148, 256, 278, 307, 322 Leiris, Michel, 44, 77, 148, 179, 221, 256 Leporello, 295

- Letters of a Portuguese Nun (Tériade edition), 237, 243 Lettres Françaises, Les (newspaper), 253-254 L'Hospied chemical works, 168 Life (magazine), 56 Limelight, 318-319 Lipchitz, Jacques, 36, 180 Loceb, Pierre, 117, 191
- Louvre (museum), 13-14, 186-187
- Lycée Carnot, 124
- Lydia (Matisse's secretary), 91-92, 127, 176, 238, 241
- Maar, Dora, 13, 15-16, 20, 55, 76-84, 95-99, 113, 117, 118, 122, 124, 128-129, 156, 162, 165, 186, 191-192, 195, 215-216, 217, 218, 244, 266, 279, 292, 308, 320-321

Madoura pottery, 166, 172, 178 Maillol, Aristide, 15, 21 Maison de la Pensée Française, 202-203, 275 Malevich, 261-262 Malherbe, François de, 181 Malraux, André, 33-34, 252 Manolo, Hugué (Manolo), 321 Manolo, Mme. (Totote), 321 Man with the Sheep, The (see, Homme au Mouton, L') Man's Fate (Malraux), 33 Man's Hope (Malraux), 33 Marais, Jean ("Jeannot"), 34-35 Marcel, see Boudin, Marcel Mariette (Braque's secretary), 132 Marseilles, 122, 225 Massacre of Chios, The (Delacroix), 187 Massine, Léonide, 139 Masson, André, 37, 267 Match (magazine), 32, 56, 217 Matisse, Henri, 17, 36-37, 62, 66, 91-92, 109, 127, 131, 134, 139, 142, 176, 185, 237-245, 247-249, 258-260, 284, 334 Matisse, Mme. Henri, 176 Matisse, Pierre 244 Mayakowsky, Vladimir, 182, 251 Ménerbes, 118-124, 130, 191, 224 Metamorphoses (Ovid), 173-176 Meyer, Marcelle, 142 Michel, M., 269, 273-274, 335 Michel, Mme., 269-274, 335 Michelangelo, 226 Milan, 278-279, 314 Miller, Lee, 276 Milliner's Workshop, The, 185-186 Mimosas, Les, 272-278 Minotaure (review), 178 Miró, Joan, 138, 157, 178-180 Modern Style, 67-68 Modigliani, Amedeo, 17, 71 Molière, Jean-Baptiste Poquelin, called, 65, 294 Mollet, "Baron" Jean, 32, 293 Monkey with Young, 287 Monsieur Verdoux, 232, 318 Monte Carlo, 141, 226 Montpellier, 13, 26, 89-81 Medical School, 177 Motherwell, Robert, 164 Mougins, 129, 155, 212 Mourir à Madrid (film), 280 Mourlot, Fernand, 83-86, 114, 163-164, 177-178, 203, 305 Murphy, Gerald, 141 Muse, The, 186 Musée d'Art Moderne (Paris), 53, 182, 184, 186 Museum of Modern Art, N.Y., 180-182

339

Nenni, Pietro, 279 Neuilly, 52, 99, 310 Nîmes, 219-220, 296, 298, 321, 329 Noailles; Marie-Laure, Vicomtesse de, 13, 222-223, 267 Notre-Dame-de-Vie, 212 Nude, Rear View (Matisse), 294 Olivier, Fernande, 9, 70, 73, 293 Ovid, 173-174, 176 Parade (ballet), 139 Paris, 13, 15, 29, 31, 54 Ile de la Cité, 20, 50 Ile St.-Louis, 52-63 Left Bank, 13, 25 Liberation of, 53, 55, 79, 119, 160, 283 Municipal Council, 292 Vert Galant, 20, 50 Pellequer, Max, 161 Penrose, Mrs. Roland, 276 Pétain, Marshal, 167 Philip II (of Spain), 160, 162 Picasso, Claude, 152, 156-157, 160, 163, 192-193, 196, 200, 205, 210, 212, 217-218, 227, 230-233, 256, 268-269, 287, 309, 326-327, 331, 334, Picasso, Maya, 53, 121, 141, 162, 215-216, 217-218, 278, 324-325, 334 Picasso, Olga Khoklova, 121, 139-142, 145-147, 192-193, 211, 292, 308, 333 Picasso, Pablo, Blue Period, 70, 72, 73, 128, 152 and book illustration, 173-178 passim break-up with Françoise, 303-335 passim Cubist period, 16, 20, 40, 64, 68, 70, 185 and dealers, 262-267 and Germans, 35-37 and Liberation, 54-56 and lithography, 83-87, 114, 164, 177-178, 202-203 membership in Communist Party, 55-57, 163, 183, 252-253 paints La Femme-Fleur, 107-111 and pottery, 167-173, 194, 202-203, 229 and sculpture, 281-294 and sculpture, 201294 theories of art, 49-52, 63-69, 84-85, 108-114, 115-117, 181-182, 202-203 Picasso, Paloma, 206-208, 212, 217, 220, 232-233, 242, 245-248, 303, 305, 309, 325, 334 Picasso, Paul ("Paulo"), 121, 140, 142, 144, 147, 192-193, 195, 217, 219-220, 223-227, 269, 206, 208, 231, 325 268, 296, 298, 331, 333 Pichot, Germaine, 74 Plato, 181 Poe, Edgar Allan, 27 Poète Assassiné, Le, 291 Pollock, Jackson, 244 Portrait of Dora Maar, 13-14 Portrait with the Polish Coat, 203

Portrait of Mlle. Rivière (Ingres), 152 Pourbus, 18 Poussin, Nicolas, 53, 116, 246 Pregnant Woman, 288 Prévert, Jacques, 33, 229 Rabelais, François, 27 Racine, Jean, 34 Ramié, M., 166-167, 169, 194, 276 Ramié, Mme., 167, 169, 194, 275-276, 285-286, 311-313, 322, 325-326, 328 Ray, Man, 14, 77 Raysséguier, Brother, 237 Reclining Woman, 127 Rembrandt van Rijn, 41, 43, 146 Renoir, P.-A., 41, 57, 138, 245 Représentants des puissances étrangères, etc. (Rousseau), 152 Réve, Le (Vence), 285 Reverdy, Pierre, 33, 71, 135-136, 177-178, 203, 256 Rigaud, Hyacinthe, 13 Rimbaud, Arthur, 38, 182 Robeson, Paul, 206 Rocking-Chair, The, 186 Rome, 139, 278-279, 314 Roque, Jacqueline, 326-327, 329-331, 334 Rosenberg, Paul, 55, 140, 142, 164, 262-263, 295 Rossif, Frédéric, 279 Rostand, Jean, 227 Rothschild, Baron Philippe de, 226-227 Rouault, Georges, 41 Rousseau, Henri (Le Douanier), 17, 138, 151-152 Rousseau, Jean-Jacques, 82 Rout of San Romano, The (Uccello), 187 Roy, Claude, 278 Rozsda, Endre, 27-28 Ruche, La, 259 Russia, 182, 257 Sabartés, Jaime, 16-17, 18, 21-22, 33, 35-36, 38-40, 81, 115, 136, 146, 155, 157-160. 161-163, 165-166, 223, 293, 297, 300, 322 Sabartés, Mme. Jaime, 158-159, 161 Sade, Marquis de, 25, 226 Saint Bonaventure on his Bier (Zurbaran), 187 St. Dominic, 238 St.-Germain-des-Prés, 187, 292 St.-Jean-Cap-Ferrat, 178, 256 St. John of the Cross, 149 St. Teresa, 149 St.-Tropez, 275, 277-278, 311 Salle Pleyel, 206, 249 Salles, Georges, 184-187 Salon d'Automne, 53 Salon de Mai, 335 Saltimbanques, Les, 88, 128, 317

INDEX

Sartre, Jean-Paul, 33, 227 Sassier, Gustave, 155 Sassier, Inès, 22, 143, 146, 152-157, 159, 161-162, 209, 325 Scheler, Lucien, 177 Serenade, 185-186 Shakespeare, William, 65 Sima, 125, 136 Simon, Aurélia, 335 Simon, Luc, 333 Skira, Albert, 173-176, 178 Soeur, Jacques, 237, 243 Spain, 33, 183 Spanish Civil War, 141 Stalin, Josef, 253-254, 265, 279 Stein, Gertrude, 60-63, 140 Steinbeck, John, 61 Stravinsky, Igor, 139 Studio, The (Courbet), 187 Sweeney, James Johnson, 180-181 Switzerland, 128, 223-224

Talleyrand, 252 Tériade, E., 177-178, 237, 256-258, 306 Thorez, Maurice, 255-256 Tintoretto, Jacopo, 247 Toklas, Alice B., 9, 60-63 Totote, see Manolo, Mme. Tower of Babel, The (Noailles), 13 Triolet, Elsà, 250-251 Triumph of Pan, The (Poussin), 53 Tuttin, M., 85-87

Uccello, Paolo, 187 Uhde, Wilhelm, 140 Ulysses and the Sirens, 126-127, 167 Utrillo, Maurice, 71

Valéry, Paul, 246 Vallauris, 17, 166-167, 178, 193-195, 199, 202, 209, 212, 226-227, 231, 243, 249, 253, 261, 266, 269-271, 274-277, 281, 297, 307, 324, 327, 333 Valsuani, 283-284 Védrès, Nicole, 227-228 Velázquez, 40, 260 Vence, 90, 176, 237 St.-Paul-de, 134, 255 Vénus du Gaz, La, 282 Verdet, André, 281 Verve (review), 178, 306 Vilato, Fin, 221 Vilato, Javier, 157, 204, 221-222, 314, 324 Villon, François, 27 Vollard, Ambroise, 40-41, 89, 193, 262-263 Vuillard, Edouard, 17, 132 Walter, Marie-Thérèse, 53, 55, 121-124 passim, 124, 141, 156, 162, 185, 191, 195-196, 215-216, 217-218, 278, 308, 320, 324 Warsaw, 199-201 Wars I Have Seen (Stein), 62 Watteau, Antoine, 152 Weisweiller, Mme., 278 Woman Eating Sea Urchins, 126-127 Woman's Head, 288 Women of Algiers, The (Delacroix), 187 World Peace Congress (Paris), 206, 249 World War I, 139, 245, 281 Wroclaw, Poland, 222 Peace Conference at, 199, 201 Zadkine, Ossip, 38, 291 Zervos, Christian, 32, 135-136, 178, 295

Zarvos, Christian, 32, 135-136, 178, 295 Ziquet, Le, 326 Zurbarán, Francisco, 187

ILLUSTRATION CREDITS

- 19. Hélène Adant/GAMMA RAPHO; copyright © by CNAC/MNAM/ Dist. RMN–Grand Palais/Art Resource, NY.
- 1. Used by permission of Atelier Rozsda.
- 20. Copyright © by Henri Cartier-Bresson/Magnum Photos.
- 16. Copyright © by Robert Doisneau/Gamma Rapho.
- 2, 4, 5, 15, 32, 33, 44. Copyright © by Françoise Gilot, used by permission of the artist.
- 29, 37. Copyright © by J.C.C. Glass.
- 35. Copyright © by Marianne Hederström Greenwood.
- 13, 14, 21, 41. Copyright © by the International Center of Photography/ Robert Capa/Magnum Photos.
- 23. Copyright © by Keystone-France/GAMMA RAPHO.
- 18, 25. Copyright © by Felix H. Man.
- 42. Copyright © by J. Paul Getty Trust, Getty Research Institute, Los Angeles.
- 28. Copyright © by Gjon Mili/Contributor/Getty Images.
- 36. Photograph supplied courtesy of Museum of New Zealand Te Papa Tongarewa.
- 9, 22, 24, 30. Copyright © 2019 by the Estate of Pablo Picasso/Artists Rights Society (ARS), New York.
- 6. Copyright © 2019 by the Estate of Pablo Picasso / Artists Rights Society (ARS), New York; image copyright © by Thomas Ammann Fine Art Gallery, Zurich, Switzerland/Artothek/Bridgeman Images.
- 8. Copyright © 2019 by the Estate of Pablo Picasso / Artists Rights Society

(ARS), New York; image copyright © by Museum of Modern Art, New York, USA/Bridgeman.

- 10. Copyright © 2019 by the Estate of Pablo Picasso / Artists Rights Society (ARS), New York; image copyright © by Private Collection/Bridgeman-Giraudon/Art Resource, NY.
- 31. Copyright © 2019 by the Estate of Pablo Picasso / Artists Rights Society (ARS), New York; image copyright © by Private Collection/Bridgeman Images.
- 7, 38. Copyright © 2019 by the Estate of Pablo Picasso / Artists Rights Society (ARS), New York; photo by Mathieu Rabeau, Musée National Picasso, Paris; copyright © by RMN–Grand Palais/Art Resource, NY.

34. Copyright © by Edward Quinn, edwardquinn.com.

40. Musée National Picasso, Paris; copyright © by RMN–Grand Palais/Art Resource, NY.

26. Copyright © by Claude Roy.

17. Copyright © by Emil Schulthess / Fotostiftung Schweiz.

39. Copyright © by the Estate of Michel Sima; photo by Mathieu Rabeau, Musée National Picasso, Paris; copyright © by RMN–Grand Palais/Art Resource, NY.

OTHER NEW YORK REVIEW CLASSICS

For a complete list of titles, visit www.nyrb.com or write to: Catalog Requests, NYRB, 435 Hudson Street, New York, NY 10014

J.R. ACKERLEY My Dog Tulip* J.R. ACKERLEY My Father and Myself* J.R. ACKERLEY We Think the World of You* HENRY ADAMS The Jeffersonian Transformation **RENATA ADLER** Pitch Dark* **RENATA ADLER** Speedboat* AESCHYLUS Prometheus Bound; translated by Joel Agee* **ROBERT AICKMAN** Compulsory Games* LEOPOLDO ALAS His Only Son with Doña Berta* **CÉLESTE ALBARET** Monsieur Proust DANTE ALIGHIERI The Inferno **ROBERT AICKMAN** Compulsory Games* KINGSLEY AMIS The Alteration* KINGSLEY AMIS Dear Illusion: Collected Stories* KINGSLEY AMIS Ending Up* KINGSLEY AMIS Girl, 20* KINGSLEY AMIS The Green Man* KINGSLEY AMIS Lucky Jim* KINGSLEY AMIS The Old Devils* KINGSLEY AMIS One Fat Englishman* KINGSLEY AMIS Take a Girl Like You* **ROBERTO ARLT** The Seven Madmen* U.R. ANANTHAMURTHY Samskara: A Rite for a Dead Man* IVO ANDRIĆ Omer Pasha Latas* WILLIAM ATTAWAY Blood on the Forge W.H. AUDEN (EDITOR) The Living Thoughts of Kierkegaard **EVE BABITZ** Eve's Hollywood* EVE BABITZ Slow Days, Fast Company; The World, the Flesh, and L.A.* DOROTHY BAKER Cassandra at the Wedding* DOROTHY BAKER Young Man with a Horn* J.A. BAKER The Peregrine S. JOSEPHINE BAKER Fighting for Life* HONORÉ DE BALZAC The Human Comedy: Selected Stories* HONORÉ DE BALZAC The Memoirs of Two Young Wives* HONORÉ DE BALZAC The Unknown Masterpiece and Gambara* VICKI BAUM Grand Hotel* SYBILLE BEDFORD Jigsaw* SYBILLE BEDFORD A Legacy* SYBILLE BEDFORD A Visit to Don Otavio: A Mexican Journey* MAX BEERBOHM The Prince of Minor Writers: The Selected Essays of Max Beerbohm* MAX BEERBOHM Seven Men STEPHEN BENATAR Wish Her Safe at Home* FRANS G. BENGTSSON The Long Ships* ALEXANDER BERKMAN Prison Memoirs of an Anarchist **GEORGES BERNANOS** Mouchette MIRON BIAŁOSZEWSKI A Memoir of the Warsaw Uprising* ADOLFO BIOY CASARES The Invention of Morel

* Also available as an electronic book.

PAUL BLACKBURN (TRANSLATOR) Proensa* **CAROLINE BLACKWOOD** Corrigan* CAROLINE BLACKWOOD Great Granny Webster* LESLEY BLANCH Journey into the Mind's Eye: Fragments of an Autobiography* RONALD BLYTHE Akenfield: Portrait of an English Village* NICOLAS BOUVIER The Way of the World EMMANUEL BOVE Henri Duchemin and His Shadows* **EMMANUEL BOVE** My Friends* MALCOLM BRALY On the Yard* MILLEN BRAND The Outward Room* **ROBERT BRESSON** Notes on the Cinematograph* SIR THOMAS BROWNE Religio Medici and Urne-Buriall* DAVID R. BUNCH Moderan* JOHN HORNE BURNS The Gallery **ROBERT BURTON** The Anatomy of Melancholy MATEI CALINESCU The Life and Opinions of Zacharias Lichter* CAMARA LAYE The Radiance of the King **DON CARPENTER** Hard Rain Falling* J.L. CARR A Month in the Country* LEONORA CARRINGTON Down Below* **BLAISE CENDRARS** Moravagine **EILEEN CHANG** Little Reunions* **EILEEN CHANG** Love in a Fallen City* **EILEEN CHANG** Naked Earth* JOAN CHASE During the Reign of the Queen of Persia* ELLIOTT CHAZE Black Wings Has My Angel* UPAMANYU CHATTERJEE English, August: An Indian Story FRANÇOIS-RENÉ DE CHATEAUBRIAND Memoirs from Beyond the Grave, 1768-1800 NIRAD C. CHAUDHURI The Autobiography of an Unknown Indian **ANTON CHEKHOV** Peasants and Other Stories GABRIEL CHEVALLIER Fear: A Novel of World War I* JEAN-PAUL CLÉBERT Paris Vagabond* **RICHARD COBB** Paris and Elsewhere **COLETTE** The Pure and the Impure JOHN COLLIER Fancies and Goodnights CARLO COLLODI The Adventures of Pinocchio* D.G. COMPTON The Continuous Katherine Mortenhoe IVY COMPTON-BURNETT A House and Its Head BARBARA COMYNS The Juniper Tree* BARBARA COMYNS Our Spoons Came from Woolworths* ALBERT COSSERY Proud Beggars* ALBERT COSSERY The Jokers* ASTOLPHE DE CUSTINE Letters from Russia* JÓZEF CZAPSKI Inhuman Land: A Wartime Journey through the USSR* JÓZEF CZAPSKI Lost Time: Lectures on Proust in a Soviet Prison Camp* LORENZO DA PONTE Memoirs ELIZABETH DAVID A Book of Mediterranean Food L.J. DAVIS A Meaningful Life* AGNES DE MILLE Dance to the Piper* VIVANT DENON No Tomorrow/Point de lendemain MARIA DERMOÛT The Ten Thousand Things **ANTONIO DI BENEDETTO** Zama* ALFRED DÖBLIN Berlin Alexanderplatz*

ALFRED DÖBLIN Bright Magic: Stories* JEAN D'ORMESSON The Glory of the Empire: A Novel, A History* ARTHUR CONAN DOYLE The Exploits and Adventures of Brigadier Gerard BRUCE DUFFY The World As I Found It* DAPHNE DU MAURIER Don't Look Now: Stories ELAINE DUNDY The Dud Avocado* ELAINE DUNDY The Old Man and Me* G.B. EDWARDS The Book of Ebenezer Le Page* JOHN EHLE The Land Breakers* EURIPIDES Grief Lessons: Four Plays; translated by Anne Carson J.G. FARRELL Troubles* J.G. FARRELL The Siege of Krishnapur* J.G. FARRELL The Singapore Grip* **ELIZA FAY** Original Letters from India KENNETH FEARING The Big Clock FÉLIX FÉNÉON Novels in Three Lines* M.I. FINLEY The World of Odysseus THOMAS FLANAGAN The Year of the French* BENJAMIN FONDANE Existential Monday: Philosophical Essays* SANFORD FRIEDMAN Conversations with Beethoven* MARC FUMAROLI When the World Spoke French CARLO EMILIO GADDA That Awful Mess on the Via Merulana **BENITO PÉREZ GÁLDOS** Tristana* MAVIS GALLANT The Cost of Living: Early and Uncollected Stories* **MAVIS GALLANT** Paris Stories* MAVIS GALLANT A Fairly Good Time with Green Water, Green Sky* **MAVIS GALLANT** Varieties of Exile* GABRIEL GARCÍA MÁRQUEZ Clandestine in Chile: The Adventures of Miguel Littín **LEONARD GARDNER** Fat City* WILLIAM H. GASS In the Heart of the Heart of the Country and Other Stories* WILLIAM H. GASS On Being Blue: A Philosophical Inquiry* **THÉOPHILE GAUTIER** My Fantoms GE FEI The Invisibility Cloak JEAN GENET Prisoner of Love ÉLISABETH GILLE The Mirador: Dreamed Memories of Irène Némirovsky by Her Daughter* NATALIA GINZBURG Family Lexicon* FRANÇOISE GILOT Life with Picasso* JEAN GIONO Hill* JEAN GIONO Melville: A Novel* JOHN GLASSCO Memoirs of Montparnasse* P.V. GLOB The Bog People: Iron-Age Man Preserved NIKOLAI GOGOL Dead Souls* EDMOND AND JULES DE GONCOURT Pages from the Goncourt Journals ALICE GOODMAN History Is Our Mother: Three Libretti* PAUL GOODMAN Growing Up Absurd: Problems of Youth in the Organized Society* EDWARD GOREY (EDITOR) The Haunted Looking Glass JEREMIAS GOTTHELF The Black Spider* A.C. GRAHAM Poems of the Late T'ang JULIEN GRACQ Balcony in the Forest* **HENRY GREEN** Caught* **HENRY GREEN** Doting* **HENRY GREEN** Loving* WILLIAM LINDSAY GRESHAM Nightmare Alley*

HANS HERBERT GRIMM Schlump* EMMETT GROGAN Ringolevio: A Life Played for Keeps VASILY GROSSMAN Everything Flows* **VASILY GROSSMAN** Life and Fate* **VASILY GROSSMAN** Stalingrad* LOUIS GUILLOUX Blood Dark* OAKLEY HALL Warlock PATRICK HAMILTON The Slaves of Solitude* PATRICK HAMILTON Twenty Thousand Streets Under the Sky* PETER HANDKE Short Letter, Long Farewell PETER HANDKE Slow Homecoming THORKILD HANSEN Arabia Felix: The Danish Expedition of 1761-1767* ELIZABETH HARDWICK The Collected Essays of Elizabeth Hardwick* ELIZABETH HARDWICK The New York Stories of Elizabeth Hardwick* **ELIZABETH HARDWICK** Seduction and Betraval* ELIZABETH HARDWICK Sleepless Nights* L.P. HARTLEY Eustace and Hilda: A Trilogy* L.P. HARTLEY The Go-Between* NATHANIEL HAWTHORNE Twenty Days with Julian & Little Bunny by Papa ALFRED HAYES In Love* ALFRED HAYES My Face for the World to See* PAUL HAZARD The Crisis of the European Mind: 1680-1715* ALICE HERDAN-ZUCKMAYER The Farm in the Green Mountains* WOLFGANG HERRNDORF Sand* **GILBERT HIGHET** Poets in a Landscape **RUSSELL HOBAN** Turtle Diarv* JANET HOBHOUSE The Furies YOEL HOFFMANN The Sound of the One Hand: 281 Zen Koans with Answers* HUGO VON HOFMANNSTHAL The Lord Chandos Letter* JAMES HOGG The Private Memoirs and Confessions of a Justified Sinner **RICHARD HOLMES** Shelley: The Pursuit* ALISTAIR HORNE A Savage War of Peace: Algeria 1954-1962* **GEOFFREY HOUSEHOLD** Rogue Male* WILLIAM DEAN HOWELLS Indian Summer BOHUMIL HRABAL Dancing Lessons for the Advanced in Age* BOHUMIL HRABAL The Little Town Where Time Stood Still* DOROTHY B. HUGHES The Expendable Man* DOROTHY B. HUGHES In a Lonely Place* **RICHARD HUGHES** A High Wind in Jamaica* **RICHARD HUGHES** In Hazard* **INTIZAR HUSAIN** Basti* **MAUDE HUTCHINS** Victorine YASUSHI INOUE Tun-huang* DARIUS JAMES Negrophobia: An Urban Parable **HENRY JAMES** The Ivory Tower HENRY JAMES The New York Stories of Henry James* **TOVE JANSSON** Fair Play * **TOVE JANSSON** The Summer Book* **TOVE JANSSON** The True Deceiver* TOVE JANSSON The Woman Who Borrowed Memories: Selected Stories* RANDALL JARRELL (EDITOR) Randall Jarrell's Book of Stories **UWE JOHNSON** Anniversaries* **DAVID JONES** In Parenthesis

JOSEPH JOUBERT The Notebooks of Joseph Joubert; translated by Paul Auster KABIR Songs of Kabir; translated by Arvind Krishna Mehrotra* FRIGYES KARINTHY A Journey Round My Skull ERICH KÄSTNER Going to the Dogs: The Story of a Moralist* HELEN KELLER The World I Live In YASHAR KEMAL Memed, My Hawk YASHAR KEMAL They Burn the Thistles WALTER KEMPOWSKI All for Nothing MURRAY KEMPTON Part of Our Time: Some Ruins and Monuments of the Thirties* **RAYMOND KENNEDY** Ride a Cockhorse* DAVID KIDD Peking Story* ROBERT KIRK The Secret Commonwealth of Elves, Fauns, and Fairies **ARUN KOLATKAR** Jejuri DEZSŐ KOSZTOLÁNYI Skylark* TÉTÉ-MICHEL KPOMASSIE An African in Greenland **TOM KRISTENSEN** Havoc* GYULA KRÚDY The Adventures of Sindbad* GYULA KRÚDY Sunflower* SIGIZMUND KRZHIZHANOVSKY Autobiography of a Corpse* SIGIZMUND KRZHIZHANOVSKY The Letter Killers Club* SIGIZMUND KRZHIZHANOVSKY Memories of the Future SIGIZMUND KRZHIZHANOVSKY The Return of Munchausen K'UNG SHANG-JEN The Peach Blossom Fan* GIUSEPPE TOMASI DI LAMPEDUSA The Professor and the Siren GERT LEDIG The Stalin Front* MARGARET LEECH Reveille in Washington: 1860-1865* PATRICK LEIGH FERMOR Between the Woods and the Water* PATRICK LEIGH FERMOR The Broken Road* PATRICK LEIGH FERMOR A Time of Gifts* PATRICK LEIGH FERMOR A Time to Keep Silence* PATRICK LEIGH FERMOR The Violins of Saint-Jacques* SIMON LEYS The Death of Napoleon* SIMON LEYS The Hall of Uselessness: Collected Essays* DWIGHT MACDONALD Masscult and Midcult: Essays Against the American Grain* **CURZIO MALAPARTE** Kaputt CURZIO MALAPARTE The Kremlin Ball CURZIO MALAPARTE The Skin JANET MALCOLM In the Freud Archives JEAN-PATRICK MANCHETTE Fatale* JEAN-PATRICK MANCHETTE Ivory Pearl* JEAN-PATRICK MANCHETTE The Mad and the Bad* **OSIP MANDELSTAM** The Selected Poems of Osip Mandelstam **OLIVIA MANNING** Fortunes of War: The Balkan Trilogy* OLIVIA MANNING Fortunes of War: The Levant Trilogy* JAMES VANCE MARSHALL Walkabout* **GUY DE MAUPASSANT** Afloat GUY DE MAUPASSANT Alien Hearts* **GUY DE MAUPASSANT** Like Death* JAMES McCOURT Mawrdew Czgowchwz* WILLIAM McPHERSON Testing the Current* MEZZ MEZZROW AND BERNARD WOLFE Really the Blues* HENRI MICHAUX Miserable Miracle JESSICA MITFORD Hons and Rebels

JESSICA MITFORD Poison Penmanship* NANCY MITFORD Frederick the Great* NANCY MITFORD Madame de Pompadour* NANCY MITFORD The Sun King* NANCY MITFORD Voltaire in Love* KENJI MIYAZAWA Once and Forever: The Tales of Kenji Miyazawa* PATRICK MODIANO In the Café of Lost Youth* PATRICK MODIANO Young Once* MICHEL DE MONTAIGNE Shakespeare's Montaigne; translated by John Florio* HENRY DE MONTHERLANT Chaos and Night BRIAN MOORE The Lonely Passion of Judith Hearne* BRIAN MOORE The Mangan Inheritance* **ALBERTO MORAVIA** Agostino* **ALBERTO MORAVIA** Boredom* ALBERTO MORAVIA Contempt* JAN MORRIS Conundrum* **GUIDO MORSELLI** The Communist* PENELOPE MORTIMER The Pumpkin Eater* MULTITULI Max Havelaar, or or the Coffee Auctions of hthe Dutch Trading Company* **NESCIO** Amsterdam Stories* DARCY O'BRIEN A Way of Life, Like Any Other SILVINA OCAMPO Thus Were Their Faces* IRIS ORIGO A Chill in the Air: An Italian War Diary, 1939–1940* IRIS ORIGO War in Val d'Orcia: An Italian War Diary, 1943–1944* MAXIM OSIPOV Rock, Paper, Scissors and Other Stories* LEV OZEROV Portraits Without Frames* **ALEXANDROS PAPADIAMANTIS** The Murderess **CESARE PAVESE** The Selected Works of Cesare Pavese **BORISLAV PEKIĆ Houses* ELEANOR PERÉNYI** More Was Lost: A Memoir* LUIGI PIRANDELLO The Late Mattia Pascal JOSEP PLA The Gray Notebook DAVID PLANTE Difficult Women: A Memoir of Three* ANDREY PLATONOV The Foundation Pit **ANDREY PLATONOV** Soul and Other Stories **NORMAN PODHORETZ** Making It* J.F. POWERS Morte d'Urban* J.F. POWERS The Stories of I.F. Powers* CHRISTOPHER PRIEST Inverted World* **BOLESŁAW PRUS** The Doll* GEORGE PSYCHOUNDAKIS The Cretan Runner: His Story of the German Occupation* ALEXANDER PUSHKIN The Captain's Daughter* **QIU MIAOJIN** Last Words from Montmartre* QIU MIAOJIN Notes of a Crocodile* RAYMOND QUENEAU We Always Treat Women Too Well **RAYMOND QUENEAU** Witch Grass **RAYMOND RADIGUET** Count d'Orgel's Ball PAUL RADIN Primitive Man as Philosopher* FRIEDRICH RECK Diary of a Man in Despair* JULES RENARD Nature Stories* JEAN RENOIR Renoir, My Father GREGOR VON REZZORI Abel and Cain* GREGOR VON REZZORI An Ermine in Czernopol*

GREGOR VON REZZORI Memoirs of an Anti-Semite* GREGOR VON REZZORI The Snows of Yesteryear: Portraits for an Autobiography* TIM ROBINSON Stones of Aran: Labyrinth TIM ROBINSON Stones of Aran: Pilgrimage MILTON ROKEACH The Three Christs of Ypsilanti* FR. ROLFE Hadrian the Seventh **GILLIAN ROSE** Love's Work LINDA ROSENKRANTZ Talk* LILLIAN ROSS Picture* WILLIAM ROUGHEAD Classic Crimes **UMBERTO SABA** Ernesto* JOAN SALES Uncertain Glory* TAYEB SALIH Season of Migration to the North TAYEB SALIH The Wedding of Zein* JEAN-PAUL SARTRE We Have Only This Life to Live: Selected Essays. 1939-1975 **ARTHUR SCHNITZLER** Late Fame* GERSHOM SCHOLEM Walter Benjamin: The Story of a Friendship* DANIEL PAUL SCHREBER Memoirs of My Nervous Illness JAMES SCHUYLER Alfred and Guinevere JAMES SCHUYLER What's for Dinner?* SIMONE SCHWARZ-BART The Bridge of Beyond* LEONARDO SCIASCIA The Day of the Owl LEONARDO SCIASCIA Equal Danger LEONARDO SCIASCIA The Moro Affair LEONARDO SCIASCIA To Each His Own LEONARDO SCIASCIA The Wine-Dark Sea VICTOR SEGALEN René Levs* ANNA SEGHERS The Seventh Cross* ANNA SEGHERS Transit* PHILIPE-PAUL DE SÉGUR Defeat: Napoleon's Russian Campaign VICTOR SERGE The Case of Comrade Tulayev* VICTOR SERGE Notebooks, 1936-1947* VICTOR SERGE Unforgiving Years VARLAM SHALAMOV Kolyma Stories* ROBERT SHECKLEY The Store of the Worlds: The Stories of Robert Sheckley* CHARLES SIMIC Dime-Store Alchemy: The Art of Joseph Cornell WILLIAM SLOANE The Rim of Morning: Two Tales of Cosmic Horror* SASHA SOKOLOV A School for Fools* VLADIMIR SOROKIN Ice Trilogy* VLADIMIR SOROKIN The Queue NATSUME SOSEKI The Gate* DAVID STACTON The Judges of the Secret Court* JEAN STAFFORD The Mountain Lion **RICHARD STERN** Other Men's Daughters GEORGE R. STEWART Names on the Land STENDHAL The Life of Henry Brulard **ADALBERT STIFTER** Rock Crystal* THEODOR STORM The Rider on the White Horse JEAN STROUSE Alice James: A Biography* **HOWARD STURGIS** Belchamber ITALO SVEVO As a Man Grows Older HARVEY SWADOS Nights in the Gardens of Brooklyn MAGDA SZABÓ The Door*

MAGDA SZABÓ Katalin Street* ANTAL SZERB Journey by Moonlight* **ELIZABETH TAYLOR** Angel* **ELIZABETH TAYLOR** A View of the Harbour* TEFFI Memories: From Moscow to the Black Sea* TEFFI Tolstoy, Rasputin, Others, and Me: The Best of Teffi* HENRY DAVID THOREAU The Journal: 1837-1861* ALEKSANDAR TIŠMA The Book of Blam* ALEKSANDAR TIŠMA The Use of Man* TATYANA TOLSTAYA White Walls: Collected Stories EDWARD JOHN TRELAWNY Records of Shelley, Byron, and the Author LIONEL TRILLING The Liberal Imagination* MARINA TSVETAEVA Earthly Signs: Moscow Diaries, 1917-1922* KURT TUCHOLSKY Castle Gripsholm* **IVAN TURGENEV** Virgin Soil JULES VALLÈS The Child RAMÓN DEL VALLE-INCLÁN Tyrant Banderas* MARK VAN DOREN Shakespeare CARL VAN VECHTEN The Tiger in the House SALKA VIERTEL The Kindness of Strangers* **ELIZABETH VON ARNIM** The Enchanted April* EDWARD LEWIS WALLANT The Tenants of Moonbloom **ROBERT WALSER** Girlfriends, Ghosts, and Other Stories* **ROBERT WALSER** Jakob von Gunten MICHAEL WALZER Political Action: A Practical Guide to Movement Politics* **REX WARNER** Men and Gods SYLVIA TOWNSEND WARNER Lolly Willowes* SYLVIA TOWNSEND WARNER Summer Will Show* JAKOB WASSERMANN My Marriage* **ALEKSANDER WAT My Century*** C.V. WEDGWOOD The Thirty Years War SIMONE WEIL On the Abolition of All Political Parties* SIMONE WEIL AND RACHEL BESPALOFF War and the Iliad HELEN WEINZWEIG Basic Black with Pearls* **GLENWAY WESCOTT** The Pilgrim Hawk* **REBECCA WEST** The Fountain Overflows EDITH WHARTON The New York Stories of Edith Wharton* KATHARINE S. WHITE Onward and Upward in the Garden* PATRICK WHITE Riders in the Chariot T.H. WHITE The Goshawk* JOHN WILLIAMS Augustus* JOHN WILLIAMS Butcher's Crossing* JOHN WILLIAMS Nothing but the Night* JOHN WILLIAMS Stoner* **ANGUS WILSON** Anglo-Saxon Attitudes **EDMUND WILSON** Memoirs of Hecate County RUDOLF AND MARGARET WITTKOWER Born Under Saturn **GEOFFREY WOLFF** Black Sun* FRANCIS WYNDHAM The Complete Fiction JOHN WYNDHAM Chocky STEFAN ZWEIG Beware of Pity* **STEFAN ZWEIG** Chess Story* **STEFAN ZWEIG** Confusion*